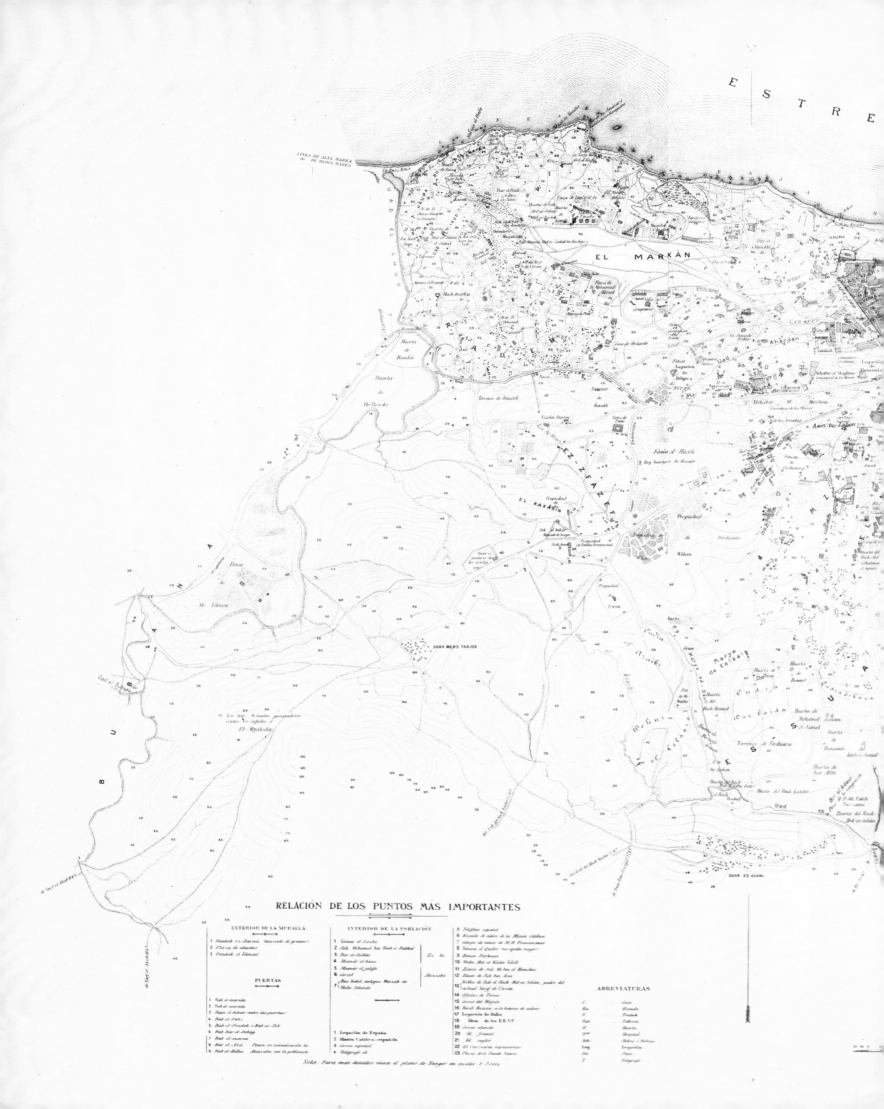

RELACIÓN DE LOS PUNTOS MÁS IMPORTANTES

EXTERIOR DE LA MURALLA

1 Fondak ez-Zaraá «mercado de granos»
2 Plaza de abastos
3 Fondak el Yámeé

PUERTAS

1 Bab el-mensiá
2 Bab el-mersiá
3 Bab el-bahar «entre las puertas»
4 Bab el-Fahs
5 Bab el-Fondak ó Bab es-Sok
6 Bab Dar-el-Dubaig
7 Bab el-marsa
8 Bab el-Aún Puerta en comunicación la
9 Bab el-Haha Alcazaba con la población

INTERIOR DE LA POBLACIÓN

1 Yámaa el-Kásba
2 Sidi Mohamed ben Tbeb el Bakkal
3 Dar es-Sultán
4 Mesmuár el-bisra
5 Mesmuár el palijía
6 carcel
7 Mulei Solimán

1 Legación de España
2 Misión Católica-española
3 Correo español
4 Telégrafo el

5 Teléfono español
6 Escuela de niños de la Misión Católica
7 colegio de niños de M.M. Francisconas
8 Yámaa el Quebir «mezquita mayor»
9 Baños Bárbaros
10 Mulei Abd el Kóder Yeilill
11 Zauia de Sidi Alí ben el Hamdúes
12 Zauia de Sidi ben Aisa
13 Kobba de Sidi el Haxti Abd-es-Selám, padre del actual Xerif d'Uazán
14 Oficinas de Torres
15 Correo del Mejzén
16 Bardt Mesuar, ó la batería de salvas
17 Legación de Italia
18 Idem de los EE.UU.
19 Correo alemán
20 Id. francés
21 Id. inglés
22 El Corrxxxxx xxxxxxxx
23 Plaza de la Fuente Nueva

ABREVIATURAS

C.	Casa
Kse	Kasaba
F.	Fondak
Fab	Fábrica
H.	Huerta
Hosp	Hospital
Hobo	Hebreo ó Hebrea
Leg	Legación
Pat	Patio
T	Telégrafo

Nota: Para más detalles véase el plano de Tánger en escala 1: 2000

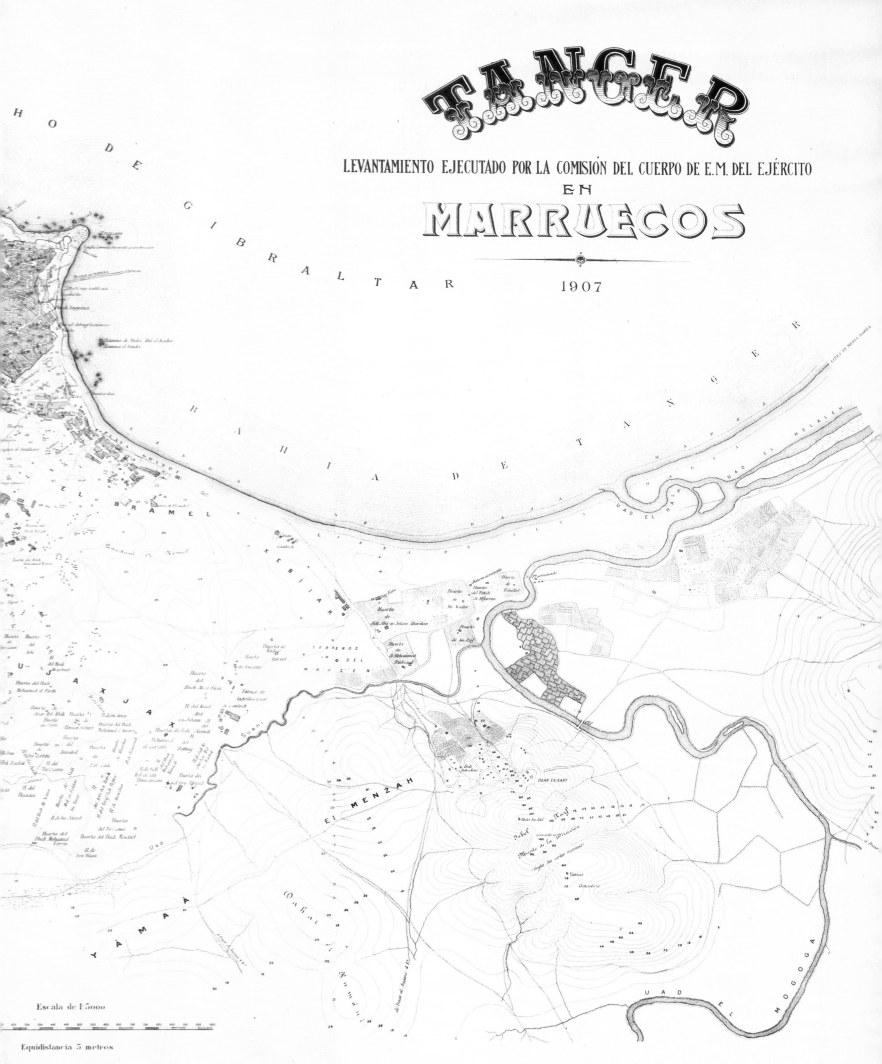

TANGER

LEVANTAMIENTO EJECUTADO POR LA COMISIÓN DEL CUERPO DE E.M. DEL EJÉRCITO

EN

MARRUECOS

1907

Escala de 1:5000

Equidistancia 5 metros

MATISSE IN MOROCCO

MATISSE IN MOROCCO
The Paintings and Drawings, 1912–1913

Jack Cowart

Pierre Schneider

John Elderfield

Albert Kostenevich

Laura Coyle

National Gallery of Art, Washington

The exhibition is made possible by a generous grant from the Richard King Mellon Foundation

The exhibition was organized by Jack Cowart and Pierre Schneider, with John Elderfield, Albert Kostenevich, and Marina Bessonova.

Painting catalogue entries and documentation were written by Laura Coyle and Beatrice Kernan.

Exhibition dates:

National Gallery of Art, Washington, 18 March–3 June 1990
The Museum of Modern Art, New York, 20 June–4 September 1990
State Pushkin Museum of Fine Arts, Moscow, 28 September–20 November 1990
The State Hermitage Museum, Leningrad, 15 December 1990–15 February 1991

This book is produced by the Editors Office, National Gallery of Art
Frances P. Smyth, Editor-in-Chief
Edited by Jane Sweeney
Designed by Phyllis Hecht

Kostenevich essay translated by Paul D. Mitchell & Co., Inc., Fairfax, Virginia

Typeset in Raleigh by BG Composition, Baltimore, Maryland
Printed and bound in Great Britain by Balding & Mansell International
on Princess Silk 150 gsm

The clothbound edition is published in 1990 in the USA and Canada by Harry N. Abrams, Inc., New York. A Times Mirror Company
Distributed in Great Britain in 1990 by Thames and Hudson Ltd, London

Cover: cat. 18, *Le rifain debout*
Back cover: cat. 14, *Porte de la Casbah*
Frontispiece: cat. 34, *Portail et minaret, Mosquée de la Casbah*

Library of Congress Cataloging-in-Publication Data

Matisse in Morocco: paintings and drawings, 1912–1913 / Jack Cowart . . . [et al.].
 p. cm.
 Includes bibliographical references.
 ISBN 0-89468-140-0 (paper)
 ISBN 0-8109-1546-4 (cloth)
 1. Matisse, Henri, 1869–1954—Exhibitions. 2. Morocco in art—Exhibitions. I. Cowart,
Jack. II. National Gallery of Art (U.S.) N6853.M33A4 1990
 759.4—dc20 89-13676
 CIP

To the memory of Pierre Matisse

Contents

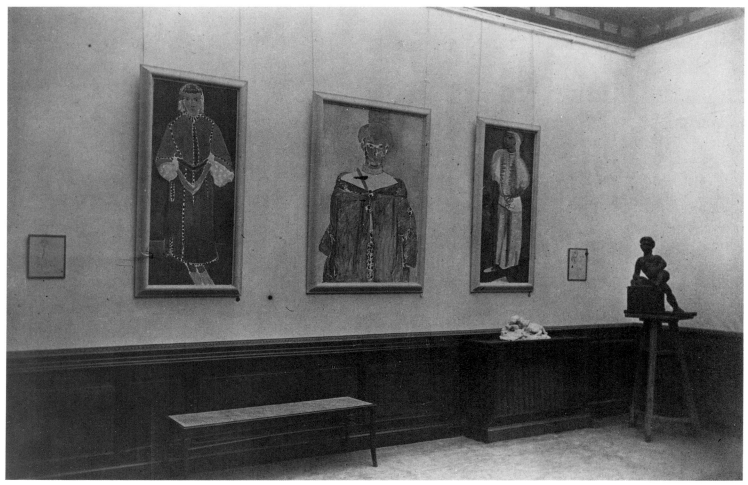

fig. 1. Matisse's April 1913 exhibition at Galerie Bernheim-Jeune, Paris

Foreword

The art of Henri Matisse, like an inexhaustible vein of some valuable and precious substance, repays efforts to mine it. The latest such project, *Matisse in Morocco*, explores a brief and crucial period in the artist's career: the two visits he made to Morocco in early 1912 and the winter of 1912–1913. This exhibition assembles the largest group of Matisse's Moroccan works ever shown together. In so doing, it reveals one of the twentieth century's greatest artists working within one of the nineteenth century's important visual traditions: turning to North Africa for exotic subjects, lush colors, and sensuous images.

This exhibition affords scholars, artists, and the public access to nearly every painting Matisse executed in Morocco, as well as to four dozen of his remarkable and little-known Tangier drawings. Furthermore, every Moroccan painting and more than sixty-five drawings of the period are reproduced in this catalogue, along with a wealth of precise documentation. Many discoveries and new interpretations relating to Matisse, his art, and events in North Africa are part of this publication.

Matisse in Morocco celebrates not only a great artist, but also a new era of cooperation between Soviet and United States arts institutions. In this exhibition, only the second time Henri Matisse's work from his trips to Morocco has been shown together (the first being seventy-seven years ago at Galerie Bernheim-Jeune, Paris), the combined talents and resources of the State Pushkin Museum of Fine Arts, Moscow; the State Hermitage Museum, Leningrad; The Museum of Modern Art, New York; and the National Gallery of Art have made possible an opportunity to appreciate once more a pivotal period in this artist's development.

The exhibition proposal, research, and publication were endorsed from the beginning with alacrity by the Ministry of Culture of the Soviet Union. We would like to thank the Soviet Embassy in Washington for their assistance. In like manner, the officials of the American Embassy and the United States Information Agency in Moscow and Leningrad have been most helpful in communication and logistics. The cultural section of the Embassy of Morocco in Washington aided our research effort. The exhibition is also the beneficiary of very generous support from private collectors and public museums in France, Sweden, Switzerland, Mexico, and the United States.

The members of the Matisse family are due our profound gratitude. In Paris, Claude Duthuit, director of the Archives Henri Matisse, and Barbara Duthuit; in Pontoise, Mme Jean Matisse; and in New York, the late Pierre Matisse, the artist's son, were of fundamental importance. We are gratified that Maria-Gaetana Matisse, the widow of Pierre Matisse, a man whose life was so influential to the great art and artists of our century, has permitted us to dedicate this catalogue to her husband's memory.

The organizing curator of this international exhibition has been Jack Cowart, head of the department of twentieth-century art at the National Gallery, working with guest curator Pierre Schneider. Research in Eastern and Western Europe, North Africa, and the United States has yielded new discoveries about Matisse and his art. This current project has evolved from Schneider's long-standing proposal that the National Gallery explore, in a thematic exhibition, Henri Matisse's lifelong search for an "artistic Paradise," particularly the artist's Moroccan phase. Scholars have long wished for such a show. Six years ago Washington's National Gallery had hoped to include these works in *The Orientalists: Delacroix to Matisse,* but was unable to obtain the necessary Soviet

loans. Our new United States-Soviet Union museum partnership has now put the appropriate means and opportunities at our disposal. Joining Cowart and Schneider were other art historians and Matisse scholars: John Elderfield, director of the department of drawings at The Museum of Modern Art, Albert Kostenevich, chief curator of modern European painting at the Hermitage, and Marina Bessonova, curator of modern French painting at the Pushkin. Each has contributed important research, essays, or editorial advice toward the realization of this exhibition and catalogue.

Recognizing the essential relationship between the public and private sectors, we greatly appreciate and are pleased to acknowledge the primary support of this exhibition, a generous grant from the Richard King Mellon Foundation. A United States government indemnity, granted through the Federal Council on the Arts and the Humanities, has been of substantial benefit in securing the international loans to this exhibition.

J. Carter Brown
Director
National Gallery of Art

Richard E. Oldenburg
Director
The Museum of Modern Art

Irina Antonova
Director
State Pushkin Museum of Fine Arts

Boris Piotrovsky
Director
State Hermitage Museum

Lenders to the Exhibition

Isabella Stewart Gardner Museum, Boston

The State Hermitage Museum, Leningrad

Moderna Museet, Stockholm

Musée de Grenoble

Musée Picasso, Paris

The Museum of Modern Art, New York

National Gallery of Art, Washington

State Pushkin Museum of Fine Arts, Moscow

Waddington Galleries, London

Private collections

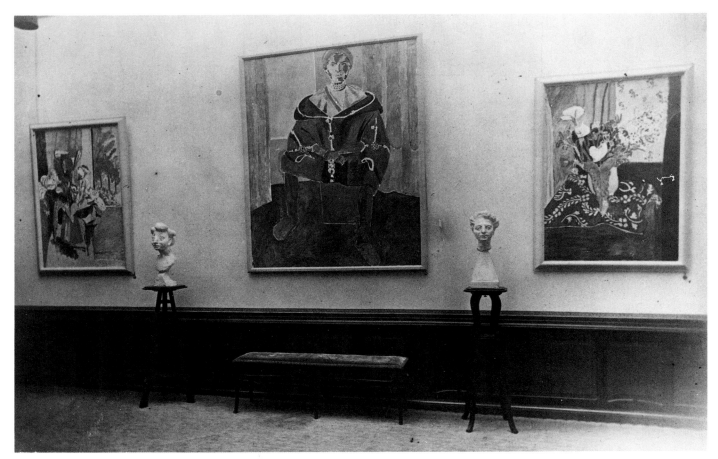

fig. 2. Matisse's April 1913 exhibition at Galerie Bernheim-Jeune, Paris

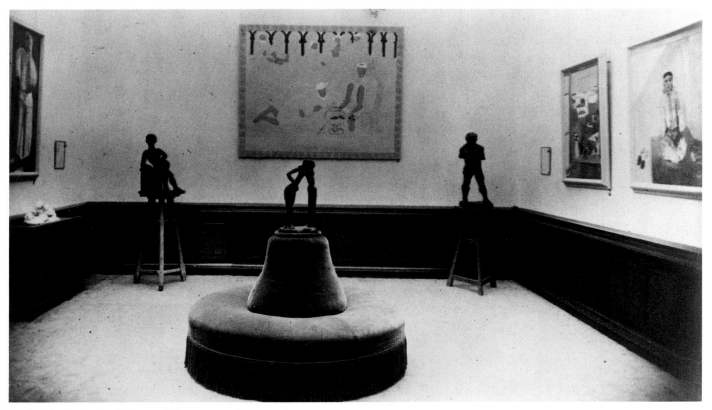

fig. 3. Matisse's April 1913 exhibition at Galerie Bernheim-Jeune, Paris

Acknowledgments

Our several years' effort to reconstruct Matisse's pursuit of an "artistic Paradise" in Morocco has been quite an odyssey. Scores of people have helped us compile a broad range of useful and new information on Morocco, Matisse, and Matisse's fellow artists Marquet, Camoin, Morrice, and Iturrino. Archives, researchers, members of artists' families, and museum professionals throughout France, Spain, Switzerland, West Germany, Sweden, Canada, Mexico, Argentina, Morocco, the Soviet Union, and the United States have been unfailing in their goodwill and cooperation.

We have been blessed with the support of many colleagues and friends who have helped and enriched this exhibition and catalogue. We thank all who have aided the progress of this complicated project. We hope they will recognize that it is they who have made so much of it possible. Our international curatorial partnership, with the added generosity of scholars, enthusiasts, lenders, and embassy officials, has contributed to what we hope is substantial progress in Matisse studies.

We are most grateful for the crucial support of the Archives Henri Matisse and of Claude Duthuit, who has so generously made references available, and to Mme Jean Matisse and Maria-Gaetana Matisse. Furthermore, we thank Mme Wanda de Guébriant of the Archives for her efforts and suggestions.

Without the aid of the family of the artist, this exhibition and catalogue could not have taken place. We thank also the other lenders of Matisse's works for their patience and the generosity that has permitted us such a surprisingly complete exhibition. All our lenders are members of a special partnership that has enabled a better understanding of the unique genius of Matisse.

We have been delighted with the energies, breadth of inquiry, and creative insights of our colleagues John Elderfield, Albert Kostenevich, and Marina Bessonova. John Elderfield has been particularly helpful in his close review of the catalogue contents and in facilitating several loans from private collectors. His comprehensive essay contributes many special insights to the work of Matisse. Albert Kostenevich's informative essay has for the first time captured the personalities of Matisse's Russian patrons. Needless to say, the paintings lent from the curatorial departments of our Soviet colleagues have proved essential.

Over the years, we five curators on this team have grown to appreciate the special pleasures, advantages, and rewards of our joint effort. We have striven to produce a publication and exhibition reflecting our many common agreements and, in some rare instances, our individual differences of emphasis. This testing process has strengthened our knowledge of the artist and our mutual friendship as well.

At the National Gallery, Laura Coyle, as the exhibition research associate, has been involved in virtually every aspect of our project. Without her dedication, this exhibition, the research program, and the quality of this catalogue would have been notably diminished. She was also primary author of the painting catalogue entries, the chronology, Appendices 2 and 3, and co-author of Appendix 1. At The Museum of Modern Art, Beatrice Kernan, assistant curator in the department of drawings, has made important contributions to many areas of this publication, especially as collaborator in the painting catalogue entries and co-author of Appendix 1.

In New York, we also thank John Rewald for generously sharing with us recollections and documentation of his discussions with Matisse on the period under study. In

Tangier, special thanks to Elena Coon Prentice, director of the Tangier American Legation Museum, for her resourceful approaches in helping us trace Matisse's visits to that city. In Paris, Pierre Agoune has been especially patient and helpful. His cooperation provided significant points of reference for our technical study of Matisse's sketchbook drawings.

Other helpful members of the National Gallery staff include D. Dodge Thompson, chief of exhibitions and Ann Robertson, exhibition officer; Laura E. Smith, development officer; Frances Smyth, editor-in-chief, Jane Sweeney, editor of this catalogue, Phyllis Hecht, our catalogue designer, and editorial assistant Ulrike Mills; Trudi Olivetti of the library staff, who compiled the index; department of twentieth-century-art staff members Cara Taussig, Amy Heilman, Catherine Craft, adjunct Annette Schlagenhauff, and intern Margaret Magner; registrar Mary Suzor; Gaillard Ravenel and Mark Leithauser and their design and installation staff; matting and framing specialists Hugh Phibbs and Steven Wilcox; paper conservator Shelley Fletcher; and so many others. In the department of drawings at The Museum of Modern Art, thanks are also due to Kevin Robbins, Kathleen Curry, Mary Chan, and Carolyn Maxwell, the latter for her important bibliographical research. James Coddington and Carol Stringari of that museum's department of conservation also deserve our thanks, as do Jeanne Collins, director of public information, Rona Roob, archivist, and James Snyder, deputy director for planning and program support. At our partner museums in Moscow and Leningrad also, dedicated staff members are involved in this complex exhibition. We hope the cooperation among these institutions might serve as an effective model for future publications and exhibitions.

Finally, we must thank all of those close to us who have endured our travels and distractions, as they have supported our grand passion for art and especially for Matisse's Moroccan paintings and drawings.

Jack Cowart
Pierre Schneider

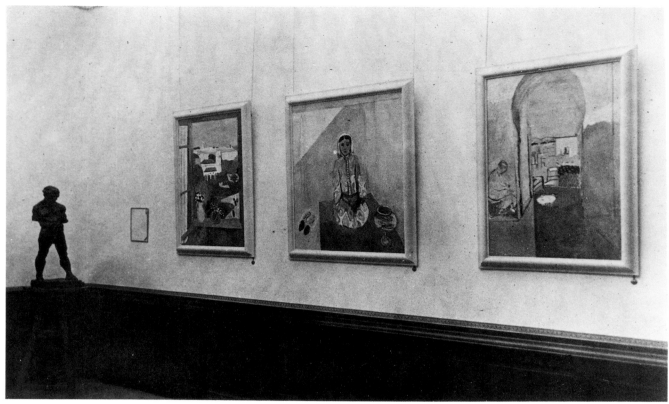

fig. 4. Matisse's April 1913 exhibition at Galerie Bernheim-Jeune, Paris

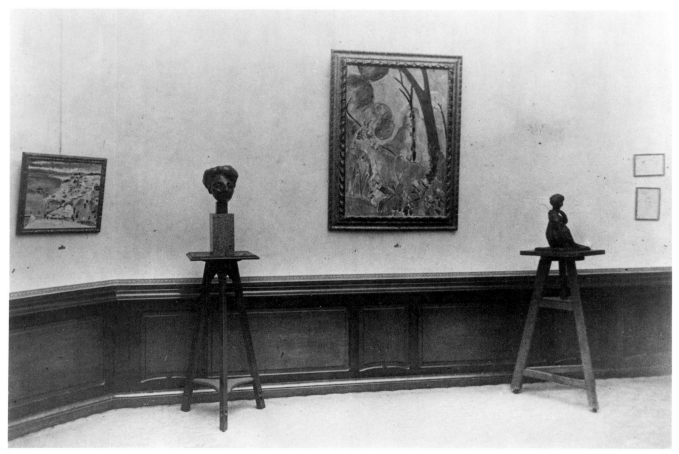

fig. 5. Matisse's April 1913 exhibition at Galerie Bernheim-Jeune, Paris

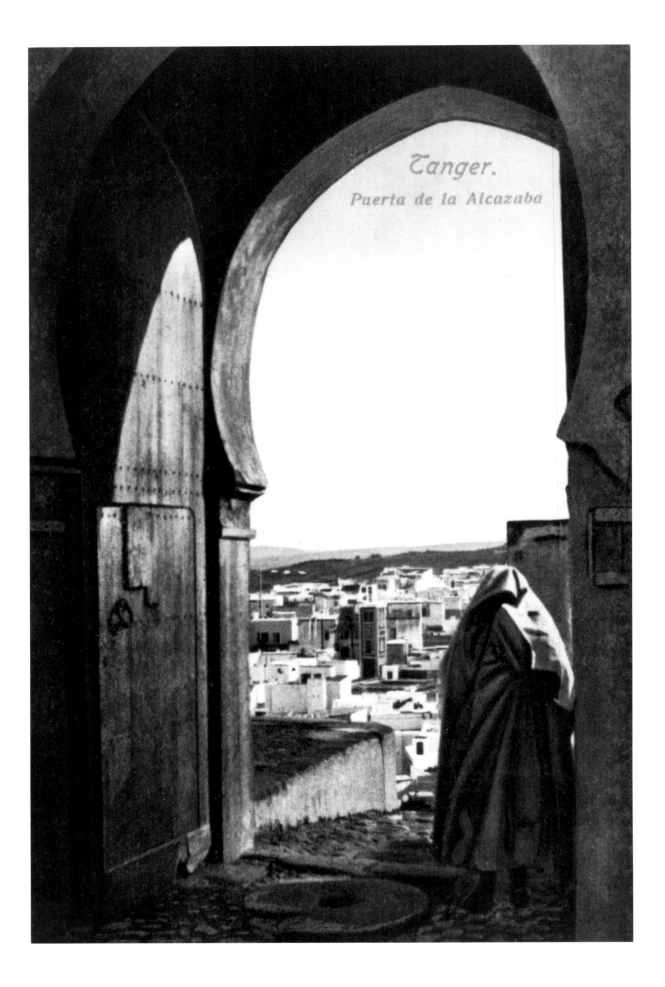

The Moroccan Hinge

Pierre Schneider

Part I

"On a slightly rough sea, but of the purest blue, the ship glides without rocking or pitching. On the left, the horizon is lined with a few clouds; on the right, by the mountains of the Spanish coast." It was nine o'clock in the morning, Monday 29 January 1912,[1] and on board of the SS *Ridjani*, which had left Marseilles some sixty hours earlier, Matisse was writing to his daughter Marguerite, back in Paris: "The mountains, which were not very high yesterday, today are elevated enough to be covered with snow." Obviously, the mood was good. "We have had a quiet crossing, we have eaten well, slept well. . . . We are arriving at Tangier much earlier than we thought we would, considering the state of the sea, that is to say at one o'clock instead of four." The barometer seemed to be as high as the artist's spirits: "Splendid weather."[2] The first of Matisse's two sojourns in Morocco, in the course of which he was to paint some of his most beautiful works, certainly those in which programmatic will and natural ease are most intimately fused, was about to begin.

Matisse should have been wary of those harmless-looking clouds. Upon landing, the travelers were greeted by torrential, inexhaustible showers. "Here, we are under rain, a veritable deluge. It seems that it has been like this for a month."[3] The days passed without any sign of improvement. Every one of the painter's friends received his messages of distress. "Shall we ever see the sun in Morocco?" he wrote to Gertrude Stein. "Since Monday at three, when we arrived, until today, Saturday, it has rained continuously, as in tropical countries. It had been like that for fifteen days. What's to become of us? It wouldn't take much to make us come back to Paris to seek the Sun. . . . It's impossible to leave our room."[4] A postcard to Henri Manguin shows Matisse no less desperate, no less tempted by the idea of fleeing: "Ever since we arrived, eight days ago, it's been a downright flood. Shall we leave again? What a misadventure!"[5]

It was Albert Marquet, however, who bore the brunt of the painter's lamentations. "Ah, my friend! what a misadventure! We arrived Monday at three o'clock. Today, we've got Saturday, as the saying goes, and we've only seen it rain harder and harder. I don't know what this means, nor do the people of Tangier, they've never seen anything like it. They are much more astonished than I am, for it had been like this for fifteen days when we got here. What to do, great God! To leave again would be ridiculous, yet it seems so natural. The light is as bright as in a cellar."[6] And Matisse continued his plaint on another card, written the same day: "While I am writing you, the rain is coming down harder than ever. You've certainly never seen it rain as hard in all your charming life. . . . Ah, Tangier, Tangier! I wish I had the courage to get the hell out."[7]

Why did I come to Morocco? Matisse asked as the storm beat against his window at the Hôtel Villa de France. It seems appropriate to ask that question ourselves.

Before going to Russia in October 1911, Matisse had had the intention to visit Sicily that

opposite page: fig. 6. *Tangier. Casbah gate*, tinted postcard. Archives Henri Matisse

winter. Back from Moscow, in November, his desire to seek the sun must have been even stronger. Yet the deeper cause of his heliotropism was not a matter of physical well-being. The constant presence of the sun provided the guarantee of stable light conditions from one working session to the next. Matisse belonged to a generation of artists who felt the obligation to work on the motif like the impressionists (in particular, outdoors), but who, unlike them, were bothered by the variability of atmospheric conditions, which were in contradiction to their own need for permanent construction. This need became so urgent for artists of the following generation that they ceased to submit to the dictates of natural appearances. This was a break that Matisse could not yet accept. Therefore the only solution consisted in finding a piece of nature that would itself be constructive by being free, as far as possible, from meteorological variations: that is, steadfastly sunny. This state would render the natural motif more beautiful but, above all, more permanent. Toward the end of his stay in Tangier, Matisse wrote Marquet: "Shall I leave on Monday? Shall I stay on? The light is superb, but the weather too variable. You'd think you were in an express train."[8] This mobility, which is incompatible with the pictorial objective that Matisse set himself, caused him to have veritable fits of anxiety, of depression. "Weather bad," he wrote Marquet again. "I have stayed on to finish a painting, if possible, but the gray weather prevents me from doing so. As April is a rainy month here, I no longer have much hope. In a word, I am displeased with my trip from the point of view of the weather, so variable. What nervous strain. . . ."[9]

The complaints addressed by Matisse to Marquet are particularly numerous and detailed not only because Marquet was the oldest and closest of his companions, but also because he was responsible for the expedition. For Marquet himself had just spent two months in Morocco. He had boarded ship at Sanary on 8 August 1911.[10] From Gibraltar, where he still was on the 14th, he informed Henri Manguin of his imminent departure to Tangier.[11] Thence he again wrote to Manguin on the 19th: "Hurry up and come while there's yet time."[12] And on the 21st: "I've not yet done anything, it's too beautiful, besides, I haven't got the time to work—long live holidays. . . . We'll soon leave for Fez where the weather is likely to be a bit warmer."[13] On the 28th, he sent Manguin "a hearty handshake" and added: "I've just gone from Tangier to Tetouan by horse—seventy miles! It has made the Arabs green [with envy]. Outdone, old Matisse!"[14] For the latter had tried, without too much success, to communicate his passion for riding to Camoin and Marquet. (The master tried to meet the pupil's challenge the following year, when he himself rode from Tangier to Tetouan.) On 13 September Marquet wrote Manguin that he was leaving Tangier for the Canaries, whence he might eventually go to Dakar.[15] On the 15th he was in Casablanca; he was still there on the 18th, for on that day he mailed a postcard to Camoin.[16] On 4 October he sent one to Manguin from Seville: "Here I am back in Europe and soon in Bordeaux."[17] Less than a week later he was back in Paris—a few days before Matisse himself left for Russia.

It is certainly Marquet who persuaded Matisse, through his words but also by the work he had done there, to spend the winter season in Tangier. Marquet must have exaggerated his laziness, or else worked intensely upon his return to Tangier: a superb series of oil paintings on cardboard mounted on canvas, all measuring 37 x 24 cm, testifies to this activity. If Matisse saw these views of the Casbah, which seems probable, he must have appreciated their subtle austerity, their palette of pale blues, whites, grays, and ochers, their colors so pure yet so close that they seem to possess the fluid softness of their tonal values, as well as the strict, almost abstract geometry of their architecture, which keeps their fluidity from turning into lability. Matisse's *Le marabout* (cat. 3), steeped in "lieblicher Bläue" (to quote Hölderlin), appears to echo these paintings by Marquet.[18]

However that may be, it was certainly Marquet who put the idea of Tangier into Matisse's head, since the latter playfully attributed to him the responsibility of the deluge that was coming down upon him. In the sequence of postcards already quoted, all postmarked on 4 February 1912 and in reality forming a single letter, one at least is missing, but it is easy to reconstruct the meaning of a sentence lost as a result of this mutilation: "[You deserve to see] me arrive at the quai Saint Michel to scold you. Good bye, *vieux cochon,* and no hard feelings, since you are not responsible for all that goes wrong."[19] All Matisse felt entitled to ask is that Marquet make amends by joining him in the storm: "When are you coming to cheer up the scenery?"[20]

In fact, Matisse was impatient to have Marquet by his side. On the back of a postcard mailed on 28 March he insisted: "My wife is leaving on Sunday for Paris, she will go to see you. But what's the matter with you? From your preceding postcard, I couldn't tell when you are coming; this one still doesn't tell me. Why don't you come as soon as possible to work in Tetouan? What better place could you wish? All those who know the country say it is the prettiest city. Perhaps I shall go to Fez with you. In any case, now is the season, later the weather will be too hot."[21]

Marquet tarried. On the day following Mme Matisse's departure on 31 March, Matisse wrote that there were rumors of serious unrest at Fez (Morocco, which had become a French protectorate in 1911, was in the final throes of the conflicts that had agitated the region since the turn of the century), and went on to say: "I had visions of us on the road—or rather visions of you, for I shall not go."[22] A second postcard, also written on 2 April, confirms his decision: "You'll soon see me: since you're not coming, I shall come to you."[23]

Thus, contrary to what most authors have said, Marquet was not Matisse's companion during the latter's first trip to Tangier. One may also doubt whether he was during the second sojourn. Matisse left Marseilles on the 6th of October, on board the SS *Ophir,* thinking he would remain a very short time in Tangier. This did not prevent him from renewing his invitation to Marquet, who at that moment was painting in Normandy: "Dear old fellow from Rouen, what's become of you? Aren't you molding away amid the Seine fogs? Here, the weather is magnificent: let's all go to Tangier."[24] When he decided to extend his stay, he asked his wife to join him. This she did in the company of Camoin: the two left Marseilles on 21 or 22 November. A new invitation went out to Marquet: "Why don't you leave that nasty Normandy fog and come spend the winter here? It will be dry, I believe, until January, probably. After that, we shall go back north toward Collioure or Barcelona. Think of your health."[25]

Marquet, however, continued to play deaf. A postcard dated 6 January 1913, containing thanks to Manguin for his Christmas greetings, ends with this invitation: "Do come and finish the season here with old Marquet."[26] "When do you arrive?" Matisse asked Marquet on 8 January. He vainly sought to tempt him: "Did Camoin tell you that we took a very pleasant bath in the sea, a week ago?" And Matisse concluded with the admonition "Don't become too moldy!"[27] Yet, two weeks later, Marquet still was not in sight, since Matisse sent him this message, dated 26 January: "Long live Life! When are you coming? The weather remains fine. We think January will be beautiful. Should February be bad, we'll take off to somewhere else—to Algeria or Tunisia. Make up your mind, once you've finished your work. We are waiting for you."[28]

If Marquet really did at last give in to his friend's entreaties, he cannot have done much more than cross his path in Tangier. For Matisse left Morocco toward mid-February 1913: a letter to Camoin, dated 27 February, informs his friend that he arrived from Tangier in Marseilles, after having passed through Menton and Ajaccio. One may question, however, whether Matisse and Marquet ever were in Morocco at the same time. In the letters written to Matisse by Camoin, who remained there after the

fig. 7. Albert Marquet, *Ruelle à Tanger,* 1912, oil on cardboard. Private collection, courtesy Galerie Robert Schmit

Matisses' departure, James Wilson Morrice, their companion there, is repeatedly mentioned, but never Marquet. Neither Matisse nor Marquet ever referred to their common presence in Tangier.[29]

Actually, Marquet did return to Morocco in 1913, as a number of pictures (two of which are now at the Musée de Grenoble) attest, but only after the return of Matisse and Camoin to France. Marquet was not sulking, however: he was afraid of rain and of the cold. On 15 November 1912 Marquet had written Camoin, whose intention to join Matisse in Morocco he had heard about: "I have received a postcard from Matisse informing me of his impending return. Are you going to go to Tangier anyway? It won't be much fun to be alone in that place to watch the rain pour down. If you are willing to put off your trip until the summer, I'll accompany you. The climate is marvelous then."[30]

And that is precisely what Marquet did, without either Matisse or Camoin. On 10 August 1913 he wrote Manguin: "Am settled in Tangier, at the Villa de France. Weather magnificent, what in heaven's name are you doing in Cassis, the most boring place in the world. Do come to Tangier, you'll see smashing things here and you'll have fun."[31] Six days later he sent Camoin a postcard: "Tangier greatly spoiled, but still smashing. We are already living it up quite nicely. What would things be like if you were here? Hurry up and come. The weather is exquisite."[32] He was back there on 27 September after one of his customary fits of wanderlust that had driven him to explore less-europeanized areas of Morocco. On that day he wrote Camoin: "Back in Tangier and quite pleased to be in a civilized place. All the fellows have left, I'm alone and shall try to take advantage of my solitude to work a bit."[33]

Between 1911 and 1913 Marquet and Matisse constantly urged each other to meet in Tangier. Both did stay there on two occasions, but most likely not together.

Matisse had had a number of predecessors in Tangier. I do not think that the example of Dehodencq, Regnault, or Clairin mattered much to him. That of the globe-trotting novelist Pierre Loti and of Eugène Delacroix, on the other hand, meant a lot. How could one resist the advice of a colleague as authoritative as Delacroix? "It is a place for painters," the latter wrote to Frédéric Villot on 29 February 1832. To be sure, all was not perfect "from the point of view of human rights and equality, but beauty is bountiful there."[34]

Nevertheless, to an interlocutor who expressed surprise that he should have gone to Tangier, "just where Delacroix had gone," Matisse replied rather testily: "I went to Tangier because it was Africa. Delacroix was far from my mind."[35] Not far enough, however, to prevent him from evoking the hills, which yesterday were "the color of a lion's skin" and which the rain had made turn "an extraordinary green," over which hung "slightly tormented skies, as in Delacroix's pictures." And Matisse added: "In fact, Delacroix's pictures faithfully represent the landscape of Morocco between Tangier and Tetouan, in the section that is covered with trees." Delacroix may have been far from his mind, but not from his eye, nor from his memory, since he executed "an extremely precise drawing" of the view of the bay of Tangier, including the Casbah and the neighboring hills, as seen from "an Arab café overlooking the harbor." And Matisse went on to point out that Delacroix had introduced this landscape into *La prise de Constantinople par les Croisés* (fig. 89).[36] He himself did a pen and ink sketch of the same beach, on which he cast a rider on a rearing horse that seems to have gallopped out of one of Delacroix's jubilant sketchbooks (cat. 27).

Delacroix had landed almost exactly eighty years before Matisse in the retinue of the comte de Mornay, whom Louis-Philippe had sent as ambassador extraordinary to the sultan of Morocco. "I am like a man dreaming and who sees things he is afraid will

escape him."[37] His fear was perfectly unfounded: the sharpness of his eye and the swiftness of his hand lost not one bit of the dazzling spectacle. From Tangier to Meknes and back, the voyage was "one that very few Christians can boast of having made."[38] The beauty of the landscapes, the splendor of the costumes, the horses' fire, the warriors' ferocity, the colorful animation of the crowds, the parades, the wild galloping, the flying banners, not to forget "the precious and rare influence of the sun, which lends all things a penetrating life"[39]—how could Delacroix fail to have been thrilled by all this?

His life sketches (for he did no formal studies during his stay in Morocco) are both marvels of vivacity and valuable ethnological documents (fig. 8). Like Matisse, Delacroix was overjoyed by seeing that Moroccan reality objectifies what, until then, had only been an artist's dream, an aesthetic fiction. To be sure, his was neither Matisse's dream nor Matisse's reality. For Delacroix, Morocco brought about the coincidence of his century's contradictory aspirations: romantic picturesqueness and realist exactness. "The picturesque is plentiful here. At every step, one meets ready-made paintings (*tout faits*) that would bring twenty generations of painters wealth and glory."[40]

Delacroix's remark explains Matisse's reticence about him. For an artist demanding that, between the moment of its conception in front of the motif and its completion the work be submitted to a lengthy passage through feeling, the notion of ready-made paintings is unacceptable. The pictorial, where it is the artist who creates the essential, and the picturesque, where everything is provided by reality, are incompatible. Matisse reproached Delacroix for giving priority to the latter over the former: "When Delacroix's imagination deals with a subject, it remains anecdotal, which is too bad. This is because of the quality of his mind, for in the same circumstances, Rembrandt shows himself noble."[41] Excessive availability of gold tends to discourage alchemists, as Matisse explained to Tériade: "Rembrandt produced biblical scenes with cheap goods from a Turkish bazaar, yet they conveyed all his emotion. Tissot painted Christ's life based on every conceivable document. He even went to Jerusalem. And yet his work is untrue and devoid of life."[42] Matisse always shied away from depicting perfect works of art. He was wont to buy popular textiles and ceramics and preferred to represent landscapes whose beauty was not flawless and to introduce his decorations into imperfect architec-

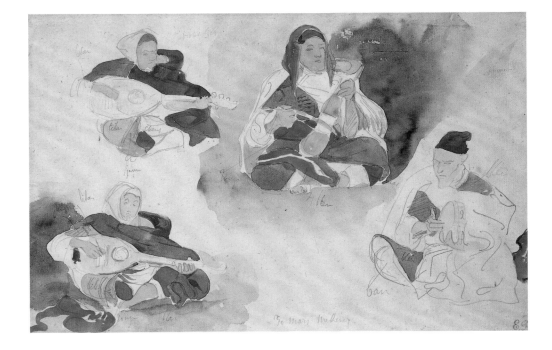

fig. 8. Eugène Delacroix, *Musiciens juifs*, 1832, from *Portefeuille Maroc*, ed. 1928, pencil and watercolor on paper. Bibliothèque Nationale, Cabinet des Estampes, Paris

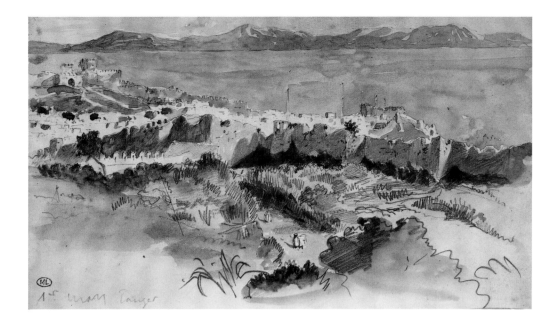

fig. 9. Eugène Delacroix, *Vue de Tanger*, folio lr, *Album d'Afrique du Nord et d'Espagne*, 1832. Musée du Louvre, Paris, Cabinet des Dessins, RF 1712 *bis*

tural settings, so that his intervention might contribute to improve them. For the same reasons he distrusted the charms of the exotic. In the autumn of 1913, as he was on the point of leaving for Tangier a third time, Matisse suddenly changed his mind: "I would probably astonish you," he wrote Camoin, "if I told you that I have made plans to spend a few months in Paris . . . thinking that I had, for the time being, to engage in an effort of concentration and that the trip, the change of climate and the excitement provoked by things new, which at first touch us primarily by their picturesqueness, would lead me to dispersion."[43]

Matisse knew what he was talking about: his sojourns in Tangier were not his first experiences of Africa. In 1906, that is to say in the very thick of fauvism, he had gone to Algeria. He had left Perpignan on 10 May and returned there a fortnight later. Fauvism was, in Derain's words, "the test of fire," a fire provoked and fanned by the heat of the sun. Matisse had probably hoped that the still greater incandescence of a Saharan summer might help him progress along his chosen path. However, it proved excessive: "the light is blinding."[44]

To be sure, there had been the scenery: beautiful as it was, however, the oasis of Biskra proved useless. "One is quite aware that one would have to spend several months in these regions before extracting something new from them. One cannot just take one's color scheme and one's system and apply it."[45] Time alone could dissolve the picturesque that stands between the painter and the pictorial. In the meantime, it was impossible to work: Matisse brought back a single landscape sketch from Algeria, quite like those he had executed on the motif at Collioure. The description of the country and of its inhabitants that he sent Henri Manguin was proportional to his disappointment as a painter.[46] The voyage had at least had the advantage of reconciling him with his familiar visual material. "At any rate, I saw Collioure again with pleasure. Before leaving for Algeria, I had found it insipid, but when I returned, it gave me an irresistible urge to paint." And Matisse had added a conclusion that reads like a cry of defiance against the advocates of picturesqueness: "In my slippers, I felt myself again." He again found himself in the only condition that allowed him to work. "Painting has totally taken possession of me."[47]

Nevertheless, we might ask ourselves whether Matisse's prejudice against Delacroix

was not largely theoretical. Should he have leafed through one of the seven sketchbooks that Delacroix, day after day, filled with remarks as well as pen and ink drawings and watercolors, he cannot have remained indifferent to some of them.[48]

Most of the time, to be sure, one could hardly imagine two forms of expression more opposite. In Delacroix, all is motion, turmoil, dynamic disequilibrium, striving for extremes—for rumbling crowds or fierce solitude. Matisse, on the other hand, favors calmness, repose, immobility. However, these differences should not be ascribed to the search for, or the refusal of, picturesqueness. Delacroix no less than Matisse selected within outward reality those elements that suited his temperament: in neither case did the painter's vision abdicate in favor of things seen.

Twenty years after his Moroccan expedition, Delacroix noted in his journal: "I began making something passing out of my trip to Africa only after I had forgotten all the little details and, in my pictures, retained only the striking and poetic side. Until then, I had been pursued by the love of exactness, which most people mistake for truth."[49] Exactness, that excessive presence of external reality, that overabundance of anecdotes on which the picturesque feeds, is incompatible with the pictorial. Truth, on the other hand, may be defined as the amount of reality compatible with the pictorial, as the point where the world's aspect and the artist's prospect, to borrow Poussin's terms,[50] are apt to meet and to become fused. This distinction had become relatively easy to establish in Matisse's time, in which the link between the act of painting and the facts painted had already been loosened and the importance of the former considerably increased at the expense of the latter. Fifty years earlier, however, it required extraordinary lucidity and courage.

Not only would Matisse not have disowned the method proposed by Delacroix for passing from exactness to truth—using memory as a decanter—but he himself resorted to it throughout his life. Indeed, his first journey to Africa had been the occasion on which he began to use it. *Nu bleu* (Baltimore Museum of Art, Cone Collection), the key picture that was to provide the protagonists for the series of mythological paintings culminating with *La danse* and *La musique* (both 1910, State Hermitage Museum, Leningrad), bears the additional title of *Souvenir de Biskra*: it was painted one year after the unsuccessful stay in Algeria. Delacroix benefited from the same delayed reaction: *Femmes d'Alger*, dated 1834, and *Noce juive dans le Maroc*, painted around 1837–1841 (figs. 10, 11), have left their mark on the posture and the disposition of the figures in

left: fig. 10. Eugène Delacroix, *Femmes d'Alger*, 1834, oil on canvas. Musée du Louvre, Paris

right: fig. 11. Eugène Delacroix, *Noce juive dans le Maroc*, c. 1837–1841, oil on canvas. Musée du Louvre, Paris

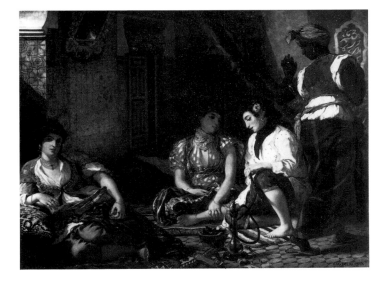

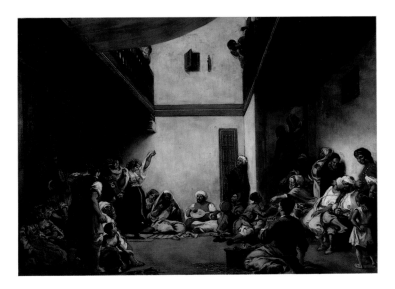

Café marocain (cat. 23). "We are all in Delacroix," Cézanne was wont to say about *Femmes d'Alger.* "Those pale pinks, those stuffed cushions, that slipper, all that limpidity, what can I say, they penetrate your eye as a glass of wine into your throat, and one is drunk at once."[51] "All": including the painter for whom Cézanne mattered more than anybody, Matisse.

In short, what Matisse held against Delacroix was not so much his work as those "twenty generations of painters" who, encouraged by his precedent, came to pick up "ready-made pictures" in Morocco.

That Matisse should more than once have expressed his lack of affinity for the peddlers in orientalism (that domain par excellence of exoticism during the nineteenth century) is hardly surprising. By insisting on the interest and on the novelty of the work's subject matter in the hope of compensating for the lack of interest and novelty of its manner, orientalism constituted an extreme case of the debate between the picturesque and the pictorial or, to put it differently, between seeing and making, which was becoming more and more explicitly the dominant concern of artistic theory and practice as the twentieth century drew nearer. The day would come when Maurice Denis would proclaim: "Before being a battle-horse, a naked woman, or some sort of anecdote, a picture is essentially a flat surface covered with colors assembled in a certain order."[52] Henceforth the subject matter was little more than a pretext, soon to be dispensed with.

Such, however, was not Matisse's position. The primacy granted to the task of embodying the artist's emotion in no way implied that the model had become indifferent to him. On the contrary, "it is the burning center of my energy."[53] This conviction posed a difficult problem: how was one to reconcile external exactness with internal truth? Matisse condemned the school of the picturesque for having betrayed both the subject represented and the act of representation. In the work of its practitioners, making is in

figs. 12 and 13. North African costumes and textiles collected by Matisse

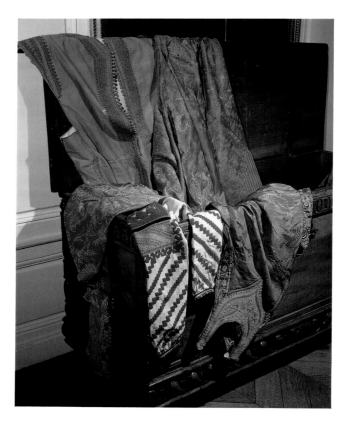
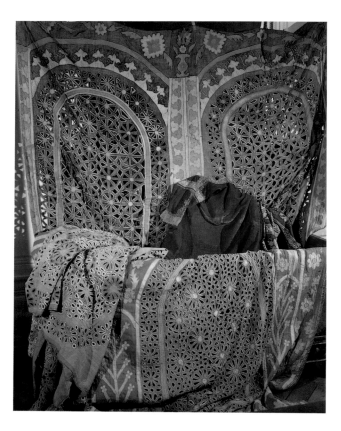

no way affected by seeing: they paint Constantinople or Cairo exactly as they would Chartres or Paris. Their brush has received strict orders not to let itself be contaminated by local aesthetics. The advice once given to imperial garrisons, "Never talk to the natives," has been translated, one is tempted to believe, into "Never paint like the natives" by such artists as Marilhat or Gerôme. In a word, exoticism is the artistic version of colonialism.

To be sure, exotic nature and modern painting do not easily make good bedfellows. Indeed, they rarely do: Matisse failed in the Alps and carefully abstained in front of the Sahara Desert and the lagoons of Polynesia. For the operation to be successful, the foreign land must cease to appear foreign and seem as familiar to the painter as the Seine at Argenteuil seemed to Manet or the Montagne Sainte-Victoire did to Cézanne. Only time permits this osmosis: "It would take several months."[54] Although Matisse traveled repeatedly through Europe and the rest of the world, he always tried to convince his interlocutors that these journeys weren't really travels but mere moves, just as he liked to describe himself as a "sedentary traveler." "I am too hostile to the picturesque to have gotten much out of traveling," he told Tériade.[55] He was perfectly aware that the remark was unfair, but he wished at all costs to avoid being called a traveler, for the term had been discredited in his eyes by the orientalists' profitable peregrinations.

This need to differentiate himself clearly from the orientalists may seem strange and somewhat excessive: their insignificance did not deserve such attention. But it becomes understandable if we remember that Matisse himself was one of the last and certainly one of the most ardent of orientalists. Looking back on his career in 1947, Matisse stated: "Revelation thus came to me from the Orient."[56]

Matisse's interest in what one might call the the aesthetics of Muslim art deeply influenced his own work.[57] He often recalled "the extraordinary exhibition at Munich"[58] devoted to Islamic art, which he visited in 1910. Actually, he had had many opportunities to familiarize himself with it before that time. It had been the subject of exhibitions in Paris in 1893, 1894, and, most important, 1903 at the Musée des arts décoratifs. Too, the Paris world fair of 1900 had brought a rich harvest of revelations. And it must be remembered that, in those days, the Louvre exhibited its collections of Mohammedan ceramics permanently. Yet Matisse probably did not become really attentive to Islamic art until the moment when his work showed similar concerns. Such, at least, was his own impression in 1925: "I felt the passion for color develop in me. At that moment, the great Mahometan exhibition was taking place."[59] The junction occurred after, and as a result of, the fauve explosion.

Matisse's aesthetic of decoration, like the aesthetic of color that implies it, possessed no equivalent, no guarantor within the grand tradition. On the contrary, despite the efforts of men like William Morris, decoration remained synonymous with minor arts. Gauguin alone had dared, both in his writings and in his works, to claim that the artisan was equal, if not superior, to the artist. Matisse unquestionably paid great attention to his message. Like Gauguin, he made ceramics, carved doors, constructed hats and dresses. Even if it is not certain that he read Gauguin's letter to Emile Bernard (June 1890), several of the Tahitian exile's friends—Daniel de Monfreid, for instance, whom he saw repeatedly at Port-Leucate, near Collioure—might easily have communicated to him the advice it contained: "The whole Orient, the great thought written in letters of gold in all its art, all that is worthy of being studied."[60]

Those letters of gold are dispersed among artisanal productions: ceramics, textiles. Matisse was ever attentive to them. He had brought back a popular vase from Algeria. From Cordoba, he returned with a crateful of ceramic tiles covered with floral and geometric motifs.[61] Fragmentary or modest though they were, these objects sufficed to

re-create the ambience of which they were a part. "Through its accessories, this art suggests a greater space, a truly plastic space. This helped me to find my way out of intimate painting."[62] It was able to do so because nothing is accessory, isolated within decorative art, everything in it contributes to the total effect and, in return, is fed by that totality. This greater, truly plastic space is diametrically opposed to the space in which Western painting, in particular easel painting, which marks the culmination of its *Kunstwollen*, has dug its niche (to which Matisse refers when he speaks of "intimacy"). Matisse was not using words lightly when he called paintings such as *La desserte rouge* (Hermitage, Leningrad) or *La musique* "decorative panels."

"First of all, one must be decorative," he affirmed in 1951.[63] To revive such an aesthetic at the very instant when cubism carried the principles of the Renaissance to their extreme consequences was indeed daring. It is easy to understand why Matisse should have wished to place his own venture under the aegis of a major culture. Moreover, it provided him not only with moral support, but also with practical help. Matisse did not only invoke Islamic art, he consulted it. Nothing, in this respect, is more revealing than the lesson he drew from his observation of rugs.

Once again, the advice had come from Gauguin: "O painters who are looking for a color technique, study rugs. You will find all the necessary knowledge there."[64] To Daniel de Monfreid he wrote, in October 1897: "Always have the Persians in mind."[65] The fascination exerted on western painters by oriental rugs has a long history, going back at least to artists as different as Domenico di Bartolo and Holbein. However, it had not really entered the active stage before the romantic period. Maxime du Camp related a remark made by Delacroix: "The most beautiful pictures I have ever seen are some Oriental rugs."[66] Such testimonials of interest grow more numerous as the end of the century drew near. In his essay "From Eugène Delacroix to Neo-Impressionism," published in 1899 and carefully read by Matisse, Paul Signac quoted Félix Fénéon: "These canvases, which bring back light to the walls of our modern apartments, which share the charm of Oriental rugs, mosaics and tapestries, are they not decorations too?"[67] Maurice Denis shared this view: "Perhaps, if we want to rediscover the presence of the sun in a work of art as real as those of Gauguin, we must go back to Gothic stained-glass windows, to Oriental rugs."[68]

Almost invariably, the contemporary reference given is Gauguin. It was he who

fig. 14. Persian ceramic tile owned by Matisse

left: fig. 15. Henri Matisse, *Les tapis rouges*, 1906, oil on canvas. Musée de Grenoble

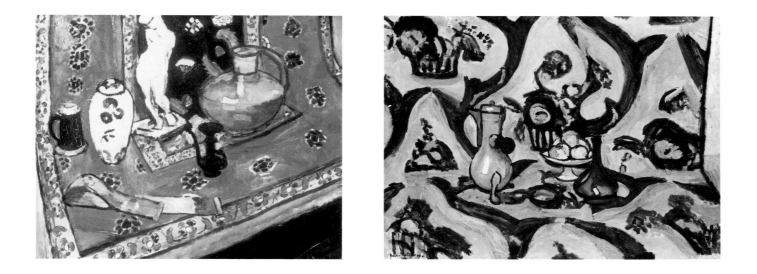

changed the character of allusions to oriental art made in the West: he discarded the picturesque in favor of the pictorial or, if you wish, orientalism in favor of orientality.

This attitude, which had only been glimpsed and tentatively adopted by Gauguin, was carried to its logical extreme by Matisse. From a very early date, he had concerned himself with rugs and, more generally, with textiles. Some of these, like the *toile de Jouÿ*, were to accompany him throughout his career. Fabrics, in fact, formed a major part of his childhood universe: in all the farmhouses of Bohain, as in the whole of Picardy, women spent the winter weaving. The painter's wife executed tapestries and he himself was once asked—and briefly attempted—to restore ancient ones. Remembering the impression made on him by oriental rugs at the Muslim art exhibition in Munich, Matisse remarked: "The Orient saved us."[69]

Unlike the orientalists, Matisse did not introduce rugs into his pictures merely to spice them with local color. Very quickly, the carpet ceases to be a neutral object and turns into an active principle. As early as *Les tapis rouges* (fig. 15), dabs of pure color in it disseminate beyond its limits. What allows them to do so is a character whose virtualities Matisse was soon to assess and to exploit: fabrics reduce any object they cover, even those conceived three-dimensionally, to flat surfaces, thereby transforming realistic representation into decorative image.

Matisse was torn between two opposite aspirations. It is likely that he was surprised and, to a degree, appalled by the flattening effect of rugs. "I have received the influence of Cézanne and of the Orientals," he wrote.[70] These were conflicting influences: Cézanne encouraged him to emphasize volume; the Orientals, to attenuate it. This "eternal conflict"[71] often provoked clashes between figure and ground, each seeking to prevail over the other. *Figure décorative sur fond ornemental* (Musée national d'art moderne, Paris) is the most striking example of this never-ending battle.

During the first years of the rug's active phase, Matisse tried to slow down its expansion. By hardening its folds, he forced it to respect, at least partially, the constraints of three-dimensionality in such works as *Les tapis rouges, Nature morte au géranium* (1910, Neue Pinakothek, Munich). Or again, he attempted to take advantage of the rug's suppleness by obliging it to signify successively surface and depth, by bending it progressively in order to pass from a vertical position to a horizontal one in *Nature morte en rouge de Venise* (fig. 16) and *Nature morte camaïeu bleu* (fig. 17). However, the rug's superficiality irresistibly gets the better of depth and chases the folds toward the edges; the weight of a bronze statue became necessary to prevent it from soaring skyward in

left: fig. 16. Henri Matisse, *Nature morte en rouge de Venise*, 1908, oil on canvas. State Pushkin Museum of Fine Arts, Moscow

right: fig. 17. Henri Matisse, *Nature morte camaïeu bleu*, 1909, oil on canvas. The State Hermitage Museum, Leningrad

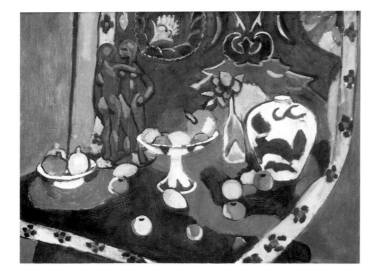

fig. 18. Henri Matisse, *Bronze et fruits*, 1910, oil on canvas. State Pushkin Museum of Fine Arts, Moscow

Bronze et fruits (fig. 18). Elsewhere, Matisse made use of the double nature of cloth, three-dimensional by virtue of its material and two-dimensional by virtue of its colors and of its décor: in *Le rifain assis* (cat. 19), the uniform green of the enormous robe stands for the warrior's bust seen frontally, at the top, and for his legs seen in perspective, at the bottom.

Matisse took possession of the world of decoration in 1909 with *La desserte rouge*. It was followed, between 1909 and 1911, by *La danse*, *La musique*, and *La conversation* (1911, Hermitage, Leningrad). From that time on, he fully mastered the "knowledge" inscribed, as Gauguin said, in golden letters in rugs: whatever they cover is reduced to a flat surface which, in turn, seeks to coincide with the picture plane. Wherever this coincidence has occurred, the decorative motifs expand beyond the fabric's limits. The reiteration of these principles turns every unique, realist representation into decorative motif by emptying it of its meaning and suppressing all hierarchies. By this time, Matisse no longer needed to experiment in this area. In *Nature morte, Séville I* and *Nature morte, Séville II* (see figs. 100, 101), both painted in Seville in 1911, Matisse coaxed the data of three-dimensionality into flatness as a bullfighter captivates and captures the bull with his muleta.

Two pictures demonstrate how thoroughly Matisse had mastered the "Persian system" on the eve of his journey to Morocco. *La famille du peintre* (fig. 19) attempts to integrate into a patterned ground a category of objects that Islamic art had cautiously barred from its compositions: the human figure. The debate between figure and ground hence assumes a particularly conflicting form here: the artist's two sons, his daughter, and his wife are pitted against a large Persian rug. The latter finds it easy to contaminate seats, sofas, and walls, which Matisse thereupon tilted forward to the picture plane. The only real difficulty is raised by the four sitters. In order to integrate them into the overall pattern, Matisse employed several stratagems. One of them, which he used again in Morocco, emphasizes the actors' dress at the expense of their flesh. As for the faces, Matisse converted their individual reality into decorative repetition by insisting on their generic similarities rather than on their differences: the same flesh tone, the same "face" sign are applied to all. The models' membership in the same family allows him to go still further: the duplication of Pierre and Jean, which reduces them to the status of a decorative motif, is justified, so to say, by the relative identity of their genetic make-up.

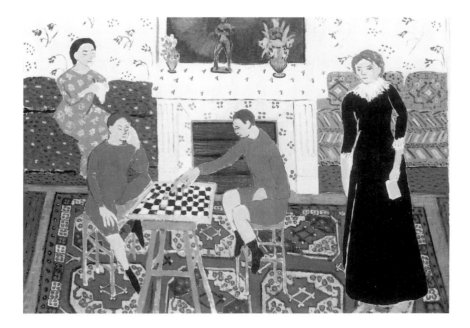

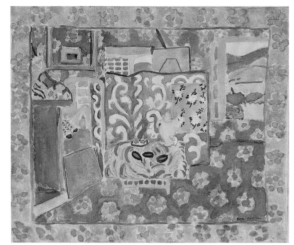

Matisse proceeded more cautiously in *Intérieur aux aubergines* (fig. 20), painted after his return from Munich. There are no humans to stir up the eternal conflict of figure and ground, which might easily cause a rift in the homogeneous fabric of the picture. *Intérieur aux aubergines* translates into a patchwork of textilelike surfaces all categories of subjects (except the human), which Matisse had previously expressed in terms of perspective: furnished interior, still life, landscape. The finished work records not only its point of departure, but also the process of its elaboration, from beginning to end: the small piece of cloth with its floral motifs, which is the initial cell from which the floral pattern, gradually invades the entire canvas. *Intérieur aux aubergines* recounts the history of the evolution and generalization of the painter's style from the presence of the rug in the picture to the picture treated as a rug. Once that limit has been reached, the rug is no longer needed as a pretext; it may then, but it is not required to, disappear. Its function has been taken over by the painting itself. Here at last we see, spread again, "that warming sun. . ., that immense Oriental rug"[72] of which Gauguin had deplored the disappearance.

Orientality thus prevented Matisse from giving in to the temptations of orientalism. A vase glimpsed in a museum, a rug seen in an exhibition sufficed to make him penetrate into the heart of the aesthetics they illustrate. Henceforth, he needed these clues no more: mastery of the mode of production renders the presence of the product superfluous.

This is the moment at which Matisse chose to go to Morocco. Paradoxical as this decision may seem, it is in keeping with the dual nature of his character.[73] Every victory, when too absolute, provoked a reaction in him. The definition and the exploration of his theory, fauvism, as well as his ever-growing mastery of the technique of color derived from the study of Oriental rugs, led Matisse well into what he at times called "abstraction" and at other times "decoration." This kind of art, which is constructed, subjective, and goes against the grain of the tradition in which he was rooted, struck Matisse as born of the triumph of his will over nature.

The stark simplification of the major pictures painted in the years 1905–1911, their radical rarefaction, reawakened the need, often felt and expressed in later years, to

left: fig. 19. Henri Matisse, *La famille du peintre*, 1911, oil on canvas. The State Hermitage Museum, Leningrad

right: fig. 20. Henri Matisse, *Intérieur aux aubergines*, 1911, watercolor on paper. Private collection

make contact again with the earth, like Antaeus. What Matisse had in mind when he spoke of earth is, first of all, the semantic content of the system of signs by which he replaced the language of realistic forms. If orientality was to be something more than a formal game, more than ornamental play, he had to master not only the network of signs woven into "the immense Oriental rug," but their meaning.

The central theme treated by rugs is the garden and, more specifically, the garden of bliss that is the Koran's idea of paradise. By a coincidence that obviously owes nothing to chance, this is precisely the content that imposed itself upon Matisse's painting at the same time as the aesthetics of fauvism. The picture in which it manifests itself explicitly bears the title *Le bonheur de vivre* (see fig. 99). It depicts the *locus amoenus* such as it has been described in classical mythology.[74] When the decorative system replaces the realist system, a religious content takes the place of a profane one. This twofold mutation had occurred in Gauguin's *La vision après le sermon*; it now happened in Matisse's *Le bonheur de vivre.* I am not concerned here with the question of why Matisse chose to express his doctrine of happiness by means of a myth sung by Hesiod and Virgil rather than in the Christian terms that constitute his own background. I merely wish to point out the abstract, antirealist character of that content. Up to then, throughout all his phases, Matisse had never ceased to be a basically realist painter.

Indeed, every important step forward in Matisse's painting took place in a specific corner of the world: he became an impressionist in Brittany, an adept of *peinture claire* in Corsica, a proto-fauve in Toulouse, a divisionist in Saint-Tropez, a fauve in Collioure. In this, Matisse remained loyal to the nineteenth century, which had treated landscape as the progressive genre par excellence, an attitude summarized by Arthur Rimbaud's well-known commandment "Find the place and the formula."[75] The adoption of the aesthetic of decoration forced Matisse to sever the link between place and formula. To inaugurate his decorative style, he used for the first time an imaginary motif: abstraction of signs is thus echoed by abstraction of meaning. The next generation would readily accept this transformation. The transitional generation to which Matisse belonged, however, still deeply dualistic, could not: it tolerated abstraction as long as reality provided an objective correlative for it. It demanded the formula *and* the place.

Once he had found his style, Gauguin looked desperately for the place that would suit it: Brittany, Martinique, Madagascar, Indochina, Polynesia were considered or tested in turn. Matisse proceeded in exactly the same way. Once his decorative manner had asserted itself, he appears to have been seized by a frenzy to travel. In summer 1910 he went to Germany to visit the exhibition of Islamic art in Munich. Winter 1910–1911 brought him to Spain, where he remained for some time in Andalusia, painting in Seville, raving about Cordoba ("Splendid mosque. Am very pleased with my trip."[76]). In Russia in October–November 1911 he was overwhelmed by the sight of icons and post-Byzantine frescoes in Moscow, to the extent that he urged the young Russian artists whom he met and who were inclined to take their cue from him—a Parisian avant-garde whose ways were just then beginning to part with his own—to seek their inspiration in them.

All these journeys confirmed his stylistic choices and broadened and deepened his language. Thus the revelation of the Christian East—Byzantine art as it survived in Orthodox Russia—proved to him the possibility of combining human figure with abstract ground without marring the decorative harmony. He could thus hope to handle human figures in the decorative mode from which Islamic art had excluded them. The unusual oblong format used by Matisse for *Amido* (cat. 8), *La mulâtresse Fatma* (cat. 15) and *Zorah debout* (cat. 16), might well be regarded as the unconscious admission of the influence exerted by the narrow, frontal images of saints Matisse had seen at the Cathedral of the Assumption in the Kremlin, for instance.[77]

Rewarding as all these trips may have been, they influenced Matisse's art at the level of its medium, but not at that of his message.[78] The partners of this indispensible alliance seemed incompatible, hence the cry of discouragement Matisse sent to Gertrude Stein on one of those dark days in Tangier: "Painting is a very difficult thing for me—there is always this struggle. Is it natural? Yes, but why is it so difficult? It is so sweet when it comes effortlessly."[79] Yet the experience in Tangier ended by living up to his expectations and by offering him a place so very suited to the formula that one cannot be distinguished from the other. Did Matisse recall Delacroix's remark, "I am like a man who dreams and who sees. . . ?" Or was he persuaded by what Marquet told him or showed him on his return from Morocco, those oils on cardboard in which subjective vision and objective view are so felicitously wed? In any case, he decided to give it a try. And what he said about the experience once it was over shows that his expectation had been fulfilled: "The trips to Morocco helped me to accomplish the necessary transition and enabled me to renew closer contact with nature than the application of a living but somewhat limited theory such as Fauvism had turned into had made it possible."[80]

The transition was necessary because Matisse found the rift opened in his work between prospect and aspect, to use Poussin's terms, since Le bonheur de vivre painful to bear; but it was difficult to imagine how to accomplish it, since the two elements involved appear to be incompatible. And to be sure, they would have irremediably remained so, had it been required that their reconciliation take place on their own plane. It is, however, achieved by light, present in both and endowed with a unique character: no matter how diverse the places where it manifests itself, it remains indivisible.

To Matisse, it was the most precious of all things. "The chief goal of my work is the clarity of light," he told Pierre Courthion in 1941, as he was contemplating his past itinerary with the lucidity of one who has just had a close look at death.[81] He constructed his pictures by color, but for light.[82] In fact, the search for the possession of light antedates its intensification following the fauvist fusion of color into light in 1905. While he was still a student of Gustave Moreau, he would turn to his fellow students and designate the canvas he was working on: "Look how it lights up the room!"[83] His way of painting changed more than once between 1896 and 1936, when he spoke the following words, but his objective never varied: "A picture must possess a veritable power for generating light."[84]

Matisse turned to landscapes, not for the sake of their configuration (their beauty, their picturesqueness), but for the light that emanates from them. His "great dazzlement"[85] upon seeing the Mediterranean for the first time, in 1898, was due to its radiance. And it was due to it again in 1916–1917, when he was met by it in Nice: "When it became clear to me that I would see this light every morning, I could not believe my bliss."[86] Matisse did not travel to see places, but to see light, to restore, through a change of its quality, the freshness it had lost as a result of being seen day after day. He left for the antipodes in search of this more intense, rejuvenated clarity (and, incidentally, discovered it quite by chance while traversing the United States).

During the various stages of his career, "inner light, mental or moral light" and "natural light, the one that comes from the outside, from the sky,"[87] will dominate in turn. And every time the one prevails, he feels the need to reacquaint himself with the other. "It is only after having enjoyed the light of the sun for a long time that I tried to express myself through the light of the spirit," he told Aragon on 1 September 1942.[88] The same is true for the period 1895–1905 and again for the years 1918–1942. The opposite is true for the period 1905–1912. The problem for him, then, was to recover his equilibrium and peace of mind, to restore a situation in which the light of the sky again dialogues with the light of the spirit, and in which they do so with equal intensity, for

only on that condition will they be able to "fuse"—the term is Matisse's—into each other.

He might have received an intimation of this new alliance from certain pictures and reflections by Delacroix and Marquet. He may have expected it to result from the conjunction of place and formula in North Africa (the miracle hadn't happened the year before in Andalusia, that Arab bridgehead in Europe, perhaps because both the people and the sun were missing). Most likely, too, he remembered, at least subconsciously, Pierre Loti's *Au Maroc*. In 1941 he mentioned it in the context of his own voyage: "It is delightful to walk beneath that vault which distills the softest light, deposits the deepest limpidities on the horizon, and the remote reaches of the endless garden through which we are travelling display, tonight, the subtlest Edenic shades."[89]

Upon his arrival, however, it wasn't into Loti's Garden of Eden that Matisse must have felt transported, but into Dante's *Inferno*:

Io venni in loco d'ogni luce muto,
Che mugghia come fa mar per tempesta,
Se da contrari venti è combattuto.[90]

Part II

The winds subsided (not without first having demolished the telegraph), and the rain, too, ceased. Hope was reborn on 12 February. "Today's the first relatively beautiful and pleasant day," Matisse wrote Marquet. "The barometer has improved by a quarter of a circle." The painter's morale followed the same ascending path. It was high time: "I am deeply depressed by this mishap. . . ."[91] To be sure, it was still only a fragile hope, for on the same day, Matisse wrote Marguerite: "The day has been superb, but this evening, a rain shower has just fallen."[92] The weather remained fluctuating for another ten days or so. Matisse evoked this period in a postcard to Manguin, dated 28 February: "At last the weather has become fine, but it is still variable. There is lots of fog, and often clouds that send picturesque shadows scurrying across the countryside. All this is beautiful, but not very conducive to work *sur nature*, which requires many sessions on the same picture."[93]

The meteorological oscillations were definitively over on the first of March. On that day Matisse wrote Baignères, a fellow painter: "I have been in Tangier for the last month. After having watched it rain for 15 days and 15 nights as I have never seen it rain, the good weather has come at last, charming, sheer delight on account of its delicacy. What I have seen of Morocco reminds me of Normandy, as far as the lushness of the vegetation is concerned, but far more varied and decorative. I am working, but as the country is so new to me, I cannot tell what will come of it."[94] The same day, Matisse wrote Manguin a very similar letter, but added a few interesting touches to his description of the quality of Tangerine light: "The weather is good at last. What mellow light, not at all like the Côte d'Azur, and the vegetation is lush as in Normandy, but what decorativeness!!! How new all this is, how difficult to render with blue, red, yellow and green."[95] A great day indeed, that March 1st, for Camoin too was treated to a variation on the general theme of joy: "After fifteen days and as many nights of rain, we are enjoying fine weather and the vegetation, which is truly luxuriant. I have started to work and I am not too dissatisfied, although it is very difficult; the light is so soft, so very different from the Mediterranean."[96]

While each of these weather reports strikes its own note, the total effect is coherent. At Tangier, Matisse was struck first and foremost by two things, the equivalent of which, it seemed, existed nowhere else: the light and the vegetation. With two excep-

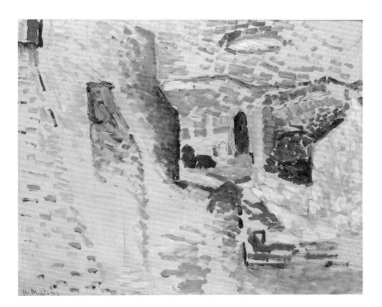

fig. 21. Henri Matisse, *Rue du Soleil, Collioure*, 1905, oil on canvas. Private collection

tions, they provided all the subjects of his painting during his two Moroccan campaigns. "Find joy in the sky, in trees, in flowers": this advice, which Matisse addressed to himself in "*Jazz*" in 1947,[97] is literally the program of the pictures painted in Tangier in 1912–1913.

Since Plato, philosophers, theologians, and poets have used light as a metaphor for the ineffable. It is therefore hardly surprising to experience considerable difficulty in describing light itself. One is thus all the happier to report a testimonial that can hardly be suspected of dreamy vagueness and lyric nebulosity: before the Second World War, so the story goes, the Pinkerton Agency sent its fledgling detectives to Tangier to perfect them in the art of tailing people. For the play of sunlight and of picturesque shadows is so subtle and so unexpected that one can easily lose sight of the person whom one is following in the streets and alleys.

For Matisse, the object of the pursuit was light itself. He gave us an extremely precise and, if we are to believe his paintings, truthful description of it. The light he sought is "deliciously delicate," "so soft," so incredibly "mellow." It combines contradictory qualities: it is both ardent and fresh; its intensity differentiates forms clearly without making their frontiers sharp and cutting. Pierre Loti noted the same traits in *Au Maroc*, the book that had left Matisse such a strong impression: "Although one distinguishes with extreme sharpness the slightest details of every object, the least crack in every wall, they are separated from us by a kind of luminous mist, which lends a vagueness to their bases, renders them almost vaporous. They look as if they were suspended in the air."[98]

When he remarked that Moroccan light is not Mediterranean, Matisse designated both the effect and the cause: the country's climate is African, but also Atlantic. The light is so intense that it tends toward solar incandescence, but it bursts through the rains. On his second trip, Matisse found the ground brown, its grass entirely parched by the summer's heat. During his first journey, on the other hand, he was privileged to enjoy that brief period when sunlight is heir to the attributes of the waters from which it emerges: freshness, fluidity, softness.

Two pictures dealing with similar motifs, *Rue du Soleil* (fig. 21) and *Le marabout*, allow us to measure the contrast between the light at Collioure and the light in Tangier,

and more important, to assess the consequent differences in Matisse's manner. The light in the small Catalan harbor is ferocious; it assails and devours forms. In the Moroccan city it is effusive, not aggressive. It does not seem to hit objects from the outside, but to spring from within them. In both cases, the colors are intense, but whereas at Collioure they radiate, they breathe at Tangier. In the 1905 picture they take possession of the canvas by projection, pelting, biting the visible, tearing it from non-existence (in Matisse's fauve paintings, the unpainted areas do not have the same importance as the painted ones). In the later picture, they proceed by pulsation, as if they were merely the tinted, outer layers of an expanding gas: Whether covered with pigments or in reserve, the whole surface is porous to the underlying void and aerated, animated by it.

Barely begun in *Le marabout*, this evolution reached its climax with the blissful levity of *Café marocain*. The fierce, preying light that overcomes *La musique* gives way to a gentle, caressing clarity that seems to emanate from both figures and ground. The ravenous solar radiance of fauvism led Matisse along natural paths to the extranatural, quasi-abstract light that signals the intrusion of a "savage god."[99] Glimpsed in *Le bonheur de vivre*, sending more and more insistent signals throughout the series of mythological pictures, it explodes openly in *La danse* and *La musique*. It is well known that, at the time he was working on these two canvases, Matisse, perhaps because he unconsciously remembered Saint Paul's experience on the road to Damascus, was afraid of losing his eyesight. *Numen, lumen:* for a painter more than for anyone, light and the sacred are apt to be synonymous.

And precious. Matisse did not repudiate fauvism, but tried to expand it beyond its somewhat limited character. Fauve light is the result of a rape, of the motif's conquest by violence. The strokes of his brush are blows dealt to a shape that resisted his will before bowing to it. To broaden fauvism meant trying to find that divine, abstract light in nature itself.

Matisse's production of the years 1912–1913 shows that he succeeded in doing so in Tangier. To such works as *Zorah debout*, *La mulâtresse Fatma*, *Le rifain debout* (cat. 18), the so-called Moroccan Triptych, or *Café marocain*, it would be more appropriate to apply the term "luminescence" than "light." In these paintings the colors are not exalted, but rather exhaled.

Fauve light was born of the encounter between sun and landscape. Past the threshhold where natural light turns into nonrealist light, landscape gives way to the human figure, for it is through the latter that Matisse found it easiest to express, as he said in 1908, "the so to speak religious feeling of life which I possess."[100] As the same causes tend to produce the same effects, Matisse instinctively refrained from returning to a genre incompatible with the manifestation of the sacred. His only two landscapes, in the strict sense of the word, probably date from the beginning of his first sojourn. *Vue sur la baie de Tanger* (cat. 2) belongs to the category of *vedute*, which are submitted to rules sufficiently precise to render the viewpoints represented interchangeable: it does not differ morphologically from *Vue de Saint-Tropez* (fig. 22) or from *Vue de Collioure* (fig. 23). The more assertively local character of *Le marabout* may possibly be attributed to Matisse's desire to respond, through the picture's tonality and composition, to the sketches painted a few months earlier by Marquet. Matisse might have seen these sketches in his friend's studio; together with Marquet's tales of his journey, they would have stimulated Matisse's eagerness to launch on the same expedition.

True, Matisse mentioned on several occasions the "landscapes" he had painted, or must paint (for Morosov) in Tangier. But does the term really suit the pictures that he briefly intended to send to the Moscow collector? Does it fit those he finally did send

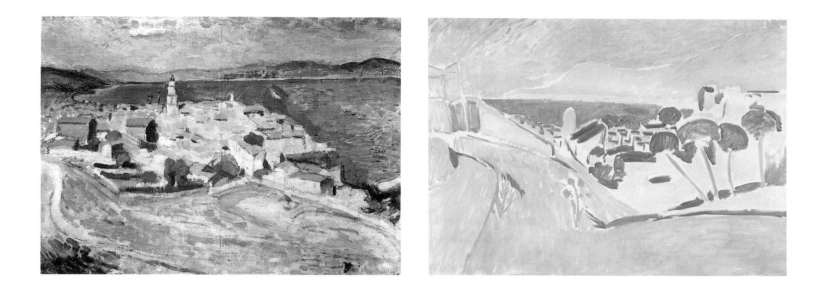

him and which have been grouped under the heading "Moroccan Triptych"? The latter's central panel represents a human figure. The one on the left deals with a theme dear to Matisse, "the charm of a window." The one on the right depicts another favorite motif, "a door's mystery." As for the three paintings done in the garden of Villa Brooks, they belong to that typically Matissian category of domesticated, framed, extraterritorialized landscapes known as gardens (a more appropriate definition might be "close-ups of nature").

That Matisse had plenty of opportunities to paint real landscapes, animated and picturesque street scenes, is demonstrated by the numerous drawings he devoted to such subjects. With the exception, however, of those that contributed to the elaboration of *Le marabout* and *Vue sur la baie de Tanger,* only the thumbnail sketches of persons, windows, and vegetation have their equivalents in painting: as if Matisse had entrusted landscape to the jealous and unrelenting guard of the pen so as not to give in to the temptation of handling it with the brush.

One would think that this abstinence from landscape might have forced him to give up the hope that had brought him to these shores: that the "light of the spirit," which an abstract will had poured upon his work since 1909, would emanate from nature itself. This fear might have been justified, had not nature, by which I mean the country and its climate, done precisely what he had expected of it, met him halfway. For it offered itself to him, not as a form, but as a force: not as landscape, but as vegetation.

After the rain ended, the revelation of vegetation had been inseparably associated with the revelation of light: struck by its prodigious luxuriance, Matisse compared it to Normandy from the point of view of its lushness ("*ardeur*"), but "far more varied and decorative."[101] (Thirty years later, the marvel of it was still fresh in his mind. He recalled his ride on the back of a mule "through a field of pure, virginal grass, in the morning's beauty. It was something exquisite."[102]) From that moment on, the ground of all the places he was fond of visiting—the hills and valleys by the city, the garden at Villa Brooks—was saturated with this extraordinary green. Pierre Loti, who had visited the same region at the same time of the year in 1889, likewise described its enchantment: "These plains were of a green tender and fresh, endlessly, the brand new green of April."[103]

left: fig. 22. Henri Matisse, *Vue de Saint Tropez,* 1904, oil on canvas. Musée de Bagnols-sur-Cèze

right: fig. 23. Henri Matisse, *Vue de Collioure,* 1911, oil on canvas. Private collection

That green and the sky's blue are the colors of spring in Tangier: their double dominion is reflected by *Le marabout* as well as by *Le rifain debout*. The city's builders had been no less attentive to this vernal harmony. In answer to the sky's blue, they covered the walls and minarets of their mosques, as well as the exterior of the English church, with green ceramic tiles. The remembrance of this dialogue between cerulean and viridian later inspired Matisse with the idea of wrapping the roof of the Chapelle du Rosaire, at Vence, with blue ceramics, "because blue goes well with grass, it brings out the green," as he explained to Frère Rayssiguier, who also reported Matisse's concluding comment: "He has seen this sort of thing in Morocco."[104]

Pierre Loti had made a strong if subconscious impression on the artist. Progressing on his mule through "this kind of sea of flowers," Matisse told his interlocutor that he experienced a sense of déjà vu. It all became clear to him when he remembered that he had read a description of the valleys between Tangier and Tetouan in a book by Loti. And Matisse concluded: "Truly, at that moment I was filled with extraordinary esteem for Loti as a painter."[105]

Loti not only preceded but also prefigured Matisse to such a degree that one may ask whether the artist's reading of *Au Maroc* was not one of the major causes of his trip. The book presents an astonishingly precise and faithful paraphrase of the scenes that were to retain Matisse's attention. Loti indulged in a veritable floral orgy. Wherever he turned his eyes, he saw "nothing but carpets of flowers." "In no flower-bed have I ever seen so lavish a display of flowers."[106] Because of the nature of the climate and of the soil, alfalfa and irises, lavender and asphodels "blossomed with the excessiveness characteristic of Moroccan plants."[107] Loti wallowed in the dizzying, intoxicating profusion of essences: "Our horses are up to their chests in flowers. Without dismounting, we could pick up whole bunches simply by stretching our arms."[108] "This unimaginable profusion of flowers" turned "the desert" into "Eden."[109] Or as the already mentioned guidebook put it: "More so than Algeria and Tunisia, Morocco is a garden."[110]

Matisse shared Loti's passion for flowers ever since his childhood. He never forgot the hypnotist who had shown him and his fellow pupils at Bohain a meadow studded with flowers where in reality there had been nothing but the pavement of a school hall. The possibility of owning a flower bed (it can be seen blazing in the background of *La conversation*) was responsible, at least as much as the need for a more spacious studio, for the acquisition of the house at Issy-les-Moulineaux.

Amid the vegetation of Morocco, this passion flared up and became overwhelming. The light that radiates from flowers enabled Matisse to survive until the deluge ended. His enthusiasm was echoed by a letter from his wife to Marguerite on 31 January 1912. "Despite the rain, the weather is mild and the flowers are all out, morning glories, heliotropes, nasturtiums and others."[111] At first, he enjoyed these things only from a distance. The hotel was very expensive, tiny and dirty, and Matisse was momentarily tempted to seek different lodgings. However, the Villa de France boasts "a superb view,"[112] which persuaded him to stay on (as we know, he painted this view during both his sojourns). As soon as the weather improved, Matisse undertook excursions on a mule and later on a horse that occupied him on many a morning and provided him with the vivid sensations of which he had read the exact description in Loti. In March he painted in the garden of "Villa Bronx."[113] Once he had completed his work and was thinking of returning to France, he revisited the villa despite the owner's misanthropic mood. "I went back to look at the Bronx garden. It is very beautiful, the white convolvulus are beginning to bloom, the lawns are studded with the yellow flowers that you know, the acacias are blossoming, spring is here. If I feel all right, I may gain by staying on."[114] Flowers obsessed him. He asked his wife, who was back in Issy: "How did you find the garden? Is it pretty? Will I be able to work in it?"[115] At last he was ready to leave

Tangier (the rain, which fell once again, helped him come to this decision). On 12 April, two days before embarking, he wrote his wife a last letter: "I am preparing to leave; I go this way and that, I look at the country, which is becoming more and more beautiful on account of the green everywhere. Yesterday, I went to the Bronx garden which is turning into pure enchantment, all the flowers are out. There is above all, a wonderful wisteria near the house. I did two drawings of it that might give you a vague idea. I took interest in the small flowers, they are exquisite. I saw a green-and-brown iris with a yellow heart which I found altogether fetching."[116]

On 6 February 1912, Matisse, trapped in the hotel by rain, had written his daughter: "I have begun a bouquet of blue irises."[117] Thus he inaugurated his Moroccan campaign with a picture of flowers. He was to paint practically nothing else during his two sojourns.[118]

This assertion needs no justification as far as the two bouquets of arums are concerned. Nor is one needed for the three views painted in the garden of Villa Brooks, *Les acanthes* (cat. 5), *Les pervenches (Jardin marocain)* (cat. 6), *La palme* (cat. 7): a garden is not a landscape but a flower reserve.[119] Even the "figures of Moroccan men and women"[120] are subjects of Flora's empire. Tall and slender, presented frontally, they have that intensity and fragility, that quality of being exceedingly endowed with a life that hangs only by a thread, that is the special privilege of stems and corollas. *Amido, La mulâtresse Fatma, Zorah debout, Sur la terrasse* (cat. 13), *La petite mulâtresse* (cat. 17) are, in short, human flowers. As for the "magnificent young Moroccan from the Rif," despite his "somewhat savage eyes,"[121] he is of the same green as the meadows by Tangier (the same holds true for Fatma). Finally, the six figures in *Café marocain*, with their white headgear, their ocher members and gray robes, stud like flowers the Moorish café's floor, which has also been transformed into meadow by its pale viridian tone.

The difference between people and plants is concentrated in the faces. If these mirrors of passions and of consciousness were to be treated with too much respect, the identification between people and plants might become impossible or appear artificial. That is why Matisse emptied the faces of his Moroccan models. But did not the suppression, in turn, imply the sacrifice of an essential part of their reality? Elsewhere than in Morocco, this would surely be the case. Here, however, it is natural for people to achieve mental emptiness. They readily fall prey, as Pierre Loti had already observed, to "I know not what distinguished indolence, a tranquility detached from everything."[122] Concentrated upon that emptiness that is fuller than fullness, they allow themselves to be invaded by the void, traversed, reduced by it to a kind of vegetative, if not vegetable existence.

What we are confronted with is not simply a metaphor but an existential experience, which had remained more or less unconscious until then and which the stay in Tangier was to impose upon Matisse's awareness. Suffice it to recall that, a few weeks before he sailed to Tangier, Matisse had been deeply moved by the icons in Ostroukhov's collection. He related his impressions to the Russian public: "Like mystical flowers, these icons reveal the souls of the artists who painted them, and it is here that we must learn to understand art."[123] To floralize humanity is to purify it. "When I see, when I study women, I often think of flowers, but never the reverse."[124] And one day he confessed to Louis Aragon that he would like to spell *flirter* (to flirt) *fleureter* (to flower). "There are flowers everywhere for whoever is willing to see them."[125] For Matisse, that willingness began in Morocco.

By taking flowers as his subject, Matisse satisfied his need to do two things at the same time. The faithful representation of nature gave him, in the case of flowers, easy access to decoration, which, since 1905, he had been able to attain only by raping, by tran-

fig. 24. Henri Matisse, *Fleurs*, c. 1943–1944, watercolor on paper. Private collection

fig. 25. Henri Matisse, *Envelope of a Letter to André Rouveyre*, 1943, ink and gouache. Det Kongelige Bibliotek, Copenhagen

scending the realist motif. For in the case of flowers the usual rapport between color and its material support is inversed. Unlike most objects, which are made of matter more or less colored, flowers are made of colors barely materialized. Consequently, the passage from tonal, representational color to pure, abstract color, which ordinarily requires an artistic operation, is, when flowers are concerned, already to a large extent performed by botany before the painter intervenes.[126] And this is particularly true in Morocco where, as Pierre Loti had noted, flowers bloomed "with that excess" that renders them, as Matisse was to emphasize, even "more decorative" than elsewhere. A garden is a concrete reservoir of abstract colors; hence the conversion of nature into painting is no longer felt there as the effect of an act of will, since that conversion takes place in nature itself. Shortly after the First World War, Matisse described his house at Issy-les-Moulineaux to a Scandinavian visitor: "There I also have a wonderful garden with lots of flowers which, to me, are the best color compositions. Flowers provide me with chromatic impressions that remain indelibly branded on my retina, as by a red-hot iron. So, the day I find myself, palette in hand, in front of a composition and know only very approximately what color to use first, that memory may suddenly spring within me and help me, give me an impulsion."[127]

The substance of flowers may be transplanted from garden to canvas without having to be modified or edulcorated in the painter's mind. "It's so sweet when it comes naturally." In Tangier the realistic representation of nature raises itself, by the grace of flowers, to the level of decorative abstraction: the sweetness of the Moroccan paintings is due to the absence of the efforts usually needed to attain that level.

Matisse's choice of subject matter has another consequence. To paint flowers is to oblige oneself to paint florally. The Moroccan pictures are not so much painted as stained. Their colors cannot be said to hover in front of objects, since the latter are practically nonexistent. The colors are these immaterial, boneless, weightless, skinless bodies—light-waves, chromatic vibrations. The corollas' excess crowns the fragility of the stems; resplendent though they are, the colors hang by a thread. Behind them lies the void, whose pulsations we perceive through the thin layers of pigment.

The forms are, so to speak, the void's moment of life. Rather than solid figures, they are passing, inconsistent configurations of the atmosphere, cloud formations precise yet impossible to capture. They pose, in fact, a difficult problem for the artist: how is he to render the unambiguous shapes of these vapors? The device of outline, though quite compatible with abstract decoration, is not so with realistic representation; as Cézanne pointed out, "there are no lines in nature." The solution found by Matisse is, in every sense of the word, luminous. He replaced positive contours (black or colored line) by

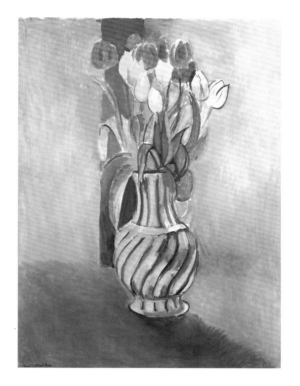

negative ones, the shapes of things surrounded by a line left in reserve. On the one hand, this device enables the painter to define forms precisely and, on the other, contributes to making the underlying void (the primed canvas, to be precise) graze the surface of the picture, which the forms barely veil and of which they constitute transitory modulations. This explains the importance of line drawing for Matisse during his Moroccan sojourns. It enabled him to satisfy two concurrent wishes, which painting forbade him to fulfill: the longing for picturesque people and places and the desire for a "system of writing by lines." In short, the Tangerine period marks the point of departure of that separation of color and drawing that was to characterize Matisse's work from the thirties onward.

Need one add to what has just been said that the word *void* is used here in its oriental sense of fullness, respiration, true life?

Matisse hoped that Morocco would help him provide a wider base for "the living but somewhat limited theory that fauvism had turned into" when it led to decoration. He expected to "renew closer contact with nature"[128] by confronting this abstract aesthetic (which I call "orientality") with the actual Orient that had engendered it. Yet, while he did once again "touch earth" in Tangier, the florality through which the contact with nature is renewed seems, at first sight, as limited as the fauve doctrine itself.

Yet it only seems so. Far from contradicting orientality, florality prolongs it, "transmits it into earth."[129] For the soil of Morocco is, as Loti put it, "nothing but carpets of flowers."[130] Actually, the novelist merely echoed the travelers who preceded him, in particular Delacroix: "Innumerable flowers of a thousand species," the painter noted on 6 April 1832, "forming carpets of the most varied colors."[131] The image of the carpet recurs constantly in his notebooks. Now, as we have seen, the rug is the quintessence of

left: fig. 26. Henri Matisse, *Tulipes*, 1914, oil on canvas. Private collection

right: fig. 27. Henri Matisse, *La danseuse créole*, 1950, painted, cut, and pasted paper. Musée Matisse, Nice

figs. 28 and 29. Henri Matisse, *Coqueli-cots*, c. 1912/1913(?), oil on canvas. Private collection

orientality in its Muslim version and as it is resurrected by Matisse in the art of the modern West. The equivalence of floral and textile parterres is so manifest that the one is almost automatically resorted to when one wants to speak of the other. "Fine grass is my floor," wrote Loti: "It is a beautiful violet carpet . . . in the midst of which three or four heads of marigold, tucked here and there, sparkle like golden wheels."[132] Conversely, the carpet's favorite theme is the flowering garden (a type of fifteenth-century tapestry is called "*mille fleurs*").

Florality and orientality are thus synonymous. More precisely, observable nature and decorative system participate in each other, like communicating vases, thanks to flowers. *L'intérieur aux aubergines* had already proclaimed this synonymity. We can detect no morphological difference between the real clematis in a vase and the ornamental ones printed on the piece of cloth pinned to the screen, nor between these and the purely abstract, imaginary ones that constellate much of the picture plane. "The European Renaissance makes it difficult to bring together the vegetal, the animal and the human," said Matisse to Frère Rayssiguier,[133] thereby implying the contrary, that the decorative Orient makes it easy.

Equivalence and synonymity are, in fact, feeble words for what is at stake here. We are not simply faced with a metaphor, but with the identity of the realm of nature and that of art. Or rather, all that which, until the Moroccan journey, had as yet been accepted by Matisse only as metaphor, is from now on perceived by him as experience. Whereas he decided to suppress the floral border that initially framed *Intérieur aux aubergines*, thereby censoring the premature admission of the osmosis between nature and art that he would verify in 1912, he allowed it to remain around *Café marocain*, whose background has, in addition, taken on that color of tender green recalling not so much the brick or stone terrace of the Moorish inn as the grass of a meadow.

Two paintings depicting red poppies and irises in a garden (figs. 28, 29), which I have previously ventured, without too much conviction, to date c. 1908,[134] express the coinci-

dence of reality and decoration effected by plants so perfectly that I am now tempted to attribute them to the Moroccan sojourn. They form a diptych of decorative panels without sacrificing a shred of realistic appearance. They read like a double icon celebrating those fragile canals, the flowers' stems, through which nature and painting communicate and miraculously nourish each other.

That miracle has a cause. The real garden and the fabric that translates it into abstract terms share the same subject matter. "And on this plateau, Allah has spread for us a white, blue and pink, absolutely untrod rug . . . : daisies, mallow and gentian. . . ," Loti wrote. "This May evening on this wild plateau is steeped in Edenic peace."[135] In the three cultural currents that inspired Matisse (the Judeo-Christian, the Graeco-Latin, and the Islamic), the garden—by which I mean the *hortus conclusus*, the pocket jungle, not that unbounded expanse known as landscape—is regarded as the earthly figure of Paradise, the *locus amoenus* of the Golden Age. That is the meaning Matisse attributed to it as early as *Le bonheur de vivre*, and continued to read in it to the end of his career. The narrow stained glass windows of the Vence chapel were conceived by him as "a garden behind a colonnade,"[136] and the motif used for the final version of the stained glass window entitled *La Jérusalem céleste* is the Tree of Life.

To be sure, the garden is not always perceived by Matisse as the figure of Paradise. Yet how could it have failed to strike him as such in a country where the flora was exceptionally brilliant and the light unutterably beautiful? How could Matisse have failed to believe that here the sacred dwells both in the real place and in the decorative formula? Working in the private park of the Villa Brooks, Matisse, it seems to me, had for the first time a revelation that needed only to be faithfully captured: the revelation of, as Goethe put it, a "heavenly message in earthly words."[137]

That garden, Marcel Sembat said, was to be "thrice redone, each time raised further toward decoration, toward calm, toward abstract simplicity. The first time I saw it, the trees and the grass on the ground gripped me with their original life. Next, the ground melted into a uniform tone, the grass became an ornamental garland of lianas, the trees turned into trees of Earthly Paradise, and the whole composition today dispenses ideal repose."[138] The imprecisions and confusions of this text, due to the fact that Sembat appears to have amalgamated Matisse's comments with his own reflections, have led to numerous misunderstandings. The ascent toward abstraction he described fits *Café marocain* better than what Sembat called "The Garden." The latter has indeed been "thrice redone," but on three different canvases. These do in fact, owing to the near identity of their subject matter and of their dimensions, make up an ensemble.[139] Sembat's text is above all remarkable for its recognition of the religious character ("Earthly Paradise") and of the importance of the triadic structure of that ensemble.

This triadism is characteristic of the manifestation of the sacred in Indo-European cultures. It is particularly evident in Christianity, where it accounts for the vogue of triptychs. The decline of faith and hence of Christian subject matter in the late nineteenth century did not cause triadic compositions to be abandoned. On the contrary, they appear to become more numerous in that period, perhaps because the disaffected signs pick up the burden of religiosity that can no longer be communicated through meanings that the new, laicized age repudiates or regards as outdated. In a word, where there are triptychs there is a preoccupation, be it subconscious, with the sacred.

In Tangier, Matisse seems to have been obsessed with the making of triptychs.[140] *Les Acanthes, Les pervenches (Jardin marocain)*, and *La palme* form such a one; *Amido, Zorah debout*, and *La mulâtresse Fatma*, another. *Paysage vu d'une fenêtre* (cat. 12), *Sur la terrasse*, and *Porte de la Casbah* (cat. 14) are universally known as the "Moroccan Triptych." Deservedly, for the three pictures had been assembled in an order specifically

wanted by Matisse, who sent their owner, Ivan Morosov, an explanatory sketch in a letter and who had already experimented with that arrangement when he exhibited his Moroccan paintings at Galerie Bernheim-Jeune. Indeed, photographs of the 1913 show demonstrate that the "Moroccan" Matisse thought in triads. After *Amido* had been sent to its buyer, Sergei Shchukin, Matisse restored the truncated trinity on the wall of the gallery by hanging *Rifain debout* in its place. For lack of a third bouquet executed in a similar format, the pair formed by the equal-size *Arums* and *Arums, iris et mimosas* (cats. 20, 21) was completed, on the gallery walls, by that enormous "mystical flower," *Le rifain assis.*[141]

One might object that this type of ABA hanging is an old academic practice, heir to the tripartite altarpieces and the triadic compositions of Christian art that it definitively replaces at the end of the eighteenth century. We know, however, that Matisse deeply felt its meaning. We know it because he said so. On 1 April 1912 he informed his wife, who had just left for Marseilles: "I wrote a nicely phrased letter to Shchukin this morning. I added a sketch representing Morosov's still life and two landscapes, the blue one and the periwinkles, they made up a nice sketch-triptych."[142] By "the blue one," Matisse probably meant *Acanthes. Pervenches*, which has usually been attributed to the second trip, might thus be one of the two "landscape sketches" Matisse reported showing to Morrice at the beginning of April, the other being *La palme*, which has also been called *Matin de Mars.*[143] In a letter of 12 April, "my still life for Morosov and my two sketches" were again associated, this time for the purpose of sharing a crate Matisse had had specially built.[144] Morosov's so-called Moroccan Triptych might therefore have initially comprised two of the garden pictures and one of the bouquets containing arums. Only *Le vase d'iris* (cat. 1) is similar in size to the three gardens . . . provided, of course, that it is them that Matisse meant! Be that as it may, Matisse returned to Morocco to paint the two landscapes that Morosov had been expecting since 1911.[145] Yet he did not receive a pair of pictures, but a trio that deserves the name "landscape" only by an extreme stretch of the imagination, since they respectively represent a window, a door, and a woman.

The combinations and permutations leading to the Moroccan Triptych as we know it now reveal the skill with which Matisse managed to reconcile a commission made by a collector (enamored with landscape painting and a landscape painter himself) with the command to paint triads, but not landscapes, issued by the voice from within. The imperative is so categorical that it overcame or slyly bypassed all obstacles. In a letter to his children written in the middle of November 1912, Matisse once again associated three drawings unrelated by their formats, their themes, and their addressees: "The three sketches below represent two Moorish girls, one of whom is intended as a pendant to Shchukin's Moroccan. The other will be for the Bernheims. The third is the little canvas for Sembat. It is only 30 by 27 cm—the two others are 1.50 meters high."[146] The diptych constituted by *Amido* and *Zorah debout* called insistently for a third panel: it was *La mulâtresse Fatma.* One may ask whether the same mental process was not at work in the case of *Les poissons rouges* (Pushkin, Moscow) bought by Shchukin in 1911. On 21 November 1912 Matisse informed Marguerite that, on this very day, he had started "a picture the size of Shchukin's "Goldfish." It is the portrait of a Riffian, a magnificent type of mountaineer, wild as a jackal."[147] Again, the diptych yearned to become a triptych, for a third picture, the same size as the two others, was painted, *Fenêtre ouverte à Tanger* (cat. 22). This trio treats in the epic key, so to speak, the themes of Morosov's lyrical Moroccan Triptych: a window, a human figure, and goldfish.[148]

The need to satisfy his longing for triads is the underlying reason for Matisse's second trip to Tangier: he intended to complete the triptychs which, until then, existed only as

dreams or in a state of incompleteness. It might be preferable to regard Matisse's Moroccan experience not as consisting of two trips, but as one voyage interrupted by a parenthesis of five months in France, which would at least protect us from the temptation of overstressing the stylistic differences between the two sojourns. Matisse alleged more prosaic reasons for his return to Morocco, such as the necessity of completing the Shchukin and Morosov commissions. Even if he had been aware of the deeper motives, he would not have boasted of heeding the call of the sacred in front of his old chums. Yet Matisse, who had arrived in Tangier on 10 October, had finished the pictures promised to his Russian clients before the end of the year. Nonetheless, he did not return to France until February 1913, not before having completed a work that was his response to another command received toward the end of the first trip. On 12 April 1912, in his last letter to his wife before leaving, Matisse wrote: "Two ideas for paintings came to me, which I plan to carry out once I get back."[149] One of these was at last finished in 1916, *Les Marocains* (cat. 24). The other, painted at Tangier, is *Café marocain*.

The physical and psychological conditions during the second trip proved very different from those of the first. Matisse, as he was later to note, did not find again the Morocco that had bewitched him once the rains were over. He had boarded the SS *Ophir* at Marseilles on 8 October. He now found the country burnt by the sun, "the color of a lion's skin." The persistent drought was, in fact, as unusual as the rain had been during the previous winter. "Everybody is in despair here, because the drought will upset the sowing season." This calamity provoked a cascade of economic repercussions that Matisse, recalling his rural background, analyzed clearly. Yet he concluded: "At heart, I am glad, because this weather is ideal for my work." Indeed, he began to work on *Le rifain debout* on 21 November, the very day on which he wrote this letter.[150]

The tension, the anxiety, the nervous strain that plagued him in March and April, caused at first by the impossibility of working because of the rain and, later, by the exhaustion resulting from the urge to make up for time lost, once the bad weather was over, did not trouble Matisse again. Little did it matter that the tender green of spring had disappeared. It now was printed indelibly in his memory, whence he could extract it whenever he wished, to begin with in *La mulâtresse Fatma* and in *Le rifain debout*. He was careful to spare his energy and contented himself with a single painting session a day. In the morning he went riding on a horse or read. "Arsène Lupin's exploits and Bergson's philosophy"[151] are among the writings he mentioned in his correspondence.

Life became even more pleasant once Amélie Matisse joined her husband in the company of Charles Camoin.[152] In December Morrice, who had been Matisse's companion during the preceding winter, also returned to Tangier. The warm comradeship that had bound them back in the nineties, when they were but budding artists eager to break with Beaux-Arts practices, was now restored, as well as the juvenile ebullience that had characterized the group. In the evening, they would meet at a café. Each one of them had a specialty: Camoin, who nearly died of diphtheria shortly after his arrival and was lovingly taken care of by the Matisses until he was cured, doted on billiards; Matisse, on movies; Morrice, on whiskey. Although it was already well into December, they even took a midnight bath in the sea.

During the day everyone worked. Here too, camaraderie prevailed. They pointed out interesting motifs to each other (often these "sights" were those they had discovered on postcards), and frequently drew them in each other's company. Both Camoin and Morrice painted their "Windows at Tangier" (see figs. 134, 126). Marquet, too, painted the view from the windows of the Hôtel Villa de France. Tangier's climate and the presence of Matisse were to prove profitable to his two companions. It drove the Canadian artist to warm up the chilly grisailles he had derived from Whistler, and it encouraged the artist from Marseilles to reconcile fauve color with the Corot-like delicacy that was his

personal note (it led Marquet to remark to Camoin, upon seeing his *View of the English Church, Tangier*: "Your delicacy will be the loss of you").[153]

In their company, Matisse was again in a serene mood. Not even the tempest that raged for four days between 7 and 11 January spoiled "those beautiful Moroccan hours."[154] Still life, the besieged painter's last recourse, no longer irritated him. "We work indoors very quietly. One can drum up a masterpiece with an orange, three carrots, and a rag."[155] There may have been something reassuring for Matisse in the presence of artists who never severed their link with nature. To be with them was, in a sense, to renew his youth as an artist trained in the wake of impressionism. After six years of abstract isolation, he thus not only made contact again with reality, but also with a group of painters who depended on the latter to the point of expecting a renewal of their art not from themselves, but from new motifs furnished by nature (hence the downright dromomania that possessed Marquet, Camoin, and Morrice).

This atmosphere of mutual understanding, expressed by shared motifs, sometimes represented quite similarly, is therefore best described as a fortuitous miracle, a fruitful misunderstanding. Whereas Matisse turned to the outside world for confirmation of the novelty born within himself, his friends expected that novelty to come from the outside. Morrice and Camoin only passingly alleviated the weight of picturesqueness that exotic lands tend to impose on the painter's brush; when Camoin painted Zorah or the Moroccan café, orientalism, which Matisse had succeeded in eliminating, got the upper hand again.

The point of departure of Matisse's version of *Café marocain* was the same as that for Camoin's *Moroccans in a Café* (see fig. 138), a place seen by chance in the course of a stroll.[156] "I've got my goldfish bowl and my pink flower," Sembat had Matisse say "That is what had struck me! Those tall devils who remained in contemplation for hours before a flower and some goldfish."[157] Such interest shown in a subject that had always held his own attention (goldfish, I believe, were regarded by him as symbols of the Golden Age) could only increase his sympathy for men plunged in an eminently artistic activity, contemplation. Their capacity for abstracting themselves from the outside world had already struck Delacroix, who called it "a gentle laziness," but drew and painted the attitudes it engendered with a kind of solemnity and nobility proving that he in no way equated it with sloth.[158] Loti, too, noticed the Arabs' "distinguished indolence," their "completely detached tranquility."[159] *Au Maroc* ends on a rather declamatory paragraph that nonetheless reads like a faithful description, down to the colors, of *Café marocain*: "May Allah allow the Arab people to keep its mystical dreams, its haughty immobility and its gray rags!"[160]

In his *Notes d'un peintre*, Matisse had proclaimed his preference for figure painting rather than for still life or landscape: "It is figure painting that enables me best to express the so to speak religious feeling that I have of life."[161] It permitted him to do so all the more since "the character of high gravity that resides in every human being"[162] is particularly evident in the contemplative men of Tangier. As a result, the view of the Moorish café links up with another series of experiences and works. On 12 April 1909, Matisse described, for the benefit of the critic Estienne, how he would fulfill the commission for Sergei Shchukin's mansion in Moscow: "It has three floors. I imagine the visitor coming from outside. The first floor is before him. An effort must be obtained, a feeling of lightening given. My first panel represents the dance, that round soaring above the hill. On the second floor, we find ourselves inside the house, within its spirit and its silence. I see a scene of music with attentive figures. Finally, on the third floor, total calm reigns and I paint a scene of repose, of people lying or dreaming on the grass."[163]

44

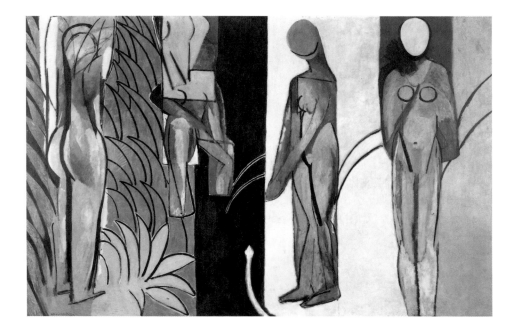

fig. 30. Henri Matisse, *Les demoiselles à la rivière*, 1916/1917, oil on canvas. The Art Institute of Chicago, Charles H. and Mary F. S. Worcester Collection

There were only two floors in Shchukin's house, unless Matisse included the ground floor in his count. The collector had asked Matisse for two, not three, pictures. However, the painter did not let material obstacles come in his way when he was seized by the triadic urge. It is precisely the triadic formulation par excellence that he glimpsed in 1909. He disposed action (*La danse*), passion (*La musique*), and a scene of contemplation in a kind of initiatic ascent toward nirvana. The last, however, exists only in the form of a *prima idea:* a watercolor representing women bathing in a river. It remained unexecuted, not so much because it hadn't been commissioned as because the Matisse of the years 1905–1910 was more apt to render tension than relaxation, to pay tribute to a savage god than to Edenic bliss.

Yet unconsciously, Matisse had not given up this triptych, for *Les demoiselles à la rivière* (fig. 30) was at last carried out in 1916. In the meantime, the little Moorish café gave him the opportunity to express in earthly words the heavenly message of the third floor. From that moment onward, we are no longer dealing with a picture to be painted "on the motif," but with an "idea for a composition," with an imaginary subject, as are all the works in which Matisse expressed his religious doctrine of happiness (*Luxe, calme et volupté* [see fig. 94], *Le bonheur de vivre, La danse, La musique,* and so forth). The terrace of the café and its lollers are ravished from their mundane status, stripped of their anecdotal details, elevated through a gradual process of elimination toward what Sembat called "abstraction" or , as Matisse himself put it, "toward ecstasy."[164]

The sublimation of an initially realistic theme goes hand in hand with a change of style, as we can see by comparing the painting with the drawings related to the place and to its occupants. The decorative border, this time frankly asserted, would have been enough to prove the change of register. However, still more tangible proofs of the transfiguration exist: the painting has been restated, reshaped under the influence of the chain of "sacred compositions" under whose spell it has fallen. The reclining figure is an immigrant from *Le bonheur de vivre.* The musician who plays a stringed instrument scraped a fiddle in *La musique,* and the man sitting with his arms wrapped around his legs also comes from that picture. The original project, which called for "figures lying in the grass," caused the café's white floor to turn a grassy green.

The *Café marocain*'s religious character is given away by the garland of arcades framing its upper border. They echo the mosque in Cordoba, which Matisse had seen and loved two years earlier. In answer to this line of arcades, a row of slippers borders the bottom of the canvas. Matisse ended by suppressing them, but they remain sufficiently visible to allow us to guess the meaning of their presence. On 28 April 1948, Matisse evoked in front of Frère Rayssiguier the "purification" of his art. In conclusion, he said: "After this purification, I left my sandals at the gate, as when you enter a mosque."[165]

The forty years of activity following *Café marocain* make what he meant by "purification" perfectly clear: not the abolition of reality in favor of abstraction, but the conversion of reality into abstraction. This conversion was to be the effect of a perpetually renewed effort. But once in his life it "came naturally." *Café marocain* embodies that unique moment when the profane loses its heaviness and is metamorphosed into the sacred before our eyes.

After this, Matisse has no longer any reason to tarry in Tangier: golden moments are not exploitable in the long run. The gentle god is no more inclined than the savage god to take orders. On the verge of returning to Tangier in the fall of 1913, Matisse changed his mind at the last minute and decided to work in Paris, "thinking," as he wrote Camoin, "that for the time being I had to do a labor of concentration and that the voyage, the change of climate and the excitement engendered by new things, which touch us primarily by their picturesqueness, would lead me to dispersion." A miracle had taken place: to expect an exception to the order of things to repeat itself is foolishness. Speaking of the extreme beauty that he had seen in Morocco, Delacroix remarked: "It is a pleasure that one might well wish to experience only once in one's life."[166]

Part III

Matisse's career may be schematically divided into three phases: the fauve period, culminating with *La musique*, to which the years of the First World War may be considered a postscript; the return to a more realistic style between 1918 and 1930; a second fauvism, in gestation during the thirties, covering the last ten years of Matisse's life. Each of these phases evolved its own set of references to the myth of the Golden Age that is central to Matisse's work. These are, successively, mythology, Morocco, and Polynesia.

Morocco ruled over the middle phase. However, this authority exerted itself in a complex way, sometimes indirectly, at others ambiguously. The temptation to make literal use of the Tangier experience was all the greater since the work done there had achieved the fusion between the sacred and reality. Matisse had first to learn at his expense that one cannot exploit the sacred at will and that it is governed by the principle, if I may be forgiven the pun, of *Noli me tangere*. This explains the failure of his attempt to paint *Les Marocains* in 1913. The objective was to provide the vision of the "third floor" illustrated by *Café marocain* with a size closer to that of *Demoiselles à la rivière*, of which this new Moroccan statement was to be the earthly synonym. Unfortunately, the Tangerine model was not yet remote enough to permit its conversion from realist view to abstract vision. For it to become possible, Matisse had to renounce all hope of painting a realist rendering of the theme and accept that it would henceforth remain inaccessible. Thus *Les Marocains* could not be born until the picture was no more than the adaptation of a memory. The process took four years.

Les Marocains is therefore the first instance of Matisse's practice of using memory as a laboratory for decanting reality into abstraction. Matisse deliberately and systematically used it during his third phase. Indeed, most of the works produced during that period

deserve the title borne by one of them, *Souvenir d'Océanie* (1953, The Museum of Modern Art, New York).

Before Matisse's return from Tahiti, *Les Marocains* remained an isolated case of a picture placed under the sign of Mnemosyne. The trips to Morocco were still too recent for the chemistry of memory to have had the time to transmute them. Above all, that chemistry is essentially a function of old age, and the Matisse who came back from Tangier was only forty-two years old.

Nonetheless Morocco rules over the Nice period (1918–1928), which has been rightly called the period of odalisques, a Morocco that has no connection either with current reality or with memories, but has to do with simulation. By dressing models who are not Arabs in Muslim clothes from north Africa, but also from French theaters and film studios, and by placing them in surroundings of *mucharabiehs*, sofas, cushions, Matisse devised *tableaux vivants*, exactly in the same way as, in those same years, he painted remakes in the key of bourgeois intimism of some of his major abstract pictures (*Pianiste et joueurs de dames* [fig. 31], for instance, reformulates *La famille du peintre*).

Matisse played this double-game with dizzying virtuosity. We are indeed confronted here with a kind of reality realistically depicted (in keeping with the spirit of the twenties, which advocated a return to premodernist aesthetics), but it is a theatrical reality, a world of artifice. We accept this Rivieran Morocco as we are willing to recognize King Lear or Creon in the gentleman whom we meet daily in the bakery, provided it be on a stage. This overtly, admittedly illusory status allows the Maghrebine avatar of the Golden Age or, to put it differently, of the religion of happiness that is Matisse's version of the sacred, to survive clandestinely in the midst of a time that did not tolerate it openly.

And with it, the language in which it expressed itself survived also: that is orientality, whose principles are summarized by the aesthetics of the rug. During the period before 1914, when the sacred and decoration dared to appear openly in Matisse's painting, patterns did not hesitate to cut loose from the fabrics that were their realist justification.

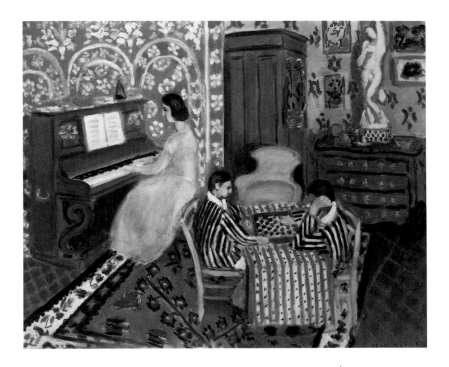

fig. 31. Henri Matisse, *Pianiste et joueurs de dames*, 1924, oil on canvas. National Gallery of Art, Washington, Collection of Mr. and Mrs. Paul Mellon

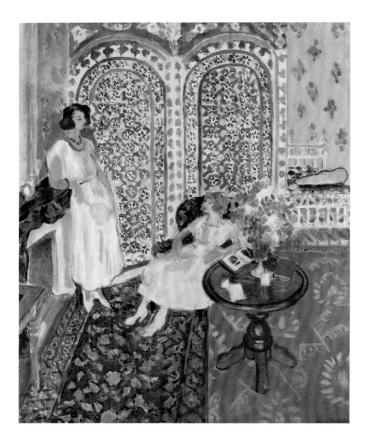

fig. 32. Henri Matisse, *Paravent maur-esque*, 1921, oil on canvas. Philadelphia Museum of Art, Bequest of Lisa Norris Elkins

Now, the floral repetitions, the chromatic scansions, the reiterated arabesques and geometric figures retreated into the object from which they originated, the rug.

The consequence of this naturalization of the abstract, which Matisse would not have achieved had the work done in Tangier not shown him that it was possible, is twofold: the Moroccan signification, the subject matter, survived only because reality has absorbed it, whereas the signs of orientality absorb reality and its language by disguising both. When we look at *Paravent mauresque* (fig. 32) or *La séance de trois heures* (1924, Private collection) we are well aware that we are being shown a three-dimensional scene, yet we see a surface. While the transpositions from major to minor that Matisse executed in the twenties plunged the significations of the Orient, as he understood them, into hibernation, they activated its signs.

That is why, although the Tangerine ensemble plays a pivotal role in Matisse's itinerary, its specific influence remains difficult to localize. Beginning in the early years in Nice, the Moroccan Orient that Matisse had lived in for two brief seasons dissolved into orientality, which it had helped to root in space and time. Orientality, on the other hand, by which I mean Matisse's penchant for decoration, had preceded the painter's sojourns in Tangier and was to become so marked in later decades that it can no longer be distinguished from his art as a whole. Nevertheless, I would venture to attribute to his Tangerine experience some accents that are not perceptible in orientality, such as he practiced it, before the two trips to Morocco.

Before 1912, Matisse's work is under the sign of a savage god; after that date, with the exception of the Barnes Foundation *Dance* that marks a return to the fierce formulation of 1910, it was born under the sign of the tender god who manifested himself in Tangier.

This change of register coincides with another transformation, brought about by the

Moroccan spring that had impressed Matisse so deeply: the growing importance of the vegetal reign as the supreme reference. What one might call the botanization of his art had started well before Tangier: "Look at a tree," he told his students, "it is like a human being."[167] Now, it became at once more explicit and more varied in its applications. The process of botanization takes place in two basic ways, corresponding to the dual aspect of vegetal life: the mode of production of Matisse's art may be likened to the plant; its products, to the flower.

Tangier had fulfilled Matisse's dream of coalescing abstraction and reality. But what in Tangier had been given freely henceforth had to be achieved by hard work. Matisse often described what it consisted of: to multiply external observations of the model until he knew the model from the inside and was able to draw it by heart (it should be noted that Matisse increasingly entrusted drawing with the task of turning a strange motif into a familiar one). When that point was reached, the artist no longer identified his subject, but identified with it. Imitation, which is compatible with realism, gave way to participation, which permitted abstract treatment of the motif. Since participation, which results from the progressive interiorization of a model initially approached from the outside, did not contradict the data yielded by imitation, the painter may expect his work to be what he said of *L'escargot* (1952, Tate Gallery, London): "an abstract panel rooted in reality."[168]

Every time Matisse attempted to describe this process of identification with the model (which I have proposed to call *metexis*), he used the metaphor of vegetation. In his well-known letter about trees to André Rouveyre, his most accomplished formulation of the doctrine of *metexis*, Matisse quoted an old oriental master as saying: "When you draw a tree, you must feel that you are rising with it."[169] This is not simply a metaphor. In order to identify with a human model, in order to pass from the realist rendering of a person to an abstract or decorative one, Matisse needed to detect or to reawaken the vegetal essence hidden within the sitter.

The new orientation manifested itself precisely between *Back II* and *Back III*. *Back I* (fig. 34) and *Back II*, still close to traditional sculpture as practised by Rodin, follow the

fig. 33. Henri Matisse, *Daphné*, study for *Florilèges des amours de Ronsard*, 1942, crayon on paper. Private collection

left: fig. 34. Henri Matisse, *Back I*, 1909, bronze. The Museum of Modern Art, New York, Mrs. Simon Guggenheim Fund

right: fig. 35. Henri Matisse, *Back IV*, 1931, bronze. The Museum of Modern Art, New York, Mrs. Simon Guggenheim Fund

canons of anatomy. On the other hand, *Back III* and *Back IV* (fig. 35) are conceived as trees. The spine, treated in relief rather than hollow, prolongs the shock of hair, thereby forming a kind of stem that traverses the entire body, like a trunk.

It is not by chance that *Back I* was modeled in 1909, at the same time that Matisse conceived *Demoiselles à la rivière*, for it is its three-dimensional counterpart. Matisse returned to the theme in 1913, at a moment when, having just completed *Café maro-cain*, he was thinking of installing his *Demoiselles* on the beach of Tangier.[170] Henceforth, the *Backs* and Morocco are organically associated in his mind, as is proved by a drawing showing a nude standing in the pose of the *Backs* against a fence behind which can be seen the English church rising above the Casbah (cat. 42). At that moment, however, Tangier had not yet had enough time to transfuse its vegetal message into a human theme. That time came in 1916: Matisse then painted *Les Marocains*, picked up once more and finished *Demoiselles à la rivière*, and modeled *Back III*, where the metamorphosis of the biological into the botanical is accomplished. *Back IV* (1930) merely clarified it to the point of near abstraction.

Metamorphosis is to be understood in the sense Ovid gave it in the story of the nymph Daphne changed into a tree. One is not surprised to find Matisse doing a pencil sketch of Poussin's *Apollon et Daphné*, nor that he should have drawn this metamorphosis on a number of occasions, in particular while working on his illustrations for *Florilège des Amours de Ronsard* (fig. 33). The myth of the nymph transformed by Apollo's love reads like a parable of Matisse's artistic method.

That method is omnipresent in the Vence chapel. A cactus provides the *Jérusalem céleste* window with its root in reality, and the theme of the other windows is the Tree of Life. After the chapel was finished, Matisse decided to turn his publisher Tériade's dining room into a profane equivalent of his religious *Gesammtkunstwerk*. A solemn plane tree (see fig. 88) in black and white ceramic tiles faces a stained glass window, as the Virgin and Child, Saint Dominic (see fig. 86), and the Road to Calvary dialogue across the nave with the colors of the Tree of Life (fig. 37).

After Tangier, the flowers returned to their vases, just as the patterns retreated into the carpets. They broke away again, with an exuberance they had not known since the Moroccan sojourns, after the operation Matisse underwent in 1941, which marked his entrance into what he called "a second life." Suddenly, veritable beds of the brightest, subtlest corollas flower on the envelopes of letters written by Matisse to his friends. They are the overture to the floral fireworks that constellate the pages of the *Poèmes de Charles d'Orléans*. Their finale will be the immense cut-outs of the terminal years: *Fruits*

et fleurs, Grande décoration aux masques (fig. 38), *La gerbe.* In these, the intensity of the floral presence short-circuits the customary reference to the decorative system: here, it is nature itself which, by means of its sheer opulence, spreads its rugs, as it had once done in Morocco.

The lesson of Morocco was never more in evidence than in the years 1945–1953, but it is not instantly recognizable. Florality and daphneization, the traits through which it most clearly manifests itself, do not require their birthplace, or even a specific place, to function. The ultimate Matisse favors motifs and a vocabulary of forms borrowed from Oceania. Earlier, I mentioned the influence exercised by Moorish mosques on the Vence chapel.[171] When the latter was completed, Matisse prepared to launch upon those great decorations that were to force him to give up easel painting for good. Before doing so, however, he painted two more pictures. The last of these is *Femme à la gandoura bleue* (cat. 25). Matisse's farewell to easel painting was a farewell to Morocco.

opposite page

above: fig. 36. Henri Matisse, illustration for *Pasiphaé*, 1981, linoleum cut. Private collection

center: fig. 37. Henri Matisse, *Study for the stained glass window "L'arbre de vie,"* 1948, crayon on paper. Private collection

below: fig. 38. Henri Matisse, *Grande décoration aux masques*, 1953, painted, cut, and pasted paper. National Gallery of Art, Washington, Ailsa Mellon Bruce Fund

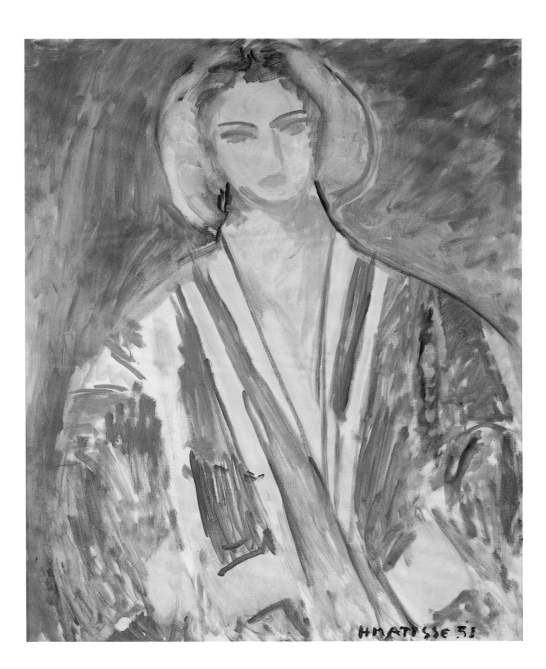

cat. 25. Henri Matisse, *Femme à la gandoura bleue*, 1951, oil on canvas, 81 × 65 (31⁷/₈ × 25⁵/₈). Private collection

The present essay and my contribution to this exhibition as a whole owe more than I can say to the unfailing help of Claude and Barbara Duthuit, as well as to that of Wanda de Guébriant. The warm support of Pierre and Gaetana Matisse and that of Mme Jean Matisse also provided indispensable encouragement. Precious, too, has been the information generously provided by the heirs of Matisse's friends and companions: Mme Grammont-Camoin, Mme Danielle Galy, and Jean-Pierre Manguin, curator of Archives de la famille Manguin. I am grateful to M. Jean Rajot for allowing me to consult certain parts of the Jean Puy archives, and to Serge Lemoine and Hélène Vincent of the Musée de Grenoble for making that institution's Tangerine information accessible to me. Valuable also was the information provided by Mme Kleinmann, Mme Paret on behalf of Fondation Wildenstein, in whose care are the Archives Albert Marquet, Robert Schmit, and Maître Paul Loudmer. Françoise Cachin of the Musée d'Orsay and Mme Jacqueline George-Besson were kind enough to listen to my questions. Françoise Viatte graciously made the Delacroix drawings and sketchbooks in the Cabinet des Dessins (Musée du Louvre) available to me for consultation, and Gérard Régnier met my requests in a most friendly fashion. Finally, I should like to express my gratitude to Danièle Delaneuville and Liliane Langellier, without whom this text would never have left the limbo of the author's nearly undecipherable draft.

1. "Par une mer un peu mouvementée, mais du plus pur bleu, le bateau glisse sans roulis ni tangage. L'horizon à gauche est bordé par quelques nuages, à droite par les montagnes de la côte d'Espagne." Archives Henri Matisse. Although mailed on 31 January, this postcard must have been written a couple of days earlier. (For this catalogue and exhibition we have been granted privileged access to much new information found in Matisse's Moroccan correspondence. Several important letters are difficult to date with precision at this time, though we have proposed a provisional placement. Further study by the Archives Henri Matisse and cross-referencing of these documents to other new sources may revise or expand what we propose here.) A postcard to Gertrude Stein mailed on 4 February informs his American friend that he arrived on the previous Monday. This assumption is further corroborated by a letter written by Matisse to his daughter Marguerite on the 31st, telling her that they had already taken two rides, his wife on a mule, he on a horse.
2. "Temps splendide." Postcard, 31 January 1912, Archives Henri Matisse.
3. "Ici, nous sommes dans la pluie, un déluge. Il paraît qu'il y a un mois qu'elle dure. . . ." Letter to Marguerite, 31 January 1912, Archives Henri Matisse.
4. "Verrons-nous le soleil au Maroc? Depuis lundi, 3 heures, notre arrivée, jusqu'à aujourd'hui samedi, il a plu comme aux pays chauds sans arrêt. Il y avait 15 jours que ça durait. Qu'allons nous devenir? Pour un rien nous reviendrions à Paris pour chercher le Soleil. . . . Impossible de sortir de notre chambre." Postcard to Gertrude Stein cancelled on 4 February 1912, Beinecke Rare Book Library, Yale University.
5. "Depuis huit jours que nous sommes là, c'est un vrai déluge. Allons-nous repartir? Quelle aventure!" Postcard postmarked 4 February 1912, Archives Henri Matisse.

6. "Ah mon ami! quelle aventure! Sommes arrivés lundi à 3 heures. Aujourd'hui, nous tenons samedi comme dit l'autre, et nous n'avons vu que pleuvoir de plus en plus fort. Je ne sais ce que ça veut dire, les gens de Tanger non plus, ils n'ont jamais vu ça. Ils sont bien plus étonnés que moi car il y avait 15 jours que ça durait quand nous sommes arrivés. Quoi faire, grand Dieu! Repartir serait ridicule, mais ça paraît si naturel. Il fait clair comme dans une cave." Postcard to Marquet, postmarked February 1912, Archives Albert Marquet.
7. "Pendant que je t'écris, il pleut plus fort que jamais. Tu n'as certainement jamais vu pleuvoir aussi fort de ta charmante vie. . . . Ah, Tanger, Tanger! Je voudrais bien avoir le courage de foutre mon camp." Archives Albert Marquet.
8. "Vais-je partir lundi, vais-[je] rester? La lumière est superbe mais le temps trop changeant. On se croit en express." Postcard written on Saturday and postmarked 6 April 1912, Archives Albert Marquet.
9. "Temps mauvais. Je suis resté pour terminer si possible une toile, mais le temps gris m'en empêche. Comme avril est un mois de pluie ici, je n'ai plus grand espoir. En somme je suis mécontent de mon voyage au point de vue du temps, si variable. Que d'énervement. . . ." Postcard to Marquet postmarked 2 April 1912, Archives Albert Marquet.
10. Postcard from Marquet to Manguin, postmarked 7 August 1911, Archives de la famille Manguin.
11. Postcard from Marquet to Manguin, postmarked 14 August 1911, Archives de la famille Manguin.
12. "Dépêche-toi de venir pendant qu'il est encore temps." Archives de la famille Manguin.
13. "Je n'ai encore rien pu faire, c'est trop beau, d'ailleurs je n'ai pas le temps ici de travailler—vive les vacances. . . . N'allons pas tarder à partir pour Fez où il doit faire un peu plus chaud." Archives de la famille Manguin.
14. "Je viens de faire à cheval le parcours de Tanger/Tetouan 70 kilomètres. Les arabes en sont verts, mais j'ai le derrière en compote. Enfoncé le père Matisse!" Archives de la famille Manguin.
15. Postcard from Marquet to Henri Manguin, Archives de la famille Manguin.
16. Postcard from Marquet to Albert Camoin, Archives Charles Camoin.
17. "Me voici revenu en Europe et bientôt à Bordeaux." Archives de la famille Manguin.
18. This is probably the picture Gino Severini had in mind when he wrote: "Matisse me montrait un jour une maquette qu'il avait faite d'après nature dans une rue de Tanger. En premier plan un mur peint en bleu. Ce bleu influençait tout le reste, et Matisse lui a donné le maximum d'importance qu'il était possible de lui donner en gardant la construction objective du paysage." Escholier 1956b, 106.
19. "Adieu, vieux cochon, sans rancune, puisque tu n'es pas responsable de tout ce qui arrive de travers." Matisse, Tanger, 4 February 1912, Archives Albert Marquet.
20. "Quand viens-tu? pour égayer le paysage." Postcard to Marquet dated 7 February and postmarked 9 February, Archives Albert Marquet.
21. "Ma femme part dimanche pour Paris, elle ira te voir. Mais qu'as-tu? D'après ta précédente carte je ne savais pas quand tu viendrais, par celle-ci je ne sais encore. Pourquoi ne viens-tu pas aussitôt que possible travailler à Tetouan? Que veux-tu de mieux? Tous ceux qui connaissent le pays disent

que c'est la plus jolie ville. Peut-être irai-je à Fez avec toi. En tout cas c'est la saison maintenant, plus tard il fait trop chaud." Archives Albert Marquet.

22. "Je nous voyais ou plutôt je te voyais sur la route car ne j'irai pas." Archives Albert Marquet.

23. "Tu me verras bientôt: puisque tu ne viens pas, j'irai te trouver." Archives Albert Marquet.

24. "Cher vieux Rouennais, que deviens-tu? Ne moisis-tu pas trop dans les brouillards de la Seine? Ici temps magnifique: allons tous à Tanger." Postcard written on 18 October and posted on the 29th, Archives Albert Marquet.

25. "Pourquoi ne quittes-tu pas ce sale brouillard normand pour venir ici passer un hiver qui sera sec, je le crois, probablement jusqu'en janvier. Après nous remonterons vers Collioure ou Barcelone. Pense à ta santé. . . ." Postcard from Matisse to Marquet, postmarked 14 November 1912, Archives Albert Marquet.

26. "Venez donc finir la saison avec le père Marquet." Postcard postmarked 10 January 1913, Archives de la famille Manguin.

27. "Quand arrives-tu? Camoin t'a-t-il dit qu'il y a huit jours nous avons pris un bain de mer très agréable? . . . Ne moisis pas trop!" Archives de la famille Manguin.

28. "Vive la Vie! Quand viens-tu? Le temps se maintient. Nous pensons que Janvier sera beau. Si février est mauvais nous filerons ailleurs—en Algérie ou en Tunisie. Décide-toi, une fois ton travail terminé. Nous t'attendons." Archives de la famille Manguin.

29. A letter to Marquet written on 8 August 1941 alludes to a "cowherding bird" ("oiseau garde-vache") he had seen in Morocco. Yet he does so in terms that do not incline one to think that the two friends had seen this unusual animal together. Schneider 1984a, 492 n. 14.

30. "Je reçois une carte de Matisse m'annonçant son prochain retour. Vas-tu quand même à Tanger? Ca ne sera pas bien rigolo d'être tout seul à voir de la pluie dans ce pays-là. Si tu veux y aller plutôt l'été, je t'accompagnerai. Le climat est alors merveilleux." Archives Charles Camoin.

31. Lucile Manguin and Marie-Caroline Sainsaulieu, *Catalogue raisonné de l'oeuvre peint d'Henri Manguin* (Neuchâtel, 1980).

32. "Tanger bien abîmé mais toujours épatant. On y rigole déjà pas mal. Que serait-ce si tu étais là? Dépêche-toi d'y venir. Il fait un temps délicieux." Archives Charles Camoin.

33. "De retour à Tanger et assez content de me retrouver en pays civilisé. Tous les copains sont repartis, je suis tout seul et vais essayer d'en profiter pour travailler un peu." Archives Charles Camoin.

34. Guy Dumur, *Delacroix et le Maroc* Paris, (1988), 10.

35. "J'ai été à Tanger parce que c'était l'Afrique. Delacroix était loin de mon esprit." Courthion 1941.

36. "Couleur peau de lion. . . . d'un vert extraordinaire. . . . des ciels un peu tourmentés, comme dans les tableaux de Delacroix. . . . En somme, les tableaux de Delacroix représentent fidèlement le paysage du Maroc, de Tanger à Tetouan, dans la partie plantée d'arbres." Courthion 1941.

37. Letter from Delacroix to J. B. Pierret, Tangier, 25 January 1832. Maurice Arame, *Le Maroc de Delacroix* (Paris, 1987), 140.

38. Letter to J. B. Pierret, Tangier, 8 February 1832, in Arame 1987, 153. The remark remained true

eighty-five years later. "Less than seven years ago," noted the Guide Michelin du Maroc of 1917, "neither roads nor bridges existed in this country."

39. Letter from Delacroix to François Villot, Tangier, 29 February 1832, Arame 1987, 162–163.

40. Letter from Delacroix to Armand Bertin, Meknes, 2 April 1832, Arame 1987, 187.

41. Letter from Matisse to Camoin, autumn 1914, in Giraudy 1971, 18.

42. Tériade 1952.

43. Giraudy 1971, 15.

44. Letter to Henri Manguin in Schneider 1984a, 158.

45. Schneider 1984a, 158.

46. See the extracts from that letter published in Schneider 1984a, 158.

47. Schneider 1984a, 158.

48. This was quite possible. Two of Delacroix's Moroccan sketchbooks were then at the Louvre, as well as some of the more formal watercolors executed upon his return and given to the comte de Mornay. A figure of a squatting Arab (Dumur 1988, 41), that of a Jewish musician at Mogador (Dumur 1988, 68–69), or that of yet another one stretched on the ground and leaning on his elbow (Louvre, RF9154, no. 20) remind us of the figures Matisse drew while working out the composition of his *Café marocain*. That Delacroix's sketches of the panorama of Tangier and of its bay should resemble the views of the same motif by Matisse is not surprising. Nor is the cubism of certain drawings dealing with architectural motifs. These belong to the visual data that reality forced upon both artists. More surprising, on the other hand, is the fascination exerted on both Matisse and Delacroix by doors, whether they open upon a city or upon a room. In 1946 Matisse evoked "the mystery of an open door" (Schneider 1984a, 446). This mystery, which provides the substance of two of the paintings making up the Moroccan Triptych, more than once inspired the older painter (for instance in Louvre, RF39050, 7v and 12v).

49. Eugène Delacroix, "Journal," in Dumur 1988, 16. In his preface to an exhibition of forty-eight of his drawings, chosen by himself, in Liège, in 1947, Matisse almost literally repeated Delacroix's formula: "L'exactitude n'est pas la vérité." Fourcade 1972, 17.

50. Letter from Poussin to Sublet de Noyers, undated, in Félibien, *Entretiens sur les vies et sur les ouvrages des plus excellents peintres anciens et modernes* (Paris, 1666–1688), 4:40.

51. Dumur 1988, 114.

52. Maurice Denis, "Art et critique," 23 August 1890, in Maurice Denis, *Du symbolisme au classicisme. Théories* (Paris, 1964), 33.

53. Louis Aragon, "Matisse-en-France," in Fourcade 1972, 162.

54. See note. 43. This, as we saw, was the reason he gave to Camoin upon returning from Morocco for not joining him in Corsica, a French *departement*, to be sure, but one rather unmetropolitan in character.

55. Interview with Tériade, 1932, in Fourcade 1972, 124–125.

56. Schneider 1984a, 155.

57. Concerning the relationship between Matisse and Islamic art, please refer to my book on Matisse (Schneider 1984a). The present essay seeks to complete and extend, rather than replace it.

58. Henri Matisse, as quoted by Gaston Diehl, *Art Present* 2 (1947), in Fourcade 1972, 203.

59. Schneider 1984a, 156.

60. Schneider 1984a, 193.

61. Another tile, of Persian origin, inspired the magnificent drawing known under the title *Nature morte à la céramique persane* (1915, Private collection).

62. Schneider 1984a, 160.

63. Matisse, 1951, in Schneider 1984a, 179.

64. Gauguin, "Diverses choses," 1896-1898, in *Oviri* (Paris, 1974), 178.

65. Gauguin 1974, 156.

66. Schneider 1984a, 162.

67. Schneider 1984a, 163.

68. Schneider 1984a, 163.

69. Conversation reported by Frère Rayssiguier, 2 January 1949, in Schneider 1984a, 680.

70. Schneider 1984a, 155.

71. Letter to André Rouveyre, 6 October 1941, in Fourcade 1972, 188.

72. Gauguin 1974, 17.

73. The definition of himself given to Camoin is well known: "I am a Romantic, with a good half of the scientific." Giraudy 1971, 77. Throughout his life this double exigency led him to compensate the moves taken in one direction by moves—be they returns—into the opposite direction. It even urged him to seek to "do two things at the same time." Schneider 1984a, 388.

74. Concerning the myth of the Golden Age and the central position of this theme and of its ramifications in the work of Matissse, I refer the reader to Schneider 1984a and its English translation published in New York (Schneider 1984b).

75. *Vagabonds (Les Illuminations)* in Arthur Rimbaud, *Oeuvres complètes* (Paris, 1972), 137.

76. "Splendide la mosquée. Suis très content de mon voyage." Postcard to Gertrude Stein, postmarked 20 November 1910. Beinecke Rare Book Library, Yale University.

77. I owe this observation to Jack Cowart.

78. In the fall of 1911 Matisse envisaged going to Sicily instead of Morocco, perhaps because that island proposed a successful synthesis between Norman West, Byzantium, and Islam, between the three cultural strains he himself was then seeking to combine. Matisse ended by choosing Tangier, but he did not completely forget his other project, since he went to Sicily in 1925. Schneider in Venice 1987, 13-35.

79. "La peinture est une chose bien difficile pour moi—il y a toujours cette lutte. Est-ce naturel? Oui, mais pourquoi avoir tant de mal? C'est si doux quand ça vient tout seul." Postcard to Gertrude Stein, dated 16 March 1912. Beinecke Rare Book Library, Yale University.

80. Schneider 1984a, 459.

81. Schneider 1984a, 659.

82. Colors are preferable to tones (*valeurs*) only because they convey stronger light. "Cligner des yeux pour ne voir que les *valeurs*, quel crime! C'est le coup de la glace noire—quelle cave!" (To squint one's eyes in order to see only *tonal values*, what a crime! It's the trick of the black mirror—what a cellar!") I am grateful to Mr. Rajot and to the heirs of Jean Puy for having made this passage from a letter by Matisse to Jean Puy (Nice, 7 April 1949) available to me.

83. Schneider 1984a, 387.

84. Schneider 1984a, 387.

85. "C'est à Ajaccio que j'ai eu mon grand émerveillement pour le Sud." Escholier 1956b, 39-40.

86. Georges Salles, preface to the exhibition of Matisse's works in Nice in 1950, in Lassaigne 1959, 94.

87. Schneider 1984a, 660.

88. Schneider 1984a, 387.

89. Loti 1889a, 81.

90. "I came into a place bereft of all light/Which moaned as does the sea during a storm/When it is whipped by conflicting winds." Dante, *Inferno*, Canto V, vv. 28-30.

91. "Aujourd'hui première journée relativement belle et agréable. Le baromètre a remonté d'un quart de cadran. . . . Je suis fortement déprimé par ce contretemps. . . ." Archives Albert Marquet.

92. "Aujourd'hui la journée a été superbe, mais ce soir une ondée vient de tomber." Archives Henri Matisse.

93. "Enfin le temps s'est mis au beau, mais c'est un beau variable. Il y a beaucoup de vapeur, souvent des nuages qui promènent sur le paysage des ombres pittoresques. C'est beau, mais peu propice au travail sur nature et à beaucoup de séances sur la même toile. . . ." Archives de la famille Manguin.

94. "Je suis à Tanger depuis un mois. Après avoir vu pleuvoir 15 jours et 15 nuits comme je n'ai jamais vu pleuvoir, le beau temps est venu, charmant, tout à fait délicieux de délicatesse. Ce que j'ai vu du Maroc m'a fait penser à la Normandie comme ardeur de végétation, mais combien plus varié et décoratif. Je travaille, mais comme le pays est si neuf pour moi, je ne puis présager du résultat." Archives Henri Matisse. Baignères was collecting funds to provide a decent funeral for the painter Brault, an old comrade of Matisse, who had just died penniless. Matisse sent 30 francs.

95. "Le beau temps est venu. Quelle lumière fondue, pas du tout Côte d'Azur et la végétation normande comme ardeur, mais quel décoratif!!! Comme c'est neuf aussi, comme c'est difficile à faire avec du bleu, du rouge, du jaune et du vert." Archives de la famille Manguin.

96. "Après avoir vu pleuvoir pendant 15 jours et autant de nuits, nous jouissons du beau temps, et la végétation qui est tout à fait luxuriante. Je me suis mis au travail, et je ne suis pas trop mécontent, quoique ce soit bien difficile, la lumière est tellement douce, c'est tout autre chose que la Méditerranée." Archives Charles Camoin.

97. Henri Matisse, *Jazz* (Paris, 1947), 133.

98. Loti 1889a, 18.

99. The formula is couched by Yeats in his journal after having seen the opening performance of Jarry's *Ubu roi*. I have tried elsewhere (Schneider 1984a, 203-287) to describe how Matisse's colors, growing progressively hotter to keep up with the incandescence of nature, pass at a certain moment beyond the threshhold where they undergo a mutation that turns objective tones into subjective ones or, to put it differently, realistic hues into abstract or decorative ones.

100. Notes d'un peintre" (1908), in Fourcade 1972, 49.

101. A guidebook contemporary with Matisse's sojourns says exactly the same thing: "The Norman meadows are there. . . ." Louis Cros, *Le Maroc pour tous* (Paris, 1913), 82. Already in 1889, Pierre Loti had written: "On dirait toujours une plantureuse Normandie." Loti 1889a, 109.

102. "Dans un champ d'herbes pur, virginal, dans la beauté du matin. C'était quelque chose d'exquis." Courthion 1941.

103. Loti 1889a, 103.

104. Conversation with Frère Rayssiguier, Nice, 20 December 1949, in Schneider 1984a, 677. At Vence the relation between the colors is the same, but inverted, since the roof of the chapel, built up along a steep slope, stands against a background of vegetation, not against the sky.

105. "Vraiment, j'ai eu alors pour Loti peintre une estime extraordinaire." Matisse was mistaken about the title of that book; he mentioned *Le roman d'un spahi*, which takes place in Senegal, whereas the appropriate passage is to be found in *Au Maroc*, a journal written by the young novelist in the course of a diplomatic mission that made him cross the sultanate in the spring of 1889. Courthion 1941.

106. Loti 1889a, 78.

107. Loti 1889a, 103.

108. Loti 1889a, 80.

109. Loti 1889a, 312.

110. Cros 1913, 272.

111. "Malgré la pluie, le temps est fort doux et les fleurs sont toutes fleuries, volubilis, héliotropes, capucines et autres." Archives Henri Matisse.

112. ". . . Une vue superbe. . . ." Letter, Mme Matisse to Marguerite, 31 January 1912 (see note 111). Archives Henri Matisse.

113. Matisse's usage "Bronx" is a deformation of the villa's real name, Villa Brooks.

114. Letter from Henri Matisse to his wife, 6 April 1912. First, Matisse had been depressed by the bad weather. Hence, when the weather turned good, he tried to make up for time lost with such eagerness he set off a fit of anxiety caused by overwork.

115. "Comment as-tu trouvé le jardin? Est-il joli? Pourrais-je y travailler?" Letter, Matisse to Mme Matisse, 6 April 1912. Archives Henri Matisse.

116. "Je me prépare au départ, je vais à droite, à gauche, je regarde le pays qui devient de plus en plus beau par la verdure qui le remplit. J'ai été hier au jardin de Bronx qui devient tout à fait enchanteur, toutes les fleurs y sont. Il y a surtout une glycine près de la maison qui est une merveille, j'en ai fait deux dessins qui pourront te donner une faible idée. Je me suis intéressé aux petites fleurs qui sont délicieuses. J'ai vu un iris vert-brun à cur jaune qui est tout à fait prenant." Archives Henri Matisse.

117. "J'ai commencé un bouquet d'iris bleus." Archives Henri Matisse.

118. A note written many years later (by Mme Matisse?) states that this picture was preceded by *Nature morte aux oranges*. Perhaps the latter was begun in those early days, then taken up again and finished toward the beginning of April. On 6 April Matisse wrote his wife: "I worked on my still life, which I won't touch any more." He may, however, be referring not to *Nature morte aux oranges*, but to one of the two still-lifes with arums.

119. I am somewhat tempted to relate the two panels reproduced in Venice 1987, 65, under the title *Coquelicots*, to a sentence in a letter written by Matisse to Mme Matisse at the end of March or by the beginning of April: "Morrice has seen the two landscape sketches, he likes them very much" ("Morrice a vu les deux esquisses de paysage, elles lui plaisent beaucoup"), Archives Henri Matisse. I had previously suggested that these works be dated "c. 1908" in that catalogue. The oblong format Matisse favored in Morocco, the irises, and the en réserve manner—typical of the Tangerine

period—in which they are delineated, the profusion of flowers of every sort, certain alliances of colors (such as pink and violet), and the pairing of the two panels, clearly revelatory of their decorative mode—a mode Matisse resorted to only when dealing with essential themes such as flowers were at that time—are my main reasons for suggesting that they might have been executed in 1912, in Tangier or in the garden at Issy-le-Moulineaux during the summer between the two trips to Tangier.

120. ". . . figures de marocains et de marocaines . . ." Letter from Matisse, 16 November 1912, Archives Henri Matisse.

121. ". . . des yeux un peu sauvages. . . ." Letter from Matisse to Marguerite and Pierre Matisse, c. 20 November 1912, Archives Henri Matisse.

122. Loti 1889a, 183.

123. Quoted by L. V. Rusakov in Barcelona, 1988.

124. Conversation between Matisse and Frère Rayssiguier, in Schneider 1984a, 594.

125. Fourcade 1972, 231.

126. Butterflies are another extreme case. In 1941, Matisse told how, passing through the Palais-Royal, in 1898, he glimpsed in a shop "a blue butterfly, but what a blue! that blue pierced my heart." Despite his very precarious finances, he purchased it for the considerable sum of fifty francs. Schneider 1984a, 350.

127. Schneider 1984a, 350–351.

128. See quotation, p. 31, at note marker 80.

129. ". . . je transmettais en terre l'équivalence de ma sensation." Verdet 1952–30.

130. Loti 1889a, 78.

131. Delacroix, 6 April 1832, in Arame 1987, 189.

132. Loti 1889a, 19.

133. Schneider 1984a, 595.

134. Schneider in Venice 1987, 65. See note 119.

135. Et sur ce plateau Allah, pour nous, a étendu un tapis blanc, bleu et rose absolument vierge . . .: pâquerettes, mauves et gentianes. . . . Cette soirée de mai sur ce plateau sauvage a une paix d'Eden. Loti 1889a, 354.

136. Conversation with Frère Rayssiguier, in Schneider 1984a, 680.

137. Schneider 1984a, 459.

138. Sembat 1920a, 10.

139. I have already indicated that the three garden pictures compose a triad, but that the latter may have, in the course of time and according to circumstances, included one or more pictures not dealing with the theme of the Villa Brooks garden. See Appendix 2.

140. More exact, but also more heavy-handed, would be the term "pseudo-triptych," for they compose triads without giving up the status of autonomous pictures.

141. Two other still lifes might have played this part: *Nature morte aux oranges*, but its principal subject is fruit, not flowers, and it is distinctly smaller than its two companion pieces; and *Vase aux iris*, whose somber tones, however, do not harmonize with the brightness and lightness of the two *arums* pictures.

142. "J'ai écrit à Stchoukine ce matin une lettre qui est bien venue. J'y ai ajouté en croquis la nature morte et les deux paysages de Morosoff, le bleu et les pervenches, ça faisait un joli croquis, triptyque." Archives Henri Matisse.

143. Archives Henri Matisse. However, in the same letter, he told his wife that he was tempted to stay longer "pour faire le paysage de Morosof."

144. Letter to Mme Matisse. Archives Henri Matisse.

145. Letter to Charles Camoin, autumn 1912, in Giraudy 1971, 13.

146. "Les trois croquis en-dessous représentent deux mauresques dont l'une est destinée à faire pendant au Marocain de Stchoukine. L'autre sera pour les Bernheim. Le troisième croquis est la petite toile de Sembat. Elle n'a que 30 cm sur 27, les deux autres ont 1m50 de haut. . . ." Archives Henri Matisse.

147. ". . . une toile de la dimension des Poissons rouges de Stchoukine. C'est le portrait d'un Riffain, un type de montagnard magnifique et sauvage comme un chacal." Archives Henri Matisse.

148. See Appendix 2 in this volume.

149. "Il m'est venu deux idées de tableaux que je compte mettre à exécution à ma rentrée." Archives Henri Matisse.

150. "Tout le monde est désespéré ici car les semailles vont être ratées à cause de la sécheresse. . . . Moi, intérieurement je me réjouis, car c'est le temps rêvé pour mon travail." Archives Henri Matisse.

151. See note 146.

152. They sailed from Marseilles on 21 or 22 November.

153. Conversation with Camoin's daughter, who had heard the remark from her mother.

154. Letter to Camoin, 23 July 1944, in Escholier 1956b, 104.

155. "On turbine à l'intérieur très tranquillement. Une orange et trois carottes avec une serviette, ça peut faire un chef d'oeuvre." Postcard to Manguin, 11 January 1913. Archives de la famille Manguin.

156. It seems to have been a classic among the sights of Tangier, for the 1917 Guide Michelin of Morocco gives the following piece of advice: "Then have yourself taken to the café Maure, view* on the city."

157. Sembat 1913, 192.

158. The attitudes depicted by Delacroix are found again in the work of Matisse. The kinship between Les femmes d'Alger or La noce juive and Café marocain are thus evident. One may ask oneself, however, whether the similarities are due to Delacroix's influence or to the persistence of attitudes transmitted from generation to generation.

159. Loti 1889a, 183.

160. Loti 1889a, 358.

161. Schneider 1984, 281.

162. Matisse 1908, "Notes d'un peintre," in Fourcade 1972, 49.

163. "Il y a trois étages. J'imagine le visiteur qui vient du dehors. Le premier étage s'offre à lui. Il faut obtenir un effort, donner un sentiment d'allègement. Mon premier panneau représente la danse, cette ronde envolée au-dessus de la colline. Au deuxième étage, on est dans l'intérieur de la maison, dans son esprit et son silence, je vois une scène de musique avec les personnages attentifs; enfin au troisième étage c'est le plein calme et je peins une scène de repos, des gens étendus sur l'herbe devisant ou rêvant." Fourcade 1972, 63. Diehl 1954, 52, gave a slightly different formulation of this text: "Enfin, au troisième étage, c'est le repos complet, et j'y peins des personnages étendus dans l'herbe, rêvant et méditant."

164. Sembat 1913, 191.

165. In conversation with Frère Rayssiguier, November 1948. Schneider 1984a, 677.

166. Letter to J. B. Pierret, 16 March 1832. Dumur 1988, 11.

167. Matisse quoted by Greta Moll in a lecture given in October 1954, in Schneider 1984a, 548.

168. André Verdet, Prestiges de Matisse (Paris, 1952), 32–35.

169. Fourcade 1972, 167.

170. See Matisse's letter to Camoin in the summer of 1913. Giraudy 1971, 16.

171. "As for the bell-tower, wrote Frère Rayssiguier, relating a conversation with Matisse that took place on 8 December 1948, he primarily conceives it in the manner of the Arab bell-towers." Schneider 1984a, 677.

Note to the Reader

For this catalogue and exhibition we have been granted privileged access to much new information found in Matisse's Moroccan correspondence. Several important letters are difficult to date with precision at this time. Further study by the Archives Henri Matisse and cross-referencing of these documents to other new sources may revise or expand what we propose here.

These entries were written by Laura Coyle with the collaboration of Beatrice Kernan, and represent not only their research, but also the shared opinions of the organizing curatorial committee: Jack Cowart, Pierre Schneider, John Elderfield, Albert Kostenevich, and Marina Bessonova.

Titles are given first in French, with English translations in parentheses. Height in centimeters is listed before width, and dimensions in inches are given in parentheses.

The provenance, exhibition histories, and literature references for each painting are found in Appendix 3.

PAINTINGS

1

Le vase d'iris, 1912
(Vase of Irises)
oil on canvas, 118 x 100 (46½ x 39⅜)
signed l.l. in black: *Henri Matisse*
The State Hermitage Museum, Leningrad

Matisse wrote his family on 6 February 1912 that he had begun a "bouquet of blue irises" that day.[1] This bouquet is surely *Le vase d'iris*, which was sold by the artist to Bernheim-Jeune on 24 May 1912,[2] because only two Moroccan still lifes with irises are known: *Arums, iris et mimosas* (cat. 21), painted on Matisse's second trip to Tangier, and this work. *Le vase d'iris* was presumably executed in the artist's room at the Hôtel Villa de France where he had been confined by rain.[3] The vase of flowers is depicted before an oval dressing-table mirror, and anticipates the many hotel and apartment interiors with still lifes and mirrors the artist would paint later in Nice.[4]

Matisse painted still lifes throughout his career. His first of flowers is dated 1898,[5] and he painted several canvases of flowering potted plants and arranged flowers around 1912–1913.[6] When he arrived in Tangier he found heliotrope, morning glories, and nasturtiums in bloom despite the rain,[7] and he was greatly impressed by the flowers in Morocco, painting three large flower bouquets. This haunting picture, however, differs from the two later higher-key floral still lifes, *Arums* (cat. 20) and *Arums, iris et mimosas*. As *Le vase d'iris* was probably the first painting completed in Morocco,[8] it may be considered a transitional work that bears comparison to the 1911 Seville paintings, such as *Nature morte, Seville I and II* (figs. 100, 101), which like *Le vase d'iris* combine a dark tonality with an abundance of patterning.

Within the compressed, shallow space of *Le vase d'iris*, the artist depicted long-stemmed reddish-purple and yellow flowers in a brown vase. He filled the areas between the thin stems with black, making the asymmetric arrangement of flowers stand out vividly. In the mirror glows a strange, jarring area of pale and dark green over an intense yellow, and behind it to the left is an area of blue shadow, which add to the odd, disjunctive character of this painting.

Shchukin acquired *Le vase d'iris* by 1913.[9] By the end of that year he had also added *Amido* (cat. 8), *Arums, Arums, iris et mimosas, Zorah debout* (cat. 16), *Le rifain debout* (cat. 18) and *Café marocain* (cat. 23) to his collection. These paintings represent all the genres Matisse painted in Morocco with the exception of landscape, which Morosov, the other great Russian collector of Matisse, preferred.

1. Archives Henri Matisse. Letter, 6 February 1912.
2. Archives Henri Matisse.
3. Matisse arrived in Tangier on 29 January 1912 in a downpour, and it continued to rain for several days, forcing him to work indoors. This still life was begun a little over a week after he arrived.
4. Examples include *Intérieur à la boîte à violon*, 1918–1919 (The Museum of Modern Art, New York), *La séance de peinture*, 1919 (Scottish National Gallery of Modern Art, Edinburgh), *Anémones au miroir noir*, 1919 (Reader's Digest Association, Inc.), and *Nature morte, vase de fleurs, citrons, et mortier*, 1919 (Mr. and Mrs. James W. Alsdorf, Chicago).
 For more information about the Nice interiors, see Jack Cowart and Dominque Fourcade, in Washington 1986a.
5. *Tournesols*, 1898 (Private collection).
6. In France he painted *Cyclamen pourpre*, 1911–1912 (Collection William P. Acquavella, New York); *Géraniums*, 1912 (National Gallery of Art, Washington); and *Fleurs et céramique*, 1913 (Städelsches Kunstinstitut, Frankfurt am Main). Flowers are also an important element in the series of six interiors with goldfish between 1911 and 1914. See Reff 1976; New York 1978, 84–86, 100–102, 197–198, 204–205; Schneider 1984b, 419–421.
7. Archives Henri Matisse. Letter, Amélie Matisse to family, 31 March 1912.
8. A note possibly made by Matisse's wife many years after returning from Morocco indicates that *Corbeille d'oranges* (cat. 4) was started before *Le vase d'iris*. Archives Henri Matisse. It appears, however, that *Le vase d'iris* was completed before *Corbeille d'oranges* (see cat. 4).
9. *Le vase d'iris* is no. 117 in Shchukin 1913, 26–27. The painting was assigned to 1912 by Izerghina 1978, 165, who wrote: "The picture *Vase of Irises* is undated, but there are reasons to believe that it was done in 1912 (this follows from an inscription on the reverse of the canvas, possibly made at Bernheim-Jeune)." Recent examination at the State Hermitage Museum confirms that a label affixed to the stretcher reads: "N19565[R] 1912 / Henri-Matisse / Le Vase d'Iris / CPPD." It is not known when or by whom the label was affixed.

Precisely when Shchukin purchased this painting is not known. A note in the Archives Henri Matisse indicates that this still life was included in "La Triennale 1912"; possibly Bernheim-Jeune sent the painting to this June and July 1912 exhibition at Galerie Jeu de Paume in Paris and Shchukin purchased it there.

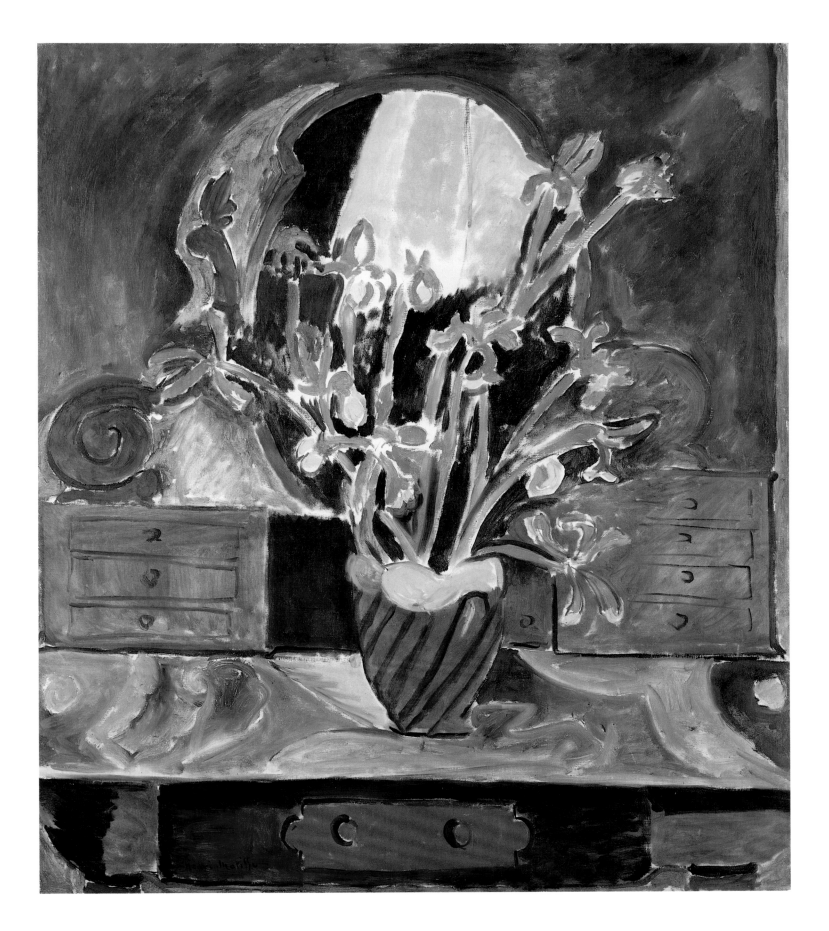

2

Vue sur la baie de Tanger, 1912

(View of the Bay of Tangier)
oil with pen and ink on canvas, 46 x 56 (18⅛ x 22)
signed l.l. in sepia ink: *Henri-Matisse*
Musée de Grenoble (Legs Agutte-Sembat)

Matisse painted *Vue sur la baie de Tanger* on his first visit to Tangier. On 27 April 1912,[1] shortly after the artist left Morocco, he sold it to Galerie Bernheim-Jeune. Matisse's friend and supporter, Marcel Sembat,[2] acquired the painting by 30 April 1912.[3] It appears to have been rendered quickly and extemporaneously, recording the artist's immediate, enthusiastic response to his exotic new environment. It also seems to have been painted during a break in the inclement weather, with its gray, cloudy sky, dark sea, and gentle hills verdant from the rain.

In this panoramic view of Tangier, Matisse combined a faithful depiction of the hills that surround the city with an interpretive rendering of the city and bay.[4] With pen and ink he first drew the main features of the cityscape with quick, wiry lines, which relate this painting closely to the spontaneous pen and ink sketchbook drawings he made in Morocco, such as *Maisons dans la médine* (cat. 33), and a more detailed drawing on quadrille paper of a similar view of Tangier, *Vue de la médine* (cat. 32), which appears to be a study for the painting.[5] The artist then filled in the drawn areas of *Vue sur la baie de Tanger* with thin washes of color, leaving much of the primed canvas untouched.

The old part of the city, the medina, is packed around a hill, and the artist chose a spot in the Casbah, the citadel of Tangier, for his view, probably from a terrace like the one depicted in the drawing *Terrasse dans la médine* (cat. 57).[6] Although the angle is not exactly the same, a similar view from the Sultan's Palace in an early twentieth-century stereograph (fig. 46) shows that Matisse included striking architectural features of the cityscape such as the white-domed *marabout* (tomb of a Muslim saint) still found where the rue Bab el Aassa and the rue Ben Raïssoul meet (figs. 53, 54), and the minaret with the palm alongside in the distance (fig. 47). However, compared to the stereograph, the space in the painting between the terrace and the hills is tilted so that the viewer hovers over, rather than looks across, the city and the bay.

1. Archives Henri Matisse.
2. Sembat wrote the first monograph on Matisse, *Matisse et son oeuvre* (Paris, 1920).
3. Fourcade 1975, 39.
4. Matisse painted several other panoramic landscapes, notably in Collioure. See essays in this volume by Schneider, p. 34, and Elderfield, pp. 206–207.
5. See Cowart essay in this volume for more on these drawings.
6. In the Casbah and medina of Tangier, houses and shops are built one against the other, solidly lining narrow, winding streets that snake around a hill. Except for the entry doors, homes rarely open onto the crowded streets. Rather, almost every house has an interior courtyard, which brings light and fresh air into the rooms, and a roof terrace, which affords both an open-air living area and privacy. See also fig. 71 for a map of the Casbah and medina.

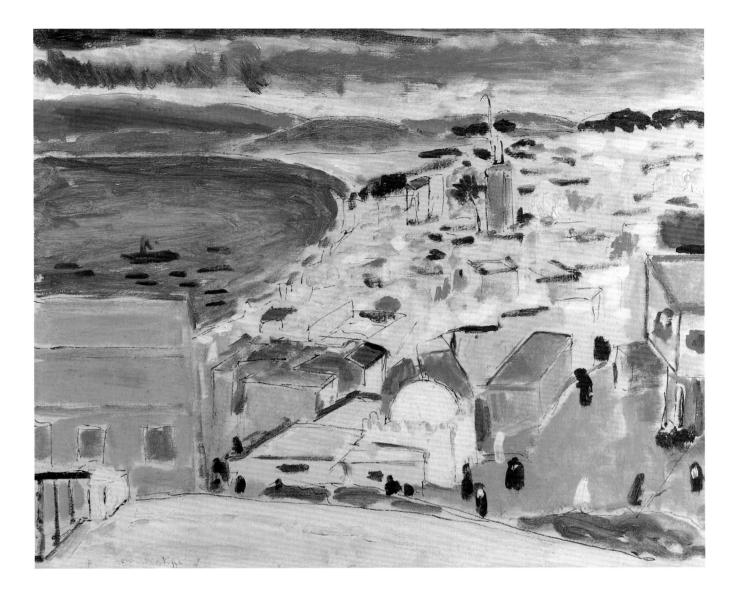

3

Le marabout, 1912/1913

(The Marabout)

oil on prepared canvas board, cradled 21.5 x 27.5 (8½ x 10¹³⁄₁₆)

signed l.l. in black: *H. Matisse*

Private collection

Matisse most likely painted *Le marabout* during his first trip to Morocco. A topographical study like the early *Vue sur la baie de Tanger* (cat. 2), it reflects the artist's initial interest in and exploration of Tangier. *Le marabout* represents an actual site in the Casbah of Tangier, the Marabout Sidi Berraïsoul on the Rue Ben Abbou (fig. 55).[1] This painting, on an easily portable, standard French no. 3 prepared panel, was probably painted on the spot.[2]

Le marabout also relates in subject and in style to Albert Marquet's paintings of Tangier made during his visit in August–September 1911. Arguably Matisse went to Tangier on Marquet's recommendation,[3] and he may well have seen his friend's paintings in muted tones of blue and gray (fig. 7) before leaving for Morocco himself. Marquet's paintings, with their straightforward rendering of Tangier's picturesque streets and architecture, invite comparison with photographs made by travelers and contemporary postcards that document similar scenes. Matisse's *Le marabout* shares with Marquet's Moroccan paintings their cool tonality as well as some of their photographic, postcardlike qualities in its subject, proportions, and use of perspective.

Although they were occasionally tinted, postcards and photographs of the time were mostly black and white, and the similiarity of Matisse's painting to them, and to Marquet's work as well, ends with Matisse's vivid, aggressive palette. His colors are strong and pure, thickly painted deep blues and greens with touches of pink and yellow on the dome. This brilliant range of color is striking for a street scene because the dominant color of the architecture in Tangier—and of this *marabout*—is white.

1. *Le marabout* was published in Aix 1960, no. 12, as *Mosquée à Tanger,* but the subject is not a mosque. Although some mosques have domes, those in Tangier are distinguished by a minaret, or tower, from which the faithful are called to prayer. Rather, Matisse's painting depicts a *marabout,* the domed tomb of a Muslim saint (*sidi*) of the Marabout sect, a highly respected religious and military community.

2. Matisse portrayed himself painting a similar *marabout* in the drawing *Henri Matisse par lui-même* (cat. 26). Matisse also depicted the Marabout Sidi Berraïsoul in sketchbook drawings (cats. 38, 56; see Cowart essay for discussion and dating of drawings) and a different *marabout* in *Vue sur la baie de Tanger* and *Les marocains* (cat. 24).

3. See Schneider essay in this volume, pp.18–19, for Matisse's motivation for visiting Tangier and for his relationship with Marquet.

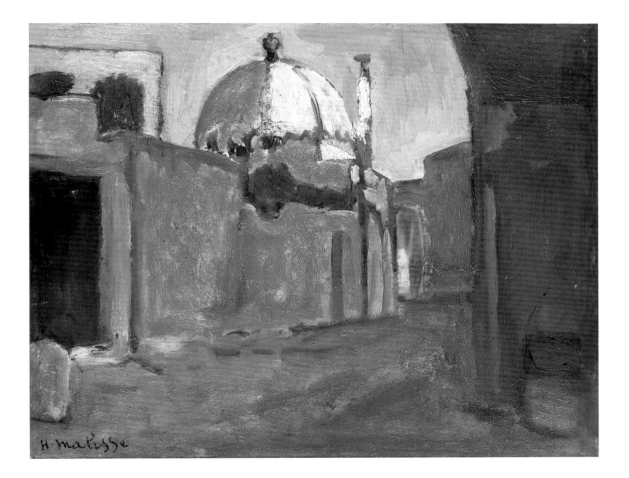

4

Corbeille d'oranges, 1912
(Basket of Oranges)
oil on canvas, 94 x 83 (37 x 32⅝)
signed l.l. in blue-violet: *Henri-Matisse*
Musée Picasso, Paris

Matisse sold *Corbeille d'oranges* to Bernheim-Jeune on 27 April 1912.[1] It is probably the still life he mentioned several times in letters home during his first trip[2] and was probably intended originally for Morosov.[3]

Three surviving sketches of *Corbeille d'oranges* (cat. 28 and figs. 42, 43) render the painting in three slightly different ways, perhaps indicating the artist's changes over time.[4] One of those sketches appears in a letter Matisse wrote to Michael and Sarah Stein, in which he described the work as it reached completion: "It's a painting one meter by one meter. Some oranges in a basket with green orange leaves. It sits on a table covered with a white silk with large bouquets of violet, white, yellow, and green flowers. The painting is almost finished."[5]

Corbeille d'oranges vividly evokes Morocco. Its brilliant oranges and lemons, with black stems and green leaves still attached, are arranged in a broad, shallow basket just as they are sold in the bountiful markets called *souks*. Still lifes of fruit, particularly of oranges, also have a long history in Matisse's work,[6] from *Nature morte à la bouteille de Schiedam* (State Pushkin Museum of Fine Arts, Moscow), 1896, to *Nu aux oranges* (Private collection), 1953, one of the artist's last works, and oranges appear many times in between.

The brilliantly colored flowered cloth in *Corbeille d'oranges* plays as important a role as the fruit. This is particularly apparent in the sketches, where the lemons and oranges, deprived of their high-key color, compete for attention with the heavily patterned flowered silk. The flowers are intriguing, for in Morocco Matisse depicted them in several forms, often removed from the wild state in which he admired them. The flowers closest to their natural state are in Matisse's paintings of gardens, in which the native flowers of Morocco grow in cultivated beds. Further removed are the vases of flowers he painted, in which the long-stemmed, cultivated flowers are cut, arranged, and brought inside. Still further are the flowers he depicted in the wallpaper of four drawings (cats. 29, 30, 31, 45) and those woven into the cloth of *Corbeille d'oranges*, which are captured in great flattened, upside-down bouquets of red, purple, yellow, and green, cascading away from the table.

Shortly after acquiring *Corbeille d'oranges*, Bernheim-Jeune sold the still life on 24 May 1912 to Carl and Théa Sternheim.[7] Pablo Picasso, who is said to have admired its vigor and spatial invention,[8] purchased *Corbeille d'oranges* during World War II. The still life was part of the 1973 Donation Picasso to the Musée du Louvre and was transferred to the new Musée Picasso in 1985.

1. Archives Henri Matisse.
2. Matisse mentioned a still life in four April letters in the Archives Henri Matisse: Monday [1 April 1912]; 2 April 1912; 6 April 1912; and 12 April 1912 (see April Morosov commission letters, Appendix 1). It may have been *Corbeille d'oranges* or *Arums* (cat. 20), but it seems more likely that Matisse was referring to the heavily painted *Corbeille d'oranges*, because the still life mentioned in the letters apparently gave him difficulty and probably took longer to paint than the thinly brushed, seemingly quickly rendered *Arums*.
3. See Appendix 1.
4. Examination in the Louvre conservation laboratory has confirmed that the artist repainted much of *Corbeille d'oranges*. Sylvie Béguin, *Donation Picasso* [exh. cat. Musée du Louvre] (Paris, 1978), 54. Rather than alter the composition with changes in the linear or geometric design, Matisse composed and recomposed *Corbeille d'oranges* as he frequently did, by layering and manipulating color.
 A note probably made by Matisse's wife many years after returning from Morocco says that *Corbeille d'oranges* was begun before *Le vase d'iris*. Even if this recollection is not strictly accurate, it may indicate that Matisse worked on the still life of oranges over an extended period.
 See also Cowart essay in this volume, p. 116.
5. "C'est une toile d'un mètre sur un mètre. Des oranges dans une corbeille avec quelques feuilles vertes aux oranges. Elle repose sur une table couverte d'une soie blanche avec gros bouquets de fleurs violettes, blanches, jaunes et vertes. La toile est presque terminée." The sketch and a fragment of the letter are printed in Russell 1970, 70 (see fig. 43). The exact date of this letter is not known. When Matisse gave the dimensions of this canvas as one meter by one meter, he was estimating. The painting is actually 94 x 83 cm.
6. See Schneider 1984b, 269, for an extensive discussion of Matisse's use of oranges as formal and emblematic elements.
7. Archives Henri Matisse.
8. Béguin 1978, 54. According to Matisse, Picasso was very proud of it. Matisse wrote to his son Pierre in February 1945: "Picasso a acheté une nature morte importante de Tanger qui a appartenue à Mme Sternheim. Il en est très fier et avec ses propres oeuvres au Salon d'Automne il a exposé d'authorité cette nature morte." Paris 1970, 80.

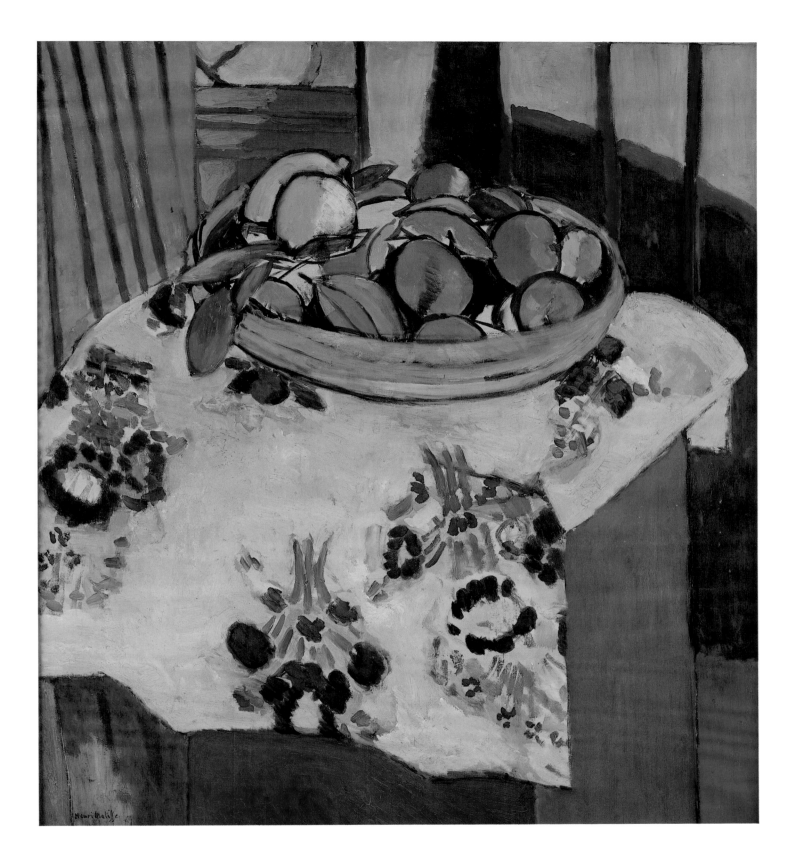

5

Les acanthes, 1912
(Acanthus)
oil on canvas, 115 x 80 (45¼ x 31½)
signed l.l.: *Henri-Matisse*
Moderna Museet, Stockholm

Matisse completed *Les acanthes*, one of three paintings of the parklike gardens in the Villa Brooks, on his first trip to Tangier.[1] He recalled later that he worked on this painting for a long time, perhaps a month and a half,[2] and thus would have started his painting by the beginning of March to be finished by the time he left Tangier in mid-April. When he arrived in Tangier, Matisse hoped to fulfill a commission for two landscapes for Morosov, and he may have considered this painting for one of the two landscapes he owed his patron before he decided to sell him the so-called Moroccan Triptych.[3]

Matisse obtained special permission to work on the grounds of the Villa Brooks, a private estate a short distance from his hotel.[4] Years later the artist vividly recalled this park, which he called the "Jardin de Bronx";[5] ". . . it was immense, with meadows as far as the eye can see. I worked in a part which was planted with very large trees, whose foliage spread very high. The ground was covered with acanthus. I had never seen acanthus. I knew acanthus only from the drawings of Corinthian capitals that I had made at the Ecole des Beaux-Arts. I found the acanthus magnificent, much more interesting, green, than those at school! My spirit was exalted by these great trees, very tall, and below, the rich acanthus provided a no less important focus of interest through their sumptuousness. . . ."[6]

Although Matisse spent considerable time and effort working on *Les acanthes*, he recounted later that he was still not happy with the painting when he left Tangier: "I made a large canvas . . . and when it didn't satisfy me, I decided that I would bring it back the following year. And to all those who saw the painting in Paris, I stopped them in their enthusiasm, telling them: 'It's not like that. It's better than that. You will see next year, when I will have reworked it.' I came back to Tangier with my painting, and I put myself in front of the landscape with the idea of retouching my work. Everything seemed much smaller than when I had seen it the first time, and I told myself: 'What I thought I had left out in my painting turned out to be there well and good and not in the landscape after all!' So I came back without retouching the painting."[7]

Matisse kept *Les acanthes* until 20 December 1913 when he sold it to Bernheim-Jeune.[8] Bernheim-Jeune sold the landscape to Léonce Rosenberg on 4 March 1914.[9] Rosenberg probably sold it to Walther Halvorsen, who in 1917 donated it to the Moderna Museet.

1. Courthion 1941, 103.
2. Courthion 1941, 103.
3. On Monday [1 April] 1912 Matisse wrote to his family that he had just written to Shchukin and had included a sketch of a still life and two landscapes for Morosov, which he described as "le bleu" and "pervenches." Archives Henri Matisse. "Le bleu" may be *Les acanthes*, but it seems more likely that it is *Paysage vu d'une fenêtre* (cat. 12). See Appendix 1 for more on the landscapes for Morosov.
4. Courthion 1941, 102. This large property was owned by Jock Brooks. The gardens were famous among the European residents of Tangier for its three-foot-long wisteria blossoms. Vaidon 1977, 157. Brooks' property was just west of the center of town, and has since been subdivided and developed for residential use.
5. Archives Henri Matisse. Letter, 6 April 1912.
6. Courthion 1941, 102–103, ". . . c'était immense avec des prairies à perte de vue. J'ai travaillé dans un coin qui était planté de très grands arbres, épanouissant très haut leur feuillage. Le sol était couvert d'acanthes. Je n'avais jamais vu d'acanthes. Je ne connaissais les acanthes que par des dessins de chapiteaux corinthiens que j'avais faits à l'Ecole des Beaux-Arts. J'ai trouvé ces acanthes magnifique, beaucoup plus intéressantes, vertes, que celles de l'Ecole! Mon esprit était exalté par ces grands arbres, très hauts, et, dans le bas, ces acanthes si riches qui formaient comme un équivalent d'intérêt par leur somptuosité. . . ."
7. Courthion 1941, 103. "J'ai fait une grande toile . . . et j'en suis revenu pas satisfait, me proposant de reprendre ma toile l'année suivante. Et tous ceux qui, à Paris, ont vu cette toile, je les arrêtais dans leur enthousiasme en leur disant: 'Ce n'est pas comme ça. C'est mieux que ca. Vous verrez l'année prochaine, quand j'y aurai retravaillé!' Je revins à Tanger avec ma toile, et je me présentai devant le paysage avec l'idée de retoucher mon oeuvre. Tout me paraissait bien plus petit que je ne l'avais vu la première fois, et je me suis dit: 'Mais ce que je croyais ne pas être dans ma toile y est bel et bien, et n'est pas dans le paysage!' Alors, je suis revenu sans avoir retouché la toile." See also Cowart essay in this volume, pp. 115–116, cat. 27, and fig. 41.
8. Archives Henri Matisse.
9. Archives Henri Matisse.

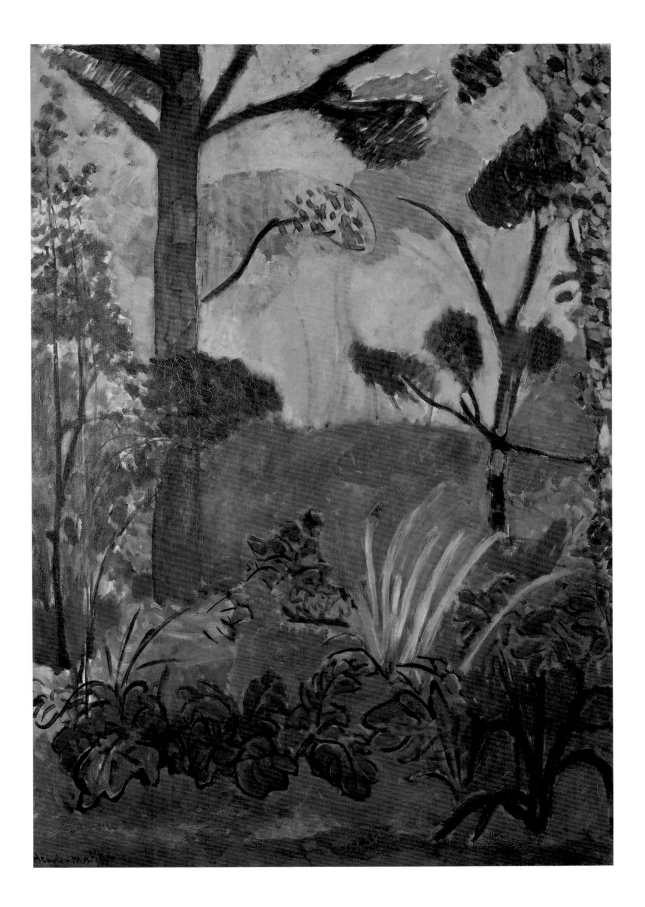

6

Les pervenches (Jardin marocain), 1912
(Periwinkles [Moroccan Garden])
Oil, pencil, and charcoal on canvas
116.8 x 82.5 (46 x 32½)
Signed and dated l.l.: *Henri-Matisse-1912*
The Museum of Modern Art, New York. Gift of Florene
M. Schoenborn

Les pervenches takes its name from its scattered accents of
pale blue periwinkles. The picture, which is also called *Jardin
marocain,* was painted in early 1912[1] in the garden of Villa
Brooks. *Les acanthes* was also painted there, and the two
pictures may even show a similar view (see cat. 5). But while
Les acanthes was a slowly developed, layered work that
caused Matisse considerable trouble, *Les pervenches* looks far
more spontaneous. Its free handling, however, covers a metic-
ulously drawn layout, as a recent infrared examination has
revealed (fig. 140). With rare exceptions Matisse followed the
drawing very closely. Since none of the drawn lines are at all
smudged, it is reasonable to assume that no alterations were
made in the process of painting. This fluent painterly inven-
tion on top of deliberated design follows Matisse's pre-
Moroccan compositional methods.[2]

The painting is mentioned by name in Matisse's 1 April
1912 letter to his family in which he said he sent Shchukin
that morning a *croquis* of a still life and two landscapes for
Morosov, the blue one and "les pervenches."[3] Matisse had
promised Morosov two landscapes.[4] Thus it seems that *Les
pervenches* was at least briefly considered for Morosov, with
the other landscape obligation to be fulfilled at that date by
the blue landscape, *Paysage vu d'une fenêtre* (see cat. 12). In a
subsequent letter of 3 April 1912, however, Matisse wrote his
family that he might stay in Tangier and do the landscape for
Morosov; and that Morrice had seen the two landscape
sketches ("*esquisses*") and had liked them very much.[5] This
letter suggests Matisse now considered only one landscape
completed (or near completion), probably *Paysage vu d'une
fenêtre.* The two "*esquisses*" mentioned are presumably *Les
pervenches* and *La palme,* neither now found suitable to com-
pleting the commission. (Indeed, in 1911, Matisse had re-
jected another landscape *esquisse* as insufficient for Moro-
sov.[6]) *Les pervenches* and *La palme,* as *esquisses,* and more
immediate records of the garden subject, may have had a role
in preparing for *Les acanthes,* the only ambitious first-trip
landscape not named in these letters, but most probably the
Morosov landscape that Matisse, on 3 April, was staying to
paint. During his second trip, Matisse recast the Morosov
commission, ultimately furnishing his Russian patron with
the so-called Moroccan Triptych. As early as 27 April 1912,
two weeks after his return to Paris from his first trip, Matisse

very certainly removed *Les pervenches* and *La palme* from
consideration for Morosov, selling both to his dealer.[7]

Les pervenches, like *La palme,* has been thought to be from
Matisse's second visit to Morocco, the two being associated
with Matisse's statement that when he returned to the Villa
Brooks the rich foliage had burned away in the summer sun.[8]
We now know that this is not true. *Les pervenches* has also
been thought to be the last of the three garden pictures: in an
ambiguously worded statement of 1920, Marcel Sembat re-
ferred either to one garden picture reworked three times or to
three garden pictures, the last with "trees changed into trees
of a terrestrial Paradise."[9] Since it is clear from their appear-
ance that neither *Les pervenches* nor *La palme* were re-
worked, and Matisse said that *Les acanthes* was not re-
worked,[10] Sembat's reference may be to *Les pervenches* as
what he construed as the third picture of the same subject. Its
arabesque tree forms do recall those of *Le bonheur de vivre*
(fig. 99), Matisse's archetypal rendering of the paradisal gar-
den. The actual chronology of the three garden pictures, how-
ever, is more likely to have been *La palme* and *Les perven-
ches* painted before, or during an intermediary stage in the
development of *Les acanthes.*

In April 1913, one year after it had been sold, *Les per-
venches* was included in Matisse's Bernheim-Jeune exhibition
of Moroccan pictures, *hors catalogue* (see fig. 5).

1. The work is presumed to have been painted between late February, when
the weather cleared, and 1 April 1912, when it was referred to by Matisse in a
letter to his family. See note 3 below.
2. See Elderfield essay in this volume, p. 213.
3. Archives Henri Matisse. It is possible of course that Matisse mistakenly
wrote "Les pervenches" for "Les acanthes," and the *esquisse* was never
under consideration at all.
4. Matisse's 19 September 1911 letter to Morosov apologized for not having
painted "his landscapes." His subsequent letter of 29 September 1912 refers
specifically to "two landscapes." See Moscow/Leningrad 1969, 129.
5. Archives Henri Matisse. See Appendix 1 for dating of this letter, and
Elderfield essay in this volume for a discussion of *esquisses,* pp. 211–219.
6. In 1911 Matisse told Morosov that one of his two Salon d'Automne
submissions that year had originally been meant for him but was unsuitable
since it was an *esquisse.* See Moscow/Leningrad 1969, 129.
7. On 27 April 1912, Bernheim-Jeune acquired *La corbeille d'oranges, Les
pervenches, La palme,* and *Vue sur la baie de Tanger* (Archives Henri
Matisse). On 12 April, two days before leaving Tangier and fifteen days
before this sale date, Matisse had written his family from Tangier that he had
had a special crate made for his still life for Morosov and his two *esquisses.*
The three crated works were presumably *La corbeille d'oranges, Les perven-
ches,* and *La palme.* This reference is somewhat puzzling insofar as all three
works were to be shortly sold to Bernheim-Jeune (with *Vue sur la baie de
Tanger,* which was destined for Marcel Sembat in Paris), and yet Matisse still
referred to the still life as being "for Morosov." See Appendix 1.
8. Courthion 1941, 101–102. See Stevens in London 1984, 212.
9. Sembat 1920a, 10.
10. *Les acanthes* was apparently not reworked when Matisse brought it
back to Morocco with him on the second trip. See cat. 5.

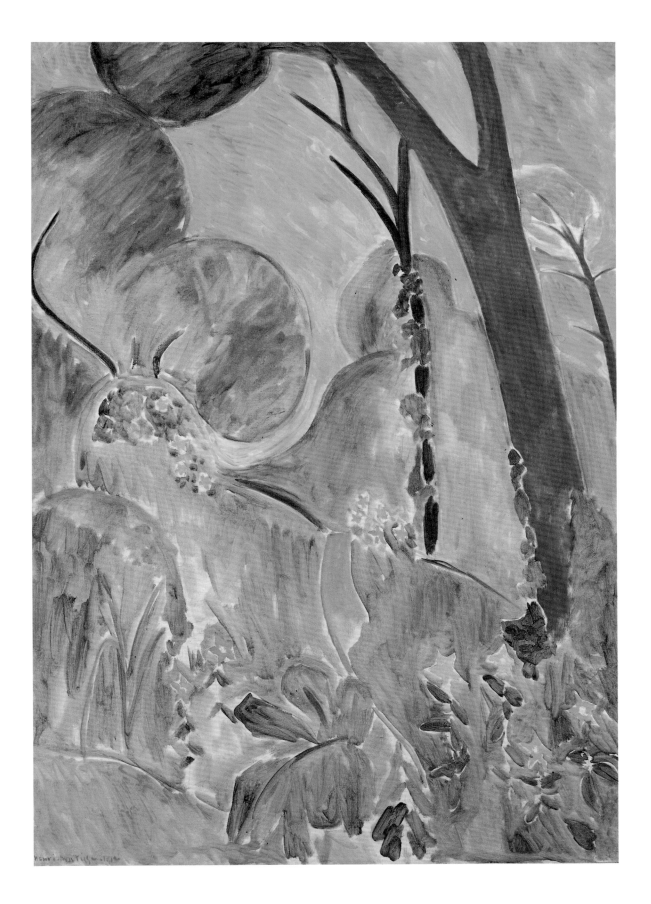

7

La palme, 1912
(The Palm)
oil and pencil on canvas, 117.5 x 81.9 (46¼ x 32¼)
signed l.r. in green: *Henri-Matisse*
National Gallery of Art, Washington, Chester Dale Fund

La palme was evidently painted in March 1912: Matisse sold
it to Bernheim-Jeune on 27 April 1912 with the title *Matin
du mars prés de Tanger*.[1] Painted in the gardens of the
Villa Brooks,[2] it is probably one of two landscape *esquisses*
he mentioned in two letters to his family, one written in late
March and the other dated 12 April 1912.[3] *La palme*, *Les
acanthes* (cat. 5), and *Les pervenches (Jardin marocain)* (cat. 6)
are often referred to as the "Moroccan Garden Triptych" and
considered a set,[4] but despite their coincidence of subject mat-
ter and size, no evidence exists to indicate that Matisse con-
ceived of them that way.[5] Still, when Matisse painted his
three garden paintings in the spring of 1912, he must have
been aware of the example of Pierre Bonnard who had re-
cently painted a garden triptych for Morosov,[6] particularly
since Matisse owed this same patron two landscapes, and
perhaps another painting. It is worth noting that Matisse fi-
nally sold Morosov a set of three paintings, the Moroccan
Triptych.[7]

If Matisse ever considered his gardens an ensemble, he did
not feel compelled to keep them together. Within two weeks
of his departure from Tangier in 1912, he had sold *La palme*
and *Les pervenches (Marocain jardin)* to Bernheim-Jeune.[8] A
year or two later, *La palme* passed from Bernheim-Jeune to
Oscar and Greta Moll,[9] German friends of the artist who col-
lected Matisse's work between around 1905 and 1914,[10]
while *Les acanthes* and *Jardin marocain (Les pervenches)*
went from Bernheim-Jeune to two different private collectors.

Matisse evidently painted *La palme* quickly. Examination of
the painting indicates that it was probably finished in two, or
at most three sessions. The artist told Barr that he painted *La
palme* in a "creation spontane, comme une flamme—dans un
élan," which Barr translated as "in a 'burst of spontaneous
creation—like a flame.'"[11] Substantial pencil underdrawing
sketched on a prepared canvas remains visible through the
thin layers of paint. Although Matisse followed the under-
drawing in *Les pervenches (Jardin marocain)* closely when he
added color, in *La palme* the underdrawing indicates only the
rough elements of the composition, and in large measure the
artist disregarded his drawing as he applied color. Palm
fronds, each created with a single stroke of paint and empha-
sized with lines scratched into the surface with the end of the
brush, radiate from the center. Stark black tree trunks and an
abstract ocher path bordered with green spread from the fan-

like core, breaking the composition into thinly painted areas
of scumbled color.

1. Archives Henri Matisse.
2. See *Les acanthes* (cat. 5).
3. Archives Henri Matisse. For more information about these letters, see
Appendix 1. See also *Les pervenches* (cat. 6) and Elderfield essay in this
volume, pp. 211–219, for an interpretation of Matisse's use of the term
esquisse.
4. For example, in London 1984b, 189: "Despite their differences in tonality,
these three paintings were intended to form a decorative triptych. . . ."
5. For a discussion of how the Moroccan paintings relate to one another,
especially as possible diptychs and triptychs, see Schneider essay in this
volume, pp. 41–43, and Appendix 2.
6. Morosov commissioned Bonnard in January 1910 to paint a triptych to
decorate the main staircase in his home in Moscow, and Bonnard finished *La
Méditerranée* (State Hermitage Museum, Leningrad), a very successful three-
panel ensemble of a garden-park in Saint-Tropez, in time to exhibit in the
1911 Salon d'Automne. Albert Kostenevich, *The Hermitage: Western Euro-
pean Painting of the Nineteenth and Twentieth Centuries* (Paris, 1976), no.
105.
 Matisse also exhibited two paintings at that Salon (Gordon 1974, 503),
including a sketch he originally intended as an idea for one of his paintings
for Morosov. See Appendix 1 and Elderfield essay in this volume, p. 211.
7. For information about the Morosov commission, see Appendix 1.
8. Archives Henri Matisse.
9. Letter from Greta Moll to Alfred Barr, 20 April 1951, translated from
German into English, ". . . Besides we owned for a long time . . . the *Palm
Leaf* . . . The *Palm Leaf* we probably had from 1913 to 1930." Letter and
translation in the Barr Archives, The Museum of Modern Art, New York.
10. Siegfried and Dorothea Salzmann, *Oskar Moll: Leben und Werk* (Mu-
nich, 1975), 62–63. The Molls were also original class members of the school
Matisse set up in Paris in 1908. Flam 1986, 221. Matisse painted Greta Moll's
portrait in 1908 while she was a student; the painting now belongs to the
National Gallery, London.
11. Barr 1951, 540, note 1. Mrs. Alfred H. Barr, Jr., who was more fluent in
French than her husband, recollected that Matisse said "Je l'ai fait tout d'un
coup, comme une flamme," or as she translated, "all in one bang." Letter
from Mrs. Alfred H. Barr, Jr., to Trinkett Clark, 27 June 1981. NGA curatorial
files.

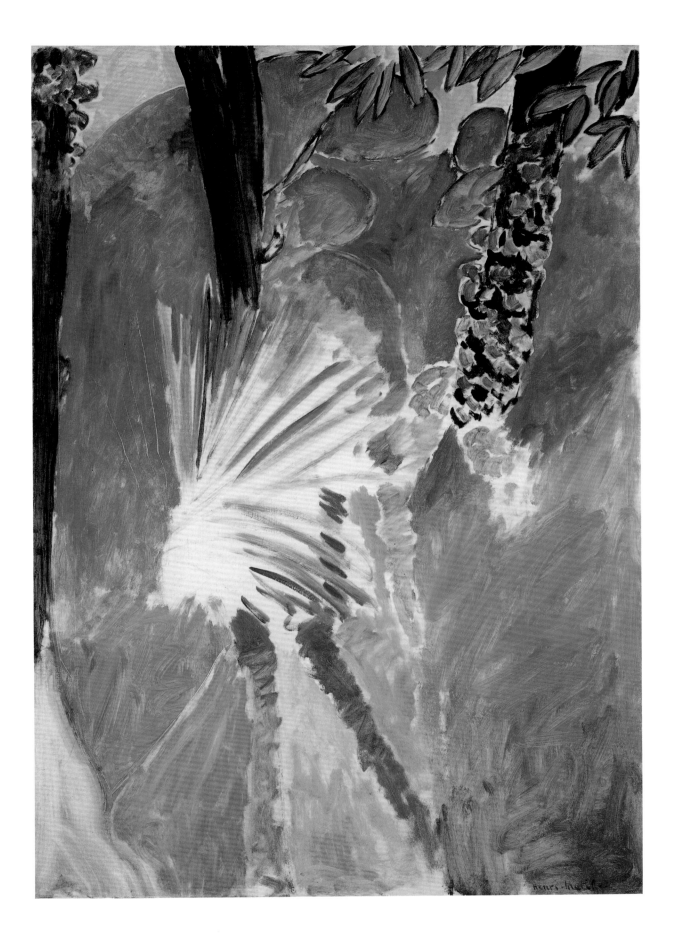

8

Amido, 1912
oil and pencil on canvas, 146.5 x 61.3 (57⅝ x 24⅛)
signed l.r. in reddish brown: *Henri-Matisse*
The State Hermitage Museum, Leningrad

Matisse painted *Amido* on his first trip to Morocco,[1] to fulfill a request from Shchukin for a "souvenir de Tanger."[2] A record of a letter of 27 April 1912 in the Archives Henri Matisse indicates that Bernheim-Jeune had seen two paintings resulting from commissions in Matisse's studio, one of which was a "marocain" for Shchukin.[3] Shchukin wrote to Matisse in August 1912 asking Matisse to send "le maroquain" to him in Moscow,[4] and a letter Matisse wrote to Camoin in the fall of 1912 mentions a "petit marocain" he had painted the previous season.[5] Although Matisse painted two other male Moroccans (cats. 18 and 19) during his sojourns, they are firmly dated to the second trip; the *marocain* referred to in the record and letters therefore must be *Amido*. On his second trip to Tangier, the artist painted a pendant to *Amido*, *Zorah debout* (cat. 16), which Shchukin also acquired.

Amido and the nine other figural paintings of Moroccans form a set of nearly ethnographic depictions of men and women in their brilliantly colored, exotic costumes. The model for this painting may be the young man who was a groom "à Valentina," whom the artist mentioned he might paint in a letter to his family in early April 1912.[6] The Villa Valentina, like the Villa de France where Matisse stayed, was one of the better hotels in Tangier.[7]

Amido, whose name is a diminutive of the common Muslim name Amidou,[8] wears typical clothing for a Moroccan who lives in town.[9] He wears a turquoise *bediaa* (vest) trimmed with peach over a white *tchamir* loosely modeled with dark gray and blue, and light purple pantaloons, called *séroual*. Slung across *Amido*'s chest is a pouch (*chekkara*). The young Moroccan stands gracefully at ease in a three-quarter pose, one hand on his hip, and gazes with long-lashed eyes toward a window.

Amido appears to have been executed rapidly. Of the three full-length, standing, single-figure paintings (see also cats. 15 and 16), this is by far the most loosely and thinly painted. The artist first drew the portrait in pencil on white primed canvas, and much of his sketchy underdrawing remains visible through the sheer, scumbled areas of color. Only the left shoulder, where pentimenti are apparent, shows evidence of having been reworked. A long narrow area of primed white canvas embellished with a run of blue scallops suggests a curtained window and, therefore, an interior setting.

1. A label affixed to the stretcher indicates that the painting was shipped from Marseilles to Paris in April 1912. It reads: "Marseille / 20 Avr 12 / P.L.M. / Paris." This is a shipping label for the Paris-Lyon-Méditerrané train line. A second label reads: "Marseille G.V." which probably indicates that the painting was shipped from Marseilles "Grande Vitesse."
2. Archives Henri Matisse. Shchukin to Matisse, letter, 13 March 1912. See also Appendix 1.
3. Archives Henri Matisse. The commission was for 6,000 francs. See also Appendix 1.
4. Shchukin wrote to Matisse on 22 August 1912: "Mais je vous prie d'envoyer les deux autres tableaux (le maroquain et les poissons d'or) à Moscou grande vitesse." Barr 1951, 555, corrected in Kean 1983, 298–299. For complete text, see Appendix 1.
5. Matisse to Camoin: "J'ai commencé par faire une mauresque sur une terrasse, pour faire pendant au petit marocain de l'an dernier. . . ." around the end of October 1912, Giraudy 1971, 13. For complete text, see Appendix 1. Matisse was not being precise when he told Camoin that he worked on the Moroccan "last year," as he did not arrive in Morocco until January 1912. Rather, by "last year" he meant the last time he was in Tangier the previous season, January–April 1912.
6. Archives Henri Matisse. Letter, 6 April 1912. See also Appendix 1.
7. Botte 1913, 32.
8. Which, like Hamido, is derived from Mohammed. Per Naïma Amahboub, first secretary for cultural affairs at the Embassy of Morocco in Washington, DC. Miss Amahboub was also extraordinarily helpful to us in identifying parts of Moroccan costume in this and the following entries.
9. Per Mohammed Habibi, director of the Musée de la Casbah, Tangier. We would like to express our thanks to Dr. Habibi, who answered numerous queries about Tangier and its people for us.

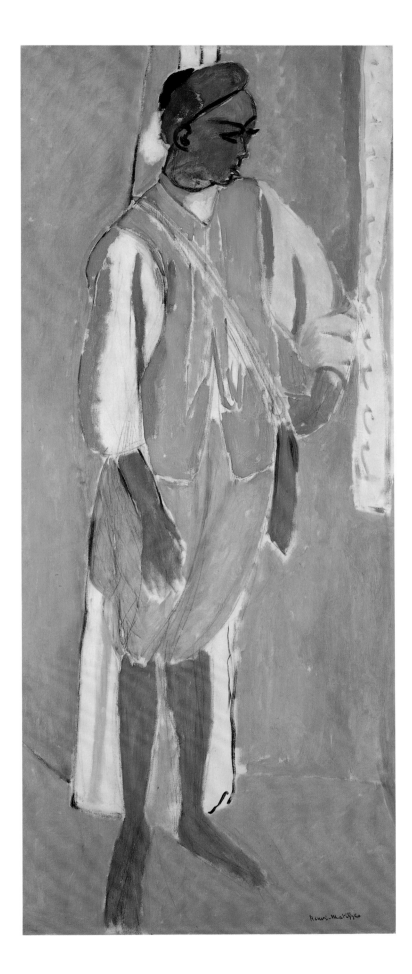

9

Zorah en jaune, 1912
(Zorah in Yellow)
oil and pencil on canvas, 81.3 x 63.5 (32 x 25)
signed l.l. in red: *Henri-Matisse*; on reverse in red: *Tanger 1912. Marocaine en jaune*
Private collection, New York

During his sojourns in Morocco Matisse completed a remarkable group of pictures of Zorah,[1] a young girl he met on his first trip. Of these only *Zorah en jaune*, which was sold to Galerie Bernheim-Jeune on 24 September 1912, can be firmly dated to the first visit.[2]

Matisse painted *Zorah en jaune* with close attention to the details of her typical Moroccan dress. He may have had in mind the example of Delacroix, who traveled to Morocco in 1832 and documented many of the people he saw in their colorful costumes (see fig. 8). This type of picture also has precedents in Matisse's 1909 paintings of women, including *L'Espagnole au tambourin* (State Pushkin Museum of Fine Arts, Moscow) and *Femme algerienne* (Musée national d'Art Moderne, Paris). The paintings of Zorah, in turn, are prototypes for the costumed models he would paint later in Nice.[3]

Matisse appears to have endured significant difficulties in drawing and painting Zorah. In early April 1912 he wrote his family that he had received permission from the proprietor of the Hôtel Villa de France, Mme Davin, to work in a studio where the young Arab girl he was painting, presumably Zorah, might come without being seen.[4] A few days later he again wrote home, saying he would have liked to work with the young girl, but it was impossible since her brother would have prevented it.[5]

Zorah en jaune sits against a scumbled bluish-green background, with her legs tucked beneath her. Nothing intrudes, and only a small bare foot breaks into the space around her. Her quiet, introspective attitude is accentuated by the closed shapes that make up her figure: her oval face; the loop formed by her clasped hands, arms, and shoulders; and the soft *takshita* (sheer dress over a matching thicker one) that envelops her. Her black hair is pulled away from her masklike face with a pink *sebnia*, which matches the color of her full lips. *Sfifa* (trimming) of orange accentuates a long diagonal that begins with the part in her hair and runs through her face down the front of her robe to the area of orange, perhaps a pillow, in the lower left corner of the painting.

Although customarily titled *Zorah en jaune*, her robe is now the color of wheat highlighted with yellow, with pencil drawing visible through the thin paint. Matisse brought this picture back to Issy-les-Moulineaux in the spring of 1912 and portrayed it in the background of *Intérieur aux poissons rouges* (fig. 107).[6]

1. In addition to this work, Matisse painted two others, *Sur la terrasse* (cat. 13) and *Zorah debout* (cat. 16), as well as an oil drawing on canvas, *Zorah assise* (cat. 10). He also drew her face three times on one sheet for *Trois études de Zorah* (cat. 44), and one more drawing, now lost, can be seen in the installation photographs of Matisse's exhibition 1913 at Bernheim-Jeune (fig. 1).
2. Archives Henri Matisse. On 2 November 1912 Félix Fénéon, Matisse's dealer at Galerie Bernheim-Jeune, wrote to Matisse to tell him that *Zorah en jaune* had been sold to a Mr. Butler of Shrivenham, England. Archives Henri Matisse.
3. Later in the 'teens and twenties, Matisse would do extensive portrait series of favored models, such as Lorette, Antoinette, Henriette, and Loulou, who were often costumed as odalisques. See Jack Cowart and Dominique Fourcade in Washington 1986a.
4. Archives Henri Matisse. Letter Monday [1 April 1912]. See Appendix 1.
5. Archives Henri Matisse. Letter, 6 April 1912. See also Appendix 1.
6. This is noted in New York 1978, 198, and confirms the proposed date of summer 1912 for the Barnes painting. In *Intérieur aux poissons rouges* Zorah's robe is bright yellow. Recent conservation examination at the Museum of Modern Art indicates that Matisse probably used two kinds of yellow pigment for the robe: certainly an inorganic pigment, which remains as highlights, and possibly an organic pigment, which can fade over time.

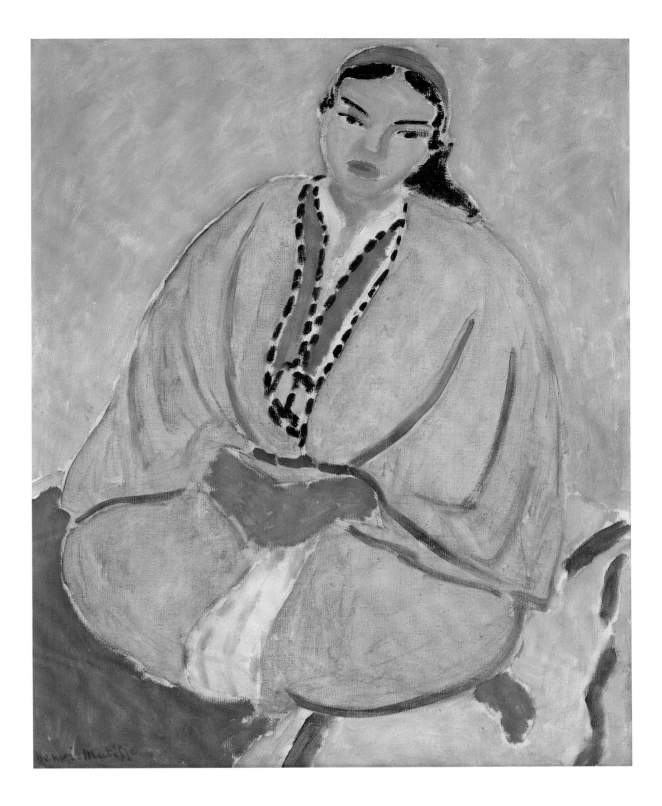

10

Zorah assise, 1912/1913
(Zorah Seated)
essence on canvas, 113.6 x 78.7 (44³/4 x 31)
signed l.r. in black ink: *H Matisse*
Private collection
Exhibited in Washington and New York only

Matisse drew this picture of Zorah in *essence*.[1] He took advantage of his medium to create one of his most graceful drawings of this period, rivaled only by a few of the recently discovered pen and ink sketches of Moroccan men.[2] Zorah's face is rendered with dark strokes, which emphasize her features,[3] while her headpiece (*sebnia*) and robe (*tchamir*) are drawn more thinly and delicately, with long, curving sweeps of the brush. The artist made few adjustments except in the placement of the arm to the right, which despite the reworking still bends unnaturally out of her billowing sleeve.

Opinions differ about what Matisse intended when he executed *Zorah assise*, one of several pictures of this young girl.[4] One possibility is that this oil drawing may have been the first stage of a painting Matisse chose not to develop.[5] Sometimes the artist drew onto the canvas with pencil, as in *Amido* (cat. 8), or in *essence*, as in *Arums* (cat. 20), and then filled in the loosely defined areas with color.[6] If it is a first stage of an unfinished painting, the painting may have been a candidate for the central painting of the so-called Moroccan Triptych.[7] This seems plausible: *Zorah assise* is, in fact, drawn on the same size standard prepared French no. 50 landscape canvas as the wings of the triptych. That a different image of Zorah in a similar pose, *Sur la terrasse* (cat. 13), ultimately became the middle panel also supports this proposition.

It has also been suggested that *Zorah assise* may be a study for *Zorah en jaune*,[8] a portrait of the same sitter in a related pose the artist painted in the spring of 1912. This seems less likely because *Zorah assise* is taller and wider than *Zorah en jaune*, and it appears improbable that the artist would execute a formal study in a larger format than the final painting.

The last possibility is that *Zorah assise* is an independent, finished drawing of his favorite Moroccan model, rather than an incomplete painting or a study for a more finished work. Regardless of how the work was begun, Matisse signed *Zorah assise*, indicating that he considered the picture complete.[9]

1. Oil paint thinned with turpentine or a similar substance that reduces the viscosity of the paint so that it may be easily applied to the surface in a thin film. Ralph Mayer, *The Artist's Handbook of Materials and Techniques* (New York, 1981), 363.
2. See Cowart essay in this volume. Matisse executed another "drawn" oil portrait in Morocco of a young woman, *La Marocaine* (cat. 11), but this is more densely painted and reworked, and retains the character of a smudgy charcoal drawing rather than a fluid pen and ink drawing.
3. Her face in this drawing is similar to the pen and ink portrait in the upper right of *Trois études de Zorah* (cat. 44). See also Cowart essay in this volume.
4. See cat. 9.
5. Paris 1975, 90, and London 1984a, 61.
6. London 1984a, 61.
7. Paris 1975, 90.
8. Flam 1986, 327.
9. Although it should be noted that it appears to have been signed after Matisse returned from Morocco.

11
La Marocaine, 1912/1913
(Moroccan Woman)
oil and charcoal on canvas, 55 x 46 (21⅝ x 18⅛)
signed l.l. in black ink: *H. Matisse*
Private collection

This painting, recorded in the Archives Henri Matisse as a drawing on canvas painted in Tangier, is published here for the first time.[1] It is quite different in spirit from the artist's other paintings of Moroccan women. Unlike the self-possessed Zorah, who addresses the viewer directly, or the nonchalant Fatma, who looks away altogether, this vulnerable young woman sits passively with her hands in her lap. In painting this gentle, reflective portrait, perhaps Matisse had in mind the sympathetic studies of Jewish and Arab women portrayed by Delacroix in 1832. With its nearly monochromatic, sketchy, and smudged handling, *La Marocaine* also differs from the other Moroccan figures in technique and style. Nevertheless, her costume appears to be that of a Moroccan, possibly a Berber tribeswoman from Tetouan,[2] which supports the dating of this picture to the Moroccan sojourns.

Although *La Marocaine* retains the quality of a sketch, Matisse signed it,[3] indicating perhaps that although not complete, he had finished working on it. The softness of her expression and pose are accentuated by the technique, which has the quality of a charcoal drawing. The curious, schematic, masklike face in the upper right corner, related to the upper-right head in *Trois études de Zorah* (cat. 44),[4] and the diagonal strokes around the figure, which suggest the rubbings of a charcoal stick, add to the graphic quality of this painting.

Although the portrait at first gives the impression of having been executed quickly, it is heavily painted and reworked. Visible where the loosely painted dark gray and white layer no longer covers the surface is evidence of various subsurface layers of blue, green, and ocher. In an early state this painting was probably more brightly colored, which would relate it more closely to Matisse's other Moroccan figures.

1. It is recorded in the Archives Henri Matisse as "Peint à Tanger en Dessin sur toile."
2. See, for example, Plate XXII in Ernst Rackow, *Beiträge zur Kenntnis der materiellen Kultur Nordwest-Marokkos* (Weisbaden, 1958).
3. The painting may have been signed later.
4. Matisse also included a schematic head in the background of one of his charcoal portraits, *Jeune fille aux tulipes (Jeanne Vaderin)*, 1910 (The Museum of Modern Art, New York).

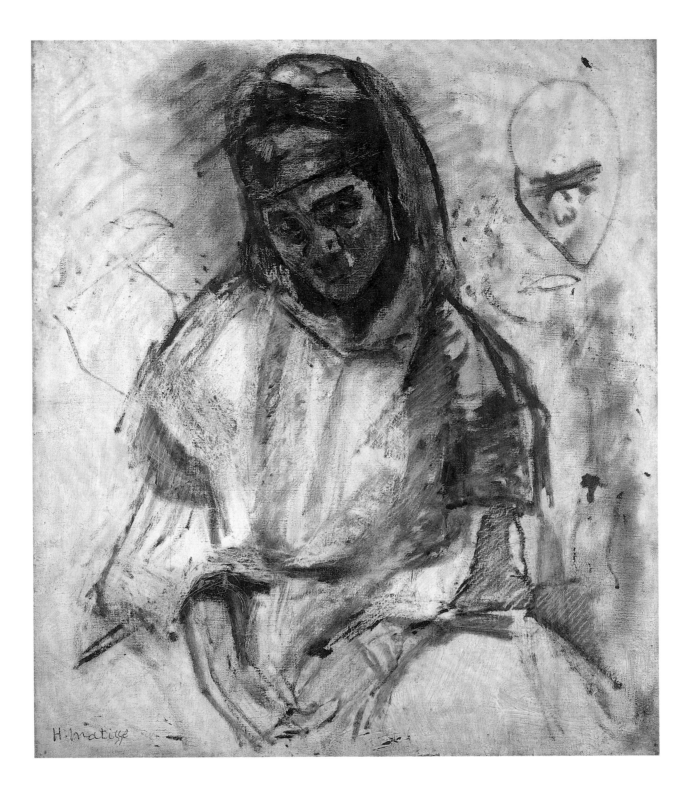

12
Paysage vu d'une fenêtre, 1912/1913
(Landscape Viewed from a Window)
oil on canvas, 115 x 80 (45¼ x 31½)
State Pushkin Museum of Fine Arts, Moscow

Paysage vu d'une fenêtre became the left wing of the so-called Moroccan Triptych, with Zorah represented in the middle panel in *Sur la Terrasse* (cat. 13) and one of Tangier's famous gates, *Porte de la Casbah* (cat. 14), to the right. The triptych was acquired by Ivan Morosov, one of Matisse's most important patrons, and it fulfilled a commission, originally for a pair of landscapes, dating back to at least the summer of 1911.[1]

Matisse recalled he had painted *Paysage vu d'une fenêtre*, the view from his window at the Hôtel Villa de France, during his first stay in Tangier.[2] It is possible that he began it with the outstanding request from his patron in mind. In a letter of 1 April 1912, Matisse mentioned two landscapes for Morosov, "le bleu" and "pervenches" (*Les pervenches [Jardin marocain]*, cat. 6).[3] "Le bleu" may have been *Les acanthes*, but it seems more probable that Matisse was referring to *Paysage vu d'une fenêtre*, the more blue of the two pictures. Corroborating this interpretation is a record of a 27 April 1912 letter in the Archives Henri Matisse, listed with the information kept on *Paysage vu d'une fenêtre*. The letter states that Bernheim-Jeune had seen "le paysage bleu" in Matisse's studio, one of two paintings resulting from commissions. The letter also indicated Matisse would receive eight thousand francs from Morosov for "le paysage bleu,"[4] the price Morosov ultimately paid for *Paysage vu d'une fenêtre*.[5]

The nature of *Paysage vu d'une fenêtre*'s subject, the Anglican church of Saint Andrew's and the city of Tangier from Matisse's hotel window, also supports a spring 1912 date. Matisse was confined to his hotel room by the rain when he first arrived in Tangier, and despite his dissatisfaction with other aspects of his lodging, he was very pleased with the view.[6] He made several drawings of the church (cats. 29, 30, 42, 69 and fig. 45),[7] and the painting offers a faithfully observed record of the scene. The artist returned to his window, probably on the second trip, to paint *Fenêtre ouverte à Tanger* (cat. 22), a freer and more subjective interpretation.

Notwithstanding arguments for a first-trip date, Matisse appears to have had *Paysage vu d'une fenêtre* with him during his second visit. The canvas hangs on the wall in the background of a photograph of Amélie and Henri Matisse, probably taken in Tangier (fig. 137), which could not have been made before late November 1912.[8] Matisse may have brought *Paysage vu d'une fenêtre* back to Tangier to rework it or paint a pendant, since he had sold *Les pervenches (Jardin marocain)* to Bernheim-Jeune shortly after returning to Paris in April 1912.[9]

It is not certain when Matisse decided to put *Paysage vu d'une fenêtre*, *Porte de la Casbah*, and *Sur la terrasse* together as an ensemble.[10] The first mention of it appears in a letter Matisse wrote from Issy-les-Moulineaux to Morosov on 19 April 1913, during the exhibition of the artist's Moroccan paintings at Galerie Bernheim-Jeune in Paris: "The three paintings in question are on exhibition at Bernheim's until today. They have been a great success and I think surely that you will be satisfied though you have waited a long time. I also think Madame Morosov will be happy. The three paintings have been combined to be placed in a given direction—that is to say, the view from the window is on the left, the gate of the Casbah on the right, and the terrace is in the middle as this sketch (fig. 141) shows you. . . ."[11]

Examination of the paintings of the Moroccan Triptych indicates that Matisse applied an upper layer of rose-pink pigment to portions of all three paintings.[12] *Paysage vu d'une fenêtre* was touched with pink in areas of the background. This same pink pigment was used in greater quantities in the upper layers of *Porte de la Casbah* and *Sur la Terrasse*, which were probably started and completed on the second trip.[13] Matisse may have all but finished *Paysage vu d'une fenêtre* on the first trip and added touches of pink paint on the second. Possibly he retouched *Paysage vu d'une fenêtre* around the same time that he was working on the other two paintings with the idea that all three be sold together to Morosov, using pink to bring them into greater harmony.

1. About the commission from Morosov that resulted in the Moroccan Triptych, see Appendix 1.
2. In the summer of 1950, John Rewald interviewed Matisse with questions prepared by Alfred Barr. The results were mailed to Barr in a 4 August 1950 letter, now in the Barr Archives (Questionnaire v), The Museum of Modern Art, New York. About this painting, the letter reads "Painted from the Hotel de France in 1912, during the first stay in Tanger. In the background appears the English Church of Tanger."
3. Archives Henri Matisse. Letter, Monday [1 April 1912]. See also cat. 6 and Appendix 1.
4. Archives Henri Matisse. See also Appendix 1.
5. Letter, Matisse to Morosov, 19 April 1913, Moscow/Leningrad 1969, 129. For the complete text, see Appendix 1.
6. Archives Henri Matisse.
7. See Cowart essay in this volume, pp. 117–118, 145–146.
8. See cat. 18, note 2. Additionally, a label on the stretcher of the work reads: "Moulineaux-Rue [. . .]/3 mars," suggesting a receiving date at Issy-les-Moulineaux on 3 March 1913. (On 3 March 1912, Matisse was just beginning his work on his first Moroccan trip.) Another label reads: "P. L. M. / de Marseille-Arène / Issy-les-Moulineaux / no. 8 / P. V." A similar label appears on the stretcher of *Porte de la Casbah* (see cat. 14, note 8). Label information was made available by Marina Bessonova.
9. See cat. 6.
10. In 1950 Matisse said that *Paysage vu d'une fenêtre* and *Sur la terrasse* "did not form a triptych with the 'porte de la Kasbah,'" though all were painted in the same year. Rewald to Barr, 4 August 1950 (see note 2).
11. Letter, Matisse to Morosov, 19 April 1913, Moscow/Leningrad 1969, 129. For the complete text, see Appendix 1.
12. The results of the technical examination of these paintings at the Restoration Institute, Moscow, were made available to us by Marina Bessonova.
13. See cats. 13 and 14.

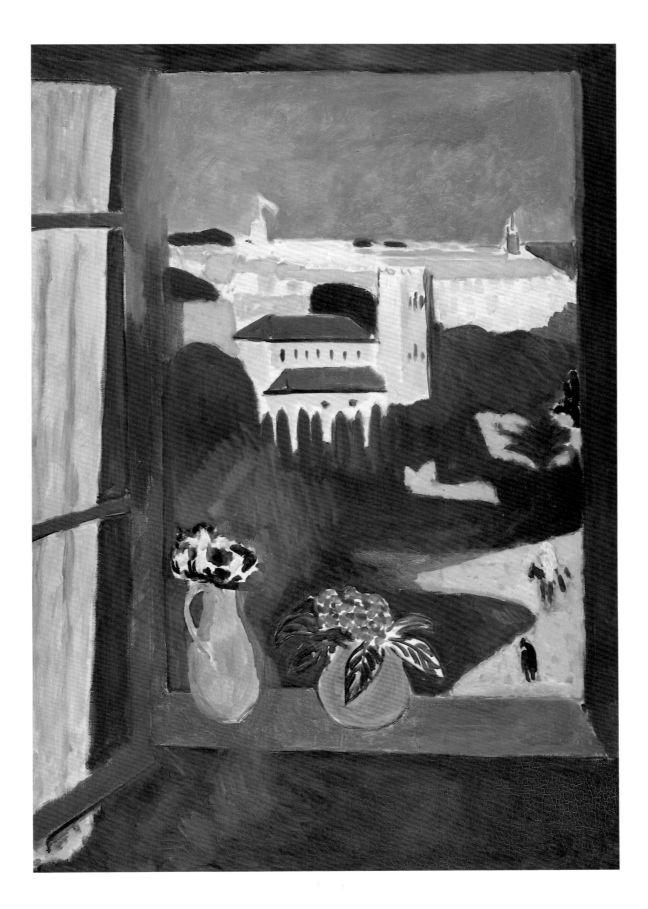

13

Sur la terrasse, 1912/1913
(On the Terrace)
oil on canvas, 115 x 100 (45 1/4 x 39 3/8)
State Pushkin Museum of Fine Arts, Moscow

This painting, the central panel of the Moroccan Triptych, shows Zorah, Matisse's favorite Moroccan model, kneeling between Moroccan attributes: her red–lined *babouches* (slippers) and a bowl of goldfish.[1] The artist recalled that he painted *Sur la terrasse* when he returned to Tangier the second time and that it showed Zorah on the terrace of her bordello.[2] Camoin remembered that he had accompanied Matisse to a brothel to paint the women who worked there, with a warning from Matisse they must "enter like doctors,"[3] presumably to remain distinct from the clients. If this was a painting Matisse worked on while his friend was there, it could not have been begun before late November 1912, when Camoin arrived in Tangier.

A family anecdote about Zorah also suggests a late second-trip date for this painting. According to one of Matisse's sons, during Amélie Matisse's second visit to Tangier she accompanied her husband to a brothel to search for Zorah, whom Matisse wished to paint again, and Mme Matisse's presence there created an uproar.[4] Since Matisse had already begun *Zorah debout* (cat. 16) before she arrived with Camoin in late November 1912, possibly she helped her husband find Zorah to paint *Sur la terrasse*.

Matisse may have painted this picture with the idea that it would become part of the Moroccan Triptych with *Paysage vu d'une fenêtre* (cat. 12) and *Porte de la Casbah* (cat. 14).[5] Unlike the window and the gate, which were painted on standard, French no. 50 landscape canvases, *Sur la terrasse* is an almost square, nonstandard size, the same height as the two wings but wider.[6] Although all three paintings are on commercially prepared canvas, the wings are the same weave and texture preprimed with white paint, while the canvas of *Sur la terrasse* is a different weave preprimed with yellow white.[7] Possibly the odd-size canvas for *Sur la terrasse* was cut specifically to hang between *Paysage vu d'une fenêtre* and *Porte de la Casbah*. If so, its larger size would have followed the tradition of multipaneled medieval and Renaissance religious painting, which gives prominence to the central panel. Zorah herself became larger as Matisse worked on the painting; an x-ray of the painting shows that she was originally about half her final size.[8]

Matisse referred to this painting as "a terrace" in his 19 April 1913 letter to Morosov rather than as a figure.[9] Perhaps this was because Matisse had promised Morosov landscapes and possibly a still life,[10] and *Sur la terrasse* was neither. Or perhaps he felt hesitant about admitting he had represented

Zorah, a prostitute, on the center panel of a triptych, a position where the Virgin appeared in some of the multi-paneled icons he saw when he visited Russia in November 1911.[11]

1. For more on goldfish, see cat. 18.
2. Rewald to Barr, 4 August 1950 (see cat. 12, note 1): "a very young girl whom M. had painted during his first trip to Morocco. When he returned there on his second trip he could not find her until he learned that she was in a public house. He got hold of her there, together with a Jewish friend of hers. She is seated here on the terrace in front of the bordello. The dark line at the top is the sky with contrasting light and shadow areas below."
3. "A Tanger, j'ai travaillé en même temps que lui d'après quelques prostituées dans leur intérieur. Matisse me disait, 'Attention, tu sais, il faut que nous allions là-dedans comme le médicin.'" Giraudy 1971, 12.
4. Told to Jack Cowart by the artist's son, Pierre Matisse.
5. However, in 1950 Matisse said the three paintings did not form a triptych, see cat. 12. About the commission from Morosov that resulted in the Moroccan Triptych, see Appendix 1. *Zorah assise* (cat. 10) may have been begun with the middle panel of the triptych in mind, to be replaced by *Sur la terrasse*.
6. While stretchers and frames were readily available in standard sizes, odd-size canvases required specially made stretchers and frames.
7. The results of the technical examination of these paintings at the Restoration Institute, Moscow, were made available to us by Marina Bessonova.
8. Matisse apparently worked on this picture in two stages. See note 7.
9. Moscow/Leningrad 1969, 129. For the complete text, see Appendix 1.
10. See Appendix 1 and cat. 4.
11. See Rusakov 1978.

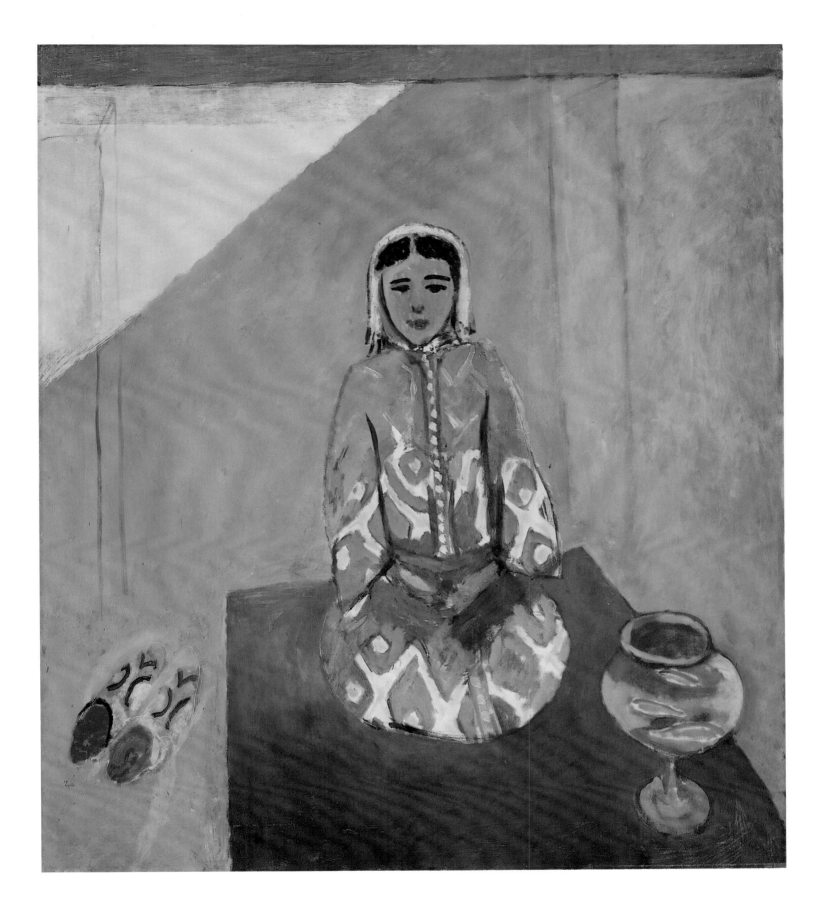

14

Porte de la Casbah, 1912/1913
(The Casbah Gate)
oil on canvas, 116 x 80 (45⅝ x 31½)
State Pushkin Museum of Fine Arts, Moscow

Porte de la Casbah, the right wing of the Moroccan Triptych, was probably painted on Matisse's second trip to Tangier. In a letter to Camoin around the end of October 1912, Matisse wrote that he was working on two landscapes that "were beginning to become serious."[1] All of the landscapes except this painting and *Fenêtre ouverte à Tanger* (cat. 22) were mentioned in Matisse's first-trip correspondence,[2] were sold by the summer of 1912,[3] or were ones the artist remembered painting on the first trip.[4] Although Matisse apparently worked on *Les acanthes* and *Paysage vu d'une fenêtre* on the first trip and brought them back to Tangier when he returned in the fall, it appears that the former was definitely finished and the latter was essentially, if not completely, finished on the first visit.[5] Therefore, the paintings mentioned in the autumn 1912 letter to Camoin are probably *Porte de la Casbah* and *Fenêtre ouverte à Tanger*.

The trellis covered with pink flowers seen through the gate may also help to date *Porte de la Casbah*. In mid-November 1912, Matisse wrote to his family describing a "petite merveille," a small Arab house with a wonderful trellis covered with morning glories, and enclosed a *croquis*.[6] This house, which is also depicted in a drawing by Morrice (fig. 65) and a painting by Camoin (fig. 136), appears in five known Matisse drawings probably dating from the second trip.[7] Also supporting a second-trip date for *Porte de la Casbah* is a label on the back of the painting that indicates the painting was shipped from Marseilles to Issy-les-Moulineaux in mid-February 1913, probably the second leg of its transport from Tangier to Issy.[8]

Porte de la Casbah features one of the best known gates in Tangier, the Bab el Aassa,[9] which cuts through the southern part of the wall surrounding the Casbah, the oldest and highest part of the city where the sultan had his fortified palace (see fig. 71). It provides access, as it did when Matisse was there, between the citadel and the medina, the rest of old Tangier. In the painting the viewer stands within the walls of the Casbah and looks through the gate down into the medina. Like the *Paysage vu d'une fenêtre*, this visually challenging subject allowed Matisse to be, imaginatively, inside and outside at the same time.

Matisse saved a postcard of the Bab el Aassa (see fig. 6), tinted pale rose, green, and blue, with the same view as the painting. The postcard reveals that the white circular form on the pink pathway of the painting was actually a stone, probably a millstone, embedded in the pavement before the gate. Also visible through the gate in the card and the painting is the Mosque of the Aïssaouas, with its leaning palm.[10]

An x-ray of *Porte de la Casbah* (see fig. 143) indicates that Matisse made significant changes in the composition of his picture.[11] Originally he included a standing figure on the right side of the painting, which corresponds loosely with the standing figure on the postcard. Matisse retained a shadowy human presence in the painting with the seated figure to the left, which appears in the x-ray to have been two figures. The final figure in the painting may relate to a reversed version of an unlocated drawing of a figure seated on a box, which was reproduced in Matisse's catalogue for his Paris 1913 exhibition at Bernheim-Jeune (see fig. 91). These seated figures are probably *bowaabs*, people who even today sit by the gates and observe those who pass through.[12]

1. Giraudy 1971, 13. For the complete text, see Appendix 1.
2. *Paysage vu d'une fenêtre* (cat. 12) and *Les pervenches (Jardin marocain)* (cat. 6).
3. *Vue sur la baie de Tanger* (cat. 2), *Les pervenches (Jardin marocain)* (cat. 6), and *La palme* (cat. 7). Archives Henri Matisse.
4. *Les acanthes* (cat. 5) and *Paysage vu d'une fenêtre* (cat. 12).
5. See cats. 5 and 12.
6. Archives Henri Matisse. Letter, c. 8–12 November 1912. See Appendix 1. For more about these drawings and a partial text of this letter, see Cowart essay in this volume, pp. 141–142.
7. Cats. 58, 59, 60, 61, and fig. 81. See Cowart essay in this volume, pp. 134–135, 141–142.
8. The label reads: "P. L. M. / P. V. / De Marseille-Arène à Issy les Moulineaux / Transit par: / 13/2 / Nombre / de colls 8." P. L. M. stands for the Paris-Lyon-Méditerrané train line. P. V. stands for "Petite Vitesse," slower service than "Grande Vitesse." 13/2 probably stands for the shipping date, 13 February. Since Matisse had only been in Tangier two weeks by 13 February 1912, it is unlikely that he would have been shipping paintings to Issy at this time. Rather, the date indicated is probably 13 February 1913, just before Matisse left Tangier after his second visit. Label information was made available by Marina Bessonova.
9. Flam 1986, 327. The Bab el Aassa, the "whipping gate," is sometimes referred to as the Porte de la Casbah, from which this painting takes its name. However, another gate, the Bab el Marchan, found at the end of a steep road that leads from the outskirts of the old city of Tangier into the northwest corner of the Casbah, is also known as the "porte de la Casbah" (see fig. 71). The Bab el Marchan appears in one of Matisse's drawings (fig. 72) and in a postcard Matisse sent Manguin (fig. 73).
10. Matisse saved a postcard of the mosque with the leaning palm (fig. 47). The mosque and the palm also appear in cat. 2.
11. The results of a technical examination of this painting at the Restoration Institute, Moscow, were made available to us by Marina Bessonova.
12. Sometimes paid and sometimes self-appointed, *bowaabs* provide a kind of community service by keeping track of what is happening in the city. Our thanks to Katie Ziglar, who kindly brought this to our attention.

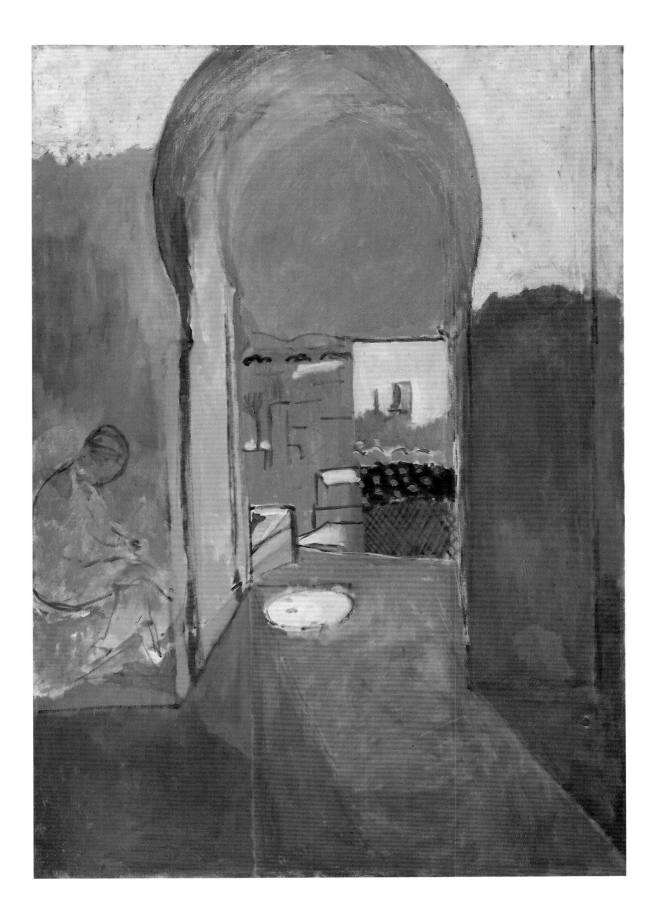

15

La mulâtresse Fatma, 1912
(Fatma, the Mulatto Woman)
oil on canvas, 146 x 61 (57½ x 24)
inscribed in 1916 by the artist: 1912
Private collection, Switzerland
Exhibited in Washington and New York only

Matisse wrote to his wife on 16 October 1912 that for Shchu-kin he had done "une mauresque" he thought wasn't bad.[1] The artist wrote on the 20th of that month that he had just finished the fourth session with "la négresse" and complained that the model was difficult.[2] Around the same time he wrote to Camoin that he was working on "une mauresque" as a pendant to the "marocain" he had painted the season before.[3] All three references are probably to *La mulâtresse Fatma*, since on his second trip Matisse apparently could not find his favorite model, Zorah, immediately.[4] Also, the reference to "la négresse" seems more appropriate to the painting of the mulatto woman than to the lighter-skinned Arab woman in *Zorah debout*. Taken together, these letters strongly suggest that Matisse initially considered *Fatma* as the pendant for *Amido* (cat. 8).[5]

Matisse included *croquis* (now lost) of both *Zorah debout* and *Fatma* with a letter to his family in early November.[6] He indicated that one of the paintings was destined to be the pendant to the "marocain" and the other for Bernheim,[7] but without the *croquis* it is not possible to tell which painting was intended for which buyer. In the end, Shchukin acquired *Zorah debout* as the pendant, and *La mulâtresse Fatma* was sold to Bernheim-Jeune on 20 March 1913. Josef Müller of Solothurn, Switzerland, bought it from him a few years later.[8]

With their unusual, identical formats, *Zorah debout*, *Amido*, and *Fatma* form a kind of triptych composed of full-length, single-figure paintings. However, Matisse never expected all three to hang together and, in fact, these paintings have never been shown together before now.[9]

In her pose, *Fatma* nearly mirrors *Amido*. Fatma stands more frontally except for her legs and feet, which are shown in profile like a figure in an ancient Egyptian wall painting. She leans informally on a table or box, and she appears merely to rest rather than to assume a pose for the artist.[10] Her expression is passive and difficult to read,[11] and it could be argued that the real subject of this painting is Fatma's exotic costume. On her head she wears a red *sebnia* with a transparent, pale blue-green veil (*herrez*). Her *caftan* of the same blue-green is scumbled with white and decorated with abstract white flowers and heavy purple and yellow embroidery. Around her hips she wears a broad, white *mdemma metrouza* trimmed with red, black, and blue stitching, and on her turned feet a pair of yellow *babouches*. Matisse set Fatma

against a background of the same color but darker than her *caftan*, and she appears to have emerged out of the ambiguous green-gray space around her. Schneider called Matisse's lithe Moroccan models "flowers translated into human terms."[12] Nowhere is that description more apt than in this vernal portrait.

1. Archives Henri Matisse. Letter, 16 October 1912. See also Appendix 1.
2. Archives Henri Matisse. Letter, 20 October 1912. See also Appendix 1.
3. Matisse to Camoin, around the end of October 1912. Giraudy 1971, 13. For the complete text of this letter, see Appendix 1.
4. See cat. 16. See also Elderfield essay in this volume, p. 223, and Flam 1986, 349.
5. It is not known when Shchukin requested a pendant to Amido.
6. Archives Henri Matisse. Letter, c. 8–12 November 1912. See Appendix 1.
7. See note 6.
8. Archives Henri Matisse.
9. *Amido* was not included in the April 1913 exhibition of Moroccan paintings and drawings at Bernheim-Jeune. *Zorah* and *Fatma* were hung on either side of *Le rifain debout* (fig. 1). For a discussion of how the paintings of this period appear to fall in groups of three, see in this volume Schneider, pp. 41–43, and Appendix 2.
10. Schneider 1984b, 467.
11. Schneider wrote of the Moroccan portraits: "The passive contemplation they are absorbed in borders less on a state of inner blankness in a Western sense (where only fullness and action have any positive value) than on the invigorating emptiness which is the supreme reward of inner activity in Eastern civilizations." Schneider 1984b, 467.
12. Schneider 1984b, 467, and also Schneider essay in this volume, pp. 37–40, 48–50.

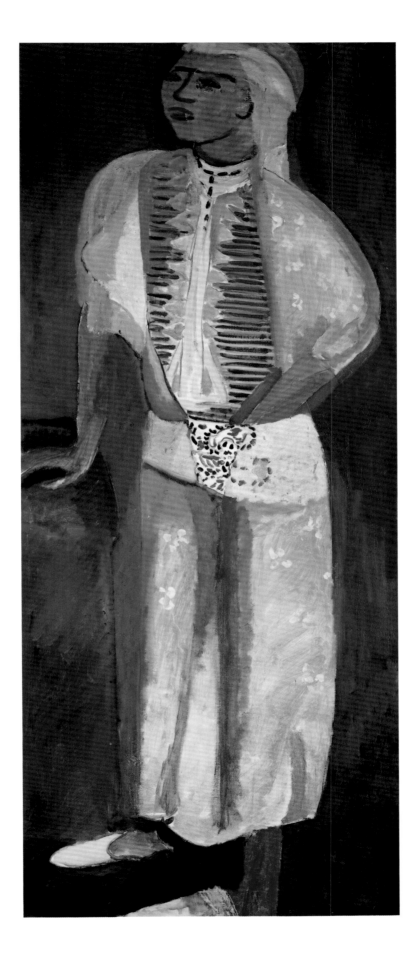

16

Zorah debout, 1912
(Zorah Standing)
oil on canvas, 146 x 61 (57½ x 24)
The State Hermitage Museum, Leningrad

Matisse apparently had difficulty finding Zorah when he first returned to Tangier in the fall of 1912,[1] but he was successful by early November, since he sent a sketch of this painting to his family around the middle of that month.[2] That autumn the artist intended to paint a pendant for *Amido* (cat. 8), which Shchukin had acquired by 22 August 1912.[3] Matisse appears to have considered *La mulâtresse Fatma* (cat. 15) to go with *Amido*,[4] but in the end Shchukin purchased *Zorah debout* as the pendant.[5]

Zorah debout and *Amido* are the same size, and each depicts a full-length, standing Moroccan figure in traditional dress. Beyond these similarities, however, the artist created variations in mood, coloring, and handling of paint. *Amido* is turned toward a window in a relaxed, graceful, three-quarter pose. The thin layers of scumbled paint over delicate underdrawing add to the casual nature of this portrait. *Zorah debout*, on the other hand, faces the viewer directly and stares intently with large, almond-shaped black eyes. She is as strident and strong as the intense colors the artist used for her portrait.

Matisse depicted *Zorah debout* standing on an orange floor in front of a background of ripe raspberry tinted with orange. She leans slightly to the left, balanced by yellow slippers that point to the right. She wears a densely painted emerald green *caftan*, enlivened along the seams with black and white embroidered trim. On her head she wears a traditional multicolored *sebnia*, which frames and accentuates her heart-shaped face. The soft ''V'' of her chin is repeated down through her figure, in her embroidered collar, her orange *mejdoul* (belt), her simply rendered arms and clasped hands, and the embroidered hem of her *caftan*. This shape is echoed as well in the contours formed by the edges of her wide sleeves.

Zorah debout has been compared to works as disparate as Hans Holbein's *Christina of Denmark* (The National Gallery, London)[6] and Persian minatures.[7] But Matisse may have been influenced more directly by the standing, single-figure, nearly life-size fresco icons he admired when he visited the Kremlin churches in the autumn of 1911.[8] These hieratic figures are painted in colors that saturate the white plaster surface. The Russian religious frescoes and panels impressed Matisse deeply, and they were certainly on his mind as late as January 1913 when Shchukin asked him, on behalf of the great collector of icons Ilya Ostroukhov,[9] to write up his impressions of the images of saints he had seen in Russia for the magazine *Sofia*.[10]

1. See cat. 13, note 2. Alfred Barr dated *Zorah debout* to the first trip citing Questionnaire v. However, examination of the materials that appear to have comprised Questionnaire v reveals no mention of this fact.
2. Archives Henri Matisse. Letter, c. 8–12 October 1912. See Appendix 1.
3. See Appendix 1.
4. See cat. 15.
5. Exactly when is not certain, but it was surely by April 1913 when it appeared in the exhibition catalogue for the Bernheim-Jeune exhibition as belonging to Shchukin.
6. Barr 1951, 155.
7. Kostenevich in Barcelona 1988, 198. Matisse went to Munich in the fall of 1910 to see a large exhibition of Islamic art.
8. For information about this trip, see Rusakov 1975. It appears that Matisse sent this painting, Shchukin's still lifes (cats. 20, 21), and *Le rifain debout* (cat. 18) with Morosov's Moroccan Triptych (cats. 12, 13, 14) to an exhibition at Gurlitt Gallery in Berlin immediately following their exhibition at Galerie Bernheim-Jeune in Paris in April 1913. In a review of the Berlin exhibition, the writer noted that Matisse had recently visited Russia and compared his Moroccan paintings to Russian icons. Kunstchronik 1913, 482.
9. Ilya Ostroukhov wrote to Alexandra Botkina on 5 November 1911 that Matisse was extremely impressed with the icons and said they were worth a trip from a city even farther than Paris. Ostroukhov was one of the first to collect ancient Russian painting. By 1910, his collection was one of the best, if not the best, in Russia. Ostroukhov was a trustee of the Tretyakov Gallery, a collector, artist, and important man in the arts in Moscow at the beginning of the century. He had made Matisse's acquaintance quite some time before the artist visited Russia in October 1911 and acted as one of his guides in Moscow. Rusakov 1975, 285.
10. Archives Henri Matisse. Letter, Shchukin to Matisse, 10 January 1913.

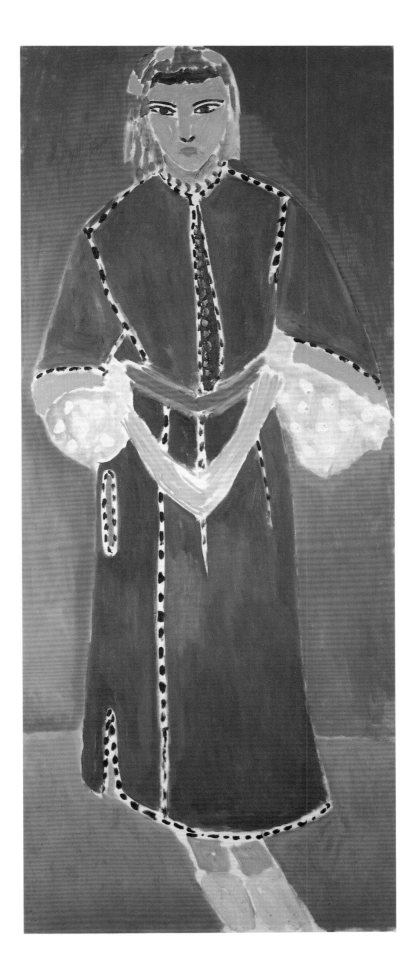

17

La petite mulâtresse, 1912
(The Small Mulatto Woman)
oil on canvas, 35 x 27 (13³/4 x 10⁵/8)
signed u.r. in blue: *Henri-Matisse*
Musée de Grenoble (Legs Agutte-Sembat)

Matisse wrote his family in mid-November 1912 that the Sembats had commissioned a *mauresque* from him on a small no. 5 canvas,[1] which is certainly *La petite mulâtresse*. With that letter the artist sent a sketch, and said the painting was not yet finished. Around this time he was also working on *La mulâtresse Fatma* (cat. 15), and the model is the same for both paintings.[2]

The smallest of Matisse's Moroccan figure paintings, the brilliantly detailed *La petite mulâtresse* glows with rich color. The young Moroccan woman sits cross-legged in a deep blue niche,[3] placed rather high up on the canvas, like a precious object on a shelf.[4] This simple background serves as a foil for her intricate and colorful costume. She wears mostly deep pink and white, from the *harraz* on her head, through her elaborately embroidered *dfina* (blouse), to her pink *séroual* (pants) touched with green. Down the front of her *dfina* she sports a black and yellow *sfifa* trimmed with green, and her waist is cinched with a red and tan *mdemma* decorated with black arabesques. Fourcade aptly compared this painting to a decorative porcelain tile, whose elements remain extraorinarily distinct and at the same time organize the surface to provide a vigorous and expressive effect overall.[5]

1. Archives Henri Matisse. Letter, c. 8–12 November 1912. See also Appendix 1. A standard French no. 5 figure canvas measures 35 x 27 cm.
 The artist made a point of mentioning the size of the painting because under his 18 September 1912 contract with Bernheim-Jeune he was not obligated to sell paintings smaller than no. 6 figure (41 x 33 cm) or larger than no. 50 figure (116 x 89) through his gallery. Nor did he owe Bernheim-Jeune fifty percent of the profit if he sold these smaller or larger paintings directly. Our thanks to Mme Wanda de Guébriant, Archives Henri Matisse, for reminding us of this. Matisse's contracts between 1909 and 1926 are printed in Barr 1951, Appendix C, 553–555.
2. Archives Henri Matisse. Letter, c. 8–12 November 1912. Matisse wrote to his family that with his letter were three *croquis* (now lost) of two *mauresques*, giving the sizes of the paintings as 150 cm for two and 30 x 27 cm for the third. The two large paintings are *Zorah debout* and *La mulâtresse Fatma*, and the small painting, which Matisse indicated was for Sembat, is *La petite mulâtresse*. Since Matisse wrote that the three sketches were of two *mauresques*, one model had to be used twice, and the model for *La mulâtresse Fatma* and *La petite mulâtresse* appears to be the same woman. Further, the catalogue for the 1913 exhibition at Bernheim-Jeune lists the same title—*La mulâtresse Fatma*—for both pictures.
3. The wall behind her may be covered in the dark, patterned cloth that appears draped over a trunk in the background of a photograph of Henri and Amélie Matisse in Tangier (fig. 137).
4. Matisse drew a similarly posed and proportioned male Moroccan that may have been an idea for a pendant to *La petite mulâtresse*. See Cowart essay and cat. 45.
5. Fourcade 1975, 20.

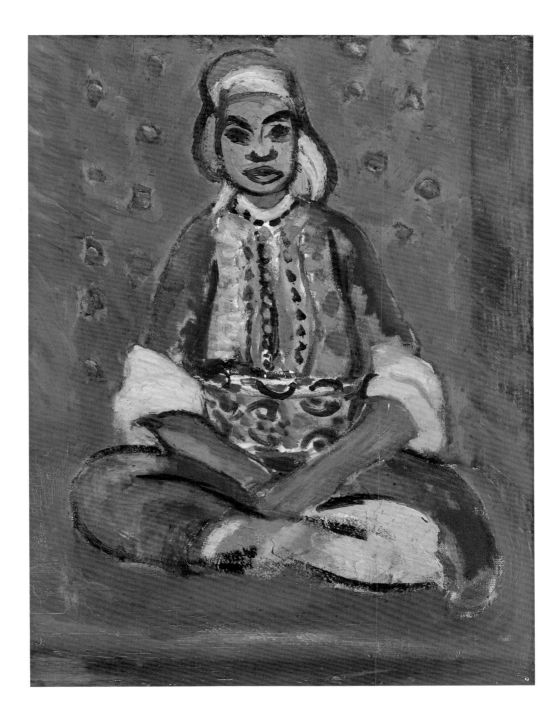

18

Le rifain debout, 1912

(The Standing Riffian)

oil on canvas, 146.5 x 97.7 (57⅝ x 38½)

Signed on reverse: *Henri-Matisse. Hotel de France. Tanger.*

The State Hermitage Museum, Leningrad

Matisse wrote to his family in early November 1912 that as soon as he finished the picture he was working on (presumably cat. 17), he would paint a young Moroccan from the Rif,[1] and he started *Le rifain debout* later that month.[2] The Riffians enjoyed an awesome reputation as fighters, and they were famous for their independence and their practice of kidnapping visitors and foreign residents of Morocco.[3] They also captured the European imagination and commanded a respect and admiration that is evident in Matisse's powerful portraits. For his review of Matisse's April 1913 exhibition of Moroccan paintings at Galerie Bernheim-Jeune, Marcel Sembat wrote the following about the man portrayed in *Le rifain debout* and *Le rifain assis* (cat. 19):[4] "And the Riffian! Isn't he marvelous, this great devil of a Riffian, with his angular face and his ferocious build?

"How can you look at this splendid barbarian without thinking of the warriors of days gone by? Such a fierce expression—just like that of the Moors of *The Song of Roland*![5]"

The Moroccan stands with regal bearing against a background of loosely brushed areas of blue, perhaps the sky, and scumbled blue and green, which split the painting lengthwise. His head, wrapped in a yellow and green *rezza*, is slightly cocked and turned to the right. His brown eyes crowned by thin brows; his broad nose and full lips are as finely rendered in the painting as they are in a related pen and ink study (cat. 46); but the gentle, almost whimsical expression in the sketch is transformed in the painting to a hard stare. Beneath a green beard and stubbled chin, he wears a pale *tchamir* with an ornamented green collar. A yellow pouch strap over his chest emphasizes the diagonal across the Moroccan's face, and ends at the top of the magenta, yellow, and blue silk tufts that run down the middle of the green wool *djellaba*.

The artist may have painted *Le rifain debout* as a pendant to Shchukin's *Poissons rouges* (fig. 108).[6] This may seem a somewhat peculiar pairing, but a connection between the two subjects does exist. Matisse probably painted Shchukin's *Les poissons rouges* in the summer of 1912 between his trips to Tangier.[7] He had painted this theme before, but since goldfish bowls were common in Morocco,[8] the *poissons rouges* theme was reinforced by his visit to Tangier. *Poissons rouges* is arguably a kind of souvenir as well as a continuation of the goldfish series and therefore a reasonable complement to *Le rifain debout*, which Shchukin acquired by April 1913.[9]

1. Archives Henri Matisse. Letter, c. 8–12 November 1912. See Appendix 1.
2. Archives Henri Matisse. Letter, 21 November 1912. Matisse wrote to his family that he had started that day a painting of a Riffian the same dimensions as Shchukin's goldfish. The goldfish picture is *Les poissons rouges* (fig. 108), and measures 146 x 97 cm, the same as *Le rifain debout*.
 Le rifain debout is partially visible in the left background of a photograph of Henri and Amélie Matisse (fig. 137). Although the photograph is not dated, it could not have been taken before Madame Matisse joined her husband in Tangier in late November 1912. The photograph remains in the Archives Charles Camoin and may have been taken by Camoin while he was in Tangier with Henri and Amélie Matisse between late November 1912 and mid-February 1913 when the Matisses left.
 Daniéle Giraudy suggested that this photograph was taken on Henri and Amélie Matisse's wedding trip in Corsica. Giraudy 1971, 9. This is incorrect because the Moroccan paintings in the background were painted several years after they married. Henri and Amélie Matisse did travel to Corsica immediately after leaving Tangier in mid-February 1913. However, it seems unlikely that Matisse would have taken his Moroccan paintings with him to Corsica instead of shipping them directly to Paris.
3. In 1908 Henry Collins Walsh wrote: "There are the Rif tribes . . . among whom Raisuli, the bandit, is a prominent leader. These people are a law unto themselves and have never acknowledged the sway of the Sultan The Rif people are quite given to capturing travelers or foreign residents in Morocco and demanding ransoms for the same, ransoms which are generally paid by the Sultan through foreign pressure, and several cases of this kind have occurred . . . notably the holding and ransom of Sir Harry McLean." "The Rifs in Morocco," *The Travel Magazine* (November 1908), 66.
 Sir Harry McLean, a Scot, a knight of Saint Michael and Saint George, and military instructor for the Shareefian army, was held by the famous Si Hamed ben Mohamed el Raisuli. Raisuli also kidnapped Walter Harris, correspondent for the London *Times* in Morocco, and Ion Perdicaris, an American millionaire and friend of the then-United States consul at Tangier. George E. Holt, "Visiting Raisuli, The Moroccan Bandit," *Travel* 22 (December 1913), 16.
4. Matisse also drew his portrait three times. See cats. 46, 47, 48 and Cowart essay in this volume.
5. Sembat 1913, 194. "Et le Riffain [sic], est-il beau, le grand diable de Riffain, avec sa face anguleuse et sa carrure fiéroce!
 "Pouvez-vous regarder ce barbare splendide sans songer aux guerriers d'autrefois? Les Maures de la *Chanson de Roland* avaient cette farouche mine!"
6. See note 2. Shchukin had requested a pendant to his fish in a letter of 22 August 1912, and he acquired three paintings of the same dimensions as *Les poissons rouges* that could be considered as possible pendants: *Le rifain debout*, *Arums* (cat. 20), and *Arums, iris et mimosas* (cat. 21). See Appendix 1.
7. The dating of the six goldfish paintings is problematic. See Elderfield 1978, 84–86, 100–102, 197–198, 204–205. For Shchukin's *Poissons rouges*, Elderfield proposed a date of summer 1912. New York 1978, 198. For a thorough discussion of goldfish as a motif in Matisse's work, see also Reff 1976, 109–115 and Schneider 1984b, 419–421.
8. Particularly in homes until the 1930s. Moroccans contemplating goldfish impressed the artist, and he depicted them together in the greatest of his paintings of this period, *Café marocain* (cat. 23).
9. The catalogue for the 1913 exhibition at Galerie Bernheim-Jeune lists *Le rifain debout* as belonging to Shchukin.

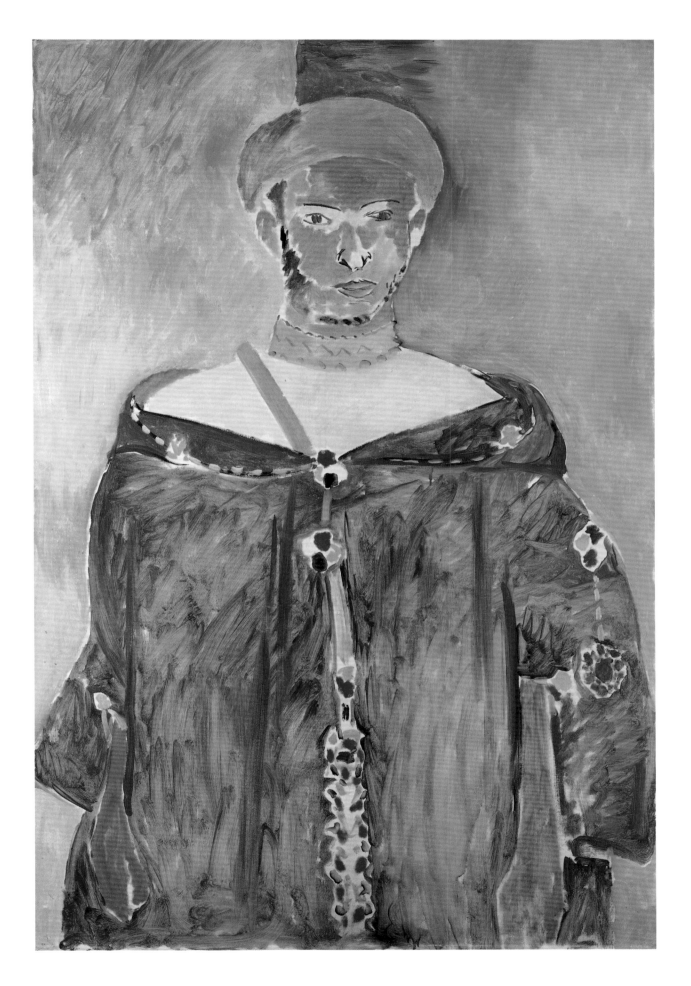

19

Le rifain assis, 1912/1913

(The Seated Riffian)

oil on canvas, 200 x 159.4 (78³/₄ x 62³/₄)

signed l.l. in deep red-pink: *Henri-Matisse*

The Barnes Foundation, Merion, Pennsylvania[1]

not in exhibition

Probably around the time that he painted *Le rifain debout* (cat. 18), Matisse portrayed the same imposing Moroccan man in *Le rifain assis*,[2] but used a more complex arrangement of rhyming forms and colors and a larger format. Of the paintings executed in Morocco, this painting is second in size only to *Café marocain* (cat. 23). The artist painted *Le rifain assis* with bravura, making only slight changes once he laid the thin veils of intense matte red, blue, green, and mustard. Little underdrawing is apparent, and only around the left knee is there evidence of repainting.

For the figure, Matisse used a color scheme similar to the one he had employed for *Le rifain debout*. Dressed in the same hooded green wool *djellaba* decorated with blue, red, and yellow tufts, the Moroccan sits squarely on a mustard-colored box with the tip of one toe in a *belgha* (slipper) of the same color touching the bottom of the canvas, and his head, wrapped in an orange and green *rezza*, grazing the top. His proud face is made up of patches of orange, yellow, and green much like those of *Le rifain debout*. Over these patches the artist drew intense eyes in very dark gray-green and a full mouth in pink. Strong V and Y shapes accent his blocky figure, for example where the mustard-colored strap over the Moroccan's chest meets the edge of his green cloak, where the edges of the hood meet the tufted opening of the *djellaba*, and where the reddish-orange hands clasp in front of his body.

The corner in which the Moroccan sits divides the background into three zones of complementary colors. In the upper left zone, a striped light orange and green floor-to-ceiling curtain borders a window on a yellow wall open to a scumbled light blue sky. To the right, directly behind the Moroccan's head and shoulders, the yellow wall extends from the corner to meet a second long orange and green striped curtain that runs along the right edge of the canvas. The lower zone, the floor of the room, is a great agitated area of raspberry, which contrasts vividly with the Moroccan's dark orange legs, the mustard yellow box on which he sits, and the *belgha* on the Moroccan's feet.

Le rifain assis as well as *Café maroccan* were for sale at Matisse's April 1913 exhibition of Moroccan paintings, and he offered them unsuccessfully to Morosov.[3] The great Danish collector of modern art, Christian Tetzen-Lund, acquired *Le rifain assis* sometime before 1920.[4] Albert Barnes purchased the painting when the Tetzen-Lund collection was dissolved around 1924,[5] and today it is permanently on view at the Barnes Foundation in Merion, Pennsylvania.

1. The Barnes Foundation does not lend objects in its collection, nor does it allow them to be published in color.
2. Matisse wrote to his family in November 1912 that he planned to begin a painting of a young man from the Rif, and started *Le rifain debout* later that month. See cat. 18. *Le rifain assis* is not mentioned in any of the known correspondence, but given its similarity in subject, coloring, and handling, it must have been painted around the same time as *Le rifain debout*. The Barnes picture was finished in time for the April 1913 exhibition of Matisse's Moroccan paintings and drawings at Galerie Bernheim-Jeune.
3. Matisse to Morosov, 19 April 1913, Moscow/Leningrad 1969, 130. For the complete text of this letter, see Appendix 1.
4. Tetzen-Lund was a corn merchant and businessman who purchased the work not only of Matisse, but also André Derain, Pablo Picasso, and Henri Rousseau, between 1916 and 1920. Margrit Hahnloser-Ingold in Washington 1986a, 264.
5. Hahnloser-Ingold in Washington 1986a, 264.

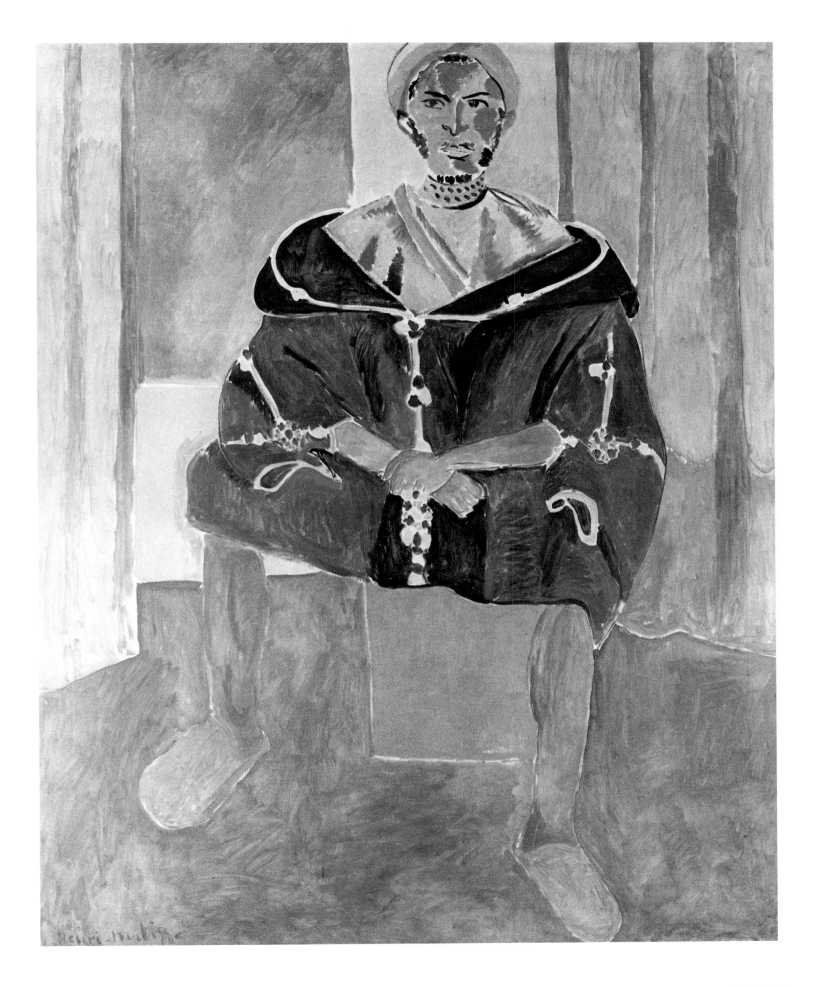

20

Arums, 1912/1913
(Calla Lilies)
oil on canvas, 146 x 97 (57½ x 38¼)
The State Hermitage Museum, Leningrad

It is not known whether Matisse painted *Arums* on his first trip to Morocco or his second. Observations can be made supporting a date on either trip.

Vegetation—including native flowers, tropical fruits, dense trees, and creeping vines—was an especially important theme of Matisse's early experience in Morocco. Matisse particularly admired the magnificent flowers he discovered growing in great profusion in Tangier,[1] and of the three floral still lifes, *Arums* best conjures up the city's light-filled, luxuriant atmosphere. The artist freely rendered the loosely arranged long-stemmed lilies in a warm, high-key palette, and his draftsmanship is more evident in this painting than in any other of the Moroccan period.[2] He drew the outlines of the conical blossoms for this great fan of lilies in slate gray paint to give them shape, and left the bright white primed canvas, touched with gray and green, to give them color. The elongated, heart-shaped leaves are also outlined and filled in with various shades of green, slate, and pale blue. To the right of the bouquet the artist drew a curtain with gray scallops over the same blue, and through the window against a blue sky he painted a landscape of quickly brushed gray trees that echo the shape of the right half of the bouquet.

The room with the curtained window in which *Arums* was painted may be the same room in which Matisse painted *Amido* (cat. 8). If in *Arums* Matisse depicted the landscape he actually saw through the window, the still life could not have been painted in the artist's room at the Hôtel Villa de France. That room had a panorama above the city of Tangier rather than this level, wooded view. On his first trip Matisse had at least limited access to a studio, which he mentioned in an early April 1912 letter saying that the proprietor of the Villa de France allowed him to work in another artist's atelier;[3] possibly *Amido* and *Arums* were both painted in this place.

The room may also be where Matisse painted *Corbeille d'oranges*. According to a note made by Mme Amélie Matisse after 1944, both *Arums* and *Corbeille d'oranges* were painted on the same nightstand.[4] This would suggest that *Arums*, *Amido*, and *Corbeille d'oranges* were all painted in the same place, not Matisse's hotel room, but probably another room with a bed. Possibly the atelier Matisse referred to in his April 1912 letter was another hotel room in the Villa de France used as a studio, which might explain why Matisse needed the permission of the proprietor of the hotel to work there.

Elderfield proposes *Arums* as an *esquisse* for second trip *Arums, iris et mimosas*, a much more finished painting which may have been intended for, and was certainly sold to, Shchukin, his most discriminating patron.[5] This does not explain why Shchukin would acquire both the painting and its *esquisse*. Still, by their subject and identical size, *Arums* and *Arums, iris et mimosas* are clearly related, so much so that the inscribed date of 1913 on *Arums, iris et mimosas* might apply to, or at least suggest, second-trip dates for both.

1. Courthion 1941, 102–103.
2. Except for *Zorah assise* (cat. 10), which is more properly considered a hybrid oil drawing on canvas rather than a painting.
3. Archives Henri Matisse. Letter, Monday [1] April 1912. This atelier has not been located.
4. With the records kept on *Arums*, Mme Matisse wrote: ". . . sur la même table de nuit a été peint nature morte *Corbeille d'oranges* de Picasso." Archives Henri Matisse. Although it is not certain when this note was made, it must have been after 1944 when Picasso acquired the painting.
5. See Elderfield essay in this volume, p. 218, and cat. 21.

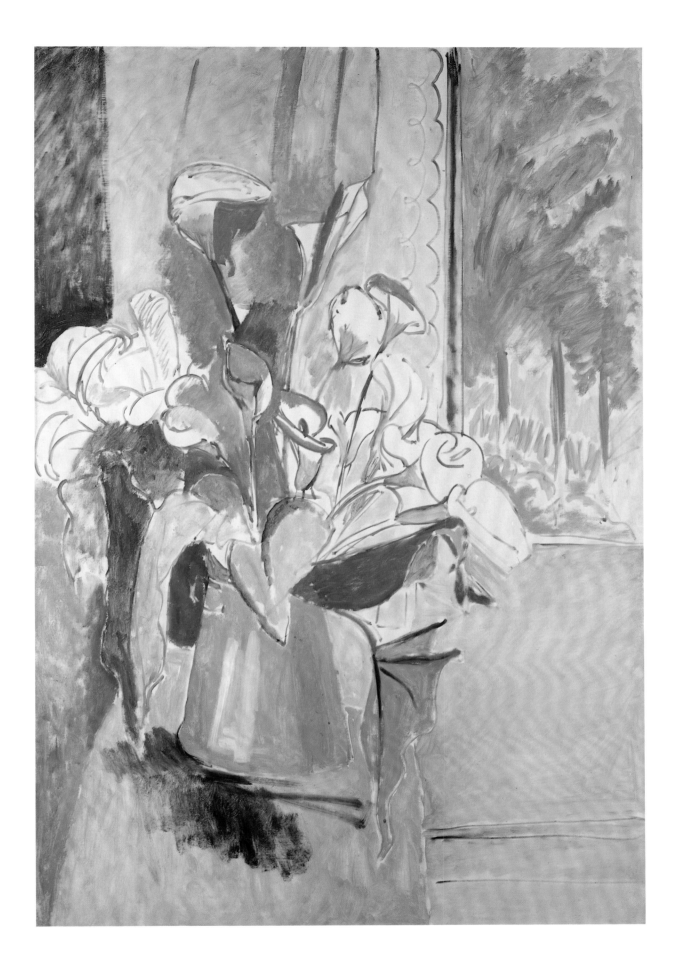

21

Arums, iris et mimosas, 1913
(Calla Lilies, Irises, and Mimosas)
oil on canvas, 145.5 x 97 (57¼ x 38¼)
signed and dated l.l. in green: *Henri Matisse Tanger 1913*
State Pushkin Museum of Fine Arts, Moscow

Matisse was extremely impressed by the flowers he saw in Morocco. One of his first paintings in there was a still life of flowers, *Le vase d'iris* (cat. 1), and this painting, also of flowers, is one of his last. He treated the irises against a dark background similarly in both paintings, and gave the lilies, though more densely painted, the same graceful curves as his other Moroccan floral painting, *Arums* (cat. 20).

The same-size *Arums* might be an *esquisse* for *Arums, iris et mimosas*.[1] The fanning bunch of lilies in *Arums*, which forms a triangular bouquet with a notable diagonal sweep from the top to the right, is placed to the left of center and is complemented by a window. In *Arums, iris et mimosas*, the flowers are more varied, moved to the center, and form a strong "V" shape, accentuated by the long lily leaf that hangs down from the vase. The background has also changed completely, from a window on a yellow wall to a busy patchwork of stripes, patterns, and solids. It may, however, be the same room in which *Arums* and *Corbeille d'oranges* (cat. 4) were painted. Mme Matisse noted that the same nightstand can be seen in both still lifes, implying that the calla lilies and oranges were painted in the same room.[2] The arrangement in *Arums, iris and mimosas* is also supported by a similar boxlike stand. The purple-striped curtain or wallpaper that appears in both *Arums, iris et mimosas* and *Corbeille d'oranges* also suggests they were painted in the same room.[3]

In August 1912, Shchukin reminded Matisse that he wanted a pendant to his *Les poissons rouge* (State Pushkin Museum of Fine Arts, Moscow).[4] *Arums, iris et mimosas* is the same size as the goldfish painting and may have been painted to accompany it.[5] Whether or not Shchukin commissioned the flower still life, he had acquired it by the time it was shown at Bernheim-Jeune in April 1913, for it is listed in the exhibition catalogue as belonging to him (see chronology). From Paris the painting was shipped with Morosov's Moroccan Triptych and probably Shchukin's other paintings[6] to a Matisse exhibition in Berlin at the Kunstsalon Fritz Gurlitt, a show that was on view at the same time as the *XXVI Berliner Secession*. One reviewer wrote: "Matisse's working method—dissecting and simplifying select segments into highly luminescent fields of pure local color, strictly avoiding all brownish and blackish shadows and modeling, and, almost like antique mosaics, vigorously adhering to this representation of reality, which has been completely transformed into the painterly, to the flat surface—can be superbly studied in these examples. Similarly in this marvelous new still life of calla lilies, irises, and mimosas seen through curtains of various colors, somewhat contrived, but chosen with delicacy, [is] a work of extraordinary quality."[7]

1. See cat. 20 and Elderfield essay in this volume, p. 218.
2. See cat. 20.
3. See Elderfield essay in this volume, p. 215.
4. Shchukin to Matisse, 22 August 1912, Barr 1951, 555, corrected in Kean 1983, 298–299. For the complete text, see Appendix 1. About Shchukin's requests, see Appendix 1.
5. Other possibilities are *Arums* and *Le rifain debout*. About how Shchukin's paintings may be considered in groups of three, see Appendix 2.
6. *Arums* (cat. 21), *Zorah debout* (cat. 16), and *Le rifain debout* (cat. 18).
7. Kunstchronik 1913, 482. Translated by Ulrike Mills. "Das Matissesche Prinzip der Zerlegung und Vereinfachung gewählter Ausschnitte in stark leuchtende Felder reiner Lokalfarben, die alle bräunlichen und schwärzlichen Schatten und Modellierungen strikt vermeiden und fast im Sinne alter Mosaiken das völlig ins Malerische umgesetzte Wirklichkeitsbild streng an die Fläche halten, lässt sich an diesen Beispielen vortrefflich studieren. Ähnlich an diesem wundervollen neuen Stilleben aus Callablüten, Iris und Mimosen zwischen verschiedenfarbigen, etwas ausgeklügelt, aber delikat gewählten Vorhängen, einem Werke von ausserordentlicher Qualität. . . ."

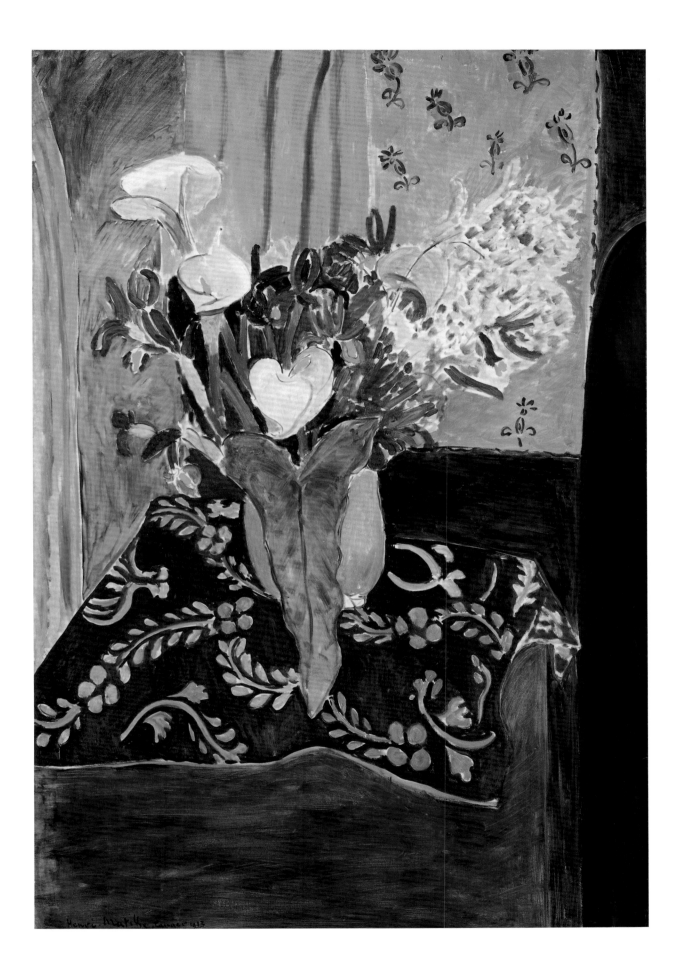

22

Fenêtre ouverte à Tanger, 1912/1913
(Open Window at Tangier)
oil on canvas, 145 x 94 (57$\frac{1}{8}$ x 37)
Private collection
Exhibited in Washington and New York only

Fenêtre ouverte à Tanger was most probably painted during Matisse's second visit to Tangier. Arguably it is one of two landscapes "that are beginning to become serious" Matisse mentioned in a letter to Camoin around the end of October 1912,[1] since the only landscapes that do not date to the first trip are _Porte de la Casbah_ (cat. 14) and _Fenêtre ouverte à Tanger_.[2]

Fenêtre ouverte à Tanger and _Paysage vu d'une fenêtre_ invite comparison because they depict views from the Hôtel Villa de France, probably from the same window. Matisse frequently executed two paintings on the same or very similar motifs, a practice that began very early in his career and includes a number of important paintings surrounding the Moroccan period.[3] As with his other pairs, Matisse altered the composition, color, and density of the paint between the two versions creating independent works not intended to be shown or sold together.[4] In _Fenêtre ouverte à Tanger_, all reference to the curtained window so apparent in _Paysage vu d'une fenêtre_ disappears; the viewpoint shifts to the right; the landscape becomes hazy; Saint Andrew's Church, the central focus of the artist's other view, is diminished and dematerialized; and color changes from a dense application of mostly deep blue to a rainbow of watercolorlike veils. The presumably later _Fenêtre ouverte à Tanger_ is also more abstract and subjectively colored than the other view, and incorporates a different and broader expanse.[5] Its yellower tonality may have been influenced by the changed, parched landscape Matisse observed when he returned to Morocco in the autumn of 1912.[6]

Matisse changed the composition of _Fenêtre ouverte à Tanger_ as he worked on the picture. He outlined the basic elements of the painting in thin gray-brown paint, and then vigorously scrubbed on color in broad horizontal zones. In certain areas he covered his initial drawing, including a large vase of flowers orginially sketched between the two bouquets on the left. Matisse's evident energetic application of paint is emphasized by the drips of paint spattered across picture's surface.

1. ". . . Ensuite deux paysages qui commencent a devenir sérieux, jusqu'ici ils n'étaient que badinage agréable. . . ." Giraudy 1971, 13. See Appendix 1 for the complete text of this letter.
2. See cat. 14.
3. For example: _Marin I_ and _Marin II_ (both, private collections), 1906; _Le Luxe I_ (Musée National d'Art Moderne, Paris) and _Le Luxe II_ (Statens Museum for Kunst, Copenhagen), 1907; _Capucines et "La danse"_ (State Pushkin Museum of Fine Arts, Moscow) and _Capucines et "La danse"_ (The Metropolitan Museum of Art, New York), 1912; and _Vue de Notre Dame_ (Kunstmuseum, Solothurn, Switzerland) and _Vue de Notre Dame_ (The Museum of Modern Art, New York), 1914. See also Elderfield essay in this volume, pp. 218–220.
4. Note Schneider's discussion in this volume of this picture as one of the "epic triptych" pictures, p. 42.
5. This view is similar to one Camoin and Morrice (figs. 126, 134) painted.
6. "L'année suivante, je suis reparti du Maroc . . . j'ai trouvé un Maroc que je ne connaissais pas, c'est-à-dire tout jaune, la terre tout en couleur peau de lion, l'herbe était burlée par l'été. . . . " Courthion 1941, 102.

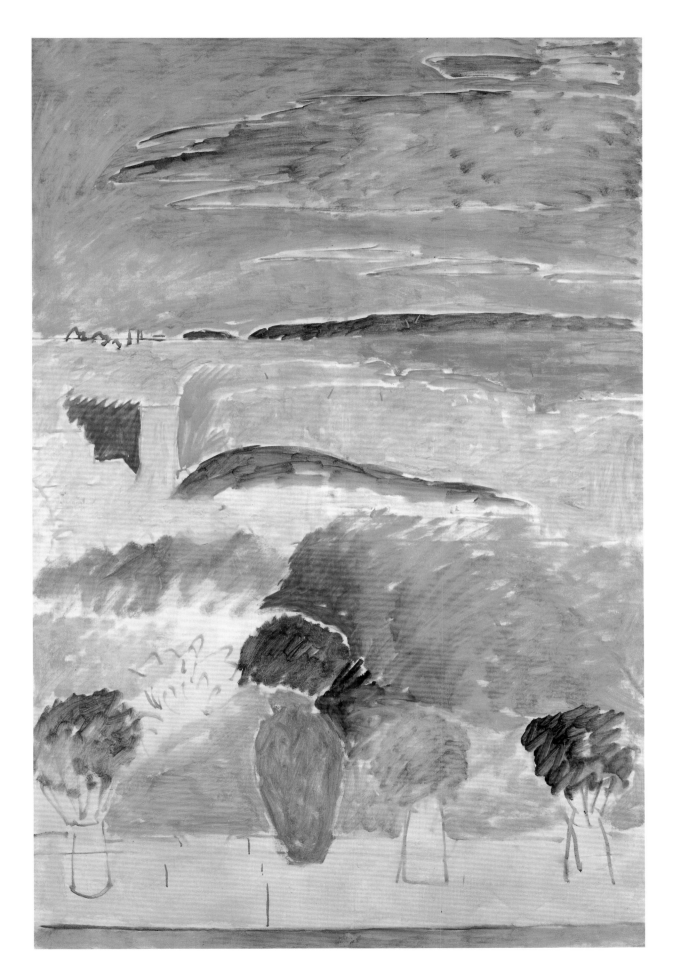

23

Café marocain[1], 1912/1913

(Moroccan Café)

distemper on canvas, 176 × 210 (69¼ x 82⅝)

The State Hermitage Museum, Leningrad

Exhibited only in Leningrad[2]

Matisse painted *Café marocain* during his second trip to Morocco.[3] In this, the largest, most abstract, and most contemplative picture he completed there, the artist distilled several of the themes he had explored during his two sojourns.[4]

With the simplest of means, the artist suffused this dreamlike painting with a melting calm. The flat, blank-faced figures,[5] in unmodulated turbans and cloaks of white and gray, appear to be paper-thin and pasted onto a tranquil field of gray green.[6] In the foreground, contemplating a bowl of red-orange fish[7] and a small vase of flowers, a figure reclines, resting on a crooked arm. Beside him another figure sits, his knees drawn up to his chest. The pentimenti of an earlier rendition of his figure surround him; across the bottom of the painting as well, a ghostly frieze of slippers the artist painted over remains barely visible. Four more figures, simple composites of flat curved gray, white, and ocher shapes, sit in the background, one holding a stringed instrument in his lap. Behind this group runs a black arcade of slender columns, crowned with keyhole arches whose openings narrow from left to right.[8] A decorative peach-colored border surrounds the painting, flattening the image further and adding to the collagelike effect,[9] and the large yellow-ocher dots in the border echo the curvilinear shapes of the figures and the archways.

The artist painted *Café marocain* in distemper,[10] a quick-drying, opaque medium that dries to a smooth, matte finish. He rarely used this water-based paint for other pictures, though notable exceptions are the matte *Le Luxe II*, 1907 (Statens Museum for Kunst, Copenhagen) and *Intérieur aux aubergines*, 1911 (see fig. 20), which shares the dry, frescolike surface of *Café marocain* as well as its stagelike setting and decorative border.[11] But while *Intérieur aux aubergines* vibrates with intensely colored patterns, *Café marocain* remains ethereal and serene.

Several recently discovered drawings relate to *Café marocain*.[12] Three (cat. 41, figs. 79, 80) show the interior of a café. *Café maure* (cat. 41) includes a group of singing and playing musicians akin to the musical ensemble in the painting. Compared to this drawing, *Café I* and *II* (figs. 79, 80) are much more loosely rendered and enigmatic, but still clearly related to *Café maroccain*. They both include a horizontal, sacklike figure to the left, which appears with a more convincing anatomy as the reclining figure near the center of the painting. The isolated figure in the left-hand corner of the painting relates not only to the seated figure in the upper left of the

more finely rendered *Café maure*, but also appears to be a reversed version of the crouching figure with crossed legs, found second from the top in *Café I* and *II*. Notably, the slippers that were painted out of *Café marocain* are distinctly rendered in all three drawings.

The drawings related to *Café marocain* and the painting may depict the same site. When Camoin wrote to Matisse in April 1913, he referred to Matisse's painting of the interior of the Café Maure,[13] which is surely *Café marocain*. Camoin also painted a Moroccan café (see fig. 138), perhaps the same establishment. No doubt the cafés of Tangier were as intriguing to Matisse and his friends as they were to an English photographer who visited Tangier in 1913 and recorded in his journal: "First we paid a visit to a Moorish Café situated down a dark lane, which gave one the feeling that one's throat may be cut at any moment. After scrambling up a rickety staircase the interior was reached, which was more reassuring. The floor was covered with rugs and one corner was set aside for European visitors. The rest was taken up by small groups of Moors playing cards or gambling. In the centre of the room squatted an orchestra and choir combined, composed of eight performers. Every now and then they tuned up and produced some extraordinary music or sang some weird song. . . ."[14]

Matisse included *Café marocain* in his exhibition at Galerie Bernheim-Jeune in April 1913 (fig. 3), and it is mentioned in two articles about the exhibition, one a short notice by Guillaume Apollinaire and the other a lengthy review by Matisse's friend Marcel Sembat. Apollinaire, who did not care for orientalism, found Matisse's Moroccan works exceptional, noting that *Café marocain* and *Porte de la Casbah* were among the only acceptable works recently inspired by contemporary North Africa.[15]

Sembat, on the other hand, wrote enthusiastically and at length,[16] describing how Matisse changed his conception of *Café marocain*,[17] moving toward a simplified, more abstract composition: "Do you remember the large canvas of the *Arab Cafe*? I recommend it to you. All of Matisse is there! If one looks carefully, one sees him in his entirety. . . .

"These recumbent figures, all in the same gray nuance, such a soothing gray, whose faces are represented by a yellow-ocher oval, you know that they were not always painted like that. Look! At the top, the man on the left, he was red! The other, next to him, was blue; the other was yellow. Their faces had lines, eyes, a mouth. The one at the top smoked a pipe. In examining the bottom of the picture, one discovers the traces of what was formerly a line of slippers. . . .

"The slippers, the pipe, the lines of the faces, the varied color of the burnooses, why have they all melted away?

"Because, for Matisse, to perfect is to simplify! Because, consciously or not, purposely or despite himself, each time he sought the best, he moved in the direction of the simple. A

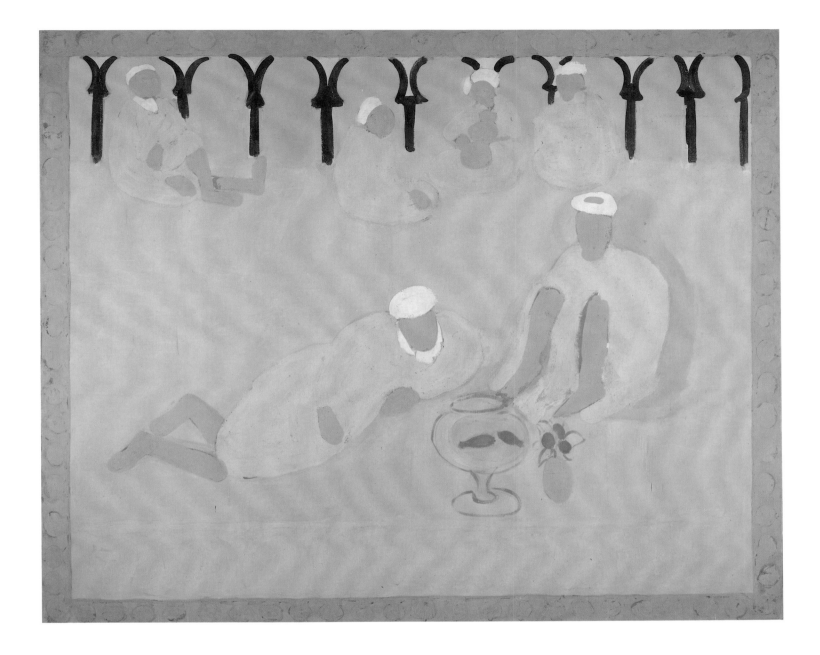

psychologist would not be fooled by this: Matisse goes instinctively from the concrete toward the abstract, toward the general.

"I pointed this out to him. 'The reason is,' he said to me, 'that I go toward my sentiment; toward ecstasy. . . .

'And then,' Matisse continues, 'there I find calm.' "[18]

Sembat quoted Matisse further: " 'I have my goldfish bowl and my pink flower. That's what struck me most, those devils who spend hours contemplating a flower and some red fish. Well, if I paint them red, this vermilion would turn my flower violet. So what can I do? I want my flower pink, otherwise it's not my flower anymore. Unlike the fish, which could be yellow, I don't care about that, so yellow is what they'll be!' "[19]

Although much of *Café marocain* appears to be based on Matisse's experience in Tangier, art-historical influences or sources for *Café marocain* have also been reasonably proposed. Barr suggested the artist remembered a miniature by Agha Reza, *A Prince and His Tutor*, which he probably saw in a great exhibition of Persian miniatures at the Musée des Arts Décoratifs in Paris shortly before returning to Tangier in 1912.[20] Kostenevich suggested an affinity with Ingres' *Odalisque and Slave*, which shares with Matisse's painting a pair of figures in the foreground (one seated and one reclining) as well as oriental and musical themes,[21] and reminds us as well that Matisse treated a musical theme in his 1910 panel for Shchukin. Though the ensemble in *Café marocain* plays a less important part than the musicians in *La musique* (1910, The State Hermitage Museum, Leningrad), the musical motif remains important and might explain the static poses of the figures, who sit as if transfixed by the music. Finally, another important source in Matisse's own work is *Le bonheur de vivre* (fig. 99), with its paradisal, dreamlike setting, reclining figures, and musicians.

Café marocain was not sold when the exhibition of Matisse's Moroccan paintings opened at Galerie Bernheim-Jeune in April 1913, and the artist offered it along with *Le rifain debout* to Morosov.[22] Matisse wrote him again in May, offering the pictures a second time, and enclosed a copy of Sembat's review,[23] but apparently Morosov was not interested. Mme Matisse, while her husband was away, showed *Café marocain* to Shchukin, who reportedly was enraptured.[24] He bought it by mid-September 1913[25] and was delighted with it. He wrote to Matisse: "The *Arab Café* has arrived in good condition and I have placed it in my dressing room. It is the picture which I love now more than all the others and I look at it every day for at least an hour."[26]

1. *Café marocain* is the title that was used in the Paris 1913 catalogue of Matisse's exhibition of Moroccan paintings and drawings. Other titles commonly used are *Café maure* and *Café arabe*.
2. *Café marocain* is restricted to display at the State Hermitage Museum, Leningrad. The painting was restored between 1956 and 1963 to treat its fragile and increasingly brittle paint layers. In a method developed by conservators L. N. Iltsen and T. D. Chizhova, the layers of distemper were strengthened and stablized with solutions of synthetic resin, but it remains prudent not to subject the painting to movement or changes in environment.
3. Camoin wrote to Matisse Saturday [12 April] 1913: ". . . Marquet me dit que tu vas faire ton exposition chez Bernheim. Je regrette bien de ne pas être à Paris, bien que je connaisse assez toutes tes toiles du Maroc pour les revoir, en y pensant, et les revoyant ainsi, je trouve que tu as beaucoup travaillé là-bas, et que tous tes efforts sont bien contenus dans l'intérieur du Café Maure, et les Riffins [sic] . . . Enfin tu dois être content." Giraudy 1971, 16. Camoin was in Tangier with Matisse only on the second trip, and thus this recollection is probably of pictures Matisse worked on while he was there.

This letter is only dated Saturday, but it refers to Marquet's exhibition, which had just closed and Matisse's exhibition, which was about to open. Marquet showed at the Galerie E. Druet in Paris 31 March–12 April 1913 and Matisse's exhibition was from 14–19 April 1913. 12 April 1913 was a Saturday.
4. Schneider ties *Café marocain* closely to Matisse's ideas of the Golden Age and of paradise. Schneider 1984b, 183, 270, 307, 420–421, 462, 467–471, 473, 488–489.
5. These figures are related to the blank-faced figures Matisse drew in Morocco (cats. 50, 51).
6. The dreamlike quality of the painting and of the figures in it may have been inspired by a commonplace activity that took place in Moroccan cafés: the smoking of hashish. One drawing (cat. 41) shows a figure smoking a pipe, another (cat. 54) shows two reclining figures, one surrounded by tendrils of smoke.
7. See also cat. 18. For more information about goldfish in Matisse's work, see Reff 1976, 109–115; New York 1978, 84–86, 100–102, 197–198, 204–205; Schneider 1984b, 350, 352, 419–420.
8. These arches are possibly fabric rather than architecture, as some kinds of Moroccan wall hangings, called *haïti*, are decorated with arches. See also the drawing by Camoin of a Moroccan café (fig. 56), which appears to have fabric with an arch motif hanging on the walls.
9. Flam 1986, 308.
10. An aqueous paint made with a simple glue-size or casein binder, such as are used in flat indoor wall painting and decoration. Ralph Mayer, *The Artist's Handbook of Materials and Techniques* (New York, 1981), 626.
11. The border on the Museé de Grenoble's *Interieur aux aubergines* is now missing, but it is known from a photograph, reproduced in Barr 1951, 374.
12. See Cowart essay in this volume, pp. 139–141.
13. See note 3 above. Maps of the Casbah also show a Café Maure near the Sultan's Palace (fig. 71). Considered with the recently discovered drawings, a more plausible location is just below the Casbah gate, Porte de la Bab el Aassa. See Cowart essay in this volume, pp. 139–141. Flam proposed the Café Baba, which still exists in this area. Flam 1986, 350. Still, Matisse's image is so highly abstracted that it is difficult to establish any site definitively, particularly for a city like Tangier in which cafés, arches, and colonnades are so common. Compared to Camoin's painting (fig. 138) and drawing (fig. 56), Matisse's radically different image of a suspended world is not unlike that of the goldfish in the bowl. Even if the site could be established, it seems very unlikely that Matisse's painting could have been painted in situ because of its size. Matisse had a studio or working space in Tangier. See *Arums* (cat. 20).
14. Leslie Wilson Hamilton, Tangier travel diary, 5 April–7 April 1913, 8. Leslie Wilson Hamilton Collection, Carpenter Center for the Visual Arts, Harvard University.
15. Apollinaire 1913, 306.
16. Sembat 1913.
17. Sembat's accounts of how *Café marocain* evolved may not be reliable. He was not in Morocco with Matisse on either trip and therefore his descriptions of how Matisse painted there are at least second-hand and should not be considered absolute.
18. Sembat 1913, 191–192; translated in Flam 1986, 351, 355. "Vous rappelez-vous la grande toile du *Café Maure*? Je vous la recommande. Tout Matisse y est! Si on regarde bien on l'y voit tout entier. . . ."

Ces personnages étendus, tous de même nuance grise, d'un gris si reposé, et dont les visages sont figurés par un ovale d'ocre jaune, sachez qu'ils n'ont pas toujours été peints ainsi. Tenez! en haut, le bonhomme de gauche, il a été rouge! L'autre, à côté, a été bleu; l'autre a été jaune. Leurs visages ont eu des traits, des yeux, une bouche. Celui d'en haut fumait une pipe. En examinant le bas du tableau découvre, la trace d'une ancienne rangée de babouches qui, devant ce café, était très éloquente.

Pourquoi les babouches, la pipe, les traites des visages, les couleurs variées des burnous, pourqoui tout cela a-t-il fondu?

Parce que, pour Matisse, se parfaire, c'est simplifier! parce que, consciemment ou non, de parti-pris ou malgré lui, chaque fois qu'il a cherché le mieux il a marché dans les sens du simple. Un psychologue ne s'y trompera pas: Matisse va d'instinct du concret vers l'abstrait, vers le général.

Je le lui fais remarquer. 'C'est' me dit-il, 'que je vais vers mons sentiment; *vers l'extase. . . .*'

'Et puis,' continue Matisse, 'j'y trouve le calme.'"

19. Sembat 1913, 192; translated in Flam 1988, 149. "'. . . J'ai mon bol de poissons et ma fleur rose. C'est ce qui m'avait frappé! ces grands diables qui restent des heures, contemplatifs, devant une fleur et des poissons rouges. Eh bien! Si je les fais rouges, ce vermillon va rendre ma fleur violette! Alors? je la veux rose, ma fleur! autrement elle n'est plus! Au lieu que mes poissons, ils pourraient être jaunes, cela ne me fait rien; ils seront jaunes!'"

20. Barr 1951, 160.

21. Although Matisse knew this painting well, the references to it here are not very apparent. The figures in the foreground have switched positions, a reclining man in a robe occupies the place of the odalisque, the music-playing motif is removed to the distance, and the balustrade of the background is replaced by an arcade.

22. Morosov had just purchased the Moroccan Triptych, *Paysage vu d'une fenetre* (cat. 12), *Sur la terrasse* (cat. 13), and *Porte de la Casbah* (cat. 14), and Matisse offered him *Rifain assis* (cat. 19) along with *Café marocain* (cat. 23). "J'espère que ces 3 toiles vous donneront envie de venir voir dans mon atelier si vous venez à Paris cet été deux grandes toiles de deux mètres sur 1.70 environ qui représentent un grand Riffain [sic] et un café arabe. Je pourrais vous en envoyer des photographies si elles vous intéressaient. . . ." Matisse to Morosov, 19 April 1913, Moscow/Leningrad 1969, 130. For the complete text of this letter, see Appendix 1.

23. "Puis-je espérer à votre prochain voyage à Paris avoir votre visite; deux importants tableaux du Maroc que j'ai chez moi pourraient vous intéresser; je préfère ne pas vous en envoyer la photographie. . . . P.S. Je vous ai fait envoyer un exemplaire d'une revue "Les Cahiers d'aujourd'hui" dans laquelle il y a sous la signature de Marcel Sembat le meilleur article qu'on ait fait sur moi." Matisse to Morosov, 25 May 1913, Moscow/Leningrad 1969, 130.

24. Schneider 1984b, 307.

25. "Sais-tu que j'ai vendu le Café marocain à Stchoukine. Le tableau doit même être arrivé à Moscou. . . ." Matisse to Camoin, 15 September 1913, Giraudy 1971, 16.

26. Shchukin to Matisse, 10 October 1913, in Barr 1951, 147. For the complete text of this letter, see Appendix 1.

Les Marocains, 1915–1916

(The Moroccans)
oil on canvas
181.3 x 279.4 (71³/₈ x 110)
signed l.r.: *Henri-Matisse*
The Museum of Modern Art, New York,
Gift of Mr. and Mrs. Samuel A. Marx

Matisse appears to have been planning a souvenir of his Moroccan trips as early as the spring or summer of 1913. Charles Camoin wrote him in late August of that year thinking such a picture was already completed and that its subject was the Tangier beach.[1] The indication that Matisse's first idea was a beach scene has led to a suggestion that he was planning to transform his *Demoiselles à la rivière* (fig. 30).[2] However, this was not the case, for when he replied to Camoin on 15 September 1913, he wrote: "I advanced my large painting of Bathers, the portrait of my wife [*Portrait de Mme Matisse,* 1913 (State Hermitage Museum, Leningrad)], as well as my bas-relief [*Back II*]. As for my large painting of Tangier, I have not begun it: the size of the canvas that I stretched does not suit the representation that I envisage for the subject."[3]

The next campaign of work was apparently begun by 22 November 1915, when Matisse wrote Camoin: "I am taking up again another painting . . . it's a souvenir of Morocco, it's the terrace of a small café with the languid idlers chatting toward the end of the day (fig. 144). You can see the small white marabout below [the terrace], the poor sketch will not tell you much. This bundle represents an Arab lying on his side on his burnoose, the two hooks are his legs."[4] *Les Marocains* began, therefore, as this sketch and a group of newly discovered sketches (figs. 78,79,80) make clear, as a work more closely related to *Café marocain* (cat. 23).

By January 1916 he was at work on the canvas as we know it today. Writing to Camoin on 19 February, he explained: "I have been totally unsettled in my mind for a month, with a picture of Morocco that I am working on at the moment (2.80 m x 1.80 m), it's the terrace of the little café of the Casbah that you know well. I hope to get myself out of it, but what troubles. I'm not in the trenches, but I seem to be there all the same."[5]

Matisse may well have worked on *Les Marocains* through the summer of 1916. It was photographed, as it appears now, in November of that year.[6] The artist kept the painting, agreeing to sell it to Mr. and Mrs. Samuel A. Marx in 1952 only on the condition that they promise to donate it to The Museum of Modern Art.[7] Talking about *Les Marocains* in 1951, Matisse observed: "I find it difficult to describe this painting of mine with words. It is the beginning of my expression with color, with blacks and their contrasts. They are reclining figures of Moroccans, on a terrace with their watermelons and gourds."[8]

The painting comprises three sections that are, as Barr pointed out, "separate both as regards composition and subject matter. . . . These three groups might be described as compositions of architecture, still life and figures."[9] The architectural section at the upper left shows the balustrade of a balcony with a pot of blue flowers (or cactus leaves[10]) at the corner, a marabout dome, a trellis, and architecture behind. Such features are found in several 1913 sketchbook drawings (such as cats. 26,38,58,59,60)[11] as well as the Camoin 1915 letter.

X-ray and infrared examinations of the painting (figs. 145–147) reveal extensive reworking. The dome was originally larger, closer in proportion and in detail to its appearance in the sketches. There was originally a sequence of dark vertical forms along the upper left and right edges, similar to the markings in the *croquis* in the 1915 letter to Camoin, and the three recently discovered 1913 drawings. The grid of tile work ran in the direction indicated in the 1915 sketch and with the same interruption by a flight of steps. (In the finished painting, a shift in direction of the tile pattern between the melons recalls the shape of these steps.) The melons that displaced the figures on the terrace were originally more numerous. Their shapes in 1916 owe much to Matisse's contemporary still lifes with circular and spherical images.[12] As completed, the painting brings to a climax his intense preoccupation with such images in that year.

The right-hand section of *Les Marocains* is more ambiguous and complex. However the 1912/1913 and 1915 sketches and the x-ray and infrared photographs help to decipher some of the motifs. The one clear image is the seated male figure with a white turban shown from the back. This was enlarged from its size in the sketch and moved into the lower right corner. Before assuming its final form, it was temporarily transformed into a forward-facing figure, possibly female,[13] and then into a shape with some resemblance to the figure in the same corner of the Cézanne painting of bathers that Matisse owned.[14] The dark oval form at the right of the head of this figure has been interpreted as an Arab with a burnoose drawn up over his head.[15] It seems also to derive from a horseshoe-arched doorway, its upper half in shadow. The x-ray shows that originally there may have been a flight of steps leading up to the doorway. If this was so, recognition of this as an architectural feature suggests an interpretation of the two linear images above it as figures before windows. The image at the top right may also derive from the crouching Arab with drawn up legs; the image to its left may be based upon the drinking figure in the sketches (figs. 79,80).

Other areas extensively reworked include that of the two juxtaposed forms to the left of the head of the seated figure.

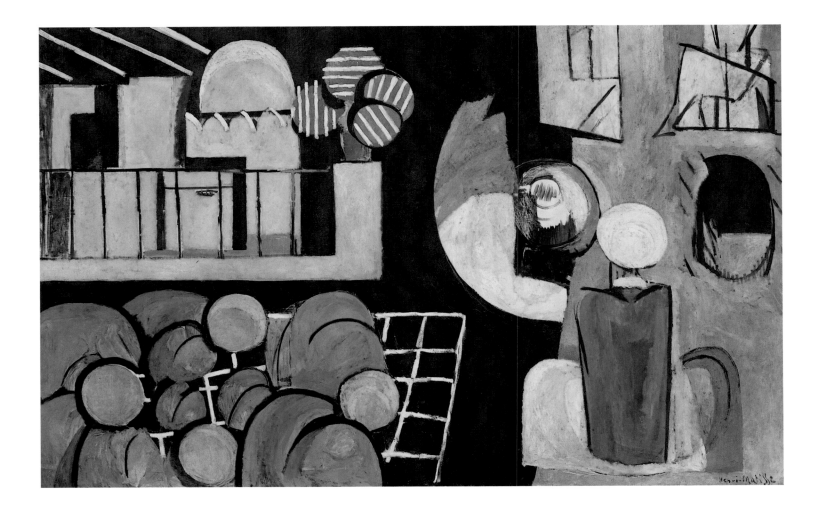

The whole area may have originally been a reclining Moroccan seen at a distance, the "bundle" Matisse referred to in his 22 November 1915 letter; the newly discovered sketches would seem to support such an interpretation. The circular form might also derive from one of any number of sources: a figure seen from above, a well, a waterpipe, a tea server and platter, a brazier, or a goldfish bowl, the latter as seen in *Café marocain*.

Although the three compositional groupings of *Les Marocains* are isolated one from the next, Matisse set up a "polyphony of both form and representational analogies"[16] that keeps the eye in perpetual movement across the work and thus joins its otherwise fragmented parts.[17]

The blackness that separates and unifies the three zones has provoked much comment.[18] It serves a representational function, as a depiction of shadow and, by extension, because of its intensity, of the heat of the sun that produces shadow. It simultaneously serves a positive coloristic function. As Matisse wrote of the contemporaneous *Coloquintes*: "I began to use pure black as a color of light and not as a color of darkness" and thereby formed "a composition of objects which do not touch—but which all the same participate in the same *intimité*."[19]

1. Giraudy 1971, 16. Camoin's undated letter is in reply to Matisse's of 6 August 1913. "Je pense que tu as dû dexécuter ton motif de la plage à Tanger, et il me tarde bien de le voir, ainsi que ton bas-relief." See New York 1978, 110–113, for a previous entry on *Les Marocains*.

2. Flam 1986, 366. It is reasonable to conclude that this painting, begun in 1910, taken up again this summer of 1913, then completed in 1916, was affected by Matisse's experiences in Morocco.

3. ". . . j'ai poussé mon grand tableau des Baigneuses, le portrait de ma Femme, ainsi que mon Bas-Relief. Quant à mon grand tableau de Tanger, je ne l'ai pas commencé, la dimension de la toile que j'ai clouée ne concorde pas avec la représentation que je me fais du sujet. . . ." Giraudy 1971, 16.

4. "Je recommence une autre toile. . . . C'est un souvenir du Maroc, c'est la terrasse du petit café avec les fainéants allanguis devisant vers la fin du jour. On aperçoit le petit marabout blanc du bas, le mauvais croquis ne te diras pas grand chose—ballot représent un arabe couché de côté sur son burnous, les 2 crochets sont les jambes. . . ." Giraudy 1971, 18. In this letter Matisse also said his Moroccan painting was the same size as his *Nature Morte àpres "La desserte"* de De Heem (Museum of Modern Art, New York), that is, approximately 180 cm high and 220 cm wide. In fact, *Les Marocains* is this height but some 60 cm wider. In November 1915, Matisse either stretched the canvas wrong or erred in his reference. This latter circumstance may be probable, given Matisse's habit of mixing up almost everything concerning numbers and the fact that the still life had just left Matisse's studio and was not readily available for verification.

5. ". . . j'ai la tête toute bouleversée depuis un mois, avec un tableau du Maroc que je travaille en ce moment (2.80 m x 1.80 m), c'est la terrasse du petit café de la Casbah que tu connais bien. J'espère m'en sortir, mais que de peines. Je ne suis pas dans les tranchées, mais je m'en fais tout de même. . . ." Giraudy 1971, 19. (Erroneously dated "19-1-1916," Flam 1986, 503 n. 19 has convincingly argued for 19 February.) This comment illuminates not only the extent of Matisse's difficulties with the picture, but reminds us also of the current harsh realities of World War I. Matisse's home in the north of France had been overrun in the invasion. His mother was behind enemy lines and he feared for her safety. The artist's son, Pierre, was also in military service.

6. Flam 1986, 504 n. 31, listed other paintings photographed in June and August 1916, suggesting that *Les Marocains* was not finished by then. That Matisse did work on it through the summer seems to be confirmed by its

relationship to *Les coloquintes* (Museum of Modern Art, New York), painted that summer, and other comparable still lifes. However, when Matisse wrote to Hans Purrmann on 1 June after "working very hard recently," he did not mention it among the paintings he described as "the important things of my life." Presumably, he had either already finished it or, more likely, had not yet taken it up again after working on it at the beginning of the year. New York 1978, 112–113.

7. Archive of The Museum of Modern Art, New York.

8. Flam 1973, 133; Tériade 1951, 43, 47.

9. Barr 1951, 173.

10. Watkins 1977, 134.

11. See Cowart essay in this volume, 139–141, concerning the various *croquis*. Matisse referred to the terrace as that of a small café in the Casbah. This could be Café Maure near the Sultan's Palace (fig. 71). Flam suggested that the site remembered is Café Baba. Flam 1986, 327. According to the Archives Henri Matisse there is no known specific reference to any café in any Matisse letter, except Café Maure. See also cat. 23.

12. See New York 1978, 112.

13. It is reminiscent of seated Zorah images.

14. New York 1978, 110.

15. Barr 1951, 173.

16. Barr 1951, 173.

17. Barr 1951, 173. Alfred Barr described the analogies thus: "The four great rounded figures in the architecture section echo the four melons in the still-life section. Yet these melons are so like the turban of the seated Moroccan in the figure section that the whole pile of melons has sometimes been interpreted as Moroccans bowing their foreheads to the ground in prayer. At the same time, to complete the circle, some of the figures are so abstractly constructed as to suggest analogies with the architecture section." The seated Moroccan in the foreground is of such architectural solidity as to resemble a column capped by a spherical ornament. This is but one of the associations that gives credence to Lawrence Gowing's suggestion that when working on the picture Matisse may have had Poussin's *Eliezer and Rebecca* (Musée du Louvre, Paris) at the back of his mind (Gowing 1979, 128).

He may also have been thinking of several other works. After his return from Morocco he began to take greater interest in boldly abstracted and geometric art. In 1913 he wrote enthusiastically about the grandeur of Hodler's compositions (Giraudy 1971, 15) and in 1914 about Seurat's "simplification of form to its fundamental geometric shapes." (Giraudy 1971, 17–18). Throughout the period of this picture's conception and execution Matisse was deeply interested in the development of cubist art. (See New York 1951, 112, for cubist associations of this picture, and Schneider 1984, 480–488, for a denial of these associations). In January or early February of 1916, when the picture was underway, Matisse wrote to Derain about "a Picasso in a new manner, a Harlequin, with nothing pasted on, only painting." (Escholier, 1956b, 112–113). This must certainly have been the Museum of Modern Art's *Harlequin*, which was much admired in Picasso's circle. The enveloping black ground of the *Harlequin* is only its most obvious link to *Les Marocains*. These potential sources are discussed more fully in New York 1978, 112.

Another earlier work must certainly have had its effect on *Les Marocains* too: in 1916 Matisse acquired Courbet's magnificent *The Source of the Loue*, whose somber simplicity he echoed in his own work.

18. See New York 1978, 112–113; Flam 1986, 414; Schneider 1984, 488.

19. Barr Questionnaire 1, 1945, Archive of The Museum of Modern Art.

H. Matisse 1915

Matisse's Moroccan Sketchbooks and Drawings: Self-discovery through Various Motifs

Jack Cowart

Henri Matisse, in an interview with Pierre Courthion, recounted a central aspect of his trips to Morocco, saying "at Tangier . . . I worked, always pursuing the same goal, that's to say, basically, the search for myself through the probing of various motifs."[1] This probing is manifest not only in his well-known major paintings, but even more convincingly in his previously unstudied and largely unpublished Moroccan drawings. Art historians have been unaware of the surprising large number and relationships of these works. A careful reconstitution of this graphic oeuvre reveals Matisse's remarkable attitudes and singular preoccupations. It is the Moroccan drawings that perhaps bring us closest to Matisse the traveler, the European romantic, the artist thrust into the luxuriant atmosphere of northern Morocco, with its exotic Casbah of Tangier and tribal peoples of the mountainous Er Rif.

Even the Matisse specialist will be surprised to learn that there are more than sixty documented drawings dating from the artist's trips to Morocco in 1912–1913, as well as two "drawn" paintings on canvas (*Zorah assise*, cat. 10, and *La Marocaine*, cat. 11). These works form a small but virtually new galaxy of Matissian imagery. I propose that at least thirty-five of these drawings can be assembled to reestablish an important series of sketchbooks executed by the artist during his second trip to Tangier.[2]

Through such drawing Matisse felt he could "gain possession" of his subject, probing the realm of the spirit, whereas his paintings in color belonged to the realm of the senses.[3] Thus the discovery of such an accumulated body of graphic work allows us to better understand Matisse's spiritual links to the subjects of Morocco. We can participate more fully in his creative process, his excitement with new motifs, the strangeness, and the atmosphere. These quickly executed drawings preserve, with no erasures, his spontaneous response to the stimuli of this exotic place, one of his "artistic paradises."

Delacroix's sketchbook journals from Morocco may well have been an initial influence on Matisse.[4] These brilliant drawings and watercolors, surrounded by a moving handwritten text, capture the visual essence of the country and document the artist's journeys there in 1832 (figs. 39, 40). The amplitude of their detail and their annotations of costumes and colors provided the source information for Delacroix's subsequent paintings.[5] Different from Delacroix's beautifully colored journal watercolor drawings of Morocco, however, are Matisse's monochromatic drawings there. At a time and place when one would most likely expect them, it is curious that there are no known watercolors, gouaches, or pastels of Morocco by him. It is as if the sun had bleached out any color destined for paper. Rather, it was the works on canvas—with watercolorlike, thinned oil paints applied transparently, translucently by vivid brushstrokes on their glowing white grounds—that make up Matisse's work in color in Tangier.

opposite page:
cat. 46. *Marocain, mi-corps*

113

The books of Pierre Loti, in particular *Au Maroc*, further fueled Matisse's interest in Morocco and the remote exoticism of North Africa.[6] An impressionistic, visual writer, Loti liberally spiced his text with descriptions of vast green rolling landscapes, wild fields of irises, daffodils, bracken, herbs, transparent blue skies, and magnificent sunlight. He recounted in vivid, evocative terms the profusion of exotic images, sounds, smells, untamed landscape, and mysterious people. Tangier for him was a city of white buildings and streets: "Tangier the White."[7] Matisse quoted Loti almost as a fellow traveler, many years after his return, to Pierre Courthion, Emmanuel Tériade, and to others as well. Matisse thus first saw Morocco through the art of Delacroix and the words of Loti. Matisse's actual trip to Morocco in January 1912 was most probably inspired by the enthusiasm and work of his close friend the artist Albert Marquet, who had just traveled there himself the preceding year.[8]

The 1912 and 1912/1913 Drawings

Of our new galaxy of drawings, thirteen in pen and ink can be dated, with relative sureness, to 1912, and a remaining twelve in pen and ink, one in graphite, and one in charcoal to the general period 1912/1913. All are on sheets of differing sizes. Most are on wove rag-content paper, and one is on thin squared drafting paper. Less than half of these early independent drawings have been published previously, and it was these that perforce defined what we thought we knew about Matisse's Moroccan drawing style and subjects. The many new drawings from this early 1912 and 1912/1913 group will now significantly modify prior notions, adding content, narrative resonance, and clearer indications of Matisse's interests and working methods. Many possess great aesthetic quality and represent several important themes not found in the thirty-five known drawings attributed to the later 1913 sketchbooks. Within Matisse's early artistic development in Morocco, it is necessary to inspect the independent drawings first before turning to the later sketchbooks, which in turn will provide even more surprises.

H. Matisse par lui-même, 1912 (cat. 26) is one of the most informative and self-aware drawings from the entire corpus of Matisse's works in Morocco. The artist portrayed himself in a tail coat and hat, sitting on a campstool, portable painting box on knees, before a *marabout* (a Muslim saint's tomb). Behind him is an evocation of a veiled and draped woman, with another traditionally garbed woman entering the scene from the right. In just a few quick strokes he captured the awkwardness, the curiosity of his

left: fig. 39. Eugène Delacroix, *Portier maure, paysage et différent croquis*, pen and ink and watercolor, folio 23r; *Femmes marocaines et Meknès vue haut des terrasses, le 1er avril 1832*, pen and ink and watercolor, folio 24r; from *Album d'Afrique du Nord et d'Espagne*, 1832. Musée du Louvre, Paris, Cabinet des Dessins, RF 1712 bis

right: fig. 40. Eugène Delacroix, *Croquis d'un kiosque et de portes marocaines*, folio 20r; and *Petite cour mauresque et kiosque*, folio 21r; from *Album d'Afrique du Nord et d'Espagne*, 1832, pen and ink. Musée du Louvre, Paris, Cabinet des Dessins, RF 1712 bis

situation: a European in the "Oriental" milieu. Beyond Delacroix and Loti, Matisse came to Islamic culture deeply inspired by his various direct prior experiences, to include the Alhambra in Grenada, a Persian miniatures exhibition in Munich, and the Russian Orthodox and Byzantine icons and large icon frescoes in Moscow. Yet in this drawing he treated himself as a person removed. He had not "gone native"; rather, wearing formal clothing, he went to the opposite extreme, as a figurative artist in a culture where strictly representational likenesses are prohibited by religious custom.

Deux autoportraits et croquis de "Les acanthes," 1912 (fig. 41) shows two conventional self-portraits of the artist flanking a small outlined scene quite similar to his Moroccan painting *Les acanthes* (cat. 5). The tightly cropped left portrait shows an intense, serious artist, with a clearly important major painting floating above where his cap should be. On the right Matisse has drawn his head and shoulders more typically, with an implied smile, less focused eyes, and a generally bemused, welcoming attitude. This is the artist dandy, comfortable in this, his passport identity image.

Paysage marocain avec cavalier, croquis de "Les acanthes," 1912 (cat. 27) marries on one sheet the Morocco of Delacroix to the Morocco of Matisse. At the left the artist depicted a Delacroix-style equestrian on a rearing horse on the broad Tangier beach before the citadel of the *medina*,[9] bringing to mind Matisse's daily ride in Tangier. In the right-hand vignette, Matisse depicted his *Les acanthes* landscape, a painting he took

great pains to complete, perhaps encompassing six weeks' work in the private Tangier enclave of the Brooks family.

Corbeille d'oranges I (cat. 28) is the most spirited of three known renderings of the Musée Picasso painting (cat. 4). Drawn in brown ink on cream wove paper, the effect is one of lush visual warmth, fully reflective of the abundance of vegetation and fruit in Morocco. The tenuous placement of a mountain of fruit, cascading over the precipice of a floral table covering, differs from the more stable composition of the finished painting, as do the length of the patterned tablecloth and various elements in the background. This detailed, elegant drawing also differs from two other known sketches (figs. 42, 43). One, a small but slightly more accurate representation of the painting, was drawn on what appears to be a book or carnet endpaper carrying the imprimatur of a Moscow lithographer-printer, and was inscribed by Matisse "Croquis d'un tableau fait à Tanger." The other sketch is found in a letter fragment addressed to Michael and Sarah Stein, in which Matisse accurately described the colors of the finished painting.[10]

above left: cat. 28. *Corbeille d'oranges I*

above right: fig. 42. Henri Matisse, *Corbeille d'oranges II* (Basket of Oranges II), 1912, pen and ink on paper, 18.3 × 12.3 (7³/₁₆ × 4⁷/₈), signed l.r. in pencil: *Croquis d'un tableau/fait à Tanger/Henri Matisse.* Private collection

below: fig. 43. Sketch and letter, Matisse to Michael and Sarah Stein, spring 1912

Vue de la fenêtre, Tanger I, II, and *III,* 1912, are three vignettes depicting the view from the window of Matisse's hotel room, no. 35, at the Hôtel Villa de France.[11] Two include both left and right window panels, still-life element(s) on the sill, and Saint Andrew's, the Anglican church directly across the street from the hotel; each of these is a variation on Matisse's important painting *Paysage vu d'une fenêtre* (cat. 12), the left panel of the so-called Moroccan Triptych. Two drawings record a view slightly farther back and lower in the room than the painting. One version (fig. 44) is spare; in a more elaborate version (cat. 29) Matisse added active pen strokes and details to visually animate the wall, sky, and middle ground, more in the spirit of his famous fauve painting, *Fenêtre ouverte à Collioure* (1905, Mrs. John Hay Whitney, New York) and its related drawing.[12] The remaining version (fig. 45) places the viewer closer to the open window. The sill defines the front plane, and more of the landscape toward the Grand Socco is visible.

Matisse's letters indicate he sent drawings home to his family. It is probably those drawings with images of paintings now known to us, outlined as vignettes within a framing line, that kept his wife and children abreast of his current work or interests. The drawings were on sheets separate from the text of the letters, so the loose drawings could be passed around without reference to more personal remarks. Apparently Matisse's friends, the artists Marquet and Camoin, were shown such drawings during their visits to his family in Issy-les-Moulineaux, since they wrote back to Matisse in Morocco acknowledging awareness of his emerging projects.

Fumeur à la fenêtre, 1912/1913 (cat. 30) adds a Moroccan model to his hotel room interior. *Deux dessins d'un fumeur à la fenêtre,* 1912/1913 (cat. 31) modifies this setting with an arched window looking into the *medina* toward the minaret of the Aïssaouas mosque, a site distinguished by one leaning palm tree, a tree that is visible not only in documentary photographs of the period (figs. 46, 47), but also in the upper right quadrant of Matisse's painting *Vue sur la baie de Tanger* (fig. 48). The rounding of the window frame and the replacement of the Anglican church with a minaret and tree are surprising if one believes Matisse to be always a strictly literal artist. He surely saw both

above left: fig. 44. Henri Matisse, *Vue de la fenêtre, Tanger I* (View from the Window, Tangier I), 1912?, pen and ink on paper, 25.8 × 17.2 (10 1/8 × 6 3/4), signed l.l. in pencil: *Henri-Matisse.* Private collection

above right: cat. 29. *Vue de la fenêtre, Tanger II*

below: fig. 45. Henri Matisse, *Vue de la fenêtre, Tanger III* (View from the Window, Tangier III), 1912, pen and ink on paper. Location unknown

left: cat. 30. *Fumeur à la fenêtre*

right: cat. 31. *Deux dessins d'un fumeur à la fenêtre*

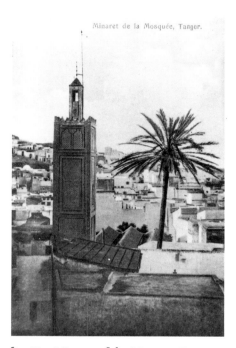

fig. 47. *Minaret of the Mosque, Tangier*, postcard, detail, Archives Henri Matisse

structures in Tangier, but in this latter sheet he has seemingly invented a view, one not visible from his window. We are left with the impression of the artist searching for a motif, a different synthesis. First published by Elie Faure in 1920,[13] this drawing's awkward off-center composition is similar to Matisse's many Nice paintings.

Both of these Moroccan sheets prefigure works such as the drawing and painting *Le violiniste à la fenêtre*, 1918, other charcoal drawings of female models playing the violin before an apartment window,[14] his drawing/painting sequence of *Fenêtre ouverte à Etretat*, 1920,[15] and, among others, his numerous late teens and early twenties paintings set before the windows and balconies of the Hôtel Beau-Rivage and the Hôtel Méditerranée et de la Côte d'Azur in Nice. In these ways Matisse preserved not only the sites of these visited cities but also located himself (the observer) in all such works. He memori-

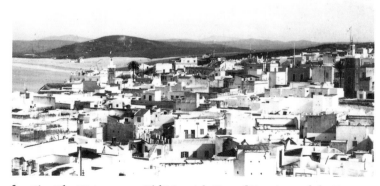

fig. 46. *The Picturesque Old Moorish City of Tangier and the Bay from the Sultan's Palace, Morocco* (detail), early twentieth century, stereograph. Prints and Photographs Division, Library of Congress, Washington

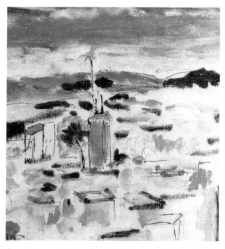

fig. 48. cat. 2. detail, *Vue sur la baie de Tanger*

118

alized his itinerant status, recording the hotel decor and the framed view as a contained, controlled vignette. To support his own creative method, the artist retreated to the meditative calm of his hotel room in the face of a jumble of new, raw, outside influences. It was a way to preserve aesthetic distance, giving him time and space to pursue painting and drawing in a selective manner.

The open Moroccan windows provided Matisse with outward-looking opportunities. He continued in this direction and developed the motif in triumphant fashion in his painted views from his Paris studio in 1914 as well as the haunting *Fenêtre ouverte à Collioure*, 1914, and *Le rideau jaune*, 1914–1915. But by the later 1920s Matisse would almost permanently turn around, putting his back to such windows. Then he would exploit not their view but their light. They provided the illumination for his painting and drawing of studio and room interiors with posed and costumed models, arranged in their own timeless stage settings of orientalist furniture and patterned hangings. By this reversal the artist established a more permanent, artificial, and exotic world of paradoxically tense but provocative grace and luxury, made to seem remote from the distractions of the outer world.

Vue de la médine, 1912 (cat. 32) is a remarkable birds-eye view of the city just outside the walls of the Casbah near the Bab el Aassa, in the vicinity of the Sultan's Palace, looking to the southeast. His vantage point seems to have been a popular one with visitors to Tangier, since numerous historic photographs were made from the same location (fig. 49). This and a related drawing (cat. 33) render the buildings in the central portion of Matisse's painting *Vue sur la baie de Tanger* (cat. 2), but from a slightly lower

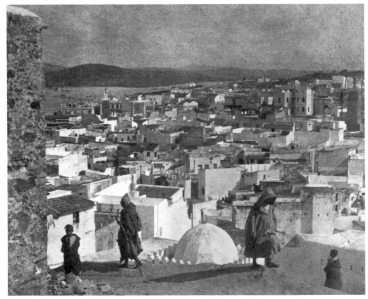

fig. 49. "Looking South over the Homes," *Travel*, February 1914, 17

above right: cat. 32. *Vue de la médine*

right: cat. 33. *Maisons dans la médine*

level than the oil. Not since Matisse's fauve and neo-impressionist paintings of Saint-Tropez, Port de l'Abaille, and Collioure in 1904–1905 had the artist lavished so much attention on a cityscape. The drawing of the ancient city (cat. 32) is unusually detailed and architectural. Its execution on the back of a thin sheet of quadrille paper leaves us with the strong suggestion of an architect's plan. Matisse accentuated, by darker ink lines, the two buildings of particular interest to him: the large one in the center with the notch in its roof and the domed *marabout* at the intersection of rue Bab el Aassa and rue Benraïsul. The remaining buildings became thin, wirelike, transparent structures. *Maisons dans la médine*, 1912 (cat. 33) is a detail of the panoramic drawing described above, with the artist's careful close-up of the intersection of three buildings and a roofline of a facing structure. The thin pen lines, on white wove paper, make no shading or halftone. We see only contours, the whitewashed mass of the buildings dissolved by the bright sunlight.

The quirky, lively spirit of these quickly sketched Moroccan drawings, and especially those containing pedestrians and animals, evolved from Matisse's early art training during the 1890s at the Ecole des Beaux-Arts. There his instructor Gustave Moreau directed him and his fellow students to study not only in the Louvre, but also, and more important, in the streets of Paris. Moreau applied the advice of popular drawing manuals,[16] that a student should make "sketches after nature from the street, in the country, wherever you go."[17] One should observe daily life and capture, in drawing, its spontaneous events, with an emphasis on "the effect," and as Eugène Carrière said, ". . . finally, the spectacle of life."[18] Delacroix was often quoted that an artist should be able to sketch a man falling out of a window before he hit the ground.[19] Such aggressive observation and sketching concepts, made formal in the term *croquis succincts*, were essential to the drawing style and attitudes of Matisse and his friends (Albert Marquet, Henri Manguin, Charles Camoin, among others).[20]

These young artists took advantage of this opportunity to escape the drawing of *académies* (posed models) in the studio or the plaster casts in the formal drawing halls at the Ecole des Beaux-Arts. Thus liberated, they produced voluminous batches of quick ink, charcoal, or crayon sketches depicting passing horse trams, pedestrians, café concert singers, or workers. In a Baudelairean spirit, artists of this epoch recorded their daily experiences, the tone and atmosphere of their modern age. Matisse and his friends' active brush or pen-and-ink silhouettes moved from their drawing sheets into their fauve-period paintings.[21] Marquet made such staffage a hallmark of his life's work.

In Morocco during both 1912 and 1913, Matisse occasionally returned to the style of his Parisian *croquis succincts* to capture passing Moroccans, their donkeys, and the

left: fig. 50. Henri Matisse, *Paysage, près de Tanger I* (Landscape near Tangier I), 1912, pen and ink on paper, 17.4 × 25.8 (6⁷/₈ × 10¹/₈), signed l.l. in pencil: *Henri-Matisse 1912*. Private collection

right: fig. 51. Henri Matisse, *Paysage, près de Tanger II* (Landscape near Tangier II), 1912, pen and ink on paper, 17.3 × 25.7 (6¹³/₁₆ × 10¹/₈), signed l.l. in pencil: *H. Matisse 1912-Tgr*; inscribed on back of former mounting board in pencil by another hand: *Page 141*. Private collection

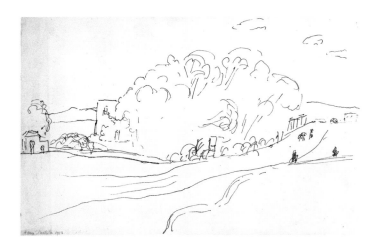

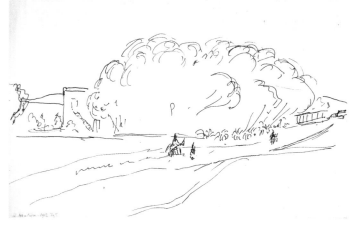

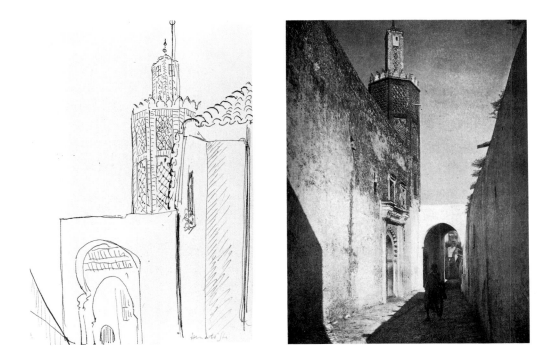

left: cat. 34. *Portail et minaret,*
Mosquée de la Casbah

right: fig. 52. *A Mosque, Tangier.* From
Pierre Loti, *Au Maroc* (1914 edition), af-
ter page 322

shifting, shimmering sense of the Casbah architecture. But while this freer style clearly implies the artist's reminiscence about his previous youthful achievements, the more experienced Matisse extended the graphic sophistication of these Tangier works. The three-score drawings mark the effective high point and the last significant time that the artist would render such scenographic streets, passers-by, and buildings.

Paysage près de Tanger I, II, 1912 (figs. 50, 51) may record one of Matisse's riding excursions out of Tangier, either to the immediate environs or to Tetouan, a village at the edge of the Rif Mountains. The drawings appear to have been done in sequence: the stand of trees gets larger and one building passes out of the frame to the left as the central building approaches. Travel in Morocco in 1912 was difficult: there were virtually no paved roads, and foreigners made forays out of Tangier by organized caravan.[22] The lack of bridges meant that rivers had to be forded and rains could paralyze any movement. But it was worth the effort and risk, Matisse said, because the countryside would bloom after the rain in a wonderful array of plants and colors.[23]

Portail et minaret, Mosquée de la Casbah, 1912/1913 (cat. 34) is one of Matisse's most detailed and fascinating architectural studies. The artist seized upon the Casbah Mosque's six-sided tower, the most elaborate in Tangier. He viewed it from a narrow street, the rue Ben Abbou, alongside the Sultan's Palace and around the corner from the Place de la Casbah. A distinctive double-arched structure shelters the mosque's door-way. The outlines of the ogee arches play against the rectilinear walls and the intricate tile and brickwork of the looming minaret and roof tiles of a neighboring building. This mosque is a large and surprising feature within the Casbah, and Matisse captured some of its mystery and power in this drawing. There is no other Moroccan-period drawing by him that indulges in such decoration, expressing his attraction to Islamic pattern, filigree, cornices, complex curves, countercurves, and arches.

Portail, Mosquée de la Casbah I, 1912 (cat. 35) is the first of two additional drawings relating to the architectural setting of the Casbah Mosque. This sheet holds a vignette of the double sheltering archway viewed from the opposite direction than that of *Portail et minaret, Mosquée de la Casbah.* The cornice on the left and the indicated rectangles

cat. 35. *Portail, Mosquée de la Casbah I*

along the right wall are doorways of private residences. Matisse portrayed the deep shadows cast by the surrounding buildings and strengthened the interior arch. The arches are actually round, but the artist pointed the second one, in a more Gothic style, adding visual lift. He reversed this relationship in the second drawing, *Portail, Mosquée de la Casbah II* (cat. 36), where the near arch rises to an elegant point and the far arch is more nearly rounded. In this larger drawing the archway expands to the full sheet, and light and shadow are equal as Matisse's pen lines mark only the contours.

Both drawings bear a direct generative relationship to Matisse's 1912 painting *Porte de la Casbah* (cat. 14), the third panel of the so-called Moroccan Triptych of the Pushkin Museum. No other preparatory drawings for the painting are known. In these two sketches Matisse explored distinctive double archways: modifications of round and pointed geometry, and how they frame a view to buildings and a flowered trellis. The Pushkin painting went through similar modification and redrawing,[24] the arches grow-

left: cat. 36. *Portail, Mosquée de la Casbah II*

right: cat. 37. *Dans la Casbah*

below: cat. 38. *Casbah: Le marabout*

ing as they were painted and repainted, emphasized arch hips becoming smoother, flattened projections. The Pushkin painting portrays not these archways before the Casbah Mosque but, rather, the Bab el Aassa, the so-called Whipping Gate, a portal just around the corner to the east. Matisse, the artist-tourist of the Casbah, made the unusual occurrence of two such double arches within a hundred meters of each other the subject of an energetic artistic response, with several beautiful drawings and one of his most important Tangier paintings.

The fourth known drawing of a Casbah archway is an astute, refined work in graphite, *Dans la Casbah* (cat. 37). Matisse reduced the topical elements to single pencil lines, portraying only the tops and front edges of the buildings, with an ethereal, floating archway and some vegetal decorative patterns on the right. We are transported to a dream state by a suffusive white atmosphere and a sophisticated tracery of thin lines. This is a meditative drawing, distilling Matisse's essence of his experience in this medieval, historic city. He did not make drawings like this again until the late 1940s in his designs for the Chapelle du Rosaire, Vence. There, in like manner, he worked toward an artistic spiritual absolute, expressing sunlight and reflected color within a surrounding atmosphere of pure white walls and glazed tiles with black lines.

Matisse's *Casbah: Le marabout*, 1912/1913 (cat. 38) is an important drawing related to not only the painted panel *Le marabout* (cat. 3), but also to picture postcards of the period. Matisse bought and sent innumerable postcards to his friends (such as the Steins, Camoin, Marquet, Manguin), and there is a sense that he chose particular images for humorous or documentary purposes. His pen and ink works occasionally took the most illustrative vantage, the "proper" photogenic, touristic setting, like a postcard. The Archives Henri Matisse contains such *marabout* postcards from the artist (figs. 53, 54). The Fine Arts Library, Harvard University, has a Tangier postcard of this specific *marabout* (fig. 55), on the rue Ben Abbou. In the exhibited pen and ink drawing the artist accentuated the contrast of light and shadow, the play of the dome and crenelation, the vine creeper, the ornate doorway against the simple shape of the street archway. He abridged the scene, focusing on the stagelike quality and the mass of the architecture. In this drawing Matisse may have remembered his 1899 monochromatic copy of Delacroix's *Rebecca enlevée par le Templier pendant le sac du chateau de Frondeboeuf*, 1858, followed in 1902 or 1903 by a drawing of the same subject.[25] The Delacroix is a highly charged abduction scene with horses, soldiers, and the flailing Rebecca in front of a towering pseudo-medieval castle. In Matisse's 1912/1913 drawing there is at least a residue of his reminiscence of the Delacroix and the historicism of its setting.

left: fig. 53. *Tangier, Tombs of Saints*, postcard. Archives Henri Matisse

right: fig. 54. *Marabout, Tangier*, postcard. Archives Henri Matisse

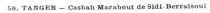

fig. 55. *Tangier, Casbah-Marabout of Sidi Berraïsoul*, postcard. The Aga Khan Program for Islamic Architecture and the Visual Collections of the Fine Arts Library, Harvard University

cat. 39. *Le dome du marabout*

There is a more telling contemporary context, however, for the treatment of the compositional elements in this drawing of the *marabout*: Matisse's evolving relationship to Parisian cubism. This 1912/1913 drawing announces a drawing and painting style (one of analysis, structure, and economy) central to Matisse's later work in 1914–1915. In *Casbah: Le marabout* geometry prevails as white rectangles and triangles intersect, project, recede. It is a kind of observed, rational cubism, more in the spirit of Cézanne than Picasso or Braque. The seeds for Matisse's cubist-period future seem to have been planted during his Moroccan experiences.[26] Several years later he produced, in a "cubist" mode, a series of portrait drawings, still lifes, and large paintings, not the least of which is the monumental *Les Marocains* (cat. 24).

Three newly discovered drawings provide further insights concerning Matisse, his visits to Morocco, and the recording of his experiences there. *Le dome du marabout*, 1912/1913 (cat. 39) is a small pen and ink, focused entirely on the dome and crenelations of the *marabout* of Sidi Berraïsoul. The artist rendered the insouciant vines sprouting where they would between the points of masonry, and a dome surely drawn taller here than it was in reality.

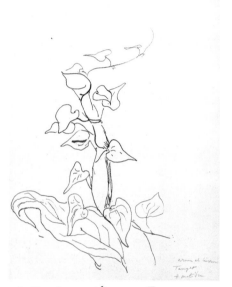

cat. 40. *Arum et liserons, Tanger*

For all of Matisse's exuberant response in his paintings and letters to the dramatic flora of Morocco, until recently not one independent Tangier-period flower drawing was known. It was reasonable to surmise the existence of such drawings, but because the artist drew flowers throughout his mature career, only a drawing actually carrying an inscription of Tangier could be securely attributed to this period. Just such a drawing has emerged: *Arum et liserons, Tanger*, 1912/1913 (cat. 40). Identified, signed, and noted Tangier by Matisse, this energetic, delicate drawing makes one yearn to see his other, now presumably lost, renderings of Moroccan flowers.[27] This Tangier drawing is a closely observed study of many varied heart-shaped leaves of a bindweed, with its climbing tendril becoming a mere wisp of a pen stroke at the top of the sheet, in contrast to the larger, heavier arum leaf at the bottom. It is an unusual composition, seemingly made from nature, perhaps in the lush private Tangier gardens Matisse was so fond of visiting. Pierre Schneider's thesis concerning the inherent florality of the artist's Moroccan figures[28] is further strengthened by the recovery of this singular flower drawing and its relationship to the figure drawings of the so-called 1913 sketchbook(s).

Café maure, 1912/1913 (cat. 41) is yet another revelation. It is Matisse's first known drawing of a complete café scene. Everything is here: the drum players; the violinist; the dancer; the *kif* (hashish) smoker; other members of the audience; their slippers; and,

notably, the artist's inscription "Café maure." The subjects are placed about the drawing sheet in a remarkably direct manner, indeed one almost anticompositional. From these quick illustrative pen lines will come the radically simplified and condensed painting, the ultimate *Café marocain* (cat. 23), which contains the artist's impressions rendered in highly refined, almost elliptical symbols. This surprising drawing, on the other hand, puts down the more descriptive facts, allowing us to "feel" the close quarters, to "hear" the eerie music and the finger cymbals of the swaying dancer, and to "smell" the pungent, intoxicating smoke. It is not at all Matisse's French café but one culturally foreign to him. This one belongs to the Casbah inhabitants and is closest in spirit to the Moorish café depicted by his traveling companion Charles Camoin (fig. 56). Several of Matisse's 1913 sketchbook drawings portray details of Moroccans beside a generic cafélike table or reclining figures presumed to be in a café, but it is this drawing that leaves no doubt as to its source and to the artist's engagement and fascination with the motif.

Two recently located drawings provocatively expand our experience of Matisse's sketching program in Tangier. *Nus de dos et vue de Tanger*, 1912/1913 (cat. 42) is a curious combination of a view of Saint Andrew's church and the Casbah citadel with three nudes. It is a surprising and incongruous work, one that has been conventionally dated to times when Matisse was in Paris. But a close examination of the drawing strongly suggest a Tangier-period date. The church and landscape are the directly observed objects; in his delicate and careful pen lines, the artist worked up a faithful, specific rendition of the view. It is the nudes that are most probably done from memory, for such forms were well known to him through his long tradition of numerous studio studies and sculptures. In 1912/1913 they would represent a continuation of his thinking about his monumental sculptural series, *The Backs*, as well as his paintings of bathers. This drawing may also contain the germ of an idea that led Charles Camoin in 1913 to think that Matisse's final painting about Morocco was to be a "bathers or beach scene."

The three nudes on this sheet depict "types," done in a general way rather than specifically observed. The small and medium-size figures are in thin pen strokes, while the giant model in the center has been drawn by a blunt reed pen. These two models float on the paper field. The third, on the right, is set aginst a striped wall or palisade, with floorboards, in a conventional art school format. The largest figure in the middle is twice the size of the right-hand figure, which, in turn, is almost twice the size of the left-hand figure. The thick reed outline of the giantess in the center emphasizes the smooth

cat. 42. *Nus de dos et vue de Tanger*

flow of her musculature. The middle-size figure is more sculptural, with hatch lines and interior modeling. The small figure is energetically rendered in a relaxed, almost dance-like pose. This curious triad balances the composition not through conventional means, but through character, shading techniques, detail, and the weight of light and dark. It is clear that the artist then filled in the upper right corner with the view from his window at the Hôtel Villa de France in Tangier.

Matisse selected this distinctive drawing to be the frontispiece of his handsomely illustrated album *Cinquante dessins*, which was published in 1920. By this curious prominence, the artist seems to have advertised the central and perhaps unexpected influence of Morocco upon his work, regardless of the drawing's nominal Parisian studio motifs. He created a complex hybrid with a haunting power and evocative message.

Le Soudanais, 1913 (cat. 43) is a rare and beautiful charcoal most probably dating from the Moroccan period. There were Sudanese mercenary soldiers in Tangier at the time, and Matisse would have had little difficulty finding a model. In this drawing we see an alert face, fully modeled from very light gray to darkest blacks, the highlights established by *estompe* erasures. The high cheekbones, full lips, disclike ear and arc of the headdress combine to give a sculptural feeling. Matisse was of course well aware of the Benin bronzes and carved tribal heads at the Musée de l'Homme in Paris, and he collected certain African carvings himself. *Le Soudanais* is a most sympathetic addition to the artists's personal catalogue of the cultural mix of Tangier as seen in his other drawings, notably those of the Jewess Zorah, the Riffian males, or his charcoal/painting of a Berber woman (cat. 11). It is an exquisite head, sensitively rendered with clearly accentuated African features forming a masklike visage, and it bears direct comparison to Matisse's 1912 charcoal of Shchukin (see fig. 121), where there is an equivalent emphasis on racial type, except that the artist's stress with the Russian was on his Asiatic character.

The final extant drawing not physically related to the 1913 sketchbook cycle is a masterpiece, the famous *Trois études de Zorah*, 1912 (cat. 44). Matisse's interpretations of the model, organized with intuitive brilliance on a single sheet of paper, form their own internal "theme and variation." These images exemplify the three ways the artist saw and painted Moroccan women. In the upper left corner of this drawing, the young girl, with rather European features, casts her head down in an introspective way, her eyes averted. Matisse carefully modulated the surface to imply volume through light and shadow, gently sculpting a pretty face reminiscent of the equally sweet features of Zorah in the central panel of the so-called Moroccan Triptych (cat. 13). This introspective character of Zorah is mirrored in the newly discovered Matisse painting of *La Marocaine* (cat. 11), a "drawn" painting, mysterious in its evolution but with a heightened chiaroscuro and emotional mood relating to the artist's treatments of Zorah in this work on paper.

fig. 57. cat. 11, detail,
La Marocaine

The upper right corner of *Trois études de Zorah* contains a frontal "mask," a condensed rendering of the model's head with emphasis placed on the eyebrows, eyes, nose, full lips, and jaw. The eyes are catlike, occluded. There is a distinct sense of the Levant, of an Egyptian pharaonic or Fayum portrait. This more severe characterization relates directly to Matisse's paintings of *Zorah assise* (cat. 10), *Zorah en jaune* (cat. 9), and, in particular, *Zorah debout* (cat. 16); nor should one neglect the curious mask caricature in the upper right corner of the *La Marocaine* (fig. 57). The bottom central portrait drawing depicts a face with more fully black-African facial structure, allowing comparison to the darker-skinned woman, *La mulâtresse Fatma* (cat. 15). In this drawing Matisse plumbed the many aspects of the personality of Zorah and the multiracial culture of Morocco.

Two additional Zorah drawings are unlocated. One is a seated figure faintly visible in the April 1913 exhibition installation of Matisse's Moroccan work at Galerie Bernheim-Jeune, Paris (see fig. 1), and the other is a profile illustrated by Elie Faure[29] (fig. 58).

What we knew previously about Matisse's Moroccan drawings derived from a dozen sketches, most of which were masterful but straightforward portrayals of his hotel window, several early painting ideas, partial renderings of Casbah architectural elements, and studies of Zorah's face. The fifteen "new," non-sketchbook drawings discussed above display a more comprehensive and vital élan. In these the artist shows us new aspects of his search for motifs, his overviews of the ancient city, his more frequent travels through its streets, gardens, cafés, and his trip beyond it. The sum of these

fig. 58. Henri Matisse, *Zorah de profil* (Profile of Zorah), 1912, pen and ink on paper. Location unknown

drawings improves our understanding of his early Moroccan paintings. We sense in Matisse an especially permeable membrane between the discipline of drawing and that of painting. We can imagine his sensations passing almost unhindered, from paper to paint and back again. We also sense an artist excited to be in a new place, under whose spell he could carry on his particularly favorable research.

Matisse's first and second trips to Morocco should not be viewed as two separate and unrelated short trips, but rather as one intense, focused, and creative journey, one of such fascination and strength that it bridged, and, indeed, carried through the brief obligatory interruption of the artist's summer stay in Issy-les-Moulineaux. His summer 1912 paintings are among some of his most glorious and important, made very much under the spell of the Moroccan experiences. Matisse began to think about some of these next paintings and subjects even before his first departure from Morocco.[30] Further, it now seems quite probable that Matisse, knowing of his imminent return in the fall of 1912, left certain paintings and art supplies stored with friends in Tangier.

The drawings should be viewed in much the same manner. Early in 1912 Matisse established several themes that he would take up again later as he continued his research of diverse motifs. He was, thus, stockpiling images both as immediate souvenirs and as direct nourishment for future inquiry or paintings. The so-called 1913 sketchbooks, as they are now reconstituted, remain the drawings most securely attributable to the artist's drawing programs of his second trip.

The Moroccan Sketchbooks

These sketchbooks are a recently discovered group of drawings that has been reassembled from several sources. The first eighteen drawings came from a portfolio of previously unpublished Moroccan-period drawings in a European private collection. The portfolio was brought to the National Gallery of Art for study and technical examination. These were found to be on the same type of cotton and hardwood-content paper, with a perforated left edge, rounded outside corners, and approximately same dimensions (average 25.7 cm height by 19.0 cm width).

Of these eighteen, all but one are in pen and ink, and the remaining drawing is in graphite. All are signed "Henri-Matisse" in Matisse's handwriting; four are signed and further dated 1913, while twelve are signed, dated 1913, and additionally inscribed "Tgr" or "Tanger." Every work that is dated carries the date 1913. Curiously, almost all of these various drawings, when inscribed, were signed in a related script. It is probable that they were signed together after the fact, not one by one as drawn. Keeping in mind Matisse's well-known habit of misremembering exact dates as well as almost anything that had to do with numbers, it may be that when Matisse signed and dated the sketchbook drawings he did so correctly knowing they had come from his second trip to Tangier. But it was a second trip that he would usually recall as being the "year after" his first trip. In truth, the second trip was the season after his first trip and comprised both years, 1912 and 1913. Nonetheless, the second trip extended into 1913, so Matisse dated all of these sketchbook sheets as 1913.

The images depicted are of seated men in traditional costume, profiles of three female heads, a number of street scenes, and several landscapes. Common stylistic qualities also distinguish these drawings and argue for their being viewed as the discrete nucleus of several dismembered, approximately contemporary sketchbooks.[31] The initial group of eighteen came to the Gallery mounted on groundwood pulp boards. On the back of some of these mounts were inscriptions in pencil. The inscriptions, often in idiomatic French, appear to be extracts or transliterations of a text dealing with Morocco or North

Africa. Some page numbers are also inscribed, indicating, perhaps, a plan to use these Matisse drawings as illustrations for a publication. No such book has been found, nor have they been related to other known works of literature.[32]

Seventeen additional drawings can be added to this group, thirteen of which have been located recently and the remaining four of which are known only through reproductions. All of this second group have substantial physical, stylistic, and thematic relations to the core sketchbook group. These combine to make the thirty-five known drawings of the Moroccan Sketchbooks.

This group is of great importance not only because of the brilliant draftsmanship of some of the drawings, but also because so few Matisse sketchbooks are thought to exist. There is a small group of varied but related drawings dating to his visits to Collioure in 1905–1906.[33] There is only one other true sketchbook cycle, from his trip through Italy in the summer of 1925. These Italian sketchbooks, which contain painting and sculpture studies or motifs, were recently documented and exhibited.[34] Additional sketchbooks, possibly relating to his other travels to Tahiti, the United States, or elsewhere, are currently unknown.

Better known is another type of sketching cycle, the famous *Thèmes et variations* of the 1940s that began in his Nice studio as bound spiral notebooks in which the artist produced a sequence of drawings after a model or of still life, progressively internalizing, simplifying, abstracting. Elsewhere Matisse had made a number of important "concentrations" of independent drawings, working quickly on multiple related sheets before a common subject. In particular are the large number of fauve-manner watercolors from Collioure, 1905; obsessive sketches for the Barnes mural *La danse*, 1931–1933; a run of masterpiece pen and ink drawings of the artist and model in the studio, 1935–1940; and a large group of drawings relating to the Chapel du Rosaire at Vence, 1946–1949. These five groups and other extended series of drawings, which all relate to complicated paintings, projects, or illustrated books, cannot properly be called sketchbooks.[35]

Thus, it is in the Moroccan sketchbooks that we can distinctly see and feel Matisse traveling, walking the streets, working, discovering the unexpected. It is only the Moroccan drawings that can be reassembled to give a cinematic sweep of a location. Through these sketchbooks we are brought to the side of the artist as he explored his rich motifs. These sketchbook drawings also display a kind of Matisse pen technique and an architecturalized, compositional drawing style hardly known to us previously. Their qualities add important illumination to a new, amplified definition of Matisse's use of drawing and his relationships to his travels, as he continued his research, as he said, "the search for myself through the probing of various motifs," breaking his visual habits by enforced contact with new light, new cultures, and new scenery. The sketchbooks, as the effective log of his second Moroccan journey, may not always be visually or intellectually inventive, but they do display Matisse's remarkably acute powers of observation. It is neither prudent nor possible to argue for an exact sequence, but for the purpose of this essay the known sketchbook drawings are grouped into related suites by subject.

Within the sketchbooks there is an unusual and strong group of eight drawings after male Moroccans and Berber tribesmen, generically but not always correctly called Rifs or Rif warriors by Matisse. As portrayed in the sketchbooks, these images reveal degrees of the artist's empathetic response and self-identification. On his return to Tangier in October 1912, Matisse wrote that the Sembats had commissioned him to paint a small picture of a Moroccan.[36] This became *La Marocaine*; perhaps *Marocain assis, devant un fond fleuri* (cat. 45) is its male counterpart. The model's head is covered by a *rezza*, his chest by a decorative *bedia*, worn over a *tchamir*; his striped pantaloons are called a *seroual*.[37] This drawing is perhaps closest to the kind of annotated sketches

cat. 45. *Marocain assis, devant un fond fleuri*

fig. 59. Leslie Hamilton Wilson, *Old Te-touan*, c. 1923. ©Harvard University, Carpenter Center for the Visual Arts

made by Delacroix, which are analytical, ethnographic records of costume and posture. Matisse framed the right and bottom edges of the sheet, perhaps planning for another painting.

The most psychologically acute portraits in the sketchbooks are seven drawings of Moroccan men, perhaps independent Berber tribesmen from the Er Rif, called Riffians. It is worth quoting at some length the description of these men written in 1908 by Henry Walsh: "In Tangier, in Tetuan [sic], and in some of the other Moorish towns, one catches occasional glimpses of these haughty, fierce-looking dwellers of the mountains. They can be distinguished by their pride of bearing and by their imperious tones and gestures, as well as by their distinctive dress. About their heads they wrap their gun-cases made of red cloth bespangled with silver; their bare, sinewy arms are entwined with narrow bands of silk, and protrude from out a coarse woolen *jelab*, fitted with a large hood which falls far down over the shoulders. Their legs also are bare and muscu-lar; on their feet they wear sandals of goatskin with the hair outside, and laced with cords of plaited alfa. Across the shoulders is slung a double pouched wallet for bullets, made of red and yellow leather, and set off with silk tufts. At the side hangs a copper powder flask, and a curved dagger. A flint-lock gun with a short stock but a very long barrel, often richly ornamented, completes the outfit of these modern Ishmaelites. The Rifs are eternal rebels, they bow to no authority, and are restrained by no laws."[38]

The most poignant is the graphite sketch *Marocain, mi-corps*, 1912/1913 (cat. 46), rendered in but a few pencil lines.[39] The muscled, powerful tribesman is dressed in the wool *djellaba*, *tchamii*, and *rezza* typical of traditional costume. This Moroccan is the model for three drawings and for two paintings, the famous large *Le rifain assis*, 1913 (cat. 19) and the Pushkin *Le rifain debout*, 1913 (cat. 18). Matisse described his Riffian subject as magnificent, with eyes a bit savage, like a jackal, thinking him also a little feline. There is so little underdrawing on the canvases of his Moroccan figure paintings that such sketchbook drawings must show Matisse perfecting his eye and hand for the essentials of the human subject. His graphite or pen and ink lines are his preparation for the images that will be made by the strokes of his brush. Whereas the paintings treat the faces as aggressive patchworks of colored brushstrokes and frozen expression, the drawing portrays a man with a subtle grace for all his implied ferocity. There is fluidity

in the soft pencil line that depicts this engaging character, with his whisker stubble and curious eyes. His mouth maintains a softness, as if he were ready to speak, only partly approaching Matisse's eventual formulaic "sign" for mouths. There is an immediacy, a credibility, a quality of witness in this and the other sketchbook drawings. Matisse indicated intimate proximity to the subject in an uncontrived atmosphere. He gave no other male portrait drawing of a stranger such character and mental rapport; the other six Riffian drawings only approximate this level of personality.

Marocain, de trois-quarts (cat. 47) is another exquisite rendering, though slightly hard-ened by the pen and ink medium. Hands with immense fingers project from the sleeve slits of the silk-tufted *djellaba*, the cloaked figure softly swells to fill out the drawing sheet. The *Marocain assis* (cat. 48) contains the general pose most closely related to the Barnes Foundation painting, but lacks the physical tension and facial expressiveness. As in almost all the sketchbook drawings, the artist worked in black ink on a pure white ground, without modulation or shading. These subjects appear to be in full sun, as much as Matisse's light-blasted drawings of the Casbah. The artist was not "painting" in any of these drawings, there is no sense of color or tonality. Such drawings are a visual/mental preparation, mastering a motif in its purest components.

The remaining four drawings of men depict a seated figure floating diagonally across the sheet. The model's arms are crossed and he leans back, weightless, spreading from the lower left of the drawing to the upper right. Matisse's genius in the use of negative space and intuitive placement of forms is evident. In *Marocain assis, main au menton I* (cat. 49) he achieved a beautiful balance between all parts of the composition and the elegant draftsmanship. We see the Moroccan tribesman dressed in a costume common to Tangier,[40] with a braided cord holding a sheathed dagger. A distillation of this model and pose is found in *Marocain assis, main au menton II*, 1912/1913 (cat. 50). Assuming a sketching program related to the progressive simplifications found in the *Café marocain* painting and various of his later drawings (most notably the *Thèmes et variations*, where Matisse habitually moved from the figurative to a more cerebral essence), this drawing should follow its more detailed mate. The pose is quite the same but the emphasis is on a more economical and thus content-laden placement of lines in its modeling and contour. The portrait features of the head are gone, as are the supplemen-tary pen strokes describing the flow of the sitter's costume. Some of the doubled lines

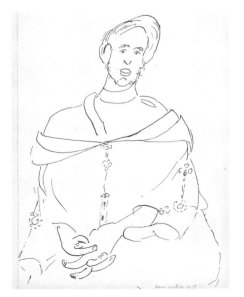
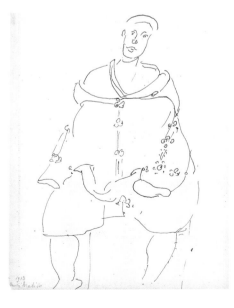

left: cat. 47. *Marocain, de trois-quarts*

right: cat. 48. *Marocain assis*

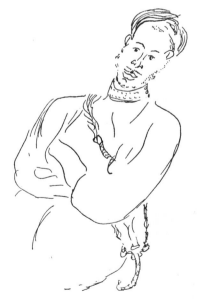

setting the Moroccan's legs in the previous drawing have become continuous single lines here. The effect is the capturing of a form in a less tentative or personalized fashion. Matisse grasped the fundamental rhythms and desired elements while he discarded the extraneous. We are left with a symbol of a seated Moroccan.

The *Marocain assis, de trois-quarts, les bras croisés*, 1912/1913 (fig. 60) relates to Matisse's more explicit portraitizing. The model is carefully documented, with beard stubble, details on his collar, the braided dagger sash holding a more clearly rendered knife handle and sheath. We see a man closely related to those in the Riffian paintings. If *Marocain assis, les bras croises*, 1912/1913 (cat. 51) is compared to the previous drawing, we see that Matisse accentuated its rhythms and linear arabesques in this latter one. The graceful flow of lines and forms dominates as the headdress drifts to the right,

above left: cat. 49. *Marocain assis, main au menton I*

above right: cat. 50. *Marocain assis, main au menton II*

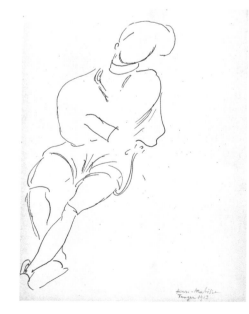

left: fig. 60. Henri Matisse, *Marocain assis, de trois-quarts, les bras croisés* (Seated Moroccan, Three-Quarter Length, Crossed Arms), 1912/1913, pen and ink on paper. Location unknown

right: cat. 51. *Marocain assis, les bras croisés*

132

cat. 52. *Trois têtes*

cat. 54. *Deux personnages allongés*

the dagger becomes an extended S curve, and the clothing billows around the torso before it finally smooths into the crossed legs and slippers.

Such open, sinuous rhythms continue in three other drawings of people seen in cafés or as passersby. *Trois têtes* (cat. 52) renders right, back, and left views of the same top-knotted woman (or perhaps three women) quickly sketched. In a fast drawing it is "the line that rules,"[41] and this is yet another example of the wit and character of Matisse's sketchbook drawings. *Soldat marocain et Hamido* (cat. 53) depicts two men from the back, presumably in a café. The figure on the right, with his hair in a long queue, is probably the soldier. Hamido on the left is in the elegant clothes of a citizen of high social standing, replete with conical fez. Curves and arabesques prevail. Hamido's left leg and foot are as graceful as the splayed legs of the café table. The upturned top mirrors the circular form of the soldier's head and the crown of the fez.

The sliding gesture of Matisse's pen is felt throughout the Moroccan drawings, as the artist himself became absorbed by the gentle climate and casual social atmosphere, where hours are spent in cafés sipping mint tea or smoking, marked by the recurring calls to prayer. *Deux personnages allongés*, 1912/1913 (cat. 54), like *Café maure* (cat. 41), is most probably a drawing preliminary to the major painting *Café marocain* (cat. 23).

It is no critical revelation that Matisse's art of the 'teens evolved from what came before and, subsequently, influenced what came after. But if we place this first group of eleven sketchbook figures into such a perspective they suggest a conspicuous new development. To begin, one area of Matisse's graphic style of 1906 favored a clean, elegant line upon a largely white ground. Examples of this style are found in his ink portrait of his daughter[42] and a number of lithographic studies from posed nudes,[43] which establish a group of unusually "classic" objects curious for a period when the artist more frequently worked by hatching, shading, and more fully describing the settings.

There seem to be few if any works carrying this classic style for the next six years. But the drought was apparently broken by the deluge of drawings in Morocco. The style was revived, particularly in the sketchbook figure and Riffian "portrait" studies, and these, in turn, seemed to encourage Matisse's voluminous drypoint figures and portraits of 1913 and 1914,[44] as well as the later etchings of the mid-teens and twenties.[45] From that point forward Matisse's signature line and ground in pen and ink drawing, etching,

cat. 53. *Soldat marocain et Hamido*

monoprint, and occasional lithographs would be supremely evident and increasingly famous. There were no Moroccan-period prints, but it can safely be said that the Moroccan sketchbook figure drawings gave birth to subsequent graphic works of profound consequence.

The combination of his Moroccan figure paintings and drawings seems to have set the style for an equally remarkable group of 1913/1914 portrait paintings. The sitters' bodies and features are freely set by thin paint, betraying their roots in drawing. The color is scumbled on, in a thin glazing style common to his 1912/1913 paintings. The coincidence is too strong to ignore when there is such a localization of remarkable works: *Portrait de Mme Matisse*, 1913 (State Hermitage Museum, Leningrad); *Marguerite in a Leather Hat*, 1914; *Marguerite in a Hat with Roses*, 1914; and *Jeune femme au chapeau corbeille*, 1914.[46]

The fact that many of the next group of sketchbook drawings may come late in his stay, after Matisse had finished so many paintings, suggests that Matisse may have gone about Tangier sketching with his friends Charles Camoin and James Wilson Morrice.[47] Comparisons of their sketches suggest that the artists worked side by side. Each, however, had distinctly different goals and levels of achievement. Morrice's dozens of sketches show quick broad jottings on a small scale, more energetic than disciplined (figs. 61–65). Camoin's drawings are more fully detailed, literal, or scenographic (figs. 66–70). Matisse's sketchbooks are freer, with more purposeful artistic intention. He ex-

above left: fig. 61. James Wilson Morrice, *Study for "View from a Window, Tangier,"* page 16, *Sketchbook no. 6,* 1912/1913. The Montreal Museum of Fine Arts' Collection, Gift of F. Eleanore and David R. Morrice, Dr. 1973.29

above right: fig. 62. James Wilson Morrice, *North African Landscape*, page 11, *Sketchbook no. 6,* 1912/1913. The Montreal Museum of Fine Arts' Collection, Gift of F. Eleanore and David R. Morrice, Dr. 1973.29

below left: fig. 63. James Wilson Morrice, page 3, *Sketchbook no. 6,* 1912/1913. The Montreal Museum of Fine Arts' Collection, Gift of F. Eleanore and David R. Morrice, Dr. 1973.29

below right: fig. 64. James Wilson Morrice, page 5, *Sketchbook no. 6,* 1912/1913. The Montreal Museum of Fine Arts' Collection, Gift of F. Eleanore and David R. Morrice, Dr. 1973.29

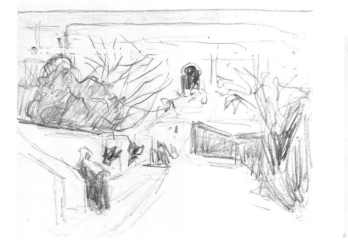

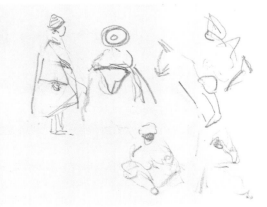

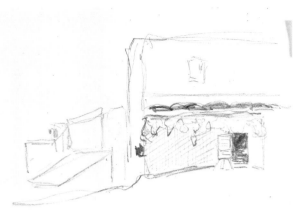

ploited contours and rhythms, using the drawings for study and for evident self-expression. These sketchbooks served as Matisse's camera, both a still camera and a movie camera. Sometimes he stationed himself before a monument and made his "picture postcard"; at other times he paced through the Casbah executing sequential drawings.

This final group of sketchbook drawings can be organized to suggest a Matissian tour through a luminous Casbah and medina. Each of the drawings has a translucence, in which a thin, almost weightless web of lines is applied to all white paper, the sheet becoming the equivalent of a lighted membrane. They have a unique, delicate, diaphanous or transparent quality. Matisse did not shade the drawings or render three-dimensional blocks of material. Rather he emphasized contours, "oriental" rhythms, the remote, faraway nature of the place, something other than European space, light, or culture.

Matisse used white here in a pictorial way even more powerful than his historic use of black. This white ground is advancing, expanding over the wiry, staccato black strokes. Under the force of the Tangier sunlight, with the reflections from white buildings washing out shadows, the mass of white overtakes the form leaving only a slight edge, to the extent that even a cast shadow is rendered by a simple line. Matisse accepted this as something new, and he did not rebalance by hatching or halftones. It is left to the

above: fig. 65. James Wilson Morrice, *Study for "Tanger,"* page 29, *Sketchbook no. 6,* 1912/1913. The Montreal Museum of Fine Arts' Collection, Gift of F. Eleanore and David R. Morrice, Dr. 1973.29

below left: fig. 66. Charles Camoin, *Sultan's Palace,* 1912/1913. Private collection

below right: fig. 67. Charles Camoin, *The Marabout of Sidi Hosni,* 1912/1913. Private collection

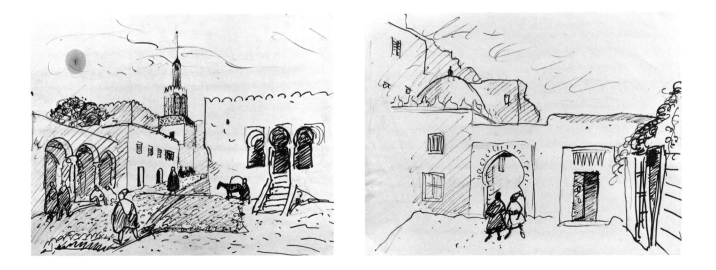

viewer to invest indicated shadows with weight, and suggested voids with space. Matisse exploited this paradoxically Arctic purity; these experiences provided substantial nourishment for his subsequent graphic art, including his 1914 *chine collé* etchings and the 1930 Mallarmé *Poésies*.[48]

Matisse's Moroccan sketchbook drawings are inherently authentic, both personally and historically. The artist maintained an objective truth, demonstrating a particular mental rapport with his subjects. He held these compositions together by quirkily selected details of native costume, cobblestones, door handles, ogival archways, and oddities of the antique geometry of the Casbah, all very different from that of France. And because of these details, many of his drawing sites can be found today.

To begin an imagined walking tour of Matisse's Tangier, six drawings record views from outside the Casbah walls. The first, *A la porte de la Casbah* (fig. 72), depicts the northern entrance to the old city (fig. 73). The next two (fig. 74, cat. 55) show possibly the Bab el Aassa from below, where men and women, donkeys and children come and go. In the background of these and two more (figs. 75, 76) we see the minaret of the Casbah Mosque. The four constitute a cinematic sequence, where the wall on the far right of *Porte avec deux ânes et leurs cavaliers* (fig. 74) is large and long and in the next two (cat. 55, fig. 75) the wall becomes shorter, indicating that the artist moved closer to the intersection. In the last (fig. 76), the wall has been passed and we could be about to turn right to mount the incline to the gate. The Forbes Collection graphite (fig. 77) sketches

above left: fig. 68. Charles Camoin, *Bab el Aassa*, 1912/1913. Private collection

above right: fig. 69. Charles Camoin, *House and Bay of Tangier*, 1912/1913. Private collection

below: fig. 70. Charles Camoin, *Two Figures with House and Lattice*, 1912/1913. Private collection

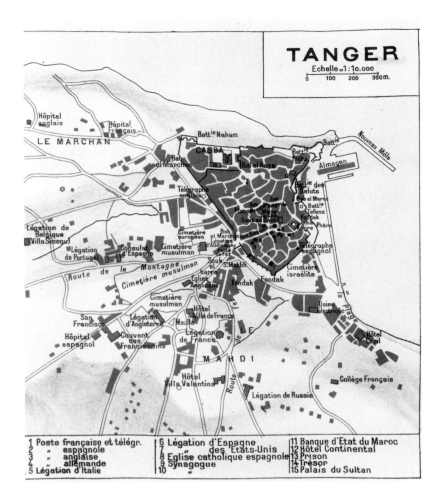

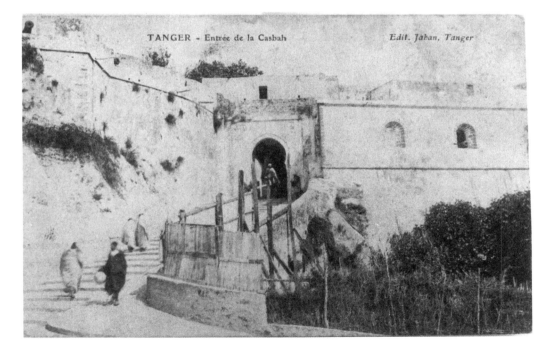

above left: fig. 71. *Tangier*, 1914. Geography and Map Division, Library of Congress

above right: fig. 72. Henri Matisse, *A la porte de la Casbah* (At the Casbah Gate), 1912/1913, pen and ink on paper, 25.7 × 19 (10¹/8 × 7¹/2), signed l.l. in pencil: *"Henri-Matisse Tgr 1913"*; inscribed on back of former mounting board in pencil by another hand: *Des théoris de femmes drapées/s'enviennent à la fontaine/p.137.* Private collection

left: fig. 73. *Tanger, Entry to the Casbah*, postcard from Matisse. Archives de la famille Manguin

fig. 74. Henri Matisse, *Porte avec deux ânes et leurs cavaliers* (Gate with Two Donkeys and Their Riders), 1912/1913, pen and ink on paper, 25.8 × 19 (10⅛ × 7½), signed l.r. in pencil: *Henri-Matisse/Tgr 1913.* Private collection

cat. 55. *Porte avec âne et personnage*

fig. 75. Henri Matisse, *Rue de Tanger, deux passants* (Tangier Street, Two Figures), 1912/1913, pen and ink on paper, 25.8 × 19 (10⅛ × 7½), signed l.l. in pencil: *H. Matisse Tgr 1913.* Private collection

fig. 76. Henri Matisse, *Rue de Tanger, trois passants* (Tangier Street, Three Figures), 1912/1913, pen and ink on paper, 25.8 × 19 (10⅛ × 7½), signed l.l. in pencil: *H. Matisse 1913 Tanger.* Private collection

another street in the vicinity, possibly depicting the minaret of the mosque at its upper right corner.

In these and many subsequent sketches Matisse put himself and the viewer squarely into the scene, as the tracery of lines spreads outward to the paper edges. *Casbah: Marabout et drapeau*, 1912/1913 (cat. 56) puts us back in the complicated architectural play of the streets, beneath an overhang slicing the upper right corner, walls notching upward to the sky filled with indications of clouds. A flag flutters in the prevailing Atlantic breezes of Tangier.[49] The dome floats above the building walls, not unlike a related construction in Matisse's 1915–1916 painting, *Les Marocains* (cat. 24).

In *Terrasse dans la médine*, 1912/1913 (cat. 57), the rapid stenography, the bursts of short pen and ink lines, give an impressionistic effect as the artist organized his view, his experiences. This drawing has its own special charm and immediacy, but it was not

above left: fig. 77. Henri Matisse, *Tanger (Tangier)*, 1912/1913, pencil on wove notebook paper, 25.1 × 19 (9⅞ × 7½), signed l.r. in pencil: *Tanger/HM*. The Forbes Magazine Collection, New York

above right: cat. 56. *Casbah: Marabout et drapeau*

left: cat. 57. *Terrasse dans la médine*

until the very recent discovery of two small sketches (probably from a pocket-size pad) and another related larger sketchbook sheet that the historical importance of all four works could be divined. In short, this particular group of four previously unpublished drawings creates a locus of observations and stylized rendering that Matisse must have consulted not only as he painted his 1912–1913 *Café marocain*, but also as he began his preliminary work in 1915 for his later monumental canvas of 1916, *Les Marocains*.

The graphite sketch *Terrasse et dome dans la médine* (fig. 78) portrays the same terrace, steps, railing and plants as *Terrasse dans la médine*, but with a view turned to the left, towards a *marabout* dome. An even more spontaneous rendering than the larger pen and ink terrace drawing, the pencil sketch undeniably connects this particular terrace, its same railing and dome, to the scene depicted in the upper-left quadrant of *Les Marocains*. The larger sketchbook *Café I*, 1912/1913 (fig. 79) depicts five figures (one is drinking, the other four lounge about). We see glasses, slippers, floor mats, and have a sense of a languid, exotic atmosphere. The abstracted, floating figures are like those of the painting *Café marocain*. The last of this drawing group is the small sketch *Café II*, 1912/1913 (fig. 80), which gives another quick rendering of the scene.

These café drawings, as well as the *Terrasse et dome dans la médine*, display a remarkable kinship to Matisse's subsequent *croquis* in his important letter of 22 November 1915 to Charles Camoin (see fig. 143). In this letter Matisse described his current plans for *Les Marocains* (though the painting would evolve into a rather different composition by its completion the following year).[50] If the two small sketches (figs. 78, 80) were not so observed, so indicative of an eyewitness, and so sharing of many common characteristics with the two larger 1913 Tangier sketchbook drawings (cats. 57,

fig. 78. Henri Matisse, *Terrasse et dome dans la médine* (Medina Terrace and Dome), 1912/1913, pencil on paper, 16.2 × 9.5 (6³/₈ × 3³/₄). Private collection

fig. 79. Henri Matisse, *Café I*, 1912/1913, graphite on paper, 26.5 × 21 (10¹/₁₆ × 8¹/₄), signed l.l. in pencil: *Tanger/HM–*. Private collection

fig. 80. Henri Matisse, *Café II*, 1912/ 1913, pen and ink on paper, 17.5 × 7.6 (6⁷/₈ × 3). Private collection

60), one might be tempted to date them closer to 1915. A more reasonable proposition, and one consonant with Matisse's working methods, however, is to imagine Matisse consulting all four of these works before composing his 1915 *croquis* for Camoin, a *croquis* that until now was the only known study relating to *Les Marocains*.

For the first time we can see that this 1915 *croquis* summarizes his thinking of the previous two years. Matisse began with what he knew, returning to the specifics of Tangier in 1912–1913 as documented in his previous drawings. The drawings do not coincide item by item with the final later products, but they clearly supplied a starting point. Through their idealized conflation these four drawings gave back to Matisse his own real experiences of Moroccan cafés, its Moroccan patrons and a terrace overlooking Tangier. From these and other sketchbook memories the artist composed the *croquis* of 1915 as a first plan for what would become by 1916 *Les Marocains*, one of Matisse's grandest souvenirs of Morocco.

cat. 58. *Médine: Maisons et treillis fleuri I*

Another group of nine Tangier drawings forms an exciting and remarkably complete panorama of the small plaza located just outside the Bab el Aassa. The works can be arranged in a striking mobile sequence where Matisse came into the plaza and made drawings from every angle, turning about to almost every corner. This established a new kind of theme and variation for him. It is not that of a painter who would take a subject and subsequently work on single-view modifications. Rather, these drawings are like those of a sculptor, inspecting a solid architectural presence from front, back, sides, circling the subject. Matisse worked here not only in time but also space. These nine plaza sketches are a rare panorama, and there are neither preceding nor subsequent examples in his oeuvre for such a moving inspection. Even his sculpture series (*Back I–IV; Jeannette I–V;* and *Henriette I–III*) maintain a more limited fixity.

The drawing sequence is introduced by a sheet showing a narrow street with building overhangs supported by diagonal braces and, in the right corner, a flowered trellis, *Médine: Maisons et treillis fleuri I,* 1912/1913 (cat. 58). There is an unusual underdrawing in this work, where a number of pale red pencil lines block in the general architectural

features. One senses the artist roughly planning the sheet to emphasize the cramped passageway, looking like a canyon lined by looming, top-heavy buildings. Then his more permanent ink lines trace over the preliminary sketch. No other known sketch-book drawing retains evidence of such initial planning. Next may come *Médine: Maisons et treillis fleuri II*, 1912/1913 (cat. 59), a vignette with the same kind of scene but now closer to the trellis and buildings. The sky of the previous drawing is reduced while the mass of the houses increases, indicating we are moved visually forward.

In the subsequent drawing *Médine: Maison arabe au treillis et marabout*, 1912/1913 (cat. 60), we seem to emerge into a plaza. This is a remarkable drawing, capturing one entire side of this open space, with a *marabout* dome down the hill to the left and a specific house occupying the right half of the composition. We know this particular structure fascinated the artist. Matisse portraitized this house not only here but both visually and verbally in a wonderful illustrated letter of mid-November 1912 to his daughter. He described the house as follows: ". . . The small house that you see on the right, through the opening of the gate, is a small marvel. It's an Arab house constructed like this [illustration of the house]. It is painted in bluish whitewash and the ground floor, a little set back, is a palisade of dark blue thin wood upon which sprout enormous dark violet morning glories. . . ."[51] Charles Camoin drew and painted from the same subject, rendering in his oil the subtle colors of the building and the lush flowers and blue trellis (see fig. 136).

Thus again we are presented with a specific relationship of subjects and images where Matisse and his fellow artists can be seen exploring Tangier together. In our constructed promenade through this plaza a close-up, *Médine: Treillis fleuri*, 1912/1913 (cat. 61), follows, depicting this trellis and flowers with a longer view to an expanse of other buildings and doorways. We remember also the painting *Porte de la Casbah* (cat. 14), which contains a portal through which lush (now dark pink) flowers grow on this house. In the drawing the flowers are treated in some detail, almost as a still life precariously perched upon a cross-hatched tablecloth. An unlocated pen and ink drawing (fig. 81) shows this particular house looking down the streets in front and behind it. Two

left: cat. 59. *Médine: Maisons et treillis fleuri II*

right: cat. 60. *Médine: Maison arabe au treillis et marabout*

cat. 61. *Médine: Treillis fleuri*

right: fig. 81. Henri Matisse, *Médine: maison arabe au treillis, passants et minaret* (Medina: Arab House, Trellis, Figures, and Minaret), 1912/1913, pen and ink on paper. Location unknown

additional sketches, *Médine: Porte, Marocain assis* (cat. 62) and *Médine: Porte, Marocain debout* (cat. 63) shift the focus back around to the plaza proper. The first emphasizes the junction of three architectural units, with a line of low hills behind. The second sketch records the same door seen previously, now with a pointed arch and a long diagonal line depicting the shadow cast by the awning.

In the striking *Médine: Deux portes* (cat. 64), the architecture appears as if constructed of elegantly wavering thin wires, dematerializing the stucco of the pure white walls. Matisse again carefully rendered the play of walls, rooflines, entrances, windows, and porches. He captured, in effect, the composite, additive nature of the Casbah. But it is an empty plaza, this time portraitizing the buildings, like the preceding Arab house and trellis. For only the second time in the eight views of the plaza there is no anecdotal human figure. In the last known sketch in this sweeping visualization, *Médine: Place*,

below left: cat. 62. *Médine: Porte, Marocain assis*

below right: cat. 63. *Médine: Porte, Marocain debout*

Marocain assis (cat. 65), the view is more distant and we now discover a terrace with a quickly drawn male figure. Matisse devoted an almost surprising effort to depicting the plaza's rough cobblestones, a little fence, roof material, the planks and studs of the door, and a cloud study in the sky. This stenographic technique is, in some cases, related to the neo-impressionist facture found in his fauve period drawings made in the south of France around 1905.

The pictorial and mental expansiveness of these scenes, in which artist and viewer have been placed well within the moving drawing scene, is further emphasized by contrast with four drawings in which the artist and viewer are more remote. *Palais du Sultan*, 1912/1913 (cat. 66) is the most explicit, a rather stiff drawing where the artist framed a scene not far removed from numerous postcard views of the same palace, a building complex today housing the Musée de la Casbah (fig. 82). *Deux vues de Tanger,*

above left: cat. 64. *Médine: Deux portes*

above right: cat. 65. *Médine: Place, Marocain assis*

below left: cat. 66. *Palais du Sultan*

below right: fig. 82. "Sultan's Palace." *National Geographic*, March 1906, page 124

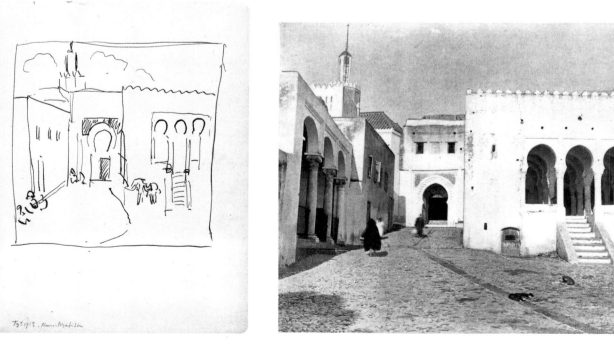

cat. 67. *Deux vues de Tanger*

1912/1913 (cat. 67) records another view of a *marabout* dome, surmounted by a harbor scene complete with steamships, in the compositional style of Matisse's friend Albert Marquet.

La baie de Tanger, 1912/1913 (cat. 68) places the viewer well outside the city to see the broad horizontal expanse of the bay, in reminiscence, perhaps, of Matisse's previous horse and rider study of 1912 (cat. 27), as well as the extended horizon visible through the implied window in the marvelous 1912/1913 painting *Fenêtre ouverte à Tanger* (cat. 22). *Tanger, l'eglise anglaise*, 1912/1913 (cat. 69) returns us to Matisse's hotel room, looking down on Saint Andrew's Church. This detailed drawing is related to his pre-

below left: cat. 68. *La baie de Tanger*

below right: cat. 69. *Tanger, l'eglise anglaise*

vious and equally scenographic *Paysage vue d'une fenêtre* (cat. 12) of the Moroccan Triptych as well as the three earlier 1912 drawings showing the open windows, still lifes, or decorative floral wallpaper (cat. 29, figs. 44, 45).

Two published but unlocated drawings complete the known cycle of Moroccan sketchbook drawings. *Environs de Tanger*, 1912 (fig. 83) is another of his impressionistic landscape pen and ink renderings, showing several small structures outside the city, with an entry portal, fences, and possibly some of the characteristic Moroccan barrier plantings of cacti around the houses. Then there is a curious, almost humorous *Etude de bétail, Tanger* (fig. 84), more properly perhaps a study of ox horns and heads. In the five portrayals on this sheet, the artist rendered one in the lower left as a formal analysis reminding us of the later Picasso sculpture that transformed a bicycle seat and handlebars into a bull's head, or vice versa.[52] The three larger studies in the center and right of the sheet portray other animal attitudes.

The Moroccan sketchbooks do not necessarily contain formal plans or strict preparatory studies for his Moroccan paintings. Rather, they seem to be his nutrient material, his acquisition of motifs. Matisse told his students, "Drawing is like an expressive gesture, but it has the advantage of permanency."[53] Fourcade has sensitively analyzed Matisse's uses of drawings, writing that the artist "drew before, during and after his

above: fig. 83. Henri Matisse, *Environs de Tanger* (Environs of Tangier), 1912, pen and ink on paper, 19.5 × 25 (7⅝ × 9⅞), signed l.l. in pencil: *Henri Matisse Tanger 1912.* Location unknown

below: fig. 84. Henri Matisse, *Etude de bétail, Tanger* (Study of Cattle, Tanger), 1912, pen and india ink on paper, 16.5 × 25.1 (6½ × 9⅞), signed l.l. in pencil: *Henri Matisse Tgr 1912.* Location unknown

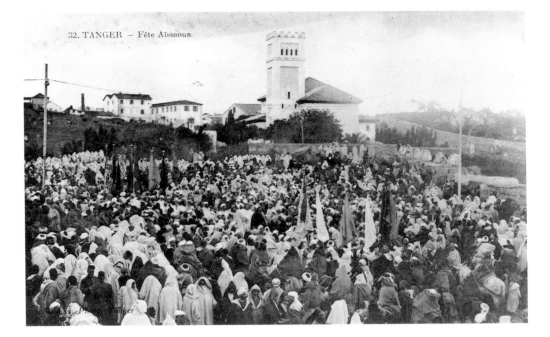

32. TANGER – Fête Aïssaoua

fig. 85. *Tangier-Aïssaoua Festival*, post-card. Archives Henri Matisse

painting. That is to say to prepare, or to help, or extend his painting work, and eventually, in these three cases, to precede it, equal it or surpass it."[54] The combined intensity of the 1913 sketchbooks and the earlier drawings offers a convincing demonstration of Matisse's expressive posture, of his energetic response to new and different stimuli. Here in Morocco he was indeed deeply involved in the research of diverse motifs to be made firm, permanent, and accessible.

Matisse was well aware of the political complexities of northern Morocco, and Tangier in particular. It was an international mixture: the Spanish controlled the area east of Tangier, to include Tetouan. Tangier, under a French protectorate, was a heterogeneous city where many nationalities gathered.[55] He was staying in a French hotel, looking at an Anglican church, the nexus of the English community. The hotel and the church fronted on the Grand Socco, the central marketplace of Tangier (fig. 85), which opened directly into the Muslim world of the Casbah with its mosques, *souks*, cafés, dark alleys, and narrow streets leading to unexpected discoveries at every turn. One heard not only the Christian bells, but also the *muezzins* calling Muslims to prayer. Matisse could not escape this curious microcosm, where European cultural tribes abutted those of North Africa, and he more than once remarked on the exotic differences.[56] The reassembled Moroccan sketchbooks strongly convey the effect that Matisse captured his "Africa."[57]

I propose that the artist continued to make sketches, stockpiling additional Moroccan souvenirs for future use, even after he had finished his major 1912 and early 1913 paintings. We know that Matisse had every intention of returning to Tangier in the fall of 1913.[58] Thus the artist's sketches could have been a necessary aid, so that he would arrive in Morocco primed for work, seduced, nourished by the rereading of his art "diary." The visits to Tangier, while being far from his last travels, represent, through his drawings instead of the paintings, his most outward-looking voyage. It is these drawings that reveal broad new facets of Matisse. The Moroccan sketchbook drawings also stand as Matisse's own journal in clear visual and intellectual homage to his provocative nineteenth-century predecessors, the great artist Eugène Delacroix and the popular author Pierre Loti.

After Morocco, Matisse was a more private, internalized artist as he considered subject matter and sources. Yet it must also be said that from 1913 to his last works Henri Matisse was always "returning" to Morocco. Noting especially the drawings, he portrayed himself in his 1916 *Autoportrait* (cat. 70) with a towel wrapped about his head, writing to Gustave Kahn: ". . . I find myself a bit Moroccan with my towel on my head and it is this that gave me the idea to sketch myself."[59] Such linkages continued throughout the next three dozen years. His monumental ten-foot-high brush drawing *Saint Dominique*, 1949, for the Chapelle du Rosaire, Vence (fig. 86), with all its religious vestments and serenity, coexists as a grand standing Moroccan Riffian in native *djellaba*

fig. 87. Henri Matisse, *Deux Femmes* (Two Women), 1951, crayon on paper. Private collection

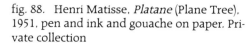

fig. 86. Henri Matisse, *Saint Dominique*, study for the Chapelle du Rosaire, Vence, 1949, pen and ink with gouache. Musée Matisse, Nice

fig. 88. Henri Matisse, *Platane* (Plane Tree), 1951, pen and ink and gouache on paper. Private collection

cat. 70. Henri Matisse, *Autoportrait* (Self Portrait), 1916, pen and ink on paper, 21 × 13.5 (8¼ × 5¼). Private collection

related to his 1913 sketchbooks. *Deux Femmes*, 1951 (fig. 87) offers suggestive glimpses of gandoura-draped Zorahs or Fatmas. Matisse's great *Platane* drawings of 1951/1952 (fig. 88) remind us of the lush foliage of his Moroccan gardens.[60] Edith Wharton grasped an essential quality of the place when she wrote in 1920: "To touch the past with one's hands is realized only in dreams; and in Morocco the dream feeling envelops one at every step. . . ."[61] And until he departed this earth, Matisse never left the many special qualities and impressions so enthusiastically gathered during his Moroccan period, as he pursued the search for his artistic self through the exploration of various motifs.

1. Courthion 1941, 101. Matisse: "à Tanger . . . j'ai travaillé, toujours poursuivant le même but, c'est à dire, au fond, la recherche de moi-même à travers des motifs divers." Thanks to Anna Brooke, librarian, Hirshhorn Museum and Sculpture Garden, Washington, who during her research sabbatical at the Getty Center made the pertinent extracts of this manuscript available to us.

2. I am especially grateful to the members of the Matisse family in Paris, Pontoise, and New York for their patience and interest which became excitement, support, and discovery as my search for drawings continued for almost two years. The Archives Henri Matisse generously provided initial references. I hope the new information contained in the present essay might now repay some of my debt to them by adding substantially to the Archive's documentation.

Thanks also to Laura Coyle, research assistant at the National Gallery. While being responsibly involved in many other areas of this present publication and exhibition, she nonetheless provided excellent, wide-ranging support and intelligent contributions to my research and writing.

I deeply appreciate the many impressions and ideas about Matisse so generously offered by my colleague Pierre Schneider. His attitudes and perceptions have added to my understanding of a most complex artist. My thanks also to Sir Lawrence Gowing for reviewing this manuscript in preparation and for his suggestions leading to various improvements.

I owe a special debt of gratitude to Elena Coon Prentice, director of the Tangier American Legation Museum. She was a most energetic and effective guide in my research of Tangerine history. The

library of the Legation Museum and many other doors in Tangier were opened to me by Ms. Prentice.

3. John Golding, "Introduction," London 1984a, 10.

4. Three sketchbooks are in the collection of the Louvre, and a fourth is at the Musée Condé, Château de Chantilly. The Louvre album (RF 1712bis), the Chantilly album, and the Louvre album Moreau-Nélaton (RF 9154) were published in two facsimile volumes: Jean Guiffrey, *Le voyage de Eugène Delacroix au Maroc I* (Paris, 1909).

5. Delacroix's *Noce juive dans le Maroc*, 1837–1841 (fig. 11), entered the Louvre in 1874 and *La prise de Constantinople par les croisés*, 1840 (fig. 89), after being in Versailles, came to the Louvre in 1885. Another much smaller version was given to the Louvre in the Donation Moreau-Nélaton in 1907, being exhibited at the Musée des arts décoratifs from 1907 to 1934. Maurice Serullaz, *Mémorial de l'exposition Eugène Delacroix* (Paris, 1963), 221–224, 230–231, 328–329.

6. *Au Maroc* was an extremely popular travel diary published by the Frenchman Julien Viaud (pseudonym Pierre Loti). The travelogue appeared first in installments for *L'Illustration*, August to October 1889, documenting the experiences of Loti as he accompanied a French ministerial caravan on expedition from Tangier to Fez the preceding spring. Loti compared the endearing native qualities of the Muslims' traditional social and religious customs to the unfortunate contemporary encroachments of modern Europe, expressing his lament that such outside influences were accelerating the decline of a noble Islamic world and Old Morocco. See Michael G. Lerner, *Pierre Loti* (New York, 1974), 88–91.

7. Pierre Loti, *Morocco* (Philadelphia, 1914, English translation), 13.

8. The adventurous Matisse was forty-two years old when he set off for Morocco. It was a sixty-hour voyage by ship from Marseilles but, as we can see in contemporary photographs, Morocco remained a remote, foreign land, only recently stabilized through the diplomatic accords of 1911. For Matisse, 1912 was less than seven years after the infamous "fauve" Salon d'Automne in Paris where his paintings had fueled critical scandal and established his reputation. From 1907 through 1911 he had completed a group of monumental, radical paintings (*Le Luxe I* and *II*, *Bathers with a Turtle*, *La desserte rouge*, *La danse*, *La musique*, *L'atelier rouge*, *La conversation*, among others), and his arrival in Tangier in January 1912 was but three months after his trip to Russia where he was the toast of Moscow.

9. While not referring to this drawing, but to another now unlocatable work, Matisse remarked to Courthion on his awareness of Delacroix: "J'ai travaillé à la Kasbah, dans un café arabe dominant toute la rade, et de là j'ai vu tout le paysage que Delacroix a copié pour mettre dans *La prise de Constantinople par les croisés*. J'en ai fait un dessin qui est extrêmement exact. Et je ne m'en attribue pas la découverte: on me l'avait indiqué. Le paysage de Delacroix dans *La prise de Constantinople par les croisés* est la vue de la Kasbah avec le fond des collines qui environne Tanger." Courthion 1941, 102. Old maps of the Casbah show a café, the Café Maure, located by the old walls, overlooking the Atlantic and bay beaches of Tangier.

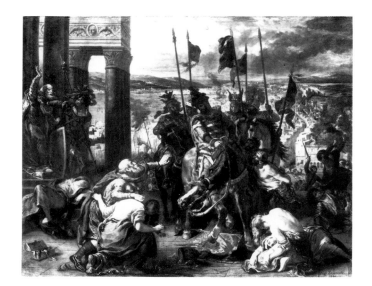

10. Russell 1969, 70. The present whereabouts of this letter is not known. The photo credit in the Russell book mentions the late Professor John Dodds, who taught at Stanford University.

11. Flam determined the room number empirically during his visit to Tangier in 1981. Flam 1986, 499 n. 16. To the best of my knowledge, the actual 1912–1913 hotel registers have not been located. Evidence in Matisse's letters suggests that the artist may have worked for short periods of time in other rooms or studio spaces, borrowed from either his friends (he mentions "the Spaniard") or friends of the hotel proprietor, Mme Davin. Another name mentioned in Matisse's letters is Mme Sicsú. Much remains to be discovered concerning Matisse's surprisingly broad acquaintanceship with the international community in Tangier. The city is one of long lineages, among both the Moroccan citizens and the Europeans and Americans. I want to thank especially Mme Maricha Lorin of Paris and Tangier for her efforts on our behalf in search of the missing Hôtel Villa de France materials. Mme Rachel Muyal, Mrs. Taylor, Thomas Govan, and honorary British consul W. Pulleyblank were most generous with their time and energies assisting my search for references to the Davin, Sicsú, and Brooks families. M. Georges Bousquet, director, Centre Culturel Français de Tanger, suggested a number of contacts relating to the Moroccan and French communities. I appreciate the interest of Annalee Newman pertaining to Nahon family members, whose Tangier properties were near those of the Brooks family.

12. See *Collioure, Drawing of a Window*, 1905, 25 × 19 cm, and the critically important painting, *Fenêtre ouverte à Collioure*, 1905, 55 × 46 cm, reproduced in Schneider 1984, 220, 221, respectively.

13. Faure 1920, 37, 43.

14. *The Violinist at the Window*, 1918, see Cowart 1987, 21. A representative charcoal drawing of a female model is *Violinist at the Window*, 1924, ill. London 1984a, 183.

15. See London 1984a, ill. 179.

16. Among the many popular drawing instruction books available during the late nineteenth century

fig. 89. Eugène Delacroix, *La prise de Constantinople par les Croisés*, 1840, oil on canvas. Musée du Louvre, Paris

in France were three by G. Fraipont, *L'art d'appli-quer ses connaissances en dessin* (Paris, 1897). *L'art de prendre un croquis et de l'utiliser*, 7th ed. (Paris, 1899), *Le dessin à la plume* (Paris, n.d.); and Guerlin's *L'art enseigné par les maitres: le Dessin* and E. Valton's *Méthode pour dessiner: 'conseils pratiques'* (Paris, n.d.).

17. Cowart 1972, 131, and Valton n.d., 69.

18. Eugène Carrière, "L'enseignement d'art et d'e-ducation: Ecrits et lettres choisis," *Mercure de France* (1919), 17.

19. Cowart 1972, 132.

20. Especially as these drawing conventions related to the artist's transition from impressionist/neo-impressionist/divisionist practices to a more independent fauve manner, see Cowart 1972, 214–249.

21. Cowart 1972, 130–138.

22. In 1913 there were fewer than eleven miles of paved roads in the country. Direction de l'Agriculture, du commerce, et des forêts, *What It Is Necessary to Know About Morocco* (c. 1926), 88.

23. See Schneider essay in this volume, p. 54 n.96.

24. See cat. 14.

25. Cowart 1972, 147 n. 18, 315 ill. 101. See also Serullaz 1963, 502–503, indicating that the Thomy-Thiéry legacy donated this painting to the Louvre in 1902. The painting, as a new acquisition, would have been available for Matisse to study and sketch.

26. Matisse's relationship to the researches of the cubists seems to have been recognized by critics almost immediately following his Moroccan period. See Escholier 1937, 123–124.

27. For an inspired exhibition of later Matisse flower drawings see Dominique Szymusiak, *Matisse Fleurs, Feuillages, Dessins* [exh. cat. Musée Matisse] (Le Cateau-Cambrésis, 1989).

28. Schneider 1984b, 466–467; see also Schneider essay in this volume, pp. 36–41.

29. Faure 1923, 29.

30. See Matisse's letter to his family, postmarked 18 April 1912, in Schneider essay in this volume, p. 56 n. 149.

31. As an outline by height: 251mm, 4 drawings; 253mm, 1 drawing; 254mm, 1 drawing; 255mm, 4 drawings; 256mm, 3 drawings; 257mm, 5 drawings; 258mm, 4 drawings; 259mm, 1 drawing; 260mm, 2 drawings.

As an outline by width: 185mm, 1 drawing; 190mm, 7 drawings; 191mm, 4 drawings; 192mm, 1 drawing; 193mm, 2 drawings; 194mm, 1 drawing; 196mm, 1 drawing; 197mm, 1 drawing; 198mm, 3 drawings; 199mm, 2 drawings; 200mm, 3 drawings. The widths change more frequently due to the binding perforation, since several retain this 10mm perforated strip. Others have been torn off or otherwise trimmed.

By referring mostly to the height, within a 2 or 3 millimeter margin of error, these sheets may have issued from at least three, possibly four, dismembered sketchbooks. One is small, c. 251mm high; another, of a medium size, c. 253–255mm; a large size, c. 256–258mm; and the largest, c. 259–260mm.

32. The drawings in this first core group are believed to have come from the collection of Félix Fénéon, Matisse's highly regarded, longtime agent dealer for the Galerie Bernheim-Jeune. Fénéon initiated a number of publishing ventures: a "Bulletin" in Bernheim-Jeune exhibition catalogues (1914); the later and more ambitious *Bulletin de la vie artisti-que* (1919–1926); and, most important, the Editions Bernheim-Jeune, which published books and albums on the artists exhibited by the gallery. (Joan Ungersma Halperin, *Félix Fénéon, Aesthete & Anarchist in Fin-de-Siècle Paris* (New Haven, 1988), 361. Matisse's mounted drawings may relate to one of these projects. Art historian, critic, and writer George Besson was a close friend of both the artist and Fénéon and may have been subsequently involved with these particular drawings. The inscriptions found on the mounting boards are recorded in the drawings entries in this catalogue.

33. See three drawings illustrated in Wally Findlay Galleries, *Henri Matisse* (New York, 1981), n.p., six drawings in Schneider 1984b (204, 206, 209, 216, 217, 220), one drawing in Musée Matisse 1989 (51), and four illustrations selected from a remarkable group of perhaps as many as twenty Collioure watercolors (224, 225).

34. Venice 1987, ills. 240–241. In most cases it is Matisse's paintings that relate to trips and/or seasons of work outside the Paris or Nice studios. See, for example, *Matisse: Ajaccio-Toulouse, 1898–1899, une saison de peinture* [exh. cat. Musée Matisse] (Nice, 1986); Cowart 1987; Judi Freeman, *The Fauve Landscape* [exh. cat. Los Angeles County Museum of Art] (forthcoming), especially as the exhibition and the catalogue essay by James Herbert pertain to Matisse and Derain in Saint-Tropez and Collioure.

35. In the final analysis Matisse seems not to have placed the same kind of reliance on sketchbooks, diaries, journals (for motifs, documentation, or ego) as, for example, Picasso (whose 175 known *cahiers* document a very broad set of personal and visual objectives), Cézanne, Klee, or so many others. For examples, see Pace Gallery, *Je suis le cahier: the sketchbooks of Pablo Picasso* (Boston, 1986); Lawrence Gowing, *Paul Cézanne, The Basel Sketchbooks* (New York, 1988); Paul Klee, *Tagebücher 1898–1918* (Stuttgart, 1988).

36. Archives Matisse, letter, early November 1912. See Schneider essay in this volume, p. 56 n. 146.

37. Particular thanks to the cultural department staff of the Embassy of the Kingdom of Morocco, Washington, especially Mme Souad Zebdi and Mme Naïma Amahboub, for their help in identifying these articles of traditional costume.

38. Henry Collins Walsh, "The Rifs in Morocco," *The Travel Magazine* 14 (November 1908), 67.

39. A letter, Archives Matisse, 21 November 1912, informed the family that Matisse had just begun a painting, a portrait of a "Rifain." See Schneider essay in volume, p. 56 n. 147. The inscribed dates of the sketchbook drawings as "1913" do not necessarily mean that they had been drawn in that year; they could have been made in 1912.

40. Thanks to Mohammed Habibi, curator, Musée de la Kasbah, for his assistance in the identification of traditional Tangier costumes and several of Matisse's sites within the Casbah.

41. Dominique Fourcade in Paris 1975, 16.

42. *Marguerite lisant*, 1906, Paris 1975, ill. p. 73.

43. For example, see no. 393, *L'Idole*, 1906, ill. 5; no. 402, *Figure de dos au collier noir*, 1906, ill. 11, Duthuit-Matisse 1983, vol. 2.

44. For example, see no. 13, *Nu à demi allongé*, 1913/1914, ill. 17; no. 15, *Portrait de Mme Matisse*, 1914, ill. 19; no. 14, *Portrait de M. M. avec bijou*, c. 1914, ill. 19, among many others. Duthuit-Matisse 1983, vol. 1.

45. For example, see no. 73, *Jeune Polonaise*, 1917/ 1918, ill. 61; no. 93, *Buste de femme avec collier et bracelet*, 1926, ill. 77. Duthuit-Matisse 1983, vol. 2.

46. For illustrations see Schneider 1984, 323, 325, and Monod-Fontaine 1979, 41, respectively.

47. Charles Camoin (French, 1879–1965) corresponded actively with Matisse and visited Tangier, arriving with Matisse's wife, Amélie, in January 1913, and staying on after Matisse's departure in February. A survey of six Camoin drawings illustrates three sketching formats. *Sultan's Palace* and *Marabout* (figs. 66, 67) are careful, illustrative views. Camoin rendered light and shadow, pedestrians and architectural features, making very close studies and fully indicating the spaces illusionistically. These two appear topically though not stylistically related to the Matisse drawings (cats. 38, 66). Another two, *Place Bab el Aassa* and *Moorish Café* (figs. 56, 68), are slightly freer, more sketchlike, recording the local colors and composition of the small square in front of the Bab el Aassa, giving us another view of this portal so important to Matisse's *Porte de la Casbah* of the Pushkin's Moroccan Triptych, documenting a scene that can still be visited in Tangier today. The café sketch adds to the documentation concerning both Matisse's painting *Café marocain* and Camoin's painting *Moroccans in a Café* (cat. 23 and fig. 138); in particular it shows a sequence of running arch motifs behind the three seated figures. Thanks to John Elderfield for reminding us that such a low arch pattern probably depicts Moroccan textiles or woven straw mats typically mounted along lower wall areas. Two impressionistic landscape studies, *House and Bay of Tangier* and *Two Figures with House and Lattice* (figs. 69, 70) show dematerialized spaces reduced to contour by abundant sunlight. These sketches may also relate to Matisse's works (cats. 58, 59, 60). I particularly thank Mme A. M. Grammont-Camoin, Paris, for her assistance in areas of Camoin research, notably in supplying photographs of these drawings, several paintings, and Camoin's photograph of Matisse and his wife in Tangier (fig. 137), granting us access to Matisse-Camoin correspondence for correction of dates and texts, and allowing us access to the compiled Camoin catalogue of paintings, from which we were able to trace works comparable to Matisse's paintings (fig. 136).

James Wilson Morrice (Canadian, 1865–1924) was in Tangier by late January or early February 1912 for a period of unknown length, and back again by January 1913, overlapping both of Matisse's trips. From his voluminous collection of small sketchbooks preserved in the Montreal Museum of Fine Arts, sketchbooks 6 and 17 contain drawings and notes from these trips. Selected sketches from sketchbook 6 show quickly jotted views from the Hôtel Villa de France window, street scenes in and around the Casbah (at least one like Matisse's cat. 60), and various *croquis succincts* of standing or seated Moroccans (figs. 61–65). The museum also has paintings and *pochades* relating to the Moroccan visit. The Art Gallery of Ontario houses collected letters of Edmund Morris and Morrice. Our thanks to Dr. Nicole Cloutier at the Montreal Museum and Larry Pfaff at the Art Gallery of Ontario for their generous assistance in our Morrice research.

48. Fourcade, in Paris 1975, 22, wrote perceptively of Matisse's Mallarmé *Poésies* illustrations: "Des eaux-fortes d'un trait régulier, très mince, sans hachures, ce qui laisse la feuille imprimée presque aussi blanche qu'avant l'impression. Le dessin remplit la page sans marge, ce qui éclaircit encore la feuille, car le dessin n'est pas, comme généralement, massé vers le centre mais rayonne sur toute la feuille." This can be taken to be in some rapport with Matisse's perceived allover drawing style and use of the ground in the 1913 sketchbooks. A projective, personal response to Matisse's use of white, line, positive and negative spaces, among other meditations, is found in Claude Fournet, *Matisse Terre-lumière* (Paris, 1985).

49. A *marabout* was commonly marked by a white flag, according to writers of the period.

50. See Appendix 1 for the text of this letter.

51. Archives Henri Matisse, mid-November 1912. The French text reads: "La petite maison que tu vois à droite, à travers l'ouverture de la porte, est une petite merveille. C'est une maison arabe construite comme ceci: /[croquis]/ elle est peinte en blanc bleuté à la chaux et le rez-de-chaussée, un peu en retrait, est palissé de petits bois bleu foncé sur les quels poussent des volubilis énormes violet foncé.

52. See Pablo Picasso, *Head of a Bull*, 1943, assemblage of bicycle saddle and handlebars, Musée Picasso. *Pablo Picasso: A Retrospective* [exh. cat. The Museum of Modern Art] (New York, 1980), ill. 373.

Two drawing images perhaps relating to the sketchbooks and most probably to Morocco, since they served as marginal illustrations of Matisse's 1913 Bernheim Jeune exhibition dedicated to his new Moroccan production, are the unlocated sketches of two donkeys (fig. 90) and of a seated figure in traditional North African costume (fig. 91). Laura Coyle notes that if one reverses this seated figure the image bears a striking relationship to the now overpainted seated figure to the left of the gateway in the Pushkin *Porte de la Casbah*. A third, a pen and ink landscape (fig. 92), depicts a harbor scene of fishermen and gulls. There are numerous suggestive relationships of the hills surrounding the Bay of Tangier and the way Matisse drew clouds in his other sketchbooks. It cannot be confirmed that this drawing is on paper related to the known 1913 sketchbooks, nor is it signed or dated in the same way.

fig. 90. Henri Matisse, *Deux ânes, Tanger* (Two Donkeys, Tangier), 1912/ 1913?, pen and ink on paper. Location unknown

fig. 91. Henri Matisse, *Marocain assis, jambe levée* (Seated Moroccan, Leg Drawn Up), 1912/1913, pen and ink on paper. Location unknown

fig. 92. Henri Matisse, *Baie, pêcheurs, mouettes à Tanger* [?] (Bay with Fishermen, Gulls, in Tangier) [?], 1912/1913?, pen and ink on paper, 20.8 × 26.7 (8 1/8 × 10 1/2), signed l.l. in pencil: *Henri-Matisse*. Private collection

53. Flam 1973, 43.

54. Translated from Fourcade in Paris 1975, 14.

55. In 1912: "Tangier, the seat of European diplomacy, has at least 20,000–30,000, of which 7,000 are Jews, 6,000 Spaniards, with 5,000–7,000 Moslems, and over 10,000 more living in huts outside the city, and a few thousand Europeans from various nationalities." Robert Kerr, *Morocco after Twenty-five Years* (London, 1912).

56. Jokingly, Matisse sent Gertrude Stein a postcard on 16 March 1912, depicting, as he wrote: "je vous envoi le coin le plus Parisian de Tanger. . . ." (see fig. 131), where the majority of the pedestrians are in European dress and most of the store signs are in French. On 22 February 1912, another card to Gertrude Stein (see fig. 110) carried his comment: "Pays où les feministes sont tout à fait inconnus— malheureusement car les hommes abusent. . . ." the card showing women straining under heavy sacks of charcoal. His selection of illustrated postcards includes camels, the Casbah, *marabouts*, minarets. His letters remark on the attitudes and difficulties of his models, his reluctant Villa Brooks patron, the various civil strifes with the Rif tribesmen, and being restricted to his hotel by either their riots or inundating rains. This was indeed a time of adventure for Matisse.

57. Among the dozens of early twentieth-century books inspired by the exotic, picturesque character of Morocco, Edith Wharton's *In Morocco*, originally published in London in 1920, and Loui... coeur de Maroc (Paris, 1913) come particular mind. Botte described the view from Matisse vorite plaza in language that has a surprising tion to Matisse's illumination and color: "Nous sortons de la Casba par Bâb-el-Aza. Le ciel, resté couvert jusqu'à présent, s'éclaircit brusquement. C'est comme si l'on venait de tirer un rideau ris. La ville qui s'étend à nos pieds, la rade et les montagnes lointaines, illuminées brusquement par une pluie de lumière, sont transfigurées. Le spectacle est féerique.

"Tout près de nous, des Arabs sont debout, . . . immobiles, et, comme dans du marbre, le soleil creuse de plis profonds leurs grands manteaux blancs. Devant eux, entre un vieux mur couronné de géraniums écarlates et un berceau de glycines violettes, par une large échappée, nous embrassons Tanger, les monts et la mer. C'est une dégringolade de cubes roses, bleus, blancs, une cascade de lumière éclatante vers les flots couleur d'opale, encerclés par le croissant doré de la plage. Au loin, la crête des Anjara s'estompe dans l ciel clair, tandis que, plus loin encore, une sorte de petite vapeur, étendue sur l'horizon, nous laisse deviner l'Europe."

58. Matisse recounted (Courthion 1941, 103) that he had his bags packed for the trip when he heard from Marquet that a studio had just become available in the building housing Matisse's former fauve-period studio (19 Quai Saint-Michel). He had left this in 1909, when he and his family moved to Issy-les-Moulineaux. The news from Marquet was so attractive that Matisse changed his plans and moved to the new Paris studio instead. World War I hindered Matisse's subsequent movement out of France for the next four years.

59. From a 4 January 1916 letter to Gustave Kahn, which included a drawing very close to the one illustrated here and discussing his current suffering from a cold infection: "Vous verrez ci-contre ma bobine de grippé que je n'ai pu faire plus sociable étant totalement abruti; je viens de prendre ma fulmigation, et je me suis trouvé un peu marocain avec ma serviette sur la tête, c'est qui m'a donné l'idée de me croquer." Le Cateau-Cambrésis 1988, 70.

60. See also other *Platane* drawings, nos. 156–158, ill. 179–181. Paris 1975.

61. Wharton 1984, 76–77.

DRAWINGS

These drawings were catalogued by Jack Cowart. The titles are given first in French and establish, through consultation with the Archives Henri Matisse, proper descriptive titles for many previously unpublished works. Height in centimeters is listed before width, and dimensions in inches are given in parentheses.

26
H. Matisse par lui-même, 1912
(H. Matisse by Himself)
pen and ink on paper, 19.3 x 25.3 (7⅝ x 10)
signed l.r. in pencil: *H. Matisse par lui-même 1912*
Private collection

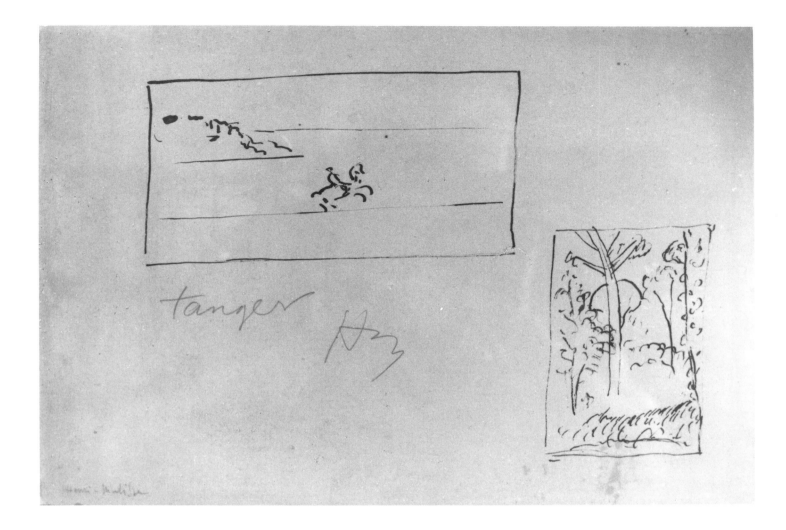

27
Paysage marocain avec cavalier, croquis de "Les acanthes," 1912
(Moroccan Landscape with Horseman and Sketch of "Les acanthes")
pen and ink on paper, 22.2 x 31.5 (8³⁄₄ x 12³⁄₈)
signed in pencil: ctr.l. *Tanger/HM*; l.l. *Henri-Matisse*
Private collection

28
Corbeille d'oranges I, 1912
(Basket of Oranges I)
pen and ink on paper, 25.5 x 17 (10 x 6¹¹/₁₆)
signed l.r. in pencil: *Tanger/H. Matisse*
Musée Picasso, Paris
Exhibited in Washington only

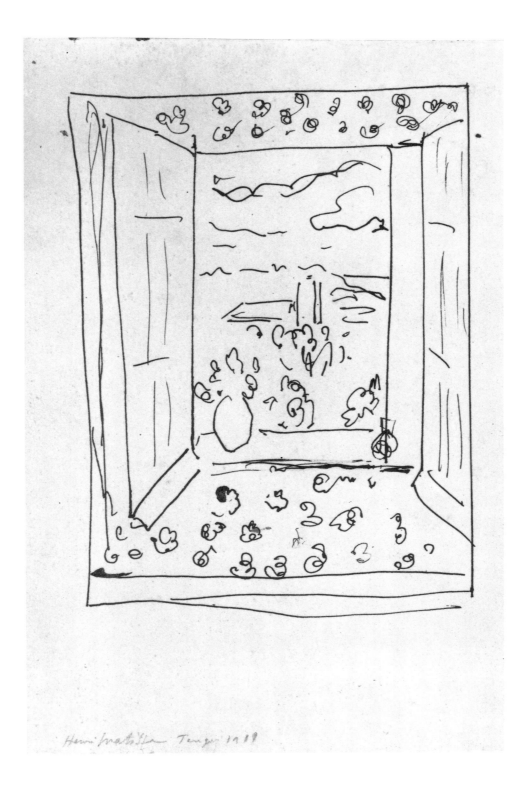

29
***Vue de la fenêtre, Tanger II**, 1912*
(View from the Window, Tangier II)
pen and ink on paper (on board), 25.7 x 16.8 (10⅛ x 6⅝)
signed l.l. in pencil: *Henri Matisse Tanger 191*[2?]
Private collection

30
Fumeur à la fenêtre, 1912/1913
(Smoker at the Window)
pen and ink on paper, 25.7 (irr.) x 17.1 (10¹/₈ x 6³/₄)
signed center r. in pencil: *Tanger/H Matisse*
Private collection

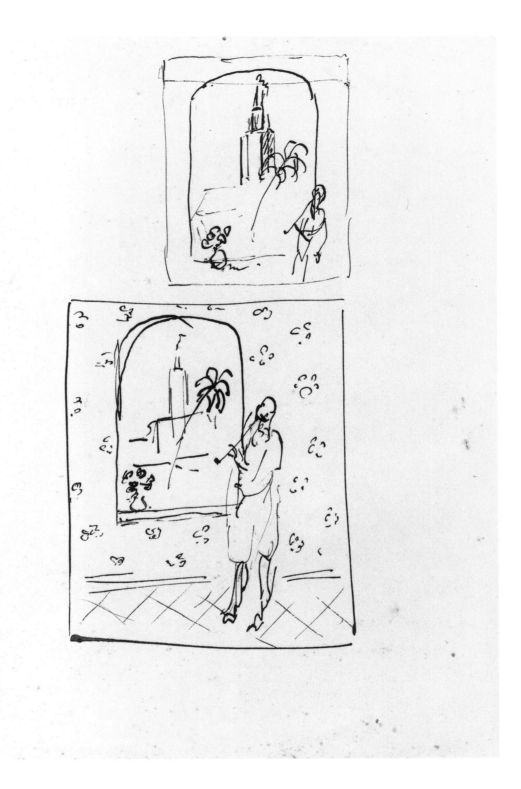

31
Deux dessins d'un fumeur à la fenêtre, 1912/1913
(Two Drawings of a Smoker at the Window)
pen and ink on paper, 31.9 x 23.3 (12½ x 8¾)
Private collection

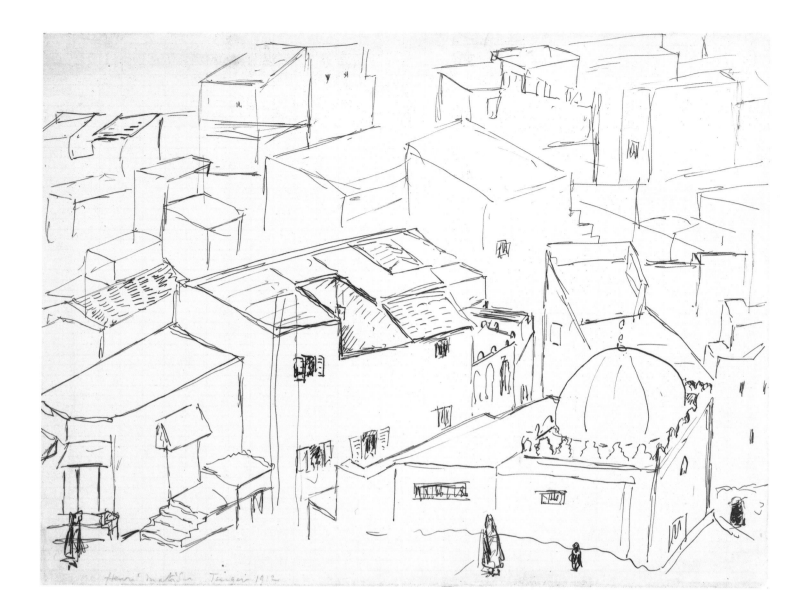

32
Vue de la médine, 1912
(View of the Medina)
pen and ink on paper, 21.4 x 27.4 (8⁷/₁₆ x 10³/₄)
signed l.l. in pencil: *Henri-Matisse Tanger 1912*
Private collection

33
Maisons dans la médine, 1912/1913
(Houses in the Medina)
pen and ink on paper, 17.1 x 25.9 (6³/₄ x 10³/₁₆)
signed l.l.: *HMatisse*
Private collection

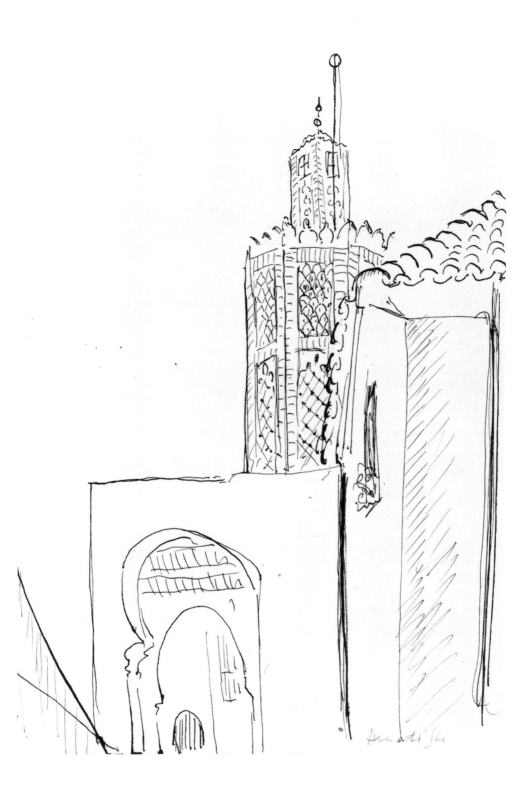

34
Portail et minaret, Mosquée de la Casbah, 1912/1913
(Portal and Minaret, Casbah Mosque)
pen and ink on paper, 25.7 x 17.1 (10⅛ x 6¾)
signed l.r. in pencil: *HMatisse*
Private collection

164

Henri-Matisse Tanger 1912

35
Portail, Mosquée de la Casbah I, 1912
(Portal, Casbah Mosque I)
pen and ink on paper, 25.8 x 17 (10⅛ x 6¹¹/₁₆)
signed l.l. in pencil: *Henri-Matisse Tanger 1912*
Inscribed on back of former mounting board in pencil
by another hand: *Entrée à la Zaouya/p. 55*
Private collection

36
Portail, Mosquée de la Casbah II, 1912/1913
(Portal, Casbah Mosque II)
pen and ink on paper, 25.8 x 17.2 (10$\frac{1}{8}$ x 6$\frac{3}{4}$)
signed l.l. in pencil: *Henri Matisse*
Inscribed on back of former mounting board in pencil
by another hand: *Sous les arceaux blancs/p. 16*
Private collection

37
Dans la Casbah, 1912/1913
(In the Casbah)
pencil on paper, 34.6 x 24.6 (13⅝ x 9¹¹/₁₆)
Private collection

38
Casbah: Le marabout, 1912/1913
(Casbah: The Marabout)
pen and ink on paper, 17 x 26 (6¹¹/₁₆ x 10) (right side of sheet folded under)
signed l.l. in pencil: *H Matisse*
Private collection

39
Le dome du marabout, 1912/1913
(Marabout Dome)
pen and ink on paper, 17.1 x 25.9 (6³/₄ x 10¹/₄)
signed l.r. in pencil: *H Matisse*
Private collection

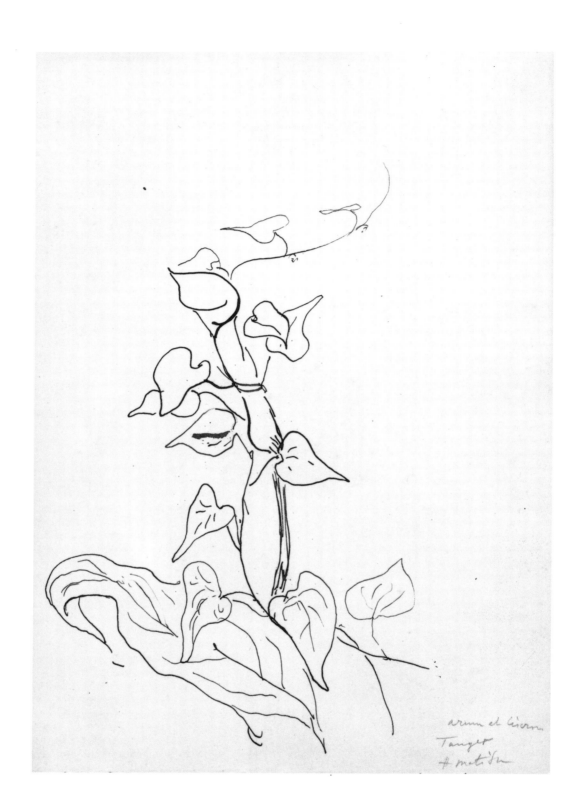

40
Arum et liserons, Tanger, 1912/1913
(Calla Lily and Bindweed)
pen and ink on paper, 32 x 22.3 (12⅝ x 8¾)
signed l.r. in pencil: *Arum et liserons/Tanger/HMatisse*
Private collection

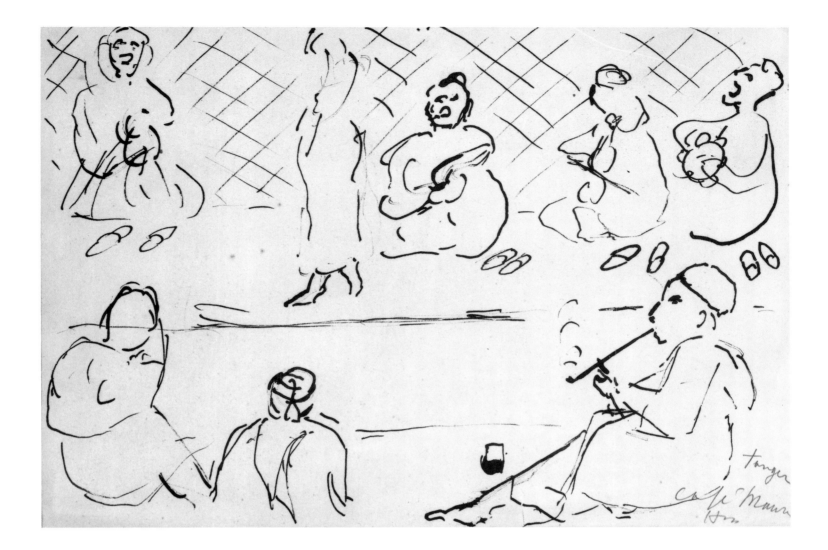

41
Café maure, 1912/1913
(Moorish Café)
pen and ink on paper, 22.3 × 32 (8³⁄₄ × 12⁵⁄₈)
signed l.r. in pencil: *Tanger/Café Maure/HM*
Private collection

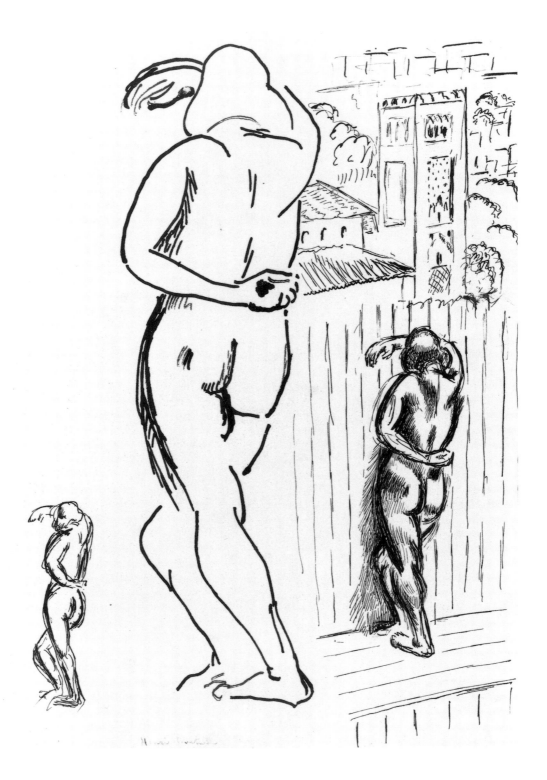

42
Nus de dos et vue de Tanger, 1912/1913
(Backs and Scene of Tangier)
pen and reed and ink on paper, 32 × 22.3 (12⁵/₈ × 8³/₄)
signed l.l. in red ink: *Henri-Matisse*
Private collection

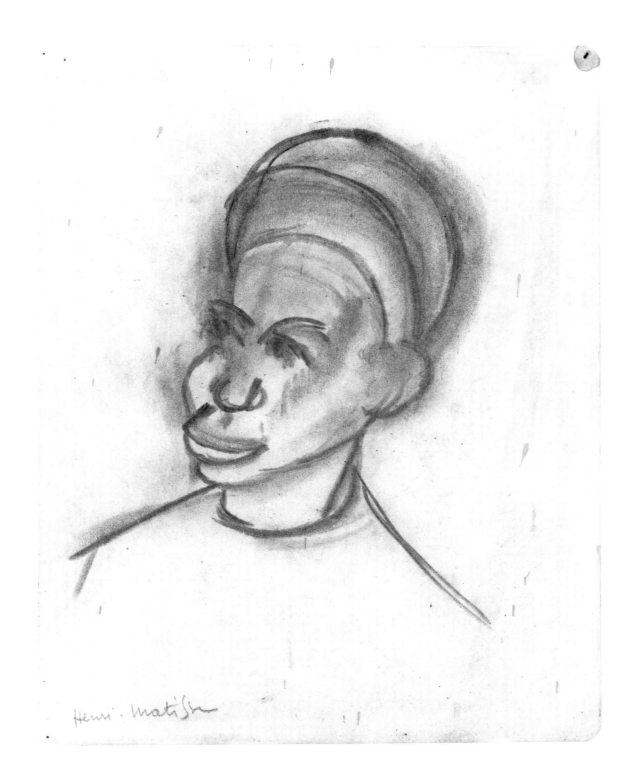

43
Le Soudanais, 1913
(The Sudanese)
charcoal on paper, 26.7 × 20.8 (10½ × 8⅛)
signed l.l. in pencil: *Henri-Matisse*
Private collection

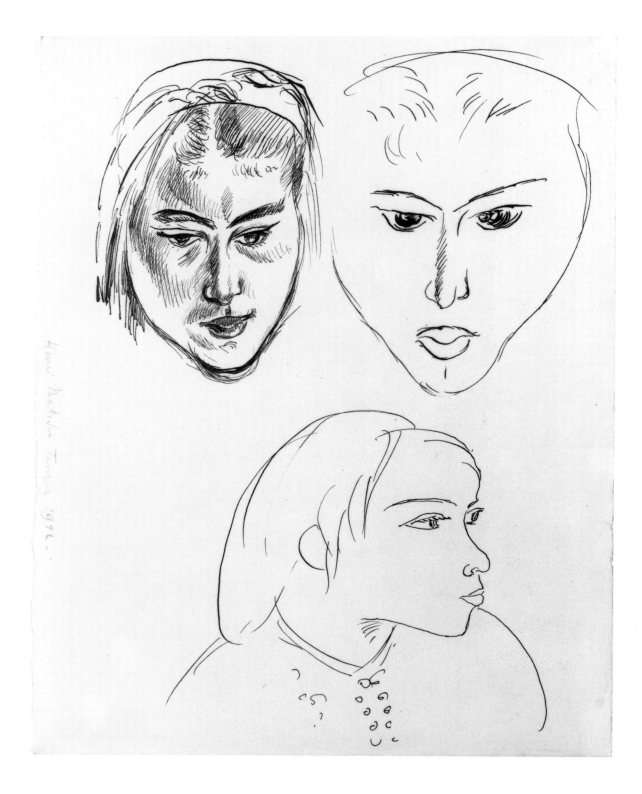

44
Trois études de Zorah, 1912
(Three Studies of Zorah)
pen and ink on paper, 31.4 × 24.8 (12³/₈ × 9³/₄)
signed vertical left edge in pencil: *Henri Matisse Tanger 1912–*
Isabella Stewart Gardner Museum, Boston
Exhibited in Washington and New York only

45
Marocain, assis, devant un fond fleuri, 1912/1913
(Moroccan, Seated, against a Floral Ground)
pen and ink on paper, 25.5 × 18.6 (10 × 7¼)
signed l.l. in pencil: *Henri-Matisse*
inscribed on back of former mounting board in pencil
by another hand: *Gr tete frontispiece*
Private collection

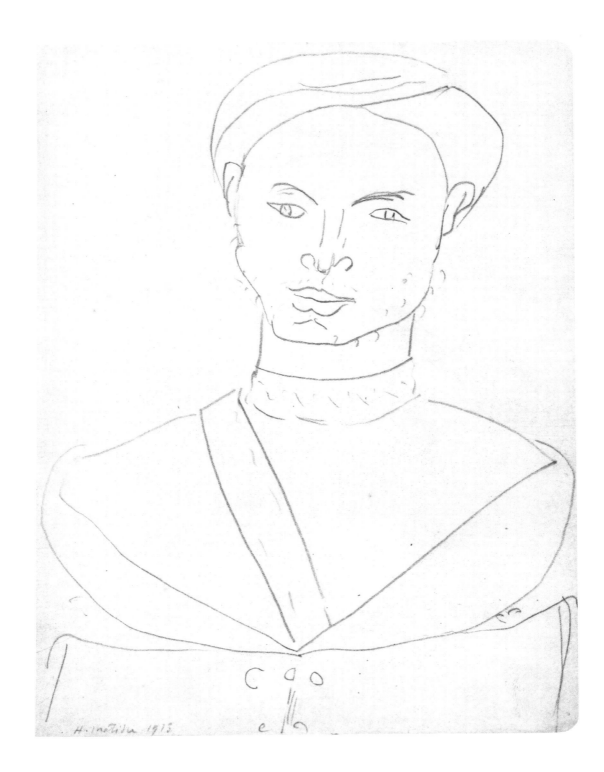

46
Marocain, mi-corps, 1912/1913
(Moroccan, Bust Length)
graphite on paper, 25.6 × 19.21 (10^{1}/$_{16}$ × 7^{9}/$_{16}$)
signed l.l. in pencil: *H. Matisse 1913*
Inscribed on back of former mounting board in pencil
by another hand: *Un jeune homme de taille
moyenne/imberbe maigre et musclé/p 143*
Private collection

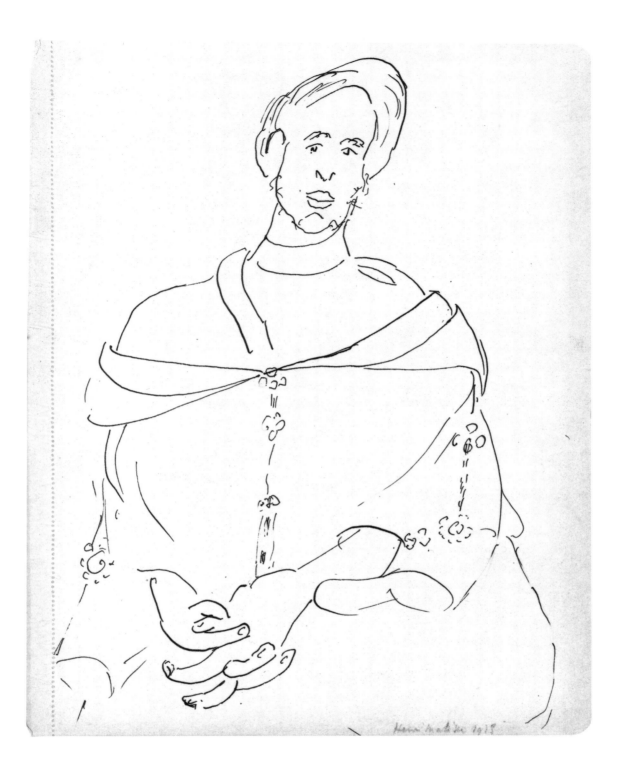

47
Marocain, de trois-quarts, 1912/1913
(Moroccan, Three-Quarter Length)
pen and ink on paper, 25.5 × 20 (10 × 7⁷/₈)
signed l.r. in pencil: *Henri Matisse 1913*
Inscribed on back of former mounting board in pencil
by another hand: *Maroquin de Méquinez. . ./poète errant. . ./ p. 150*
Private collection

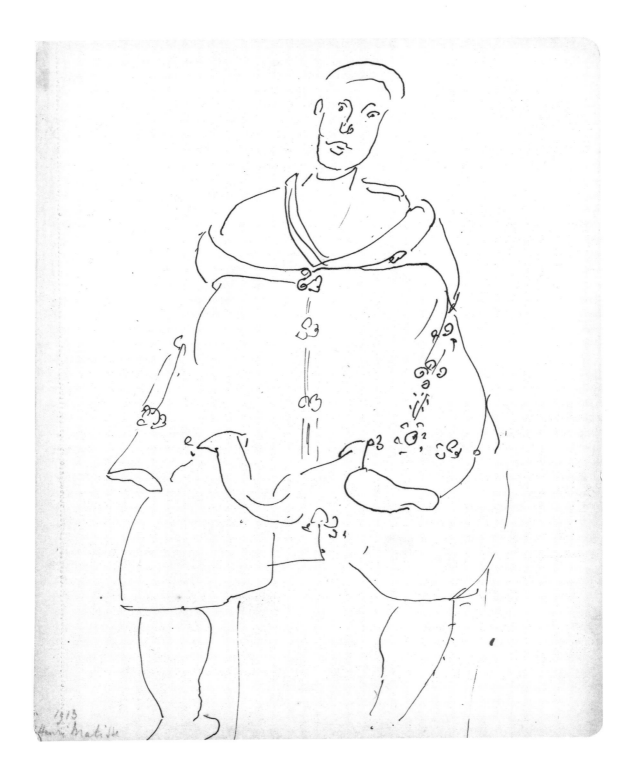

48
Marocain assis, 1912/1913
(Seated Moroccan)
pen and ink on paper, 25.7 × 20 (10⅛ × 7⅞)
signed l.l. in pencil: *1913/Henri Matisse*
Private collection

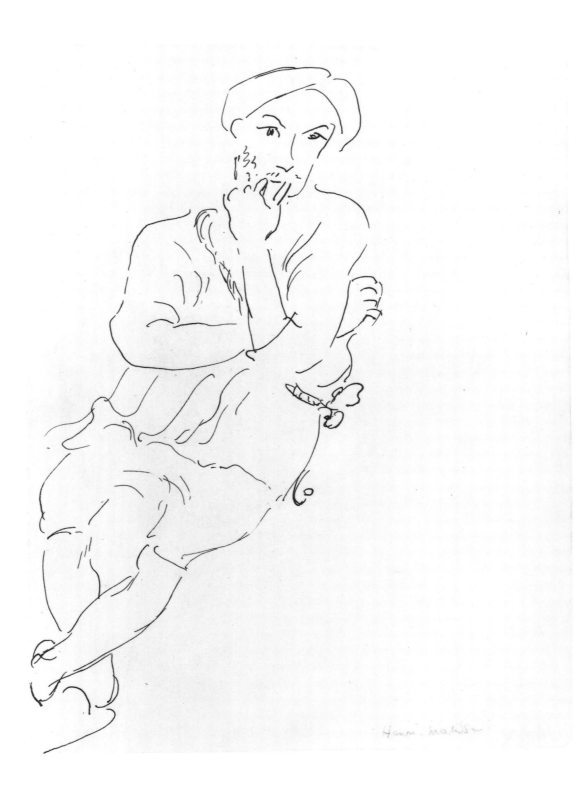

49
Marocain assis, main au menton I, 1912/1913
(Seated Moroccan, Hand on Chin I)
pen and ink on paper, 26 × 19.6 (10¼ × 7¾)
signed l.r. in pencil: *Henri-Matisse*
Waddington Galleries, London

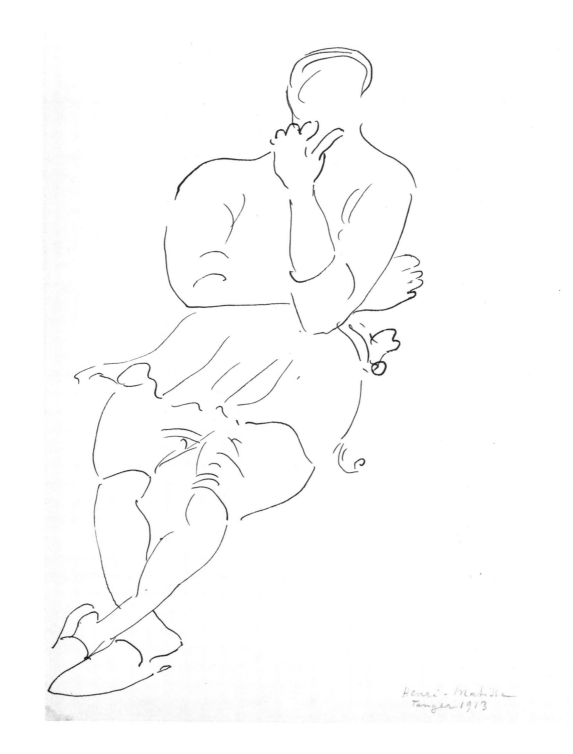

50
***Marocain assis, main au menton II**, 1912/1913*
(Seated Moroccan, Hand on Chin II)
pen and ink on paper (on board), 25.9 × 19.2 (10¼ × 7½)
signed l.r. in pencil: *Henri-Matisse/Tanger 1913*
Private collection

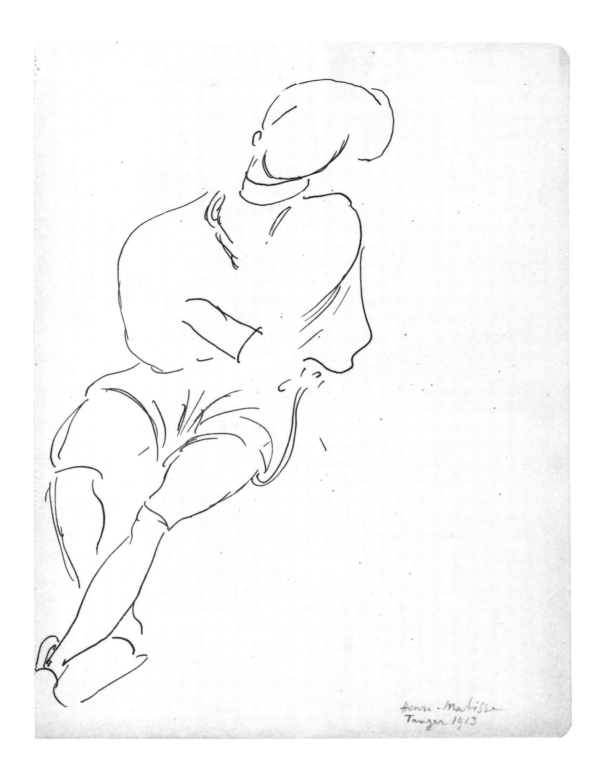

51

Marocain assis, les bras croisés, 1912/1913

(Seated Moroccan, Crossed Arms)

pen and ink on paper, 25.7 × 19 (10⅛ × 7½)

signed l.r. in pencil: *Henri-Matisse/Tanger 1913*

Inscribed on back of former mounting board in pencil

by another hand: *le regard noyé dans la vapeur du ciel/encor lilas [?]/p. 125*

Private collection

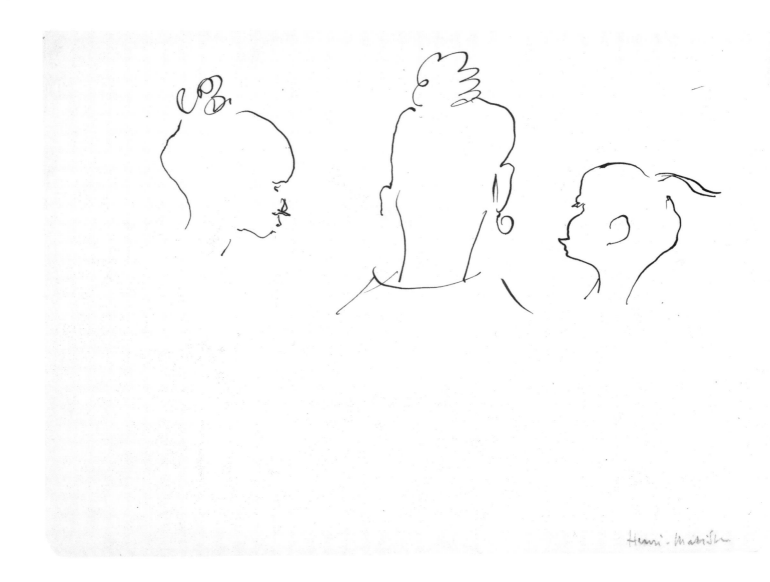

52
Trois têtes, 1912/1913
(Three Heads)
pen and ink on paper, 19.3 × 25.6 (7⁵/₈ × 10¹/₁₆)
signed l.r. in pencil: *Henri-Matisse*
Inscribed on back of former mounting board in pencil
by another hand: *Messaoud/page 102*
Private collection

53
Soldat marocain et Hamido, 1912/1913
(Moroccan Soldier and Hamido)
pen and ink on paper, 25.6 × 19.1 (10¹/₁₆ × 7¹/₂)
signed l.l. in pencil: *Henri-Matisse-1913 Soldat Marocain et Hamido*
Private collection

54
Deux personnages allongés, 1912/1913
(Two Lounging Figures)
pen and ink on paper, 19.8 × 25.4 (7¹³/₁₆ × 10)
signed l.l. in pencil: *Henri-Matisse Tgꞓ 1913*
Inscribed on back of former mounting board in pencil
by another hand: *seigneurs nomades/p. 96* and two lines of text crossed out
Private collection

55
Porte avec âne et personnage, 1912/1913
(Gate with Donkey and Figure)
pen and ink on paper, 25.9 × 19.1 (10³/₁₆ × 7¹/₂)
signed l.l. in pencil: *H. Matisse Tg͘ᵗ 1913*
Inscribed on back of former mounting board in pencil
by another hand: *De la page 1 à la/page 5*
Private collection

56
Casbah: Marabout et drapeau, 1912/1913
(Casbah: Marabout and Flag)
pen and ink on paper, 25.8 × 19.1 (10⅛ × 7½)
signed l.r. in pencil: *Henri-Matisse Tgʳ 1913*
Private collection

57
Terrasse dans la médine, 1912/1913
(Medina Terrace)
pen and ink on paper, 19.7 × 25.5 (7³/₄ × 10)
signed l.r. in pencil: *Henri Matisse Tgr 1913*
Private collection

58
Médine: Maisons et treillis fleuri I, 1912/1913
(Medina: Houses and Flowered Trellis I)
pen and ink on paper with red pencil, 25.2 × 19.9 (9⅞ × 7⅞)
signed l.l. in pencil: *HM*
Private collection

59
Médine: Maisons et treillis fleuri II, 1912/1913
(Medina: Houses and Flowered Trellis II)
pen and ink on paper, 25.1 × 20 (9⅞ × 7⅞)
signed l.r. in pencil: *HM*
Private collection

60
Médine: Maison arabe au treillis et marabout, 1912/1913
(Medina: Arab House, Trellis and Marabout)
pen and ink on paper, 18.7 × 25.7 (7³/₈ × 10¹/₈)
signed l.l. in pencil: *Henri-Matisse Tgʳ 1913*
Private collection

61
Médine: Treillis fleuri, 1912/1913
(Medina: Flowered Trellis)
pen and ink on paper, 19.4 × 25.5 (7⅝ × 10)
signed l.r. in pencil: *Henri-Matisse Tgᵣ 1913*
Private collection

62
Médine: Porte, Marocain assis, 1912/1913
(Medina: Door, Seated Moroccan)
pen and ink on paper, 19 × 25.7 (7¹/₂ × 10¹/₈)
signed l.l. in pencil: *Henri-Matisse Tg͟r 1913*
Inscribed on back of former mounting board in pencil
by another hand: *La Zaouya jouit du droit d'asile/page 106*
Private collection

63
Médine: Porte, Marocain debout, 1912/1913
(Medina: Door, Standing Moroccan)
pen and ink on paper, 19.8 × 25.1 (7³/₄ × 9⁷/₈)
Private collection

64
Médine: Deux portes, 1912/1913
(Medina: Two Doors)
pen and ink on paper, 19.8 × 25.1 (7³⁄₄ × 9⁷⁄₈)
signed l.l. in pencil: *Tanger*
Private collection

65
Médine: Place, Marocain assis, 1912/1913
(Medina: Plaza, Seated Moroccan)
pen and ink on paper, 19.9 × 25.1 (7⁷⁄₈ × 9⁷⁄₈)
Private collection

66
Palais du sultan, 1912/1913
(Palace of the Sultan)
pen and ink on paper, 26 × 19.1 (10¼ × 7½)
signed l.l. in pencil: *Tgᵣ 1913. Henri-Matisse*
Inscribed on back of former mounting board in pencil
by another hand: *Page 199/Deux autres nègres qui s'en irant [?]*
à pied sont la, assis/immobiles contre le mur
Private collection

196

67
Deux vues de Tanger, 1912/1913
(Tangier, Two Views)
pen and ink on paper, 25.6 × 19.3 (10¹/₁₆ × 7⁵/₈)
signed u.l. in pencil: *Henri Matisse/Tg. 1913*
Inscribed on back of former mounting board in pencil by another hand:
L'eau bien faisante. . ./paradis des eaux. . . ./p. 173
Private collection

68
La baie de Tanger, 1912/1913
(Bay of Tangier)
pen and ink on paper, 19.9 × 25.3 (7⁷/₈ × 10)
signed l.l. in pencil: *Henri-Matisse-baie de Tanger 1913*
Private collection

69
Tanger, l'eglise anglaise, 1912/1913
(Tangier, English Church)
pen and ink on paper, 25.7 × 19 (10⅛ × 7½)
signed l.l. in pencil: *Henri-Matisse Tg⁻ Eglise anglaise 1913*
Private collection

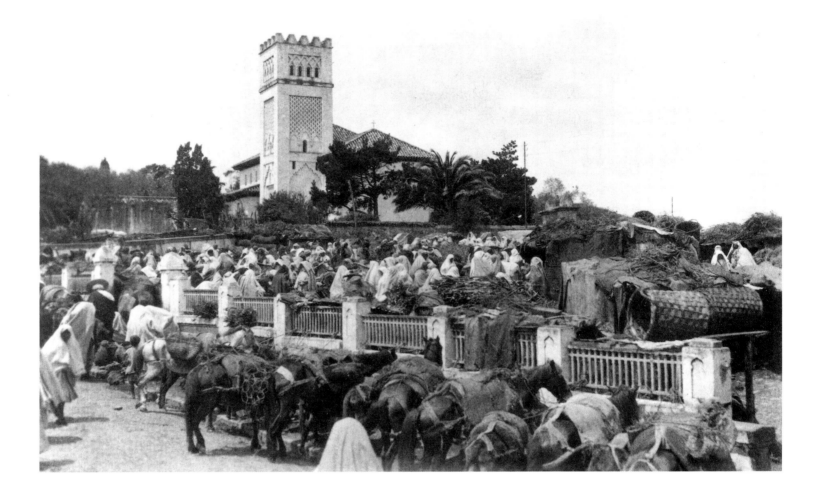

Matisse in Morocco:
An Interpretive Guide

John Elderfield

We shall not cease from exploration
And the end of all our exploring
Will be to arrive where we started
And know the place for the first time.

T. S. Eliot, *Little Gidding*

1. A temperamental voyage

It was raining when Matisse first arrived in Tangier at the end of January of 1912. It continued to rain for a month: heavy, driving rain, often so stormy as to keep the mail boat in the harbor and the artist in his hotel. So when the weather finally broke, the face of Morocco, having thus been shielded from view, came even more as a revelation.

The paintings that Matisse made in Morocco fully deserve our attention as condensations of his sensations before an extraordinary subject; indeed, the revelation of Morocco was of a luxuriance that so matched the prevailing condition of his art as to release from him as great a fluency of painting as he had ever shown.[1] He was there for two periods of three and four months with a six-month hiatus, from late January to mid-April of 1912 and from 8 October of 1912 to mid-February of 1913, and made some two dozen paintings, the great majority of which are ambitious, sometimes extremely ambitious works. On no other foreign voyage did Matisse produce important paintings, let alone an extended series of them. He spoke on occasion of how foreign travel allowed him to appreciate space and light other than he was accustomed to,[2] but only his journeys to Morocco produced immediate, significant evidence of what he saw. We recognize in these paintings a form of pictorial equivalence to the world that is unique to them, and value them for it. And yet, there is another and greater reason for the importance of these works.

"It seems to me that the reader of a good travel-book," wrote Norman Douglas, the author of many, "is entitled not only to an exterior voyage, to descriptions of scenery and so forth, but to an interior, a sentimental or temperamental voyage which takes place side by side with the outer one."[3] Matisse's Moroccan paintings recount such an interior voyage. They describe the growth of his artistic temperament in a direction that brought to a triumphant conclusion a major period of his life's work and opened another of extremely different character. They describe a transition, that is to say, which is what a journey is.

Travel, of course, is a traditional metaphor for moral, emotional or intellectual development, particularly travel to an unknown land. Matisse's first purely invented composition, *Luxe, calme et volupté* of 1904 (fig. 94), took its title from Baudelaire's poem "L'invitation au voyage," and assumes familiarity with the other than utilitarian mean-

opposite page: fig. 93. Leslie Hamilton Wilson, *The Charcoal Market*, c. 1923. ©Harvard University, Carpenter Center for the Visual Arts

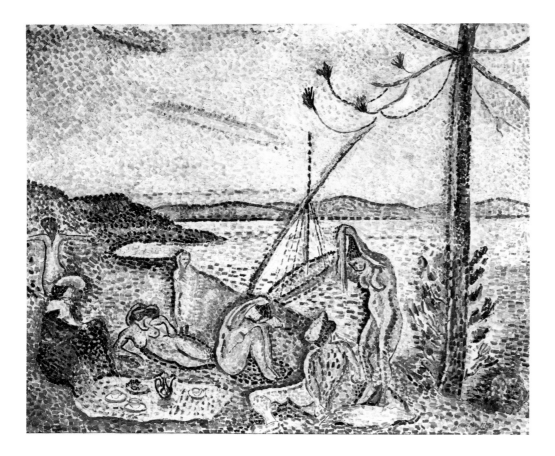

fig. 94. Henri Matisse, *Luxe, calme et volupté*, 1904–1905, oil on canvas. Private collection, Paris

ing of transportation. At times the unknown land will be the traveler's final destination; more often the place from which the traveler returns, replenished by the experiences of the journey. In either case, it will have required exploration. It is no accident, then, that periods of great artistic change are often also periods of great geographical expansion. Certainly, many of those who partook in the journey that led to modern art were also travelers. Since romanticism, the figure on the open road has been a staple of the modern imagination. And even within romanticism, though more quickly in painting than in writing or in music, the sun had begun to replace the moon as what the traveler followed.[4] The road led to ever warmer worlds.

When the weather cleared and Matisse finally saw Tangier, he was quickly reminded of two romantics who had preceded him there. "I found the landscapes of Morocco," he said, "just as they had been described in the paintings of Delacroix and in Pierre Loti's novels."[5] At times the sense of déjà-vu was specific and even unnerving. Making a drawing of the bay of Tangier and the neighboring hills, he realized that Delacroix had used the same landscape in his *La prise de Constantinople par les Croisés* (see fig. 89).[6] Even stranger: "One morning in Tangier," he said, "I was riding in a meadow; the flowers came up to the horse's muzzle. I wondered where I had already had a similar experience—it was in reading one of Loti's descriptions in his book *Au Maroc*."[7] In Morocco, it seems, what Matisse called "the reality created by art as opposed to objective reality"[8] already held sway.

Matisse took Dickens to read, the first writer to see the life of his times as a gigantic pulsation toward and away from the great industrial centers and to see these centers as spreading cancers on a green landscape.[9] It is another characteristic of modern travel, both imaginary and real, that it must take the traveler farther and farther away in order

to escape the blight of the modern city. In that process, alternatives are discovered to the very culture the city contains and symbolizes. Thus, travel is at once cause of and trope for the dissolution of that culture and for the hopes and anxieties accompanying that dissolution. By the time Matisse went to Morocco in 1912, modernism's erosion of the homogeneity of European culture was already quite advanced. Matisse himself had been contributing to it.

It becomes more and more difficult to imagine what it meant for artists of Matisse's generation to witness and contribute to the breakup of a homogeneous culture. What it meant for their understanding of their history—to be forced, for the first time, constantly to be revising that history because they were constantly exploring alternatives to the culture recorded in it—is something that already is hard to grasp. When we study Matisse in Morocco (or related topics like the impact of "primitivism" or of popular culture on modern art), we do so while accustomed to being surrounded by a multiplicity of cultural models and to striving to address their competing claims.[10] It is, perhaps, because there is no longer an *imperium* that we are able to study topics of this kind. But so accustomed have we become to the need to keep writing and rewriting our own histories, to keep pace with the proliferation of cultural models, old and new, we can easily forget that history was not always thought to be quite possibly a species of fiction but once comprised a form of order, and might still.

In 1919, seven years after Matisse went to Morocco, T. S. Eliot characterized the historical sense as requiring a man to write "not merely with his own generation in his bones, but with a feeling that the whole of the literature of Europe from Homer and within it the literature of his own country has a simultaneous existence and composes a simultaneous order."[11] Matisse, like other artists of his generation, came to maturity with a comparable order of culture in his bones. If anything, the art of his European past was more real to him than that of all but the smallest minority of his immediate predecessors and contemporaries. And yet, for more than a decade before Eliot wrote the foregoing words and before virtually all of his contemporaries, Matisse had been seriously challenging the limits of the standard corpus of artistic models—not as a matter of policy but because the progress and freedom of his own art seemed to require it. Since 1906 to be precise, while continuing to consider what the standard artistic models of his own culture might mean for him, Matisse began additionally to consider whether his own culture was able to provide in its own models the meaning he sought. Before that date, he had looked at and admired non-European art, enjoying especially its more unsophisticated forms. (Of the cheap Japanese prints he bought, he observed: "But isn't eloquence even more powerful, more direct when the means are vulgar?")[12] But he had worked and thought almost exclusively within the context of a homogeneous European culture, stretching and extending it, to be sure, but never seriously considering its alternatives. In 1906, he began to look elsewhere. It is not a coincidence that he made his first short trip to Africa that year. And it is also not a coincidence that, when asked why he went to Morocco six years later, he replied, "because it was Africa."[13]

When Matisse first visited Africa—he went to Algeria in the spring of 1906—his art was in a moment of transition, at the end of an extremely intense and highly productive period of painting that began in the summer of 1905 and is now usually described as fauvism. Just before leaving France he had completed *Le bonheur de vivre* (see fig. 99), his seminal image of Arcadian contentment that adumbrated the style and the sentiment of a new, post-fauvist decorative art. Whereas fauve paintings (fig. 5) used contrasting colors applied in small, allover brushstrokes to produce a sense of dazzling vibration that evoked the flux of the natural world, decorative paintings (fig. 96) used contrasting colors in large, flat areas to a far calmer and more artificial effect. By the time

Matisse returned to Africa, to Morocco six years later, his new decorative style had been brought to its fruition, most notably in the sequence of large, invented figure compositions that culminated in 1910 with *La danse* and *La musique* (both State Hermitage Museum, Leningrad). And recently he had adapted this approach to paintings of observed subjects with a scale and grandeur quite equal to the invented ones, as in his four great decorative interiors of 1911. Three of these works, moreover, *La famille du peintre* (see fig. 19), *L'interieur aux aubergines* (see fig. 20), and *L'atelier rose* (see fig. 103), are not only decorative but (to varying degrees) richly ornamented, while the fourth and last, *L'atelier rouge* (see fig. 102), exhibits a sudden simplicity that tends even to the austere. His work thus seemed again to be in transition when he returned to Africa in 1912.

In their different ways, virtually all of Matisse's important decorative paintings of 1906–1912 are indebted to his experience of non-European cultures, symbolically opened to him by his first African visit. "When the means of expression have become so refined, so attenuated that their power of expression wears thin," he wrote later, "it is necessary to return to the essential principles which made human language. They are, after all, the principles which 'go back to the source,' which revive, which give us life."[14] He was referring to fauvism by means of this primitivist analogy. Fauvism was, indeed, Matisse's way of going back to the source of pictorial language. Once that was in place, he could "go back" to non-European cultures for their sustenance, engaging primitivism itself for the sake of its vitality, to which his art was now amenable.

By 1907 Apollinaire was pointing out that Matisse had studied the arts of Egypt, Greece, Asia, pre-Columbian America, and Africa as well as Europe and that his art was a synthesis of these interests.[15] It was not quite that. Rather, Matisse, feeling that in the extremity of fauvism he had reached the limits of his own language, was testing out parts of other languages to see if they suited him. (It is significant that in 1908 he opened his own art school and wrote an aesthetic manifesto, "Notes d'un peintre": education was on his mind.) And, additionally, it was more often the spirit than the style of primitive art in which Matisse was interested. We see this from the very start with the *Nu bleu* of 1907 (Cone Collection, Baltimore Museum of Art), which he described as a "souvenir" of a specific oasis he saw at Biskra in Algeria the year before.[16] Its intensity and concentration are what Matisse thought of as African and what made the non-European so much more than attractive, but actually necessary to him. Fauvism had come to seem too fugitive in its evocation of visual flux. The non-European, seeming far less empirical and perceptual in basis, offered a suitable model for the kind of "condensation of sensations" he said he was then seeking.[17] And most important, it did so in a way that allowed Matisse entirely to bypass Cézanne.

If Matisse can be said to have had one overwhelming ambition in the early part of his career, it was to match Cézanne and, like him, make from impressionism and empiricism an art as authoritative and lasting as that of the museums. Matisse had been struggling with Cézanne's art from 1900 until fauvism had suspended the contest by taking him beyond Cézanne's orbit.[18] The end of fauvism reengaged the contest and, coinciding with Cézanne's death in 1906, made it possible for Matisse to fight again to free himself from his dependence. The struggle continued until 1907–1908 and the decorative style was fully formed. When it was, it comprised Cézanne-inspired figure compositions and still lifes painted in a style so opposite to Cézanne's, so flat and compartmented that Cézanne would have scorned it and called it Chinese. A sequence of non-European interests informed it, ranging from prehistoric painting to Japanese prints, and a sequence of European ones, from Giotto to Puvis de Chavannes.

Matisse's decorative style is usually characterized as post- and anti-fauve. Insofar as his fauve paintings (see fig. 95) comprise excited, allover accented fields while his

decorative paintings (see fig. 96) comprise fields divided by arabesques into broad, calm areas, this description is correct. Matisse supported this division of his art when he spoke of having "tried to replace the vibrato with a more expressive, more direct harmony, simple and frank enough to provide me with a restful surface,"[19] and explained that he had become dissatisfied with paintings that recorded "the fugitive sensations of a moment," preferring "to risk losing charm in order to obtain greater stability."[20]

At the same time, however, Matisse would refer to the whole of his art from 1905 through 1910 as fauve because it was antinaturalistic.[21] Whether using observed or invented subjects, his art of this entire period could not be said to try to match the appearance of nature, only to reduce from and deploy analogously to nature a sequence of basic pictorial forms and colors. Before 1904, when Matisse became seriously involved with the theory of neo-impressionism or divisionism (from which his own fauvism emerged), he had been mainly an empirical, depictive painter, not hesitating to simplify, exaggerate, or reimagine what he saw but unwilling actually to be arbitrary. After that date he seemed to throw off such constraints. Anything that hinted at imitation seemed suspect. To compare two compositionally similar *sous-bois* paintings by Matisse of 1902 and 1905 (figs. 97, 95) is to see what might be almost the work of two different artists—a nineteenth- and a twentieth-century artist even. A comparable landscape of 1911 (see fig. 96), though stylistically very different from that of 1905, is clearly of the same genus. What links the 1905 fauve landscape and the 1911 decorative landscape, and separates them from that of 1902, is that their coherence depends upon adjustments of color, of hue, quite independent of tonal modeling. They surrender the kind of tonal nuance traditional to a depictive art for construction by means of color. And whereas a picture constructed by means of tone tends if not always to darkness then usually to density (even when constructed across the entire tonal scale) because tonal shading absorbs light, a picture constructed by means of color tends if not necessarily toward lightness then usually to brightness and openness because it reflects light. Such a color-constructed picture seems, in fact, actually to produce light, not to imitate light. That, simply, is what Matisse meant at times by fauvism. In this sense, everything from 1905 through 1910, and beyond into some of the Moroccan pictures, is fauve.

It becomes tempting to associate the absence of connecting tonal tissue in such pictures not only with their independence from natural appearances, but also with their freedom from the strands of history. Certainly they rejoice in their artificiality and their decorativeness in a way that Matisse associated with the primitive and that we now associate with the modern. By 1911, however, Matisse was becoming concerned about where his approach was taking him.

Fauvism had begun as a way of responding more directly to nature, but turned out to have withdrawn Matisse from nature. In its decorative phase, through 1910, it increasingly had led him away from observed subjects. Insofar as the four great interiors of 1911 show Matisse returning to observed subjects for his most important paintings, they comprise the beginning of the end of his fauve period in its broadest interpretation. The change they reveal from the invented to the observed accompanies another, equally important change: from the primal to the contemporary—at least, to the contemporary in a primal, exotic interpretation. Instead of describing events without a particular location, Matisse began describing locations free from particular events, especially human action. Instead of painting stories (*Les joueurs de boules*, Hermitage, Leningrad, *La danse*), Matisse was painting places (*L'atelier rose*, *L'interieur aux aubergines*), and as he did so a compositional coherence based on the narrative continuity of parts of a picture was replaced by one based on the simultaneity of their existence. Additionally, the nature of his primitivism had changed. The intensity and concentration of the African

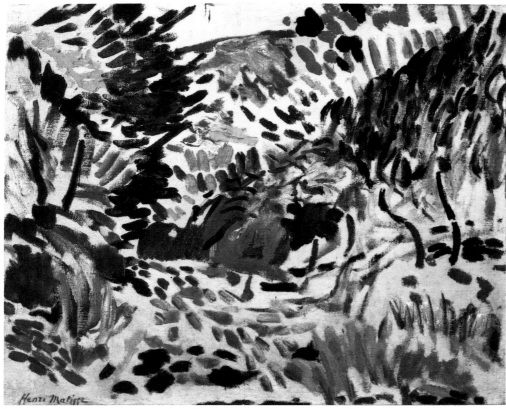

fig. 95. Henri Matisse, *Paysage à Collioure*, 1905, oil on canvas. Collection Mrs. Bertram Smith

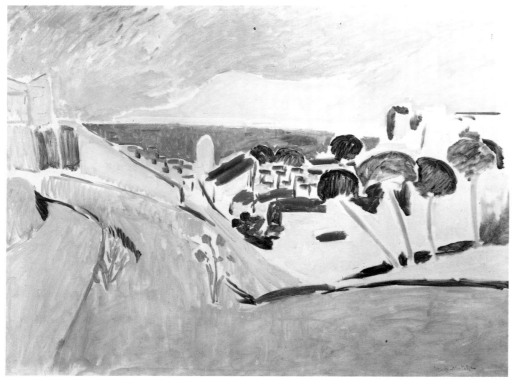

fig. 96. Henri Matisse, *Vue de Collioure*, 1911, oil on canvas. Private collection

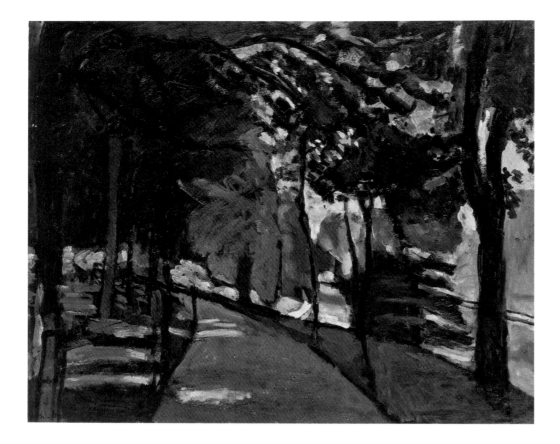

fig. 97. Henri Matisse, *Sentier, Bois de Boulogne*, 1902, oil on canvas. State Pushkin Museum of Fine Arts, Moscow

was replaced by something far more luxurious, namely by the oriental, or by the Islamic which conflated the African and the oriental. To an important extent, it was the influence of oriental and Islamic art in 1911 that showed Matisse how he might return to observed nature, brought fauvism finally to an end, and opened the way for a far more extensive involvement with nature in Morocco the year after.

In the autumn of 1910, Matisse had seen a great exhibition of Islamic art in Munich. Shortly thereafter he had visited the important Moorish monuments in Córdoba, Seville, and Granada in southern Spain. These experiences must certainly have influenced his decision to visit Morocco in 1912. In the Munich exhibition, he said, he found "new confirmation" of what he might do. "Persian miniatures, for example, showed me all the possibilities of my sensations. I could find again in nature what they should be. By its properties this art suggests a larger and truly plastic space. That helped me to get away from intimate painting."[22] That is to say, he had wanted to get away from intimate painting (of the kind displayed by the 1902 landscape, fig. 97) but his method of doing so, fauvism, had led him away from nature. Persian miniatures, however, suggested how he could maintain the large, plastic space of fauvist decorative art by rediscovering it in nature. "Thus my revelation came from the Orient."[23]

At first it was not clear to him what the most important, most personally useful implications of oriental and Islamic art were. In 1911 he could not easily isolate their spatial, pictorial qualities from the compositional devices that produced them. The dense repeat patterns, patchworklike layouts, decorative borders, and so on that he experimented with that year give a most radical look to the paintings in which they dominate but also the slightly dated look of premature innovation. "It was later," Matisse said, "before the icons in Moscow, that this art touched me and I understood Byzantine painting. You surrender yourself that much better when you see your efforts confirmed by such an ancient tradition. It helps you jump the ditch."[24] Matisse had

made a short trip to Russia late in 1911 and was particularly impressed by icons and wall paintings. What he seems to have been saying is that the less ornamented works of art he saw in Russia, by reminding him of his own, earlier decorative pictures, paved the way for his appreciation of eastern art in general—and for his rediscovery of nature without surrender of decoration.

Matisse thought Russia was "like a huge Asian village."[25] Back in Paris for only about two months, he set off with his wife for Africa, for Morocco. "The voyages to Morocco," he said, "helped me accomplish this transition, and make contact with nature again better than did application of the theory of fauvism, which was lively but had become somewhat limiting."[26]

It would be wrong to conclude from all this that Matisse in Morocco was trying to redo fauvism after nature. True, in 1911 he had become even more interested than before in intrinsically decorative subjects that thereby allowed him to make naturalistically decorative paintings. Morocco promised such subjects, his friend Albert Marquet (who was there in 1911) presumably told him, and Matisse found them there. But even if Morocco did seem to be already aesthetic, its nature reminding Matisse of art, this did not mean that nature had done much of Matisse's job for him. Matisse had been helped by using highly controlled, decorative subjects such as interiors and still lifes with already formalized ornamentation on already flat surfaces. To paint from raw nature again was very different and Matisse had not had much experience of it recently. Moreover, the natural landscape in Morocco was not, in fact, a fauve one. It reminded Matisse of Delacroix and Pierre Loti and it caused him some difficulties to adjust to it. He was overjoyed by how different the light was to what he was accustomed to: "so gentle," he wrote to his friend Charles Camoin on 1 March 1912; "it's quite different from the Mediterranean."[27] But in two weeks time he was complaining how hard he found it to paint. He expected painting to be a struggle, "but why have so much of it? It's sweet when it comes of its own accord."[28]

For painting to come sweetly and of its own accord, Matisse had either to make nature conform to the existing requirements of his art or make his art as it existed conform to the requirements of nature. He chose the latter. His choice had enormous implications. Not the least of them was that it allowed Morocco to release from Matisse a natural luxuriance for his art. He found in Morocco a newly relaxed splendor that more readily allowed his fluency as a painter to blossom than did the subjects he had addressed previously. The decorative interiors of 1911 are mental images. Matisse had reimagined what was real. And their power as paintings owed much to their transformation of the commonplace. Morocco reversed the equation. Matisse used real observation to represent what seems to be imaginary. The power of the Moroccan paintings is in their formation of the uncommon: they convince us, as no previous paintings by Matisse had succeeded in doing so, that Arcadia is a real place.

There was a price to be paid for this. Among the other implications of Matisse's choice was that fauvism, in the broadest sense of that term, had finally to come to an end because it was antinaturalistic; that so eventually would decorative art because it was part of fauvism in this sense and inimical to the practice of depiction; and so in its turn would Matisse's exploration of non-European art because that was inseparable from his exploration of the decorative. I know that the Moroccan pictures are often said to be decorative and exotic. Some are. But some are not, revealing instead the end of the decorative and the exotic. In fact, Matisse's return to Africa in 1912 effectively closed the period of his exploration of non-European sources opened by his first African visit of 1906 as well as the epoch of decorative art this exploration accompanied. There is no evidence to suggest that Matisse went to Morocco in order to prove to himself that he

had finished with non-European sources. (It is conceivable, however, that he was very curious about his reexposure to specifically African ones.) But that was the result: a reengagement with topical European culture in the so-called experimental period that followed. The heritage of Morocco was not a new encounter with or new version of the exotic, as sometimes is claimed, but the end of the exotic. (When the exotic did return, in the Nice period, it was in an extremely domesticated form.) Moreover, the end of the exotic and the decorative did not come simply in reaction to the Moroccan sojourn but began during it. It began as soon as Matisse set up his easel in front of a motif that excited him more than did an exotic decoration. Already in 1911 in France he had found the flower beds in his own garden to be "more beautiful than the most beautiful Persian carpet."[29] In 1912 in Morocco, nature guided art.

It suited some early, uncomprehending critics to think that Matisse in looking beyond Europe had surrendered his commitment to the priority of European culture. And there is still too much said about how he changed European art and not enough about how he preserved it. For even his most drastic attack on the homogeneity of his own culture, which began in 1906, was finally for him a way of renewing his culture, of re-creating a new, personal homogeneity for himself. As renewed, it was inescapably, radically altered by his absorption in the art of other cultures. But the end of his explorations was that he would arrive where he started. Morocco, it turned out, was on his way home.

2. A kind of paradise

In winter in Tangier, the rain often ends late in the afternoon; when it does, the dark blue clouds split open to spill out a pinkish beige onto the previously white walls of the Casbah, the shadows turning cool green in contrast. Loti was correct in describing Tangier as the white city.[30] But its whiteness is that of a canvas waiting to receive color—blue, pink, and green—that nature provides.

In the gardens and in the surrounding countryside the same pinkness, suffusing the sky, turns lavender on the trunks and branches of trees while the same greenness is similarly adjusted, toward blue, by the dense foliage. And whether in town or in country, simultaneously with this sudden tinting of the world comes another transformation of it, one that would be called more remarkable if it could be separated for comparison. Surfaces both of light and of shade appear to vibrate, not only at their meeting, which is to be expected with any such complementary contrast, but also internally, as if the suddenly sprung radiance of color had loosened the very structure of the existing substance, immingling with it in a still-tremoring suspension. More even than the hue itself, this effect of color as if suspended in some almost lacteal medium is the marvel produced by Moroccan light. When Matisse most successfully re-created it, he did so by means of scumbled layers of thin, transparent, and translucent pigment. He still continued, as previously, to spread color as a single flat film. But in Morocco he also began to spread it as a layered substance. The complex reality of the subject was analogized by improvising a new richness from the reality of the paint.

The effect of pearlescent light that I am describing is dramatized when the sun's beams are low, as at dawn or in the late afternoon. *Les acanthes* (cat. 5) must have been brought to its conclusion toward the end of the day. Such an effect, however, is a function not mainly of the angle of light but of its intensity and softness together. Thus it also exists at bright high noon and in summer too. *Sur la terrasse* (cat. 13) is the vehicle of its most compelling realization since Delacroix painted his *Sultan du Maroc* in 1845. What Baudelaire said of Delacroix's work is also true of Matisse's: "In spite of the splendour of its hues, this picture is so harmonious that it is grey—as grey as nature, as

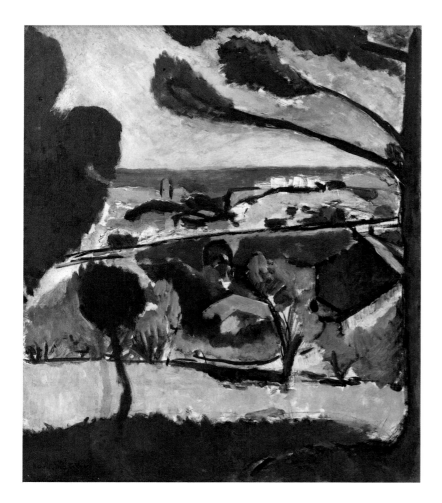

fig. 98. Henri Matisse, *Vue de Collioure et la mer*, 1911, oil on canvas. The Museum of Modern Art, New York, Nelson A. Rockefeller Bequest

grey as the summer atmosphere when the sun spreads over each object a sort of twilight film of trembling dust."[31]

Matisse's first, three-month stay in Morocco, early in 1912, was dominated by paintings of the Moroccan setting. (The second was dominated by paintings of Moroccan people.) When he arived in Tangier, however, he was kept indoors by the rain. The first Moroccan painting, *Le vase d'iris* (cat. 1), was begun on 6 February, [32] one week after his arrival, and was presumably made in his small bedroom at the Hôtel Villa de France. The dark tonality of this picture has been associated with the gloomy weather during the time it was painted, of which Matisse complained very bitterly.[33] That tonality also associates it with two still lifes painted in a hotel bedroom in Seville about a year earlier (see figs. 100, 101), as does its somewhat claustrophobic patterning. Neither its somber coloration nor its rigid composition are what we think of as characteristically Moroccan; only the reflected curtains in the mirror suggest, by the ease and simplicity of their parallel light bands, the enchantment Matisse would find once he went outside.

In mid-February the weather improved enough for exploration of the city. Two small topographical studies (cats. 2, 3) could well have been painted then. But it was not until March that Matisse began to settle into his work. And his original plan may well have called for him to be preparing to leave, for on 12 March he wrote to his children in France that he had decided to stay in order to finish a picture.[34] At the end of the month, his wife Amélie did go home, but without her husband. On 1 April, Matisse was writing again, this time to Marquet, that he had stayed to finish a picture, but it was raining

again and he could not work on it.[35] The picture must be a landscape, then.[36] It is almost certainly *Les acanthes*, which Matisse remembered he had painted on the first trip and had taken him a long time, perhaps a month and a half, working in a luxuriant section of the Villa Brooks property on the outskirts of the old city.[37]

For Matisse, a work after nature succeeded to the extent that it did more than simply "register fleeting impressions," which impressionist and early fauve paintings had done.[38] "Underlying this succession of moments which constitutes the superficial existence of beings and things, and which is continually modifying and transforming them," he wrote in "Notes d'un peintre," "one can search for a truer, more essential character, which the artist will seize so that he may give to reality a more lasting interpretation." Previously that aim had tended to distance his painting from nature. To the extent that art made nature durable it smoothed out the details of natural appearances. *Les acanthes* is such an important picture because Matisse for the first time since before the fauvist period simultaneously conveyed the flux of nature and the essential stability of nature underlying its continually modifying surface. A Collioure landscape of the summer of 1911, *Vue de Collioure et la mer* (fig. 98), anticipates *Les acanthes* in its composition of strict verticals and horizontals, softened by elements of foliage; in its color range, dominated by the axis of blue and magenta; and in its scumbled paint application. But the Collioure picture lacks the complex layering of the Moroccan one, which suggests the continuously pulsating movement of nature. In Morocco, Matisse began to address nature as a phenomenal, changing thing. His painting, therefore, began to take on that character too.

The improvisatory character of *Les acanthes* sets it apart from the preceding major works of Matisse's decorative period, which were far more preplanned. To paint from ever-changing nature made preplanning difficult. This is why there are no landscapes among the major works of the decorative period. Matisse periodically had attempted to paint landscapes that were simultaneously true to nature and decorative,[39] but the demands of nature and of decoration seemed to be contradictory and one or the other had triumphed. That, however, was precisely why landscape was so important to Matisse in Morocco. Turning away from decoration and toward nature, Matisse found that landscape isolated, as no other genre quite did, the opposite poles with which he was struggling and attempting to reconcile.

One of the tasks that Matisse set himself in Morocco was to fulfill a commission to make two landscapes for Ivan Morosov and a still life for Morosov's wife.[40] Morosov was one of Matisse's two important Russian patrons (the other being Sergei Shchukin) and a great lover of landscape painting; indeed, an amateur landscape painter himself. It is uncertain when Matisse agreed to paint landscapes for Morosov but it must have been with some trepidation; for we know that, when accepting the commission, he warned his patron that he was uncertain when he could fulfill it.[41] There must have been moments when Matisse regretted the decision, so much trouble did the whole business cost him. At the end of the previous summer, on 19 September 1911, he was already writing apologetically to Morosov that he had been thinking about his landscapes since arriving in Collioure but was afraid he would not be able to do them until later. "You will see at the Salon d'Automne," he continued, "a landscape that had been destined for you and remains only in the state of a sketch (*esquisse*)," adding that he was now working hard on an important decorative work (presumably *L'interieur aux aubergines*) but that he would make the landscapes "as soon as possible." Matisse showed two works at that year's Salon d'Automne, a landscape and a still life, each described as an "*esquisse decorative*."[42] The landscape was probably *Vue de Collioure* (see fig. 96), a thinly painted, harmonious composition.

When Matisse used the word *esquisse* he was using a technical term established by nineteenth-century academic practice meaning a compositional sketch, a freely painted work that prepared for a finished picture.[43] He did not mean a freely painted work that could itself be taken up again and brought to a greater degree of finish; that was an *ébauche*. Neither did he mean a quick sketch that might either prepare for or remember a composition; that was a *croquis*, a thumbnail sketch. Nor did he mean a quick study after nature; that was either an *étude*, if it showed a detail or a schematic outline of the subject, or a *pochade*, if it recorded the "effect," or atmosphere and chiaroscuro, of the subject. Strictly speaking, an *esquisse* was held to reveal an artist's independent invention, to reveal inspiration, whereas an *étude* or a *pochade* were the records of observation. That is to say, an *esquisse* stressed making or invention and an *étude* or *pochade* stressed finding or recording. In practice, certainly in Matisse's practice, an *esquisse* based on an observed subject, particularly a plein-air subject, demanded finding as well as making. Indeed, Matisse made a point of the fact, writing in "Notes d'un peintre" of 1908 that when actually at work before nature the artist should believe he is copying—finding—even though, when he reflects on what he has done, he must realize that his picture is an artifice—an invention.[44] For all that, it is clear that *Vue sur la baie de Tanger* and *Le marabout* (cats. 2, 3), for example, are *études* or *pochades*, not *esquisses*. They are studies from nature, not compositions after nature. *Vue de Collioure* is an *esquisse* because nature is decoratively arranged. But because it is an *esquisse*, it could not actually fulfill part of the Morosov commission. For that, Matisse presumably would need to make a second, more finished composition where he would "strive to give the same feeling, while carrying it on further."[45] That was the task he took with him to Morocco.

The same day, 1 April 1912, that Matisse wrote to Marquet saying he had stayed in Tangier to finish a picture, which we presume is *Les acanthes*, Matisse wrote a letter to his family that confirms he was working on the Morosov commission in Morocco. Indeed, the unfinished picture notwithstanding, what he wrote to his family would seem to imply that the commission had been completed; Matisse referred to a sketch (*croquis*) he had made of the still life and two landscapes for Morosov, one blue and one of periwinkles.[46] The blue painting, we know, is *Paysage vu d'une fenêtre* (cat. 12).[47] The painting of periwinkles is clearly *Les pervenches*. Two days later, however, on 3 April, Matisse wrote to his wife that if he felt well enough he would stay to do the landscape for Morosov, adding that James Morrice (the Canadian painter, working in Tangier at the time) had seen his two landscape *esquisses* and liked them very much.[48] The commission, therefore, was not complete after all, but still required that Matisse finish another landscape, *Les acanthes*. Clearly, either *Paysage vu d'une fenêtre* or *Les pervenches* was in fact unsuitable. *Les pervenches* was the unsuitable work because, like the previously rejected *Vue de Collioure* of 1911, it was an *esquisse*; with *La palme*, one of the two *esquisses* referred to as completed in the 3 April letter. *Les acanthes* is too complex, too densely painted a picture to qualify as an *esquisse*; and besides, if it took Matisse a month and a half's work, as he said it did, he was still working on it. Thus, *Les acanthes* was originally intended to accompany *Paysage vu d'une fenêtre*; two blue landscapes. Consequently, while it, *Les pervenches*, and *La palme* are often associated as a triptych (they are identical in size), even said to have been intended as a triptych, there is simply no evidence of such association or intention on Matisse's part.

Les pervenches and *La palme*, completed either before *Les acanthes* or while it was still under way, are preplanned works, drawn first and painted afterwards. *Les pervenches*, in particular, is painted on top of a most meticulously drawn layout in pencil which Matisse followed very carefully indeed, hardly ever allowing his apparently spontaneous brushwork to cross predetermined lines.[49] As such, it follows a method

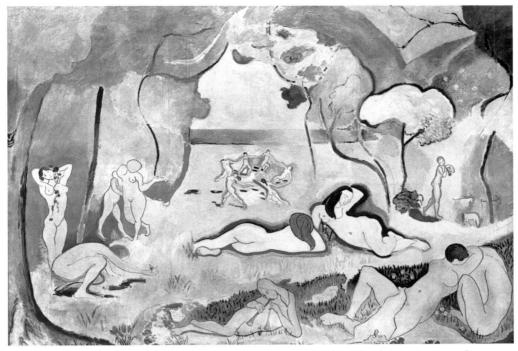

fig. 99. Henri Matisse, *Le bonheur de vivre*, 1905–1906, oil on canvas. The Barnes Foundation, Merion, Pennsylvania

Matisse began using in his divisionist paintings of 1904, revived in his decorative period, and was a matter of standard practice by the time he went to Morocco.

Matisse's divisionist paintings, like *Luxe, calme et volupté* (see fig. 94), were carefully designed by drawing on the canvas, then their drawing was gone over with touches of color of more or less equal size. But Matisse came to feel that this separation of drawing and coloring, as successive operations, created a conflict between the two that limited the freedom of both, checking the flow of his drawing and the spread of his coloring. His succeeding, early fauve pictures of 1905 (see fig. 95) were therefore actually drawn in color, from impulsively drawn, colored linear fragments. "I was able to compose my paintings by drawing," Matisse said of these works, "in such a way that I unified arabesque and color."[50] *Le bonheur de vivre* of 1905–1906 (fig. 99) ended this union of drawing and color. It initiated another two-part system: this time of arabesque contour drawing followed by flat color infilling. This method did not limit the freedom of drawing or coloring in the way that the divisionist method did. But it meant creating an exact match between the shape and the color of each circumscribed area so that, as Matisse put it, "the color was proportionate to the form. Form was modified according to the interaction of neighboring colors. The expression came from the colored surface, which struck the spectator as a whole."[51]

Matisse had two ways of achieving this: by developing the color composition in the process of painting, using only very schematic preliminary drawing on the canvas, and by preplanning, which could include the use of an *esquisse*, even a cartoon, as well as detailed preliminary drawing on the canvas.[52] He used the first of these approaches throughout most of the decorative period. It was Cézanne's method of painstaking adjustment, requiring transpositions from one color to another and alterations in drawing until the composition was thus intuitively realized. Its advantage was its precision; its liability, for Matisse, an effect of tension, even at times of unease, produced by the

design changes that could be extremely troubling. Matisse, therefore, also used the preplanned approach. He did so in 1906–1907 at the beginning of the decorative period when he was consciously repudiating the unplanned, apparently unfinished look of his early fauve canvases. He did so again in 1909–1910 as his decorative period came to a climax and as he sought effects of harmony and calm. In 1911, it was his preferred method. The four great decorative interiors were painted on top of most carefully drawn frameworks.

It required of Matisse an extraordinary discipline to imagine a design that would not need changing, to establish it precisely on the canvas, and then to set about filling it in with color, hoping that each area was such that the color within it would seem "conclusively present."[53] And yet, that was what the act of painting had become for Matisse by the time he left for Morocco. "This all or nothing is very exhausting," he reasonably complained while working on *La famille du peintre* in 1911.[54] We can only marvel at the perfection of the result. And, in works like *Les pervenches*, at its fluency, too.

La palme was less fully prepared by drawing and was apparently painted in a "burst of spontaneous creation—like a flame."[55] There is evidence of this not only in the broad brushwork, less respectful of clean edges between colors, but in such details as the swiftly scratch-drawn lines that define the left side of the palm and that by happy accident hit, through the canvas, the crossbar of the stretcher, swerving together as they move down. The three landscapes have been said to convey three moods: contemplative, lyrical, and exultant.[56] They also convey the effect of penetrating successively deeper into the forested garden. And additionally, they stand as representatives of three ways of making a landscape painting: *Les acanthes* through long improvisation; *Les pervenches* through careful planning; *La palme* through spontaneous expression. Their methodology is matched by their meaning: in them landscape is, respectively, as ancient as nature—old and durable beneath its mutating forms; as ancient as artifice—its formalized trees transplanted from the Arcadian landscape of *Le bonheur de vivre*; and immediately present—vivid, just grown, here and now. Morocco allowed Matisse to "make contact with nature again,"[57] he said. But nature was not a single thing. He was exploring his options.

He was also trying to fulfill a commission. We remember that he had been commissioned to paint two landscapes for Morosov and a still life for Mme Morosov. And we have seen that by early April 1912 the two landscapes were probably to be *Paysage vu d'une fenêtre* and *Les acanthes*. This is confirmed by what happened when Matisse returned to France: he sold *Les pervenches* and *La palme*, while reserving *Les acanthes* and *Paysage vu d'une fenêtre*, both of which pictures he took back to Morocco on his second visit when he finally completed the Morosov commission.[58]

Paysage vu d'une fenêtre will be discussed below in the context of that visit, when we will learn that this was the only picture discussed so far that remained a part of the Morosov commission. But now, we should know that the aforementioned still life is almost certainly *Corbeille d'oranges* (cat. 4).[59] This wonderful picture is to still life what *Les acanthes* is to landscape: the most fully realized image of Morocco in its particular genre and the work with which Matisse struggled to realize it. The surface is heavily overpainted, and some idea of the changes that Matisse made can be had from the three *croquis* of the picture that exist (see cat. 28, figs. 42, 43).[60] He seems mainly to have reduced the area of the floral cloth thereby to buttress its lightness and delicacy with a surrounding sequence of more harshly colored panels, within which it floats, causing the basket of oranges and lemons that it supports to float also, apparently weightless, near the top of the picture. It is the most tectonic of the first-trip paintings; in many respects, the most complex and sophisticated. But then, Matisse was vastly more experienced as a painter of still lifes than of landscapes.

It is difficult to be sure, but *Corbeille d'oranges* was probably painted in a room or on a veranda of a building on the Villa Brooks property, in precisely the same space that *Arums* and *Arums, iris et mimosas* (cats. 20, 21) would be painted on the second Moroccan visit. The brown verticals before a low curve in the top right corner may well be abstractions of trees on a rising ground, as seen in *Arums* through a window in the same position. If this was the setting of the picture, it adds poignancy to the effect that the picture provides of precious fruits of nature isolated from nature by man-made geometry and existing only as excerpts or in an artificially reproduced form. And nature itself was apparently just outside.

Matisse had long been interested in representations that raised questions about the differences between artifice and reality, that did so thematically and iconographically—often by juxtaposing representations of nature and representations of representations of nature, as here. He was also interested, as we have seen, in how the very act of making paintings from nature raised similar questions, but did so technically and procedurally. In 1911, when he returned to observed subjects for his major compositions, he was forced to reconsider problems of artifice and reality and would sometimes find himself both intrigued and frustrated by the impossibility of making truly credible representations. That year he told a visitor that he found it instructive to compare the flowers blossoming in his garden with their images in the gardening catalogues from which he had chosen them. How crude the reproductions seemed. "In fact, compared to the colors here [in the garden], my paintings aren't much better than those reproductions," he conceded. "Sometimes I put flowers right alongside my paintings, and how poor and dull my colors seem!" Nothing in nature is "finally, a well-defined color that can be painted."[61]

The vividness of Moroccan vegetation must have made Matisse's available means seem even more meager, for he was truly enraptured by the gardens there. Even after having packed his canvases ready to return to France, he could not resist another visit to the Villa Brooks; he was thrilled by the flowers, he said.[62] But how to convey the emotions he felt when he could not adequately reproduce their source? During that farewell visit to the Moroccan gardens, he wrote to his family that he had two ideas for pictures come to him, which he intended to paint on his return home.[63] It was back in France, pondering on the experience of Morocco, that Matisse invented new strategies for reproducing not nature but the emotions he felt before nature, by exploring more complex, more profound cross-references between nature and art.

When Matisse started to paint for the very first time, during a long convalescence when he was twenty years of age, he was startled and delighted by how it affected him. "I felt transported into a kind of paradise," he said. "In everyday life I was usually bored and vexed by the things that people were always telling me I must do. Starting to paint I felt gloriously free, quiet and alone."[64]

The Moroccan garden was a place of freedom, quiet, and solitude, a kind of paradise; and Matisse did not object when his friend Marcel Sembat wrote that he had transformed the Moroccan landscape into a terrestrial paradise.[65] It was, in fact, the first of three specific venues that Matisse chose to represent the ideal conditions of his art, and the seminal one: the second, Nice, was a reimagination of Morocco; the third, Oceania, a replacement modeled on it. After *Le bonheur de vivre*, in which Matisse first imagined what his paradisal garden might look like, *Nu bleu* had attempted to locate it geographically in an African oasis. But the location did not take and the depicted landscapes of his art became increasingly bare, primal, even forbidding. Returning to Africa in 1912, after having seen oriental gardens in representations and Moorish ones in reality, he discovered a more cultivated than primitive pastoral; as such, one more easily transported

back home. In France, in the late spring and summer of 1912, he began methodically to picture his own surroundings as a kind of paradise.

Before Matisse left Morocco for the first time, however, one further development occurred in his representation of it. He particularized its identity. None of the Moroccan landscapes or still lifes contain imagery that particularize the place of their creation. Except for the two small *pochades* of Tangier itself, we have not yet encountered anything that can be considered topographical. But before Matisse left Morocco this first time he did specify the identity of the place. He did so in two ways: conventionally in *Paysage vu d'une fenêtre*, which shows the view from his hotel bedroom window; this picture will be considered later. And unconventionally in *Amido* and *Zorah en jaune* (cats. 8, 9), which particularize Morocco by showing the costumes of its inhabitants.

Both pictures were made quite late on the first trip. Matisse seems to have had difficulties finding models who would pose for him, particularly women because of the law of the veil. Only Jewesses and prostitutes were exempt. Matisse was therefore obliged to work in secret. On 1 April, he wrote to his family that the proprietress of the Hôtel Villa de France, Mme Davin, had found him a studio where "the Arab girl," presumably Zorah, could come without being seen.[66] However, on 6 April he wrote again, saying that he had wanted to work with "the young girl," but it was impossible because her brother was about and would have killed her. But "the young groom at Valentina" was free and might pose.[67] Presumably this is Amido. Since Matisse did paint Zorah as well as Amido during his first trip to Morocco, the problem of her brother must have eventually been solved. Clearly Zorah was a model whom Matisse was willing to take trouble over. That he found her particularly sympathetic is evidenced by the beautiful drawings he made of her face (cat. 44)—rare both for their revelation of character and for the carefulness of their draftsmanship among the Moroccan drawings, which are usually summary and schematic; also by the fact that he made a point of seeking her out when he returned to Morocco at the end of the year.

There will be more to say about *Zorah en jaune*, and also about *Amido*, when we look at the paintings Matisse made on his second trip to Morocco. But it is worth observing now just how curious it is that Matisse, by painting costumes, gives far more particular a sense of Moroccan place than in all but very few of his paintings of Moroccan settings. The paradox that place in a picture is depicted by means of its potentially most movable element must necessarily affect the meaning of its depiction, and raise questions about the identity of the place so strangely, obliquely described.

3. The reality created by art

The paintings that Matisse made in the spring and summer of 1912, between the two Moroccan trips, develop the theme of artifice and reality raised by renewed contact with nature on the first trip. They do so, however, in a new and methodical way. A benefit of travel, Matisse once observed, is that, by stopping the usual mental routine, it "will let parts of the mind rest while other parts have free rein—especially those parts repressed by the will. This stopping permits a withdrawal and consequently an examination of the past. You begin again with new certainty. . . ."[68] After the first trip to Morocco, Matisse began again not only with new certainty but also with new clarity. His examination of the past seems to have included a review of his working procedures. The result was a new way of making decorative pictures after nature.

Matisse's new way of working derived from his experience of painting from nature in Morocco, and involved reinterpretation of the function of an *esquisse*. Traditionally, a completed, finished work made after an *esquisse* effectively picked up the process that

the *esquisse*, in its completion, temporarily suspended. For Matisse this had been possible for invented compositions (also for simple, iconic images like decorative portraits) because the process itself was internal to the pair of paintings—and to Matisse's reactions to the paintings as they were made.[69] But this approach did not suit the creation of compositions after nature because the process of their creation was not purely internal to the painting or paintings in question and to Matisse's reactions at each stage. Matisse's reactions to nature, too, entered the equation. He could not pick up, simply from an *esquisse*, the process of realizing a subject after nature. Implicitly, there would have to be a second visit; he would have to consult his sensations in front of nature again.

This left Matisse with three options. First: he could continue to develop a single painting, reworking its design and color together, until it recorded something more than an initial reaction to the subject. This was Cézanne's method. Matisse had used it for *Les acanthes*, revising the picture for more than a month and a half. Even then, Matisse worried that he had failed fully to grasp the reality of the subject. He therefore would take the picture back to Morocco on the second trip, only to discover, he said, that what he had thought was missing from the picture was in fact there, but not in the landscape.[70] That had changed with the seasons. But he had to go back to check what his sensations had been. This first option, of continuous, improvisatory painting, would remain a necessary way of proceeding.

Second: Matisse could reconceive just the color of a picture, leaving its design intact. This method, which required if not careful preplanning then extreme self-discipline, was continuous with the general approach of his decorative period. He had used it before Morocco in works like *L'atelier rouge*. He used it after the first Moroccan trip when, in the spring of 1912, he repainted in vivid Moroccan colors the still life that became known as *Cyclamen pourpre*.[71] And he would use it on the second Moroccan trip, most notably for *Zorah debout* (cat. 16). But this was a less flexible method than the first and would eventually be abandoned.

Third: Returning to a subject, Matisse could make a new picture to reflect his new experience of the subject, but not to develop and complete the process begun in the preceding picture (as with a traditional *esquisse*); rather, to recapitulate that process to a different end. This third option was the one that Matisse began to develop after the first Moroccan trip. It involved reinterpretation of the *esquisse* as, more than a preparatory work, a fully realized, self-contained record of Matisse's immediate sensations before a subject to be followed by a second, newly conceived painting of the same subject, and possibly more. This, effectively, is how the three Moroccan landscapes were produced.

Whereas earlier, a painting that looked unfinished, or sketchlike, was in fact not finished,[72] reengagement with nature in Morocco led Matisse to accept a lesser degree of finish as appropriate to fully realized paintings of observed subjects. Now, an *esquisse* could be a self-contained work. By thus abandoning any hierarchy of finish, such as was intrinsic to his conception of decorative art, Matisse could produce parallel versions of the same subject at different levels of finish, using different procedures, in different modes. Indeed, he would be encouraged to make both multiple works and stylistically unlike ones, each work reconceiving the subject in a new mode. This led him into a period of increasingly radical experimentation while allowing him to maintain contact with nature at the same time. To proceed like this was, after all, truer to the nature of reality itself, which manifested itself in many, different, and often unusual versions. The implication of this was an art whose understanding of reality was of something continuously moving and changing, always annihilating and reconstituting, something entirely immaterial. Matisse came to insist on this: "That is how you can explain the role of the reality created by art as opposed to objective reality—by its non-material essence."[73]

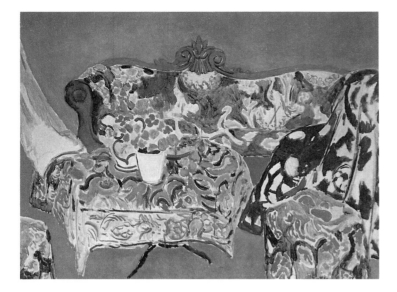
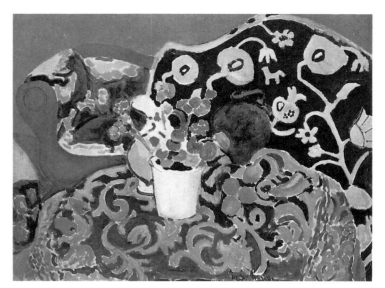

left: fig. 100. Henri Matisse, *Nature Morte, Seville I*, 1911, oil on canvas. The State Hermitage Museum, Leningrad

right: fig. 101. Henri Matisse, *Nature Morte, Seville II*, 1911, oil on canvas. The State Hermitage Museum, Leningrad

Before Morocco, Matisse's two Seville interiors of 1911 (figs. 100, 101) had been his first pair of paintings where the one seems more than merely a reorganization of the other, but rather a reexperience of what is seen in the other, as if at a different moment of time.[74] Their subjects intersect rather than exactly concur. Then, *L'atelier rose* and *L'atelier rouge* (figs. 102, 103) offer not only a more familiar, descriptive and a more formal, symbolic version of Matisse's studio. To notice the intersection of their views is also to see how, as if in the turning of one's head, a room is utterly transformed. To look at a thing from a different angle is to see a different thing. That is one of the lessons of working from nature. To pan across a room, or a landscape, is to watch the room or the landscape transform into a sequence of independent views, each descriptive of the place but self-sufficient and complete. The Moroccan landscapes seem also somehow cinematically sequential as they take us successively deeper into the garden. Matisse's experience of making sculpture had taught him that the wholeness of an object is a function of the separate, complete views that it affords.[75] But it was only after his first trip to Morocco that his explorations of multiple versions of reality truly began. Its first masterpieces were the two versions of *Les capucines à "La danse"* and the two *Poissons rouges et sculpture* paintings of identical size.

The two versions of *Les capucines à "La danse"* are still a traditional *esquisse* (fig. 104) and a definitive composition (fig. 105), made in that order and not in the opposite one as is commonly supposed.[76] The two *Poissons rouges et sculpture* paintings (figs. 106, 107), however, offer alternative rather than successive versions of reality. Indeed, what looks like the *esquisse*, seeming more fresh and spontaneous, is actually more developed in its abstraction than the more solid and densely painted version. They launched a whole sequence of paintings in pairs and groups, each showing the same or similar subjects in different keys or modes.

A number of the paired paintings are in the revised *esquisse*-and-composition format. Back in Morocco the second time, *Fenêtre ouverte à Tanger* (cat. 22) is a lighter, more abstracted version of *Paysage vu d 'une fenêtre*, while the freely painted *Arums*, though actually a preparation for *Arums, iris et mimosas*, is also an independent, alternative conception of the subject. Later, the two 1914 paintings of *Notre-Dame*[77] are among a sequence of paired versions of a single subject in more naturalistic and more abstracted

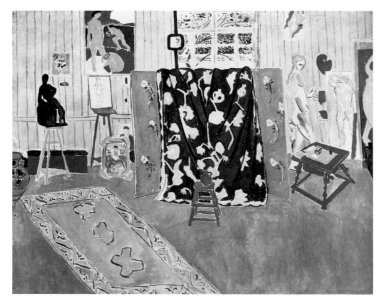

fig. 102. Henri Matisse, *L'atelier rose*, 1911, oil on canvas. State Pushkin Museum of Fine Arts, Moscow

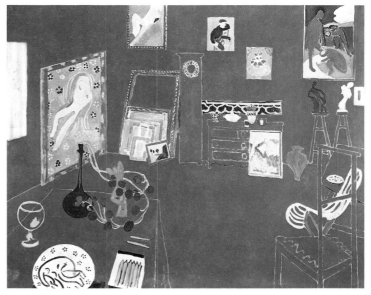

fig. 103. Henri Matisse, *L'atelier rouge*, 1911, oil on canvas. The Museum of Modern Art, New York, Mrs. Simon Guggenheim Fund

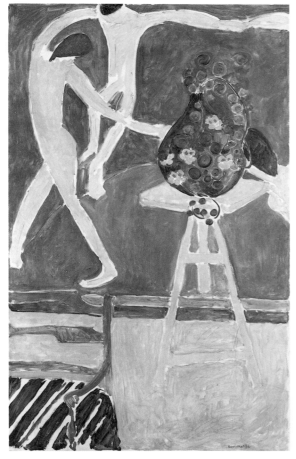

fig. 104. Henri Matisse, *Les capucines à "La danse,"* 1912, oil on canvas. The Metropolitan Museum of Art, New York, Bequest of Scofield Thayer

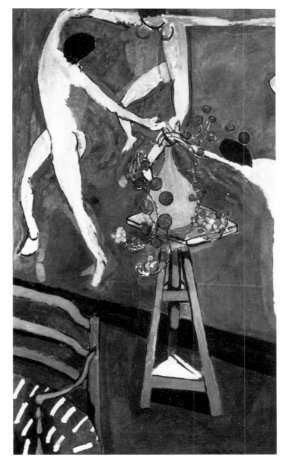

fig. 105. Henri Matisse, *Les capucines à "La danse,"* 1912, oil on canvas. State Pushkin Museum of Fine Arts, Moscow

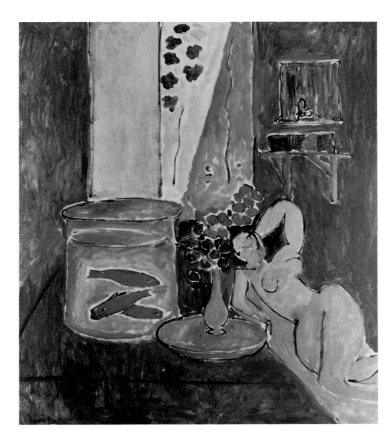

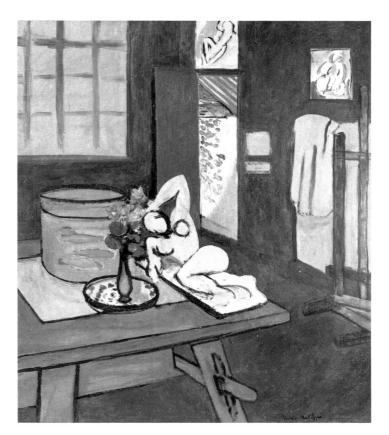

left: fig. 106. Henri Matisse, *Poissons rouge et sculpture*, 1912, oil on canvas. The Museum of Modern Art, New York, Gift of Mr. and Mrs. John Hay Whitney

right: fig. 107. Henri Matisse, *Intérieur aux poissons rouge*, 1912, oil on canvas. The Barnes Foundation, Merion, Pennsylvania

forms. Other pairs comprise the same or similar subjects posed or arranged differently but alike in their handling. Back in Morocco, *Le rifain debout* and *Rifain assis* (cats. 18, 19) are pictures of this kind. So, later, are the two versions of *Sculpture et vase de lierre* of 1916.[78] Yet other pairs of pictures, though similar in technique, reveal extremely different versions of reality, as with the two *Poissons rouges* of 1914.[79] The possibilities were inexhaustible.

And there were groups of paintings. The series of paintings of Zorah developed on the return trip to Morocco sets the pattern for later, larger groups of images of other models, of Lorette in 1916–1917, of Antoinette in 1919, and so on.[80] Additionally, the form or format established in the representations of one model would spawn similar representations of another model. Thus, the enclosed, organic form created for *Zorah en jaune* on the first Moroccan trip was reprised on the second not only for Zorah herself (in *Zorah assise* and *Sur la terrasse*, cats. 10, 13) but also for the model Fatma in *La petite mulâtresse* (cat. 17). Similarly, the tall-panel format used for *Amido* on the first trip was reused on the second for both Fatma (*La mulâtresse Fatma*, cat. 15) and Zorah (*Zorah debout*). After Matisse's return from that second Moroccan trip, he began, with his *Portrait de Mme Matisse* of 1913 (Hermitage, Leningrad), a series of portraits of different sitters on the same scale that are like variations on a single theme. Everything intersects and exists in multiple form. That was the lesson of new, direct contact with the natural world.

It is ironical, then, that the one subject Matisse found himself unable to address by means of his newly flexible method was landscape. For Matisse, however, landscape painting seemed to have been the habitual means of liberating his vision, of reassessing and reformulating his art through contact with nature in its most variable form. And once the liberation had occurred, he had to leave landscape painting alone. Making

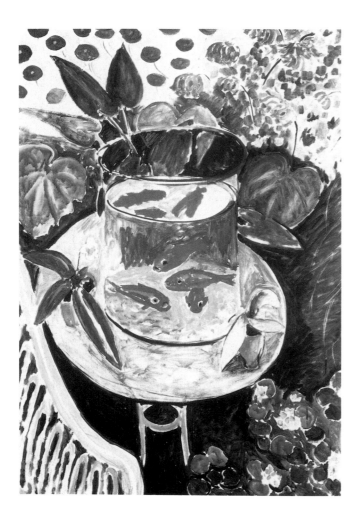

fig. 108. Henri Matisse, *Poissons rouges*, 1912, oil on canvas. State Pushkin Museum of Fine Arts, Moscow

landscapes in Corsica in 1898 had profoundly affected the direction of his art. The same had happened in Collioure in 1905. In both instances, he stopped concentrating on landscape painting within a few years. If Morocco in 1912 was different, it was only in the abruptness with which he stopped. After making the three Moroccan landscapes he entirely abandoned the genre, not to return to it until 1917—then to effect major change in his art yet again.[81] He did make paintings that included views through windows of landscapes, among them some very important paintings, but there was nothing truly plein-air.

And yet, the Moroccan landscape was not forgotten. Back in France in 1912, Matisse re-created it imaginatively for himself. In Morocco he had been fascinated to see men contemplating goldfish.[82] His *Poissons rouges* (fig. 108) is a still life set on a table in his garden at Issy. And it is also a remembrance of Morocco, viewed symbolically as a lush oasis. The *Poissons rouges et sculpture* paintings go one step further. They juxtapose, in Matisse's studio, flowers, goldfish, and the sculpture, *Nu couché* of 1907, which was made simultaneously with the *Nu bleu* as a souvenir of his visit to Algeria of the year before. Memories of the two African visits are thereby combined. (And in one of the paintings (fig. 107) we see, shown on the wall of the studio, *Zorah en jaune*.)

These are, at one level, paintings of souvenirs, of trophies. But they are also very much more. They are evidence that Matisse's new methods of making decorative compositions after nature had generated their own subjects. Matisse had come to require new subjects for paintings—nominal, external subjects—that allowed him to explore the

internal subject basic to the decorative composition after nature: namely, the relationship of decoration and nature, of artifice and reality, of making and finding. Before Morocco, Matisse's art had tended toward decoration. Travel had released that part of it previously repressed by the will; his art had returned to nature. Now, nature itself could no longer be painted, apparently. But nature and art could still be combined. Their combination is the subject of the *Poissons rouges et sculpture* paintings. Flowers are excerpted from nature into an artificial state. Art, however, is animated; sculpture painted as if alive. And the Moroccan fish, objects of aesthetic contemplation, swim in an aqueous environment flattened to the surface like a picture. All is found and then arranged, set in an interior where art is made, but the interior opens onto the natural world, and in one of the paintings (fig. 106) a liquid space spreads continuously through the two zones. The harmony of the natural and the artificial, of making the natural aesthetic, is the controlling metaphor of both works. And that harmony, thus indicated iconographically, is actually effected by color, apparently nonmaterial and certainly all-embracing.

The power of the reality created by art through color is the central, dominating theme of Matisse's paintings between the two trips to Morocco. The first, thinly painted version of *Les capucines à "La danse"* (fig. 104) shows an image taken from nature that has been inserted within the depictive space of a painting. The second version (fig. 105) announces the fusion of the two spheres, and color, one color, preserves their union. One color, if sufficient in its saturation and intensity and if limitless in its spreading and yet also corporeal, will now serve. The blue of Cézanne's *Bather* compositions is Matisse's preferred choice. For the moment it will harmonize anything, even *Conversation*, a profoundly troubling picture Matisse had been struggling with since 1908 (see fig. 117).[83] It is not at all clear what *Conversation* depicts: domestic anxieties; nature contrasted to art; alienation from the paradisal garden. Probably all of these things. Certainly their reconciliation.

Four of the pictures Matisse completed in the spring or early summer of 1912 were purchased by Sergei Shchukin, his principal Russian patron: *Conversation*; the second, more developed version of *Les capucines à "La danse"*; a painting of identical size, also dominated by blue, called *Le coin de l'atelier* (State Pushkin Museum of Fine Arts, Moscow), and *Poissons rouges*. Shchukin visited Matisse at Issy-les-Moulineaux in late July to make his selection. At that time he also acquired *Amido*, the first-trip painting.[84] (By 1913 he had purchased another first-trip painting, *Le vase d'iris* (cat. 1), but quite when is unknown.) And, additionally, he commissioned Matisse to make for him a pendant to *Poissons rouges* and a pendant to *Amido*.[85] The latter took priority, it seems,[86] and was to be painted when Matisse returned to Morocco.

So were the two landscapes for Morosov that Matisse still had to do. Morosov had been pressing Matisse to get them done. As had happened the previous summer, Matisse told Morosov that he would have them finished in time for the Salon d'Automne.[87] Again he did not do so. And although he had decided by mid-August what he would be sending to that Salon,[88] he put off telling Morosov until the last moment. Not until the very eve of his departure for Morocco, 29 September, did he confess: "I am embarrassed to write to you that I have not been able to do your two landscapes; that, in consequence, they will not be at the Salon as I had written you, but that I leave tomorrow for Morocco where I count on painting them."[89] So Matisse had yet that commission to fulfill.

Matisse traveled to Morocco alone this time, his wife remaining at Issy-les-Moulineaux, and he apparently intended to stay only long enough to fulfill his obligations to his two patrons.[90] He arrived on 8 October, again lodged at the Hôtel Villa de

France, and immediately set to work. Eight days later he wrote to his wife that he had painted a Moorish woman for Shchukin and begun a landscape for Morosov.[91] The "*mauresque,*" he wrote later that month to Camoin,[92] was to be a pendant to the Moroccan boy [*petit marocain*] he had done the previous year (namely *Amido*). But windy conditions and an irritating model [*modèle agaçant*] were against him. Consequently, when he had thought the picture was finished, he took it back home but he had not dared to turn it around and look at it lest he be dissatisfied. "It is a decorative canvas that I am required to do and I think that will be it, but I would have wanted more." Matisse went on to say that he was making "two landscapes that are beginning to become serious" after having been "only agreeable child's play" and that the *mauresque* and the two landscapes were the reason for his being in Tangier.

The irritating model was Fatma; and the larger of the two works called *La mulâtresse Fatma*, identical in size with *Amido*, was Matisse's first conception of the decorative canvas for Shchukin.[93] He must have turned the picture around and gone back to it, for on 20 October he wrote to his wife to say that he was painting "the negress" and had just completed the fourth sitting that afternoon. She was not an easy model, he added, remarking that if Hamido [Amido?] were not there, he would be in trouble.[94] But Zorah, the sympathetic model from his first trip, was eventually found. It was a painting of her, *Zorah debout*, that eventually fulfilled the Shchukin commission.[95] *La mulâtresse Fatma* was a compositionally more appropriate pendant to *Amido*: the figures in the two paintings have matching oblique poses. But *Zorah debout* went to Shchukin instead because it was the more decorative work.

Matisse's first trip to Morocco had accompanied a move away from decoration and toward nature. His paintings between the two Moroccan trips had addressed the contrast, and reconciliation, of decoration and nature. Now back in Morocco, two broad developments occurred. First, in figure paintings the scales tipped back toward the decorative again to bring his decorative period to a triumphant conclusion. Second, in the outdoor scenes, *Sur la terrasse* and *Porte de la casbah* (cats. 13, 14), Matisse pursued further the improvisatory method of painting he had used for *Les acanthes* on the first trip and had been using for works painted between the two trips. Discovery of form purely in the process of painting would become the basis of his so-called experimental period of the war years. Shchukin's request for a decorative picture may have helped, even initiated the first of these developments. But it was one that Matisse gladly followed. If the spring and summer of 1912 had shown him anything it was that decoration and nature could be reconciled and that color beyond the ordinary would do it. Matisse's first month back in Morocco, painting from the figure and needing to fulfill a decorative commission, encouraged him to explore color from nature as a decorative element at quite a new level. He therefore did not go back to France as soon as he had planned but, summoning his wife to join him, and Camoin too, remained in Morocco to compose additional decorative works.

It is not accidental that these decorative works are painted from decorative subjects, namely figures wearing brightly colored costumes. However, Matissse's paintings are not merely depictions of the decorative. They are intrinsically decorative. The color is literal as well as depictive: it cloaks the canvas as the costume it depicts cloaks the figure. The carefully adjusted panels of color that, in the absence of tonal tissue, form the costumed figure, form the decorated surface. The costume is the surface.

This is also to say that the image is the picture. Full-length figures are on tall, narrow canvases. Half-length and seated or crouching figures are on broad rectangles. The picture is proportionate to the pose. That symbiosis is important too. But it makes possible the more important one. Each figure is costumed and each picture is constructed like a costume. Each surface comprises colored panels apparently stitched

together down linear seams. And although each panel is flat and unmodulated, usually, and drawn up frontally against the next, they all billow, apparently. For all the delicacy of these pictures, they do convey, although not the density of bodies, their sense of inflation. They swell with a most elusive kind of abundance, which suffuses, indiscriminately, figure and ground. Such an animating breath had filled the garden pictures (*Les pervenches*, in particular, seems a billowing garment of color, and the ivy-covered sapling to the right of center a fastening like that to be found on a Riffian's robe.) There, it made an easy buoyancy of the world. In some of the figure pictures it does that too. Zorah, especially, seems to float in her representations. But what it mainly does is to enlarge the figure, suffusing the whole surface with its corporeality; the surface absorbs it as its own.

4. The genius of the place

Travel is an implicit quest for anomaly, said Paul Fussell.[96] We travel in search of the strange and the wonderful and we try to remember the marvels we have seen. It is, therefore, a most unusual traveler who does not bring home a souvenir, which is in effect a kind of synecdoche that stands for the larger context of marvels from which the traveler chose.

And yet, a souvenir is not so much a part that is representative of a whole as it is a representative part chosen from a selection of parts that compose the whole. Insofar as travel is a quest for anomaly, its pleasures are epicurean, are moments of bliss and not continuous satisfaction. Therefore it savors, indeed it comprises fragments: experiences chosen for their extractable pleasure even more than for their representative force. Souvenirs are chosen thus, and if they do represent the whole it is because the whole has been experienced as a collection of parts, not continuously as a fusion. Souvenirs are details you take home.

Nineteenth-century orientalism was obsessed by details. It was the topographical detail (often the surfeit of detail) that gave credibility to representations, authenticating even the most extraordinary pictorial inventions. Thus the tile work in Gerome's *Le bain maure* (fig. 109), to take a familiar example, makes credible by virtue of its apparent authenticity not only the Moorish bath itself but the erotic fantasy played out against its backdrop. Details supposedly present to describe the real directly in fact provide what Roland Barthes called "the reality effect" (*l'effet de reel*) for the work as a whole. Linda Nochlin has made this point to show how the supposed scientific or ethnographic realism of nineteenth-century orientalism used science or ethnography for nonscientific, nonethnographic, indeed nonrealist ends.[97]

Actually, some of the tile work in *Le bain maure* is not Moorish at all but Egyptian.[98] The detail does not have to be authentic; for how would the viewer know whether it was? Rather, it has to conform to the viewer's expectation of what in that particular context is authentic. The function of the detail, in particularizing the setting, is to reinforce the drama that completes the setting. Thus, in *Le'bain maure*, white glazed tiles with ornate decoration recapitulate the theme of the naked white woman in an exotic setting. A contemplative native scholar, in Ludwig Deutsch's *Le scribe* (see London 1984b, cat. 19), is better served by warmer, friendlier architecture in picturesque disrepair. Exactly the same principle guides the purchase of souvenirs: they seem authentic to the extent that they confirm our prejudices about a place. In their detail is a map of our preconceptions. But what does it mean, then, not to have detail at all?

Beyond the Petit Méchunar, or plaza, of the Casbah in Tangier is the Bab el Aassa, the gate that marks the boundary of the Casbah and the rest of the medina (old city).

fig. 109. Jean-Léon Gerome, *Le bain maure*, c. 1870, oil on canvas. Museum of Fine Arts, Boston, Gift of Robert Jordan from the Collection of Eben D. Jordan

Immediately to the right of this gate is a wall of tile work similar to that in Gerome's picture. Matisse's *Porte de la casbah* (cat. 14) is a view of the Bab el Aassa. The vertical blue line down its right edge marks the beginning of the wall of tile work that Matisse excluded. Some of the most important of his immediately pre-Moroccan pictures, the 1911 decorative interiors, had contained a plethora of ornamental detail. When later, in Nice in the 1920s, he sought to create for his art an exotic, luxurious mood, he did so by using Moroccan screens, carpets, costumes, and so on. In Morocco itself, however, his paintings were extremely free of topographical detail. While the figure paintings are ethnographically correct in the components of the costumes they show, those paintings are so much all costumes, the decorative costume comprising the decorated surface, that their details do not function as such, as details, incidental to the main theme. They compose the main theme itself. Details, appearing as they usually do at the meeting of colored panels, stitch together the colored panels from which costume and painting together are made. Details are, etymologically, the whole cut into pieces; in Matisse's costume paintings the details tailor the whole.

And in his other Moroccan paintings Matisse deliberately avoided detail. It is the general—light—and not the specific—detail—that gives them their sense of place. Consequently, their sense of place is not particularized. Matisse's Morocco is not there and then. It is everywhere present.

That last phrase comes from Coleridge, from the passage in *Biographia Literaria* where he said that "our genuine admiration of a great poet is a continuous undercurrent of feeling; it is everywhere present, but seldom anywhere as a separate excitement."[99] The

detail, in these terms, is the separate excitement and the art of detail is the art of picturesque excitement. Matisse's aim is continuous pleasure.

Linda Nochlin correctly emphasized the association of authenticating detail and the picturesque; also that the nineteenth-century pursuit of the picturesque was akin to tracking an endangered species that retreated farther and farther away.[100] But she was far too optimistic, I believe, when she said that the picturesque is avoidable simply by using (like Courbet) contemporary instead of exotic costumes and the conventions of democratic, popular culture instead of domineering, high culture, or simply by using (like Gauguin) true, primitivist-influenced flatness instead of lying Western illusionism. Courbet and Gauguin may, indeed, have escaped the picturesque, although I am not sure that they, especially Gauguin, entirely did. But in principle, the contemporary popular detail is no less useful as an authenticator than the exotic detail, and no less desirable to possess. And primitivist-influenced, modern flatness will merely present the detail as if on a tray instead of (as previously) within a box; will merely substitute new picturesque decoration for old picturesque illustration. While the detail remains of separate interest, offering separate excitement, so remains the picturesque, which takes pleasure in the detail for all that it stands for, suggesting that, too, may be possessed.

But there is another kind of pleasure, which rejoices in the absence of mere interest and requires of its source that it deliberately avoid the easy glamour of extractable stimulants. This is not to say that Matisse is a superior artist when he avoids all topographical detail; rather that he is when his infatuation with the particulars of visible appearance is conveyed by no less an infatuation with the substance of paint. Detail may flourish, therefore, but never deceptive detail. Thus, one of the Moroccan landscapes is not inferior to the other two because its acanthus leaves are more precisely delineated than are the periwinkles and the palm in the other two. It is at least the equal to its companions: in part, because we actually see the absence of pretense in the painting. As Lawrence Gowing has observed of Constable, we are never allowed to suppose that a landscape painting consists of leaves.[101]

That Matisse in his Moroccan pictures generally avoided detail, whereas before and after he rejoiced in detail, suggests that he felt the need of its authentication only when he was away from the source of the detail, when he was painting something inauthentic. It also suggests that the drama he was describing in the decorative compositions of 1911 and in the Nice interiors of the 1920s required the explanation, the reinforcement, of ornamentation while what he was describing in the Moroccan pictures did not; rather, required the absence of ornamentation, of detail. He could not be more specific about what he was painting in Morocco because what he was painting there was not, in an important sense, specific to Morocco at all. Which is not only to say that real observation served to represent an imaginary way of life. It is also to say that Matisse went to Morocco not because it was strange but because he hoped and expected to find something familiar there.

The year 1912 that covered Matisse's two trips to Morocco is an extremely important one in the political history of that country; it saw the final completion of Morocco's long journey to colonial submission. When Delacroix went to Morocco, eighty years earlier, it was as part of a diplomatic mission to expand French influence in North Africa. By the turn of this century, France had begun to make military incursions into the country. In 1904, an *entente cordiale* with Britain had secured recognition of French influence in Morocco in return for recognition of British influence in Egypt, and a similar agreement with Spain ceded a small Spanish sphere of influence in northern Morocco for French preeminence everywhere else. France bolstered its position by encouraging Morocco to borrow from French banks and securing the right to collect customs receipts in return.

The result was an increase in scattered violence against the French and other foreigners; also, protests against French influence by Germany. But the Algeciras Conference of 1906 legitimized the interests of France, which increasingly made use of police actions, nominally to suppress violence against its nationals, to effect military colonization. After the French occupied Fez in 1911, purportedly to support the sultan and protect European residents, Germany again protested and positioned a warship off Agadir to threaten its intervention. The result was another *entente cordiale*, of November 1911, in which Germany acknowledged French supremacy in Morocco in exchange for acknowledgment of German supremacy in central Africa. The sultan was therefore obliged to sign the Treaty of Fez of 30 March 1912, which formally established Morocco as a French protectorate while recognizing the special status of Tangier as an international city.

On 1 April 1912 or thereabouts, Matisse wrote to Marquet that he had been planning to go to Fez (he had just made a quick trip to Tetuoan) but that the situation was dangerous there.[102] This is the only reference in all the known correspondence or memoirs of Matisse to his showing any interest in the political situation of Morocco. But uprisings, supressions, kidnappings, skirmishes between rival factions, and the like seem to have been common enough occurrences throughout this period and not of pressing concern since they always happened somewhere in the interior. So they were nothing to write home about unless they interrupted one's travel plans; bad weather was bigger news. In any event, it was as well that Matisse did not go to Fez. Earlier, the French had withdrawn their troops from the city and, not anticipating strong local reaction to the Treaty of Fez, had not thought to return them. On 17 April the entire European population of Fez was massacred and the fearfully mutilated bodies displayed before the Sultan's Palace. Matisse had left Morocco three days earlier, after a farewell visit to the gardens of the Villa Brooks, where he was "thrilled by the flowers." By the time that he returned to Morocco six months later, the French resident-general appointed in the aftermath of the events at Fez had effectively conquered the country, making Morocco a French colony.

Tangier itself, of course, had long been a highly Europeanized, international city. Morocco was known as "el-Maghreb el-Aqsa," the Far West (of Islam), with Tangier its most western and westernized point. As may be seen from a picture postcard that Matisse sent to Gertrude Stein on 16 March 1912 (see fig. 131), the more public squares were crowded with people in European dress. And there were a lot of artists. (The circumstances are not quite clear, but it seems that Matisse had to flee one studio he had rented because of the presence of eleven Belgian painters in the same building.)[103] To go outside Tangier, only possible by horse or donkey, would be to become if not an explorer at least a traveler; in Tangier, one was really a tourist, surrounded by a very large, benevolent, colorful and very poor population, eager to please.[104] Matisse was not blind to the injustices that he saw. There was a large charcoal market next to the English church that he could see from his hotel bedroom window (see fig. 93). On 22 February 1912, he sent to Gertrude Stein a picture postcard of female charcoal-carriers (fig. 110), writing: "A country where feminists are completely unknown—unfortunately because the men abuse the women."[105] However, his Moroccan figure paintings are in no sense realistic to what must have been the wretched conditions in which Zorah or Fatma or Amido lived. But Matisse was never a psychological portraitist. "I seldom paint portraits," he observed in 1912, "and if I do, only in a decorative manner. I can see them in no other way."[106] The figure paintings are not portraits and we have no right to expect them to be.

Matisse worked within the established context of orientalist representations. As an imaginative artist, he preferred the discipline, and the freedom, of a conventional dramatis personae. His cast of characters included: among men, the dangerous, colorful

Tanger, Maroc. Porteuses de charbon

fig. 110. *Tanger, Maroc, Porteuses de charbon*, postcard from Matisse to Gertrude Stein, 2 February 1912. The Beinecke Rare Book and Manuscript Library, Yale University

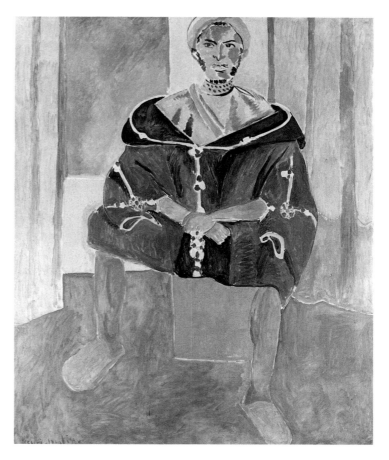

warrior, the quiet helpful servant, the contemplative, hashish-drugged idler; among women, the mysterious sexual object, the proud negress. Matisse did not exaggerate or exploit these stereotypes; there is no voyeurism or moralizing or condescension in his representations. But neither did he deny these stereotypes; they form the conventional backgrounds on which his highly personal representations are drawn—from which his representations take their mythic, nonreportorial character and in contrast to which the personal form of that mythology is displayed.

So when Matisse painted his Moroccans as a mysterious backward race, as much primal as exotic but tending to inertia, he was using established conventions as a way of painting his own personal pastoral, his *rêve du bonheur*. This is why he was compelled to generalize: because Arcadia could be anywhere. (Thus *Zorah debout* not only recalls any number of Persian miniatures; as Alfred Barr observed, it also brings to mind Holbein's *Christina of Denmark*.)[107] This is why he had to avoid detail: because Arcadia is an imaginary location and cannot be specified. This is why he purged figures of expression: because he was painting not contemporary individuals but atemporal, representative types. (Even Manet's comparable images look positively animated, in contrast.)[108] And this is why he so rigorously flattened everything to the surface. The light of Morocco did tend to flatten.[109] So did the very familiar images of Morocco that Matisse must have seen, namely travel photographs: at times, there are striking resemblances between such photographs and Matisse's paintings (fig. 111, cat. 19). But mainly, it was representation of Arcadia that required flatness. It was not something to be seen in deep space, not something real to be observed as if through a window. It was something imaginary to be projected on the surface of memory, something that spread out over the surface as a map did, and like a map it signified rather than described. The *Café marocain* (cat. 23) is such a map of Morocco as an Arcadia.

left: fig. 111. *Two Merchants of Tangier,* from Vincent Sheean, *An American among the Riffi* (New York, 1926).

right: cat. 19. *Le rifain assis*

There is a considerable range of pictorial feeling across the group of Moroccan figure paintings. While not characterizations of people, they are characterizations of types; Matisse did vary his technique from subject to subject in the interpretation of character. Thus, he interpreted the character played by Fatma (a friendlier version of the traditional proud negress) by using denser, more compacted paint than he did for the character played by Zorah (an innocent version of the mysteriously sensual odalisque), who got a lighter, more ethereal treatment, and he reserved the most fluid treatment of all for the part of the colorful warrior, assumed with great equanimity by the Riffians, whose images have been freely improvised from very liquid paint. And in each of these cases, the characterization extended to the entire pictorial surface, not merely to the boundaries of the represented character.

In line with this, *Café marocain* may be thought of as Matisse's interpretation of the character of the meditating Moroccan. But this subject is very different from the others and must be painted very differently: because it asks for characterization of that part in the Moroccan cast where character, as such, is sublimated and disappears. In reverie and contemplation, all is reduced to an almost featureless state, to a pale, tonal similarity that mutes the individual self, blurring the division between it and its surroundings. And yet, to the observer, the individual self seems enclosed within itself, abstracted, deprived of communication with its surroundings. Matisse's picture allows of such interpretation as an illustration of Moroccan reverie. It was certainly based on a café that he visited and shows a view of Moroccan life he found fascinatingly exotic and personally sympathetic.[110] That is to say, it is simultaneously a condensation of reality and a model of the imagination.

Matisse would later muse about "some paradise where I shall paint frescoes."[111] This is, effectively, what he had done in making the *Café marocain*: using not oil but a water-based, distemper medium for the delicate continuity of its matte surface and working in an environment he had come to think of as paradise, he progressively reduced the image until it reached the state of clarity that for him was grace. "To perfect is to simplify" is the motto of his last decorative composition for twenty years.[112]

His period of decorative art was thus ended, not to be reopened until after he took another exotic journey, to Tahiti, in 1930. And then, commissioned to paint a mural for Dr. Barnes, did his sight of the lunettes over the windows in the house at Merion perhaps recall the arcade of a Moroccan cafe? We do not know. But the pastel tonality was reprised and the dance that Matisse painted was of extremely relaxed measure.

Shchukin acquired *Café marocain*, just as he acquired other major decorative works made on the second Moroccan trip: *Zorah debout, Le rifain debout, Arums*, and *Arums, iris et mimosas. Zorah debout*, we remember, had been painted for Shchukin as a pendant to the first-trip picture, *Amido*. When that was completed, by early November 1912, Matisse began his paintings of Riffians.[113] He may have intended one as the promised pendant to Shchukin's *Poissons rouges*: a letter of 21 November refers to his having started a Riffian painting the same size as Shchukin's *Goldfish*.[114] And yet, *Poissons rouges* and *Le rifain debout* make an unlikely combination. *Arums, iris et mimosas* is also of the same size as *Poissons rouges*; it is boldly inscribed "Henri-Matisse, Tanger 1913;" and it was prepared by the *esquisse* titled *Arums*. Two still lifes seem far more appropriate companions. In any event, Shchukin was satisfied. It was not Shchukin but Morosov whose commission posed a problem.

With exemplary promptness, Matisse had begun a landscape for Morosov within days of his arrival back in Morocco in mid-October 1912. By the end of the month, he was working on two landscapes. Matisse had promised to paint two landscapes for Morosov plus a still life for Morosov's wife. He fulfilled all three obligations with the so-called

Moroccan Triptych (cats. 12, 13, 14), which contains neither landscapes nor still life but, rather, a view of Tangier from Matisse's hotel bedroom window, a picture of Zorah, and a view of a Casbah gate. It is uncertain when Matisse confessed to Morosov what the subjects of these paintings were. Even in early April 1913, nearly two months after he had left Morocco, he was still saying he had painted Morosov two landscapes and a still life.[115] It may well not have been until 19 April, the closing date of Matisse's short Bernheim-Jeune exhibition of his Moroccan paintings, when he sent Morosov a sketch of his three works along with the news that their exhibition had proven a great success.[116] Morosov could hardly have been expected to guess all their subjects from their titles: *Porte de la casbah* was clear enough but *Paysage vu d'une fenêtre* borders on the disingenuous (for the view is of the city, not a landscape in a strict sense), and *Sur la terrasse* could be construed to be actually deceptive (for without this title it would be unlikely that Zorah's location could be named). As it turned out, Morosov was delighted by his pictures. Matisse may have helped his case by saying that they could be combined in an ensemble. (This implies that they were not definitely painted with this in mind.)[117] Their combination seems to have encouraged Morosov to think about commissioning Matisse to do another three-panel work.[118] Morosov soon thought better of it, however.

Paysage vu d'une fenêtre had probably been painted near the beginning of Matisse's first Moroccan visit, recording early impressions of the lush, rain-drenched city of Tangier.[119] His other Moroccan window painting, *Fenêtre ouverte à Tanger*, was painted early on the second visit,[120] and shows almost the same view but under very different conditions. When Matisse returned to Morocco, the winter rains had not yet started and he was shocked to find how parched everything was as compared to when he was there last.[121] *Fenêtre ouverte à Tanger* describes a fiercely sun-scorched landscape. The freest of all the Moroccan paintings, it is evocative of the shimmer of extraordinary heat. It is probable that both window paintings were at one time intended for Morosov.[122] They do form a pair of pictures in two keys, or climates, or spatial conceptions. The contrast that they afford would be recapitulated in another pair of window pictures, no less great, *La fenêtre bleue* and *Le rideau jaune*.[123]

Sur la terrasse and *Porte de la casbah* are, in technique and palette, paired works and must certainly have been painted around the same time on the second trip.[124] In these most remarkable pictures, Matisse conflated the dense Cézannism of the previous summer with the lightness and openness characteristic of second-trip Moroccan compositions. Their scumbled, layered handling, which aerates them, is finer and more economical than anything Matisse had done previously in a similar manner. It associates them. But so also does their green, pink, and blue palette and their composition by means of depicted architecture that is both flat and frontal and allows bold geometric division of the pictorial space. Conceptually, however, they are quite unlike, the two different areas of the Casbah they show offering Matisse dissimilar pictorial possibilities. It is unknown when he thought to combine them with *Paysage vu d'une fenêtre* to make a triptych. But it was the logical conclusion of the Moroccan experience, not only to paint reality as multiple but to combine in one large work its multiple forms. Anchored by the heavier, more sensual beauty of the window painting, the triptych imagines Morocco as a most ethereal place of perfumed atmosphere and shifting iridescent light where different, disjunctive realities coexist. Morocco—reality—remains mysterious because it cannot be reduced to a single thing; because its representations remain mysterious, refusing single explanation.

The triptych may conceivably show three moments of a single day: from left to right, dawn, noon, and dusk. When Matisse sketched the pictures for Morosov,[125] he accentuated the English church in the left picture and the tower of the mosque in the right one:

a contrast of the Christian and the Islamic, perhaps. And perhaps they show us being taken successively deeper into the Casbah: out of the hotel, from whose windows the walls of the Casbah are seen, through the Casbah gate, and finally reaching its mysterious, exotic center. The increase in size of the figures shown in the three works, taken in this order, does provide an effect of approaching a destination: the end of a journey within the Moroccan journey, an interior, sentimental, or temperamental voyage coterminous with the outer one. Certainly the effect of different degrees and distances of openness and closure afforded by the three frontal surfaces is crucial to the intersecting meanings of the three works. So is the effect of different degrees of specificity. The left picture offers access to a readily comprehensible reality; the right picture to a far less certain one; the center picture shows a readily comprehensible reality but one whose meaning is uncertain. And yet, for all this, the Moroccan Triptych does not come to our attention as an obscurity that requires clarification. In this respect it is unlike and much greater than the schematically simplified *Café marocain*, which suspends us between reality and abstraction, inviting us to decipher what its sign system might mean. The Moroccan Triptych is not a problem to solve, not something exterior to us which we have to face; it is a mystery in which we are caught up, which we accept because it absorbs us.[126]

The main thrust of Matisse's second Moroccan trip had been the creation of a new, more luxuriant kind of decorative art. That development reached its climax, and conclusion, with the *Café marocain*. In the Moroccan Triptych, Matisse put his decorative style behind him to pursue what immediately before Morocco had been a minority investigation: of the reality to be created in the manual, empirical process of painting. In pursuing his decorative style he had become an extremely radical artist, open to non-European sources, and capable of masterpieces of conception. But the separation of painting and drawing inherent to that style was finally limiting. Drawn linear designs tinted with color might produce carpets of color, not paintings. (If the *Café marocain*, as an essentially decorative work, adopts the modality of the carpet down to its patterned border, then the Moroccan Triptych, as an essentially pictorial work, adopts the modality of the window.) The Moroccan Triptych shows Matisse's reinvolvement with the process of painting at a newly profound level.

Nothing was certain, therefore, before the act of painting. Matisse still first drew out the image on the canvas, but now it was not a design to follow; rather a proposition, a hypothesis put forth. In *Porte de la casbah*, a second figure, to the right of the arch, proved unnecessary. In *Sur la terrasse*, Zorah was originally much smaller, as was her bowl of goldfish whose bulging distortion is the result of Matisse's change of mind.[127] This painting itself, larger than its companions, may have been a second conception of this motif. *Zorah assise*, the beautiful *essence* drawing on canvas that Matisse clearly could not bear to lose under layers of painting, is of the same dimensions as each of the triptych wings. Reality was simply unknown now before it was imagined in paint. In each part of this great composition, surely the greatest of Matisse's imaginations of Morocco, the spirit, the genius of the place is in its painting. This is also to say: each of Matisse's pictures is what he said a picture of Cézanne's was, not "a moment of nature" but "a moment of the artist."[128]

The Moroccan experience was not forgotten when Matisse returned from Morocco the second and last time in the spring of 1913. Its influence is felt in many subsequent works right through to some of the paper cut-outs of his last years. Increasingly, however, the influence so interweaves with others that, while it may be drawn out for separate examination, its force is not separate, and such examination must be careful neither to exaggerate it nor to simplify it nor to draw out the wrong thread. Thus the 1950 cut-out

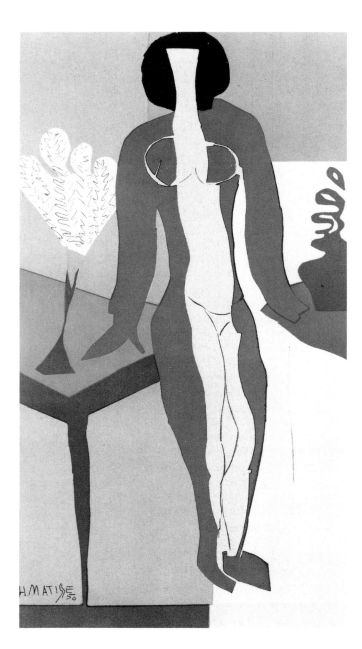

fig. 112. Henri Matisse, *Zulma*, 1950, paper cut-out. Statens Museum for Kunst, Copenhagen

Zulma (fig. 112) may reasonably be considered of Moroccan lineage, a re-created Zorah by way of certain 1920s and particularly 1930s Moroccan remembrances in the form of paintings of odalisques. But we exaggerate this connection if we neglect to notice the deco stylishness of Matisse's work of the 1930s, and its transmission to *Zulma*; and we simplify this connection if we fail to notice the similarity of *Zulma* to the right-hand figure of Matisse's great *Demoiselles à la rivière* (see fig. 30), begun in 1909 or 1910 but completed in 1916 with memories of Morocco somewhere in mind.[129] So *Zulma* refers twice, differently and both times obliquely to Morocco, and to non-Moroccan experience as well.

Every later work will offer similar complications. To stay just with the cut-outs, *Tristesse du roi* will recall Morocco but by way of recalling Delacroix's *Femmes d'Alger*.[130] *Grand Decoration aux masques* will seem to recall Morocco by recalling its decorative tile work. But more likely it recalls the Alhambra in Granada, therefore pre-Moroccan experience.[131] And so on.

At various moments in Matisse's early Nice period, however, Moroccan reference seems very explicit. Then he made numerous paintings of odalisques in exotic costumes before staged decorative settings. At the beginning and at the end of this period, for example in *Déjeuner oriental* of 1917 and in *Odalisque et tabouret* of 1928,[132] Matisse depicted actual black or oriental models as if in some Middle Eastern harem. More often he dressed up his regular model. In the early and mid-1920s when most of these representations were made, it was Henriette Darricarrère who assumed the role of an odalisque, posed in what amounted to a makeshift theater constructed from hanging patterned textiles and Moorish screens. "I do odalisques," Matisse explained, "in order to do nudes. But how does one do the nude without it being artificial? And then, because I know that they exist. I was in Morocco. I have seen them."[133] The nude is an artificial convention, not to be found in life as nakedness is. To make the nude seem real in art meant finding nakedness in life in its most artificial form. "As for odalisques," he added later, "I had seen them in Morocco, and so was able to put them in my pictures back in France without playing make-believe."[134] This is to say: what Matisse was creating was made up, of course, but it was not mere make-believe because Matisse did believe in its reality. Morocco had shown him such a reality. Now he was painting it.

Of course, he was painting a fantasy—a private oasis of earthly delights—but fantasy not in the sense of the incredible, not as something entirely separated from reality, but rather what reality can be confused with and mistaken for. And insofar as the Nice odalisques are remembrances of Morocco, they are fantasies, in this same sense, of Morocco too. Matisse may have seen in Moroccan brothels women dressed and posed like those he painted in Nice. But he did not paint them in Morocco. The Moroccan paintings may be sensual but they are never sexual. What Matisse made in Nice was, therefore, not a re-creation of the Moroccan experience; rather, a re-creation of what it might have been. This is why it is presented as drama: to make it persuasive. This is why it had to be so thoroughly detailed: to make the drama seem authentic. And this is why it required a realist style: to persuade us that it is true. While flat modern simplification produced a "grand style," Matisse said, the use of half tones was "much closer to the truth."[135]

More than the objects of pleasure, the continuity of shimmering light produced by films and thin layers of color associates the Nice-period paintings with those done in Morocco. Whites breathing through color, perhaps the most important of the lessons Matisse learned from Cézanne, spread unifying light to express the homogeneous spectacle of the world. But there was another and even more radical way that light and its continuity could be expressed: an entirely opposite way, by using "black as a color of light and not as a color of darkness."[136] In 1916, three years after his return from Morocco and one year before he first moved to Nice, Matisse used this method to paint *Les Marocains* (cat. 24).

This, his definitive "souvenir du Maroc," as he described it,[137] is luminous without being light. And its black unifies by first dividing. The multiplicity of reality, explored in the Moroccan paintings separately, is suggested in one work. The three zones, denoting architecture, melons, and Moroccan men, seem independent memories. They appear to have been observed from different angles. Matisse used the spatial cell convention he learned from Islamic art in this stylistically most nonexotic context.[138] But these separate souvenirs of Morocco are linked by the continuity of the black field as if by a continuous undercurrent of feeling. Black is suggestive of light. It evokes the intensity of tropical sun and shadow, their erosion of form, and conveys a remarkable sense of physical heat. As important, however, black is "a force . . . to simplify the construction,"[139] the simplifying force of memory, which remembers Morocco not merely for its climate or its light or its individual marvels but for its continuous mystery. And yet, its

mysteriousness is quite unlike that of the Moroccan Triptych, say; it is not quite celebratory of Morocco. It is a form of elegy.

When Matisse first thought to paint a large remembrance picture of his Moroccan experience, shortly after the April 1913 Bernheim-Jeune exhibition of his works made in Morocco, he considered a beach scene. He soon abandoned that idea and, instead, eventually reworked his large *Demoiselles à la rivière*, giving it what could well be a Moroccan setting.[140] In any event, 1913 was a year of change and readjustment. Matisse reestablished contacts with the Parisian avant-garde, took long walks and horse-rides with Picasso,[141] confronted cubism; his art was too much in flux for an important synthetic work. He considered returning to Morocco for the winter but at the very last moment decided against it, saying that he did not want the temptations of the picturesque to disperse his energies.[142] It was not until late in 1915 that he was able to settle to what he obviously considered a definitive painting. He began it as a reprise of *Café marocain*. As completed in 1916, it could hardly be more different. Both are products of pictorial reduction and elimination. In the earlier work, the result is simplification that produces calm by having removed anything disturbing. In the later work, the result is simplification that accepts—within an environment of calm—contradiction, dissonance, and extraordinary tension.

Matisse had returned from the opportunism of clarity to the conscientiousness of anxiety, and would spend the rest of his life trying to get back. *Les Marocains* remembers Morocco in 1916, at the height of a terrible war, the destroyer of nature to an extent no previous war had been, the tangible agent of the antipastoral.[143] Therefore that picture remembers not only what is past but also what is lost. The Golden Age had always been in the past. Pastoral had always been instinct with elegy.[144] But it had always, before, seemed recoverable.

This is not to say that Matisse is forever a changed artist because of the war. Rather, that his so-called experimental period of the war years effectively ended the youth of his art and its idealized peace. His reinvolvement in Morocco with the discovery of form purely in the process of painting prepared for what happened in the experimental period; so did his return to nature and the discovery of its visual uncertainty as being so extreme as to require multiple and stylistically various representations. There was not a sudden break in Matisse's artistic development after Morocco as is often claimed. And yet there was a most critical change. He would again paint pictures with the freshness of those he made in Morocco, but never of the same innocence. When Matisse returned from Morocco, it was to begin a longer and more arduous journey.

Among those who have commented helpfully on this text, I want particularly to thank Beatrice Kernan, with whom I have regularly discussed both details and broad questions of chronology and interpretation; then Jill Moser, who talked through with me its argument at a decisive moment, and James Leggio, who made crucial suggestions after reading the penultimate draft. I am also grateful to Jack Flam and William E. O'Reilly for their advice and encouragement. Additionally, I have benefited from the parallel work undertaken by my fellow authors on this project and from the efforts of all of those who contributed either to its research or to the preparation of this publication and whose names are given in the Acknowledgments. I thank them most sincerely.

1. The idea, discussed in more detail below, that the Moroccan environment itself was a realization of the state of luxuriousness that Matisse previously had been inventing for his art was first proposed in Gowing 1968, 30; revised in Gowing 1979, 117.

2. "Entretien avec Tériade," 1930, in Fourcade 1972, 102–103; trans. Flam 1973, 60.

3. Quoted in Paul Fussell, *Abroad. British Literary Traveling Between the Wars* (New York, 1982), 203. Many of my thoughts about Matisse's traveling have been provoked by this useful and entertaining book.

4. Fussell 1982, 137–141, discussed "the new heliophily" as a twentieth-century phenomenon, which grew in the interwar period as a reaction against the restrictions on travel and psychic gloom of the First World War. In the visual arts, however, it begins with orientalist painting.

5. E. Tériade, "Matisse Speaks," in Flam 1973, 133.

6. Courthion 1941, 102.

7. E. Tériade, "Matisse Speaks," in Flam 1973, 133.

8. "Entretien avec Tériade," 1930, in Fourcade 1972, 105; trans. Flam 1973, 61.

9. Matisse referred to reading Dickens in a letter of 12 March 1912 (Archives Henri Matisse). For this characterization of Dickens: Northrop Frye, *The Modern Century* (Toronto, 1969), 37–38.

10. A stimulating discussion of this difficulty appears in Denis Donoghue, *The Arts Without Mystery* (Boston, 1983), 69–70.

11. "Tradition and the Individual Talent," in *The Sacred Wood* (1920, reprinted London and New York, 1980), 49. See Donoghue 1983, 69, for discussion of this quotation.

12. "Le chemin de la couleur," 1947, in Fourcade 1972, 203; trans. Flam 1973, 116.

13. Courthion 1941, 104.

14. E. Tériade, "Constance du fauvisme," 1936, in Fourcade 1972, 128; trans. Flam 1973, 74. The relationship of this text to Matisse's primitivism was suggested in Flam 1986, 170–174.

15. *La Phalange*, 15 December 1907. Quoted in Barr 1951a, 101–102.

16. Barr 1951a, 94.

17. "Notes d'un peintre," 1908, in Fourcade 1972, 43; trans. Flam 1973, 36.

18. Matisse first escaped Cézanne's orbit in 1904, in fact, when he allied himslf to neo-impressionism, or divisionism, and carefully preplanned his works instead of using Cézanne's method of intuitively developing them on the canvas itself. These procedural alternatives become important to the decorative period and hence affect what happened in Morocco, as is discussed later.

19. E. Tériade, "Visite à Henri Matisse," 1929, in Fourcade 1972, 93; trans. Flam 1973, 58.

20. "Notes d'un peintre," 1908, in Fourcade 1972, 43, 45; trans. Flam 1973, 36–37.

21. E. Tériade, "Matisse Speaks," 1952, in Flam 1973, 132. Here, Matisse discussed his "Divisionism, 1904" as having led to his "Fauvism, 1905–10," whose limitations were overcome with the help of the voyages to Morocco. This, of course, is an unconventional interpretation of the term fauvism, which is usually reserved for the period around 1905 in the art of Matisse and his colleagues at that time. It has the advantages, however, of not artificially isolating a short, transitional episode in Matisse's art and of indicating the extent to which Matisse was alone in pursuing the full implications of fauvism.

22. "Le chemin de la couleur," 1947, in Fourcade 1972, 203–204; trans. Flam 1973, 116.

23. "Le chemin de la couleur," 1947, in Fourcade 1972, 203–204; trans. Flam 1973, 116.

24. "Le chemin de la couleur," 1947, in Fourcade 1972, 203–204; trans. Flam 1973, 116.

25. Matisse quoted Shchukin to this effect in Courthion 1941, 104, but stated it as his own observation in E. Tériade, "Matisse Speaks," 1952, in Flam 1973, 135.

26. E. Tériade, "Matisse Speaks," 1952, in Flam 1973, 133.

27. Giraudy 1971, 14.

28. Postcard of 16 March 1912 to Gertrude Stein. Beinecke Rare Book and Manuscript Library, Yale University.

29. Ernst Goldschmidt, "Strejtog I Kunsten: Henri Matisse," *Politiken*, 1911, in Flam 1988, 128–129.

30. Loti 1889b, 13.

31. "Salon de 1845," quoted in Washington 1984, 129.

32. See cat. 1.

33. Flam 1986, 325. Virtually every letter by Matisse of late January through mid-February 1912 complains about the rainy weather.

34. Archives Henri Matisse.

35. Archives Albert Marquet. See Schneider essay in this volume, p. 18 n. 9, for text of this letter.

36. This is confirmed by Matisse's letter to his family of 3 April 1912, where he wrote that if he felt well enough he would stay in Tangier to do his landscape for Morosov (Archives Henri Matisse).

37. Courthion 1941, 102–103. Matisse told Courthion that he was impressed by the acanthuses at the Brooks property, having previously known them only from the drawings of Corinthian capitals he had made at the Ecole des Beaux-Arts. "I found the acanthus magnificent," he said, "much more interesting, green, than those at school." For Matisse, the Ecole des Beaux-Arts was a hated symbol of dead classicism. His remarks were presumably accompanied by laughter, and it is funny that he could think of this scene as one of preclassical pleasure with preossified acanthuses, "much more interesting, green."

38. "Notes d'un peintre," 1908, in Fourcade 1972, 45; trans. Flam 1973, 36–37, and for the following quotation.

39. This problem only arose after the early fauve period, for then Matisse generally abandoned the preplanning characteristic of divisionist-style paintings like *Luxe, calme et volupté*, and when he retained preplanning (as with *Le port d'Abail* and *Les toits de Collioure*; both 1905, ill. Flam 1986, 122, 139) it was to regress into a divisionist style. Deco-

rative period landscapes that first address the problem include *Les aloès* and *La berge* of 1907 and *Vue de Collioure* of 1908 (ill. Flam 1986, 204, 205, 231). See also notes 50 and 69, below.

40. Matisse's letter to Morosov of 19 September 1911, quoted in part later in this paragraph, refers to "landscapes" (Moscow/Leningrad 1969, 129). A letter of 1 April 1912 mentions a still life and two landscapes for Morosov (Archives Henri Matisse). A letter from Shchukin to Matisse of 11 April 1913 refers to the still life as intended for Mme Morosov (Archives Henri Matisse). See Schneider essay in this volume, p. 42 n. 142, and Appendix 1 for relevant texts.

41. This is clear from Matisse's letter to Morosov of 19 September 1911, quoted in part later in this paragraph, (Moscow/Leningrad 1969, 129).

42. The still life was presumably *Nature morte aux aubergines*. See New York 1978, 82.

43. See Albert Boime, *The Academy and French Painting in the Nineteenth Century* (New Haven and London, 1986), 43–45, 78–89, 137–139, 149–157; Richard Shiff, *Cézanne and the End of Impressionism* (Chicago and London, 1986), 74.

44. "Notes d'un peintre," 1908, in Fourcade 1972, 52; trans. Flam 1973, 39.

45. "I always use a preliminary canvas the same size for a sketch (*esquisse*) as for a finished picture, and I always begin with color. With large canvases this is more fatiguing, but more logical. I may have the same sentiment I obtained in the first, but this lacks solidity and decorative sense. I never retouch a sketch: I take a canvas the same size, as I may change the composition somewhat. But I always strive to give the same feeling, while carrying it on further." Clara T. MacChesney, "A Talk with Matisse," 1912, in Flam 1973, 51.

46. Archives Henri Matisse.

47. A "*paysage bleu*" for Morosov is recorded in a letter of 27 April 1912 to Matisse from his dealers, Bernheim-Jeune, and a photograph of *Paysage vu d'une fenêtre* inscribed thus is in the same hand as the letter (Archives Henri Matisse). Without this evidence, one would be tempted to believe that *Les acanthes* was the picture referred to on 1 April since it seems to have been under consideration for Morosov in this period. It is possible, of course, that Matisse mistakenly wrote "Les pervenches" for "Les acanthes" and the *esquisse* was never under consideration at all. In any event, it would seem to have been out of consideration very soon. On 12 April, two days before his departure for France, Matisse wrote to his family that he had had a special crate made for his still life for Morosov and his two *esquisses*. On 27 April, Bernheim-Jeune formally acquired these three works (as well as *Vue sur la baie de Tanger*, which went immediately to Marcel Sembat). We must therefore presume that their special crating was made because Matisse had assigned these works to his dealer.

48. Archives Henri Matisse. See Appendix 1.

49. See cat. 6 for an infrared photograph of this work, which reveals its drawn framework.

50. Statement recorded by Gaston Diehl, 1954, in Fourcade 1972, 93. See London 1984a, 38–40, for the place of drawing in Matisse's divisionism and early fauvism.

51. E. Tériade, "Visite à Henri Matisse," 1929, in Fourcade 1972, 96; trans. Flam 1973, 58.

52. For the changes in Matisse's concept of drawing with *Le bonheur de vivre*, see London 1984a,

51–54. His use of carefully drawn frameworks in fact preceded the decorative period, being a characteristic of some of his divisionist paintings (see note 39, above). And his occasional use of full-scale cartoons also began in the divisionist period, deriving from Signac and Cross, with whom Matisse worked in 1904 (see Catherine C. Bock, *Henri Matisse and Neo-Impressionism 1898–1908* [Ann Arbor, 1981], 69; Roger Benjamin, *Matisse's "Notes of a Painter"* [Ann Arbor, 1987], 202). In Matisse's decorative period, the drawn framework at times was only schematic, as may be seen by a photograph of *La nymphe et le satyre* of 1909 in an early state (Flam 1986, 248). In this respect, Matisse followed Cézanne in eschewing too much preplanning and developing the work on the canvas itself. (See Benjamin 1987, 195–196). By 1911, however, he was again making extremely detailed drawn frameworks, as may be seen by an in-progress photograph of *L'atelier rose* (Flam 1986, 303). He had thus come full circle, and his new confrontation with nature in Morocco eventually functioned akin to that in Collioure in 1905, as a way of liberating himself from unduly restrictive compositional procedures. See note 69, below, for details of Matisse's *esquisses*.

53. See note 51, above.

54. Postcard to Michael Stein, 26 May 1911. Reproduced and quoted in Barr 1951, 152–153.

55. Quoted in Barr 1951, 156.

56. Flam 1986, 349.

57. See note 26, above.

58. *Paysage vu d'une fenêtre* may be seen in a photograph (fig. 137) that also shows a fragment of *Le rifain debout*, a picture that was definitely painted on Matisse's second Moroccan trip. Matisse told Courthion in 1941 that he brought back *Les acanthes* on the second trip (see note 70, below). This invites speculation that these two blue landscapes, considered as a pair, were to have been the two landscapes for Morosov.

59. A still life is first referred to in a letter of 1 April as "viable" and "at last . . . beginning to take shape." When Matisse packed it on 11 April, it was finished but "barely dry." (All letters, Archives Henri Matisse). The only other extensively developed still life, *Arums, iris et mimosas* (cat. 21) is dated 1913. *Corbeille d'oranges* did not survive as a component of the Morosov commission, being sold shortly after Matisse's return to France (see note 47, above).

60. See cat. 4.

61. See note 29, above.

62. Letter of 12 April 1912 (Archives Henri Matisse).

63. Letter of 12 April 1912 (Archives Henri Matisse).

64. Raynal 1950, 28.

65. Sembat 1920a, 10.

66. Letter of 1 April 1912 (Archives Henri Matisse). See Appendix 1 for text of the letter.

67. Archives Henri Matisse. It is often said, following Barr 1951a, 159, that Zorah was a prostitute. But Barr reported that Matisse had said Zorah was nowhere to be found when he returned to Tangier and that she was eventually discovered in a brothel. The letter of 6 April suggests that she was not a prostitute when Matisse was first in Morocco, but a young girl under her brother's protection, which was why he had to paint her in secret. Presumably she became a prostitute later, which was why Matisse had trouble finding her when he returned to Tangier.

68. "Entretien avec Tériade," 1930, in Fourcade 1972, 102; trans. Flam 1973, 60.

69. As early as 1899, Matisse had painted companion versions of the same subject (*Nature morte aux oranges*; see Flam 1986, 64, ill. 67), but his first pair of pictures in the *esquisse*-and-finished-composition format appears to have been the two versions of *Le jeune marin* in 1906 (ill. Barr 1951, 334–335). Matisse first began actually to exhibit works as *esquisses* in 1907, showing four pictures under that description at that year's Salon d'Automne: *La musique, Le luxe* (ill. Barr 1951, 79, 340), and two landscapes that may well have been *Les aloès* and *La berge* (see note 39, above). Of these, only *Le luxe* led to a more finished companion work of the same size (ill. Barr 1951, 341). *La musique* of 1907 prepared only very generally for *La musique* of 1910 (ill. Barr 1951, 364), which could hardly have been imagined in 1907. There were no second versions of the landscapes. In 1909–1910, Matisse produced *La danse* following the *esquisse*-and-finished-composition format (ill. Barr 1951, 360, 362), after having neglected this approach since 1906–1907. Its use therefore belongs to the beginning and the climax of his decorative period and is preceded and followed by the use of detailed preparatory drawing (see note 52, above). At his 1910 retrospective exhibition at the Bernheim-Jeune gallery, Matisse exhibited two earlier paintings as *esquisses*: an untitled, unidentified work of 1904, noted as belonging to M. A. R. (M. André Rouveyre?), and an *Esquisse pour "Le bonheur de vivre"* of 1905, noted as belonging to M. M. S. (M. Michael Stein), therefore Barr 1951, 321, left, which is not in fact an *esquisse* in the strict sense of the term. Matisse's only other two exhibited *esquisses* were those shown at the 1911 Salon d'Automne (see text, above). By 1912, however, Matisse had become so absorbed in his revised version of the *esquisse*-and-finished-composition format that he gave an interviewer to understand it was habitual to him (see note 45, above).

70. Courthion 1941, 103.

71. Flam 1986, 337, ill. 338. The earlier state of this painting can be seen depicted on the wall in *L'atelier rouge*.

72. When Matisse first exhibited paintings as *esquisses* in 1907, he had been criticized for it because these paintings were, by the standards of his circle, finished works. (Michel Puy, "Les Fauves," 1907, trans. Flam 1988, 69). However, he may well have chosen to describe certain paintings in this way to show that he had repudiated the unfinished look of his preceding, early fauve works. (See Flam 1986, 209, 212).

73. "Entretien avec Tériade," 1930, in Fourcade 1972, 105; trans. Flam 1973, 61.

74. Flam 1986, 296.

75. See Pierre Schneider, "Matisse's Sculpture: The Invisible Revolution," *Art News* 71, no. 1 (March 1972), 70.

76. The common assumption has been that the Pushkin picture preceded the Metropolitan work. However, from Clara T. MacChesney, "A Talk with Matisse," 1912, in Flam 1973, 51, it is clear that Matisse referred to these two paintings (although they are not mentioned by name) and that he indicates the order in which they were made as opposite to that commonly assumed. This is noted in Flam 1986, 500 n. 42, but Flam nevertheless discussed these works as having been made in the other order.

77. Ill. Flam 1986, 381, 382.

78. Ill. Flam 1986, 426, 427.

79. Ill. Flam 1986, 379, 398.

80. See Flam 1986, 441–456; London 1984a, 75–79, 171–177.

81. Matisse's Trivaux landscapes of 1917 (see Flam 1986, 456, ill. 462–465) mediate his return to a more naturalistic style in the early Nice period. In that period, however, Matisse made landscapes without effecting major revision of his art as a whole.

82. Sembat 1913, 191–193. For goldfish in Matisse's art of this period, see Reff 1976; New York 1978, 84–86, 100–102.

83. *Conversation* has been dated to 1908 (Gowing 1979, 97, without explanation), 1909 (Barr 1951, 126, following Matisse's recollection that he had started it before *La danse*), and 1911 (Schneider 1975, 76–82, following the suggestion of Matisse's daughter, Marguerite Duthuit). Flam more reasonably proposed "that it was started in 1908, around the same time as *Harmony in Red* [*La desserte rouge*], though the last touches may not have been done until the late spring of 1912" (Flam 1986, 249). *Conversation* clearly bears a conceptual relationship with *La desserte rouge* (ill. Barr 1951, 345). Equally clearly, Matisse did not show it to its eventual purchaser, Shchukin, when the latter visited Paris in October 1911 (for the date of this visit, Rusakov 1975, 285), for Shchukin wrote of it in the summer of 1912 in terms that show he had only just seen it. Shchukin visited Matisse around 20 July 1912 (a letter from Shchukin to Matisse of 19 June 1912 announced the proposed visit; another of 2 July thanked Matisse for having reserved for him some paintings for his grand salon and his dining room, both letters Archives Henri Matisse). On 6 August 1912, back in Moscow, he wrote to Matisse asking that a frame be made for *Conversation* and that Matisse should send, as soon as possible, the paintings for his salon (Archives Henri Matisse). And on 22 August 1912, writing about the group of his new purchases, he observed: "I think a great deal of your blue painting (with two people), I find it like a byzantine enamel, so rich and deep in its color. It is the most beautiful painting in my memory." (Kean 1983, 298–299). *Conversation*, its surface reveals, was entirely repainted by Matisse. Given his exposure to icons in Russia in the autumn of 1911 and the similarity of its blue coloration to that of known spring and early summer 1912 paintings, it is reasonable to suppose it was repainted then.

84. On 13 March 1912, while Matisse was in Morocco the first time, Shchukin wrote to him there asking that he reserve for him a "souvenir de Maroc" (Archives Henri Matisse). *Amido* was presumably this picture. See cat. 8.

85. That Matisse had been commisssioned to paint a pendant to *Amido* is clear from letters he wrote to his family on 16 October 1912 (Archives Henri Matisse) and to Camoin in late October 1912 (Giraudy 1971, 13). Both letters are quoted in part below. For the circumstances surrounding the other purchases, see note 83, above. Shchukin did not get these paintings immediately, however. Matisse secured his permission to exhibit *Conversation* at Roger Fry's *Second Post-impressionist Exhibition* at the Grafton Galleries in London in October 1912 and *Le coin de l'atelier* at the Salon d'Automne the

same month. He subsequently asked his patron if he could send *Les capucines à la danse* to the Salon d'Automne. This can be deduced from Shchukin's reply to Matisse, by letter on 22 August 1912, when he agreed to Matisse's request but asked that the remaining two pictures, *Poissons rouges* and *Amido*, be sent to him without delay, and reminded Matisse: "Do not forget the companion-piece for my fish (le pendant pour mes poisons [sic])." (Kean 1983, 298–299).

86. In late October 1912, Matisse wrote to Camoin saying he had come to Morocco to do a *mauresque* and two landscapes (Giraudy 1971, 13). The two landscapes were for Morosov. That the *mauresque* was for Shchukin is confirmed by Matisse's letter to his family of 16 October 1912, quoted in part below.

87. This may be deduced from the letter quoted below, note 89.

88. See note 85, above.

89. Moscow/Leningrad 1969, 129. This letter shows that Matisse had not yet definitely decided to give *Paysage vu d'une fenêtre* to Morosov. See note 57, above.

90. Writing to his wife as early as 20 October 1912, Matisse said he was planning to return home (Archives Henri Matisse).

91. Archives Henri Matisse.

92. Giraudy 1971, 13.

93. Although *Zorah debout* (cat. 16) was the painting that eventually went to Shchukin, Matisse cannot be referring to this work. Zorah was a sympathetic model. Besides, she was nowhere to be found when Matisse returned to Morocco and only after a considerable search was she found in a brothel (Barr 1951a, 159).

94. Archives Henri Matisse.

95. Writing to his family on 8 or 12 November 1912, Matisse referred to three paintings of two *mauresques*: a small painting commissioned by Marcel Sembat, which he had not yet finished, and two completed paintings, both 150 cm tall, one destined to become the pendant to the Moroccan boy (*Amido*), the other intended to go to his dealer, Bernheim-Jeune (Archives Henri Matisse). The painting for Sembat is *La petite mulâtresse* (cat. 17), the smaller of the two paintings that Matisse exhibited under the title *La mulâtresse Fatma*. The other two paintings are the large *La mulâtresse Fatma* (cat. 15) and *Zorah debout* (cat. 16). It is unknown when Matisse decided which painting should go to Shchukin and which to Bernheim-Jeune.

96. Fussell 1982, 167, for suggestions absorbed in these remarks.

97. Linda Nochlin, "The Imaginary Orient," *Art in America* 71, no. 2 (May 1983), 122–123.

98. See Washington 1984, 143.

99. This passage is discussed in Donoghue 1983, 80, to which my observations on pleasure are indebted.

100. Nochlin 1983, 122.

101. "The Modern Vision," in *Places of Delight. The Pastoral Landscape* (Washington, 1988), 226.

102. On 28 March, Matisse had written to Marquet saying that he might go to Fez. Clearly, he had changed his mind very quickly. (Both letters, Archives Albert Marquet.)

103. Letter of 6 April 1912 (Archives Henri Matisse).

104. For an amusing account of the differences between explorer, traveler, and tourist, see Fussell 1982, 37.

105. Beinecke Rare Book and Manuscript Library, Yale University.

106. Clara T. MacChesney, "A Talk with Matisse," 1912, in Flam 1973, 52.

107. Barr 1951, 155.

108. See Manet's *La sultane* of 1870 in the E. G. Bührle Foundation, Zurich. Another instructive comparison is with Géricault's portrait of a negro in oriental costume of c. 1822–1823 at the Albright-Knox Art Gallery, Buffalo.

109. Even the academic, Henri Regnault, in Tangier around 1870, felt impelled to abandon chiaroscuro as inappropriate to non-European light: "I tell you that I am escaping modelling," he wrote back home. (See Shiff 1986, 85). Earlier, in 1857, Gautier had more generally observed that oriental subjects offered an escape from traditional modes. See Stevens in Washington 1984, 19–20).

110. See cat. 23.

111. Louis Aragon, "Matisse-en-France," 1943, in Fourcade 1972, 205; trans. Flam 1973, 95.

112. Sembat 1913, 191–192.

113. Matisse's letter of c. 8–12 November 1912, which refers to his three paintings of two *mauresques* (see note 95, above) concludes by Matisse saying that as soon as he is finished with the painting for Marcel Sembat (*La petite mulâtresse*) he will begin another of a young Moroccan from the Rif.

114. Archives Henri Matisse.

115. On 11 April 1913, Shchukin wrote to Matisse to say that he was very pleased Matisse had finished four pictures for him as well as the two landscapes for Morosov and the still life for Mme Morosov (Archives Henri Matisse).

116. Moscow/Leningrad 1969, 129–130.

117. It is worth noting exactly what Matisse wrote to Morosov: "Les trois tableaux ont été combinés pour être placés ensemble et dans un sens donné—c'est à dire que la vue de la fenêtre vient â gauche, la porte de la Casbah â droite, et la terrasse au milieu comme ce croquis vous le represent." Matisse stopped short of saying that they were conceived as a triptych, saying instead that they have been put together as one. It cannot be assumed that Matisse put them together to ensure that all three would be accepted by Morosov (though, given the tortured history of this commission, that possibility cannot be entirely ruled out), but it can reasonably be assumed that the idea of combining them either arose during their painting or followed it. Matisse had sketched a triptych for Morosov in his letter to Shchukin of Monday [1 April] 1912 (see text and note 46, above). But on 29 September 1912 he was still writing to Morosov about his two landscapes (see note 89, above). It would seem impossible, therefore, that the conception of this triptych preceded the second trip. Indeed, even toward the end of October 1912 Matisse wrote to Camoin saying he had returned to Tangier to do a *mauresque* (for Shchukin) and two landscapes (for Morosov). By then he was working on the two landscapes and still not thinking about a triptych (see text and note 92, above). It should finally be noted that Matisse informed Alfred Barr that the three pictures in question did not form a triptych although they were painted in the same year (Barr 1951, 159, without citing a source, but using information from Questionnaire v preserved in the archives of The Museum of Modern Art.)

118. Reported by Shchukin to Matisse in his letter of 10 October 1913 (Barr 1951, 147).

119. It may be presumed that it was well advanced by 1 April 1912, when Matisse referred to it in a letter to his family as simply "le bleu"; it is possible that it was reworked somewhat on his second trip. See cat. 12. Flam 1986, 499 n. 16 recorded that Matisse painted from Room 35. The room has two windows—one facing the English church; the other, at right angles, facing down to the bay— and is only some twelve feet square, as I was able to observe in 1989.

120. If by the end of October 1912 Matisse was working on two landscapes (see text and note 92, above), these can only be *Fenêtre ouverte à Tanger* and *Porte de la Casbah.* Matisse reported working on the two landscapes in a letter to Camoin. It is highly unlikely that he would refer to *Sur la terrasse* as a landscape in this context.

121. Courthion 1941, 102.

122. Matisse referred on 12 October 1912 to the first landscape he began on the second trip as intended for Morosov and later that month to the two landscapes on which he was working, together with the *mauresque* (for Shchukin), as the reasons that had brought him back to Morocco. (See text and notes 91, 92).

123. Ill. Flam 1986, 363, 412.

124. Matisse was certainly at work on *Porte de la Casbah* by late October 1912, if not before. See note 120, above.

125. Moscow/Leningrad 1969, 129–130. See fig. 141.

126. The distinction between a problem and a mystery is Gabriel Marcel's and is discussed in Donoghue 1983, 12.

127. Matisse's changes can be noticed in the x-ray photographs of these two pictures. See cat. 13, Appendix 3.

128. Quoted in Barr 1951, 38.

129. See Flam 1986b, 366; Schneider 1984b, 459, 488–489.

130. These works are illustrated and their association noted in Gowing 1979, 192.

131. This association is noted by John Hallmark Neff in *Henri Matisse. Paper Cut-Outs* (St. Louis 1977), 32, and these works illustrated, 33, 252–253.

132. Ill. Barr 1951a, 415; London 1984a, 186.

133. E. Tériade, "Visite à Henri Matisse," 1929, in Fourcade 1972, 99; trans. Flam 1973, 59. This passage is adapted from London 1984a, 83–84.

134. E. Tériade, "Matisse Speaks," 1952, in Flam 1973, 135.

135. Giraudy 1971, 21.

136. Quoted in Barr 1951, 190.

137. See cat. 24.

138. Golding 1978, 12–13.

139. "Témoignages de peintres: Le noir est une couleur," 1946; trans. Flam 1973, 106.

140. See note 129, above, and cat. 24.

141. Matisse told André Verdet that in 1912 or 1913 he would take walks with Picasso and they would exchange ideas: "Our differences of opinion were amicable. At times we were strangely in agreement." (Quoted Schneider 1984b, 483). The first contemporaneous evidence to substantiate actual meetings between Matisse and Picasso at this time appears in Judith Cousins, "Documentary Chronology," in William Rubin, *Picasso and Braque. Pioneering Cubism* (New York, 1989), 421, 422 (entries for 22 July and 29 August 1913).

142. To Camoin, 15 November 1913 (Giraudy 1971, 15).

143. See Paul Fussell, *The Great War and Modern Memory* (London and New York, 1971), 231.

144. Fussell 1982, 210.

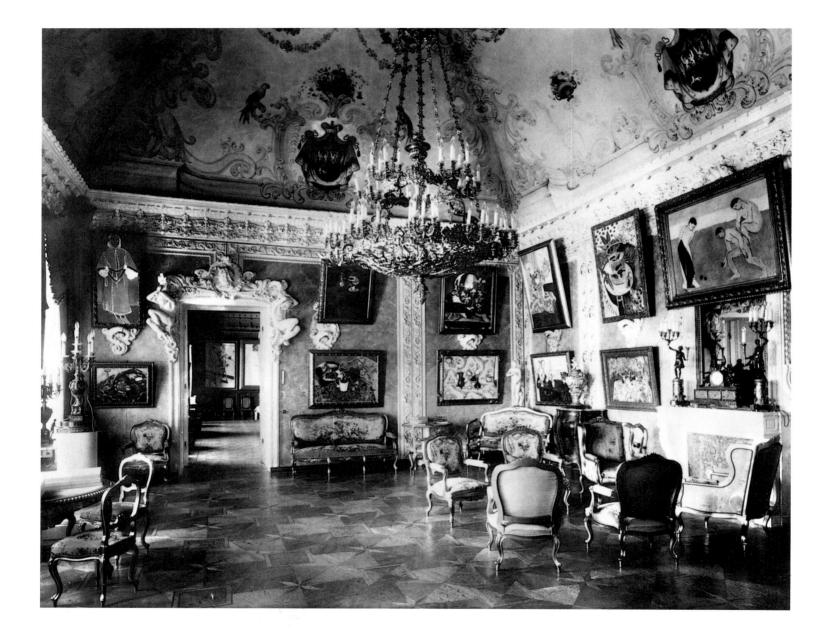

The Russian Collectors and Henri Matisse

Albert Kostenevich

Was it an accident that a number of Matisse's most important Moroccan paintings ended up in Russia? In a matter like collecting one can never completely eliminate the element of chance, all the more so if the artist and the collector live far from one another and do not meet often. Yet there is a reason that Russia became the home of the best Matisse canvases.

Luck undoubtedly attended the man who went to Paris from far-off Moscow in search of the paintings he needed. But it was more than luck, for this man knew what he wanted. In an amazing way he saw farther than other collectors, and the paintings that brought him pleasure would serve the cultural development of a society not yet ready to welcome his efforts.

At the beginning of the twentieth century the art lover who resolved to purchase Matisse paintings acted at his own risk. He did not find support in public opinion. Museums did not give him landmarks. Criticism, in the main, remained hostile. Even the few colleagues who collected the new art were rarely able to keep pace with the man who rushed far ahead. In Russia it was Sergei Ivanovich Shchukin (fig. 114), born in

opposite page: fig. 113. *Interior of Shchukin's House, Matisse Room*, c. 1914

fig. 114. *Sergei I. Shchukin*, 1910

Moscow in 1854 and died in Paris 1936, who stood ahead of the others. Time has justified what were perceived in his time as collecting eccentricities. In his behavior a logic was revealed that was just as convincing as the logic of the work of the artist himself.

The collecting activity of Sergei Ivanovich Shchukin made Russia the first country to import the works of Henri Matisse. Shchukin began to buy Matisses in about 1904–1905, when few, even in the relatively narrow circle of the Paris vanguard, knew the artist. Ivan Abramovich Morosov (fig. 115), who was born in Moscow in 1871 and died in Karlovy Vary, Czechoslovakia, in 1921, began to collect art about a decade later than Shchukin, but overall achieved equally impressive results. Shchukin and Morosov, both members of very wealthy Moscow merchant families, were responsible for bringing a remarkable group of impressionist and post-impressionist French paintings to Russia, among them an exemplary group of the works of Matisse.

The two collectors worked in concert. There were not enough connoisseurs of avant-garde painting to give rise to any rivalry between them. Though they were men of different generations and temperament, Shchukin very energetic, quick and slim whereas Morosov on the contrary was big as a bear, slow and preferring to think over his steps, one cannot say they had nothing in common. Shchukin and Morosov believed that they were doing something for the common good. They bought from the same dealers. When they met in Paris they attended exhibitions together. Both studied abroad, Shchukin in Gera in Saxony, Morosov in Zurich. They came into contact in their business affairs, for the former traded and imported textiles, the latter produced them. It is difficult to pinpoint their first meeting, but it was probably in the mid-nineties in the mansion of Morosov's brother Michail, a meeting place of leading Russian painters—Vrubel, Serov, Korovin, and others.

Unfortunately, Shchukin's archives were not preserved.[1] Therefore his early collecting activity has been only approximately established. We know that the Moscow merchant owned paintings in the early 1890s. In the first half of that decade Shchukin's entire collection was composed of Russian paintings. These were pleasant things, professional but not very original, such as the landscapes of R. G. Sudkovsky, which reliably served as decorations for a splendid merchant home. B. W. Kean, Shchukin's and Morosov's biographer, believes that Sergei Ivanovich had nothing to do with this collection, and that it came to him along with the house he lived in.[2] This group of objects that he himself possibly had not chosen pushed him into collecting, and he augmented it with landscapes of the now little-known French artist Charles Guilloux, paintings of the Norwegian Fritz Thaulow, possibly of the Englishman Frank Brangwyn, and nineteenth-century Russian pictures as well, before parting with it sometime in the mid-1890s.

The assumption exists that Shchukin sold his Russian collection because he did not hope to compete with P. M. Tretyakov, who in his gallery had created the best museum of national art. There may be some truth in this, but not the whole truth. Shchukin undoubtedly was ambitious in his own way, and did not want his gallery to be an artistic copy of something that already existed. More important is that having become seriously attracted to art, he realized that the main activity in European painting was in Paris. He understood that the future belonged not to the standardized products of the official salons but to the works of the impressionists and the movements they brought to life.

The first stage (1897–1904) in the major collecting activity of Shchukin is associated with impressionism, and especially with the works of Claude Monet. It is definitely known that in 1897 Shchukin brought Monet's *Lilacs au soleil* (State Pushkin Museum of Fine Arts, Moscow) from Paris. Sometimes this date is taken as the starting point. His choices rapidly changed to post-impressionist paintings not because Shchukin became disillusioned about Monet, but because he recognized that the canvases of Cézanne, Van Gogh, and Gauguin had become the most important bridges to modern art.

Very little is known about S. I. Shchukin's collection in the earliest years of this century. The unpublished memoirs of M. V. Sabashnikova provide the earliest outline of his gallery. Here is a 12 February 1903 entry from her diary: "Last evening Katya Balmont and I, and an artist from Paris, Valushin, went to the Shchukins' to look at their collection of paintings. I saw Monet's Rouen cathedrals, his sea, and other things by Lobre, Brangwyn, Cozanville, Renoir, Ménard, Degas, Cottet, Carrière, Whistler, and finally Puvis de Chavannes' *Pauvre pecheur.* The host was courteous, lit one chandelier after another, and explained the merits of his paintings. He himself looks like a sly butler, his gray hair is slicked to his forehead, and his eyes gaze like mice peering out of holes. There is something incompatible between his keen understanding of art and the selectivity and nobility of his paintings, and his base, peasant appearance."[3]

At the turn of the century canvases by the impressionists and their followers were not received with unanimous favor by Russian society. The note of challenge contained in such works, the desire to shock, did not guide Shchukin, as it did not guide Morosov after him. Rather, both men truly loved the avante-garde art they collected. Their passion for art soon turned into their life's work. Like the Tretyakov brothers, Shchukin and Morosov acted with conviction; they hoped to serve Russian society, disregarding its initial reaction. The idea of creating collections that could in time be transformed into true museums inspired both. At the moment Shchukin met Matisse, the existence of a true gallery of new French art in Shchukin's house on Znamensky Lane (fig. 116) had become a fact, a fact known in the cultural circles of both the Russian and the French capitals.

It is not known when Shchukin and Matisse first met. Most likely the inevitable

encounter between Shchukin, the boldest Russian collector, and Matisse, the French master who strode most resolutely toward new horizons in art, took place in 1904. It is remarkable that Shchukin was able to sense Matisse's potential even before Matisse was discovered by the Western art community. Shchukin brought his first Matisses to Moscow before the artist's succès de scandale at the Salon d'Automne in 1905. For each of them it was a time of taking a decisive step. The artist was moving to the limits of fauvism, and was truly revolutionizing painting by simplifying artistic means and by granting to color almost unlimited powers. The collector had begun to expand his holdings, providing a place not only for impressionist paintings, but also for those that later came to be united under the rubric of post-impressionism. Shchukin was then interested in Matisse's still lifes, in particular such a proto-fauvist work as *Poterie et fruits* (1901, State Hermitage Museum, Leningrad), where the primacy of color over light was decisively asserted, and thereby the departure from the principles of impressionism.

By the time of their meeting, Shchukin was acting boldly and confidently in selecting works of art, although he had been practicing his avocation for little more than a decade. Given that he was not a young man when he began collecting and that his initial interests were similar to those of many other art lovers of the day, the swift evolution of his tastes is nothing short of amazing. In 1904 Shchukin was fifty years old, an age when a man is rarely capable of change and his behavior and his tastes have usually been fully defined. This seemingly fit Shchukin, if one has in mind the everyday living and business habits that had been assimilated in his youth. However, he was also inclined to take risks, and had a passion that, combined with shrewd judgment, enabled him to be exceptionally successful in the family business he had taken over from his father, the trading house Shchukin and Sons. Shchukin also purchased paintings with passion as much as calculation. Dealers were forced to reckon with the collector's habit of taking pictures home for a time for a test. "I was lucky that I was able easily to pass this first test," recalled Matisse later, probably referring to Shchukin's purchase of *Vaisselle sur une table* (1900, Hermitage, Leningrad).[4]

In 1908 the prominent Russian critic P. P. Muratov wrote that Shchukin's gallery "has long enjoyed a widespread reputation and well-deserved fame among artists and en-

fig. 116. *Shchukin's House*, c. 1914

lightened friends of art." When these lines were written Shchukin's collection had probably been well known for four or five years. In this time the gallery "had the most decisive influence on the destiny of Russian painting in recent years. It was destined to be the strongest conduit of western artistic trends into Russia, so vividly expressed in the works of Claude Monet, Degas, Cézanne and Gauguin, which belong to it. . . . The job of the gallery collector was not limited solely to satisfying his own artistic taste and personal inclinations in art. To a certain degree it became systematic work, with the goal of representing the artistic evolution in the second half of the last century through prominent examples."[5]

Muratov divided the paintings in Shchukin's gallery into five periods. The first, a transition from the realism of mid-century to impressionism, stretched out until 1875. Its main landmark became *Le déjeuner sur l'herbe* (1866, Pushkin, Moscow) by Manet. The second period (1875–1889), the most brilliant time of impressionism, was represented in the collection by the paintings of Monet, Renoir, and Degas. It merged naturally into the third stage (1889–1895), the time of late impressionism, with the series paintings by Monet, as well as various accompanying phenomena (Moret, Lobre, and others). The fourth period ran from 1895 through 1906. Its meaning and importance are affirmed most of all by the presence of Cézanne and Gauguin. And from here is drawn a straight path to Matisse.[6]

"A small group of the latest acquisitions of S. I. Shchukin can be placed in the last, fifth period of his artistic evolution. But there is no opportunity to foresee its limits in time, for this period has just begun. Its starting point is the works of Cézanne and Gauguin. Some of the young artists, such as Girieud, who is represented in the gallery, almost literally repeat Gauguin. Others manifest the ability for independent movement along the outlined path of decorative painting. As the paintings in Shchukin's gallery show, the gifted Henri-Matisse began with close imitation of Cézanne and Gauguin. In his later things there is a desire to move the line forward more than Gauguin did, and to strike the eyes with still bolder, sometimes disharmonious combinations of colors."[7]

It is not surprising that to Muratov, an admirer of Renaissance painting, the color combinations of Matisse's canvases seemed disharmonious. What is surprising is the fact that, already in mid-1908, perhaps even due to Shchukin's explanations, the critic saw in Matisse an heir to Cézanne and Gauguin. There is no record of precisely which of Matisse's works belonged to Shchukin at that time, but it can be assumed with confidence that two early still lifes had come into the collection: *Vaisselle sur une table* (1900, apparently the "test," which the artist later recalled) and *Poterie et fruits* (1901). The first shows an obvious influence of Cézanne, and the second of Gauguin. It is more than likely that by 1908 Shchukin possessed two early Matisse landscapes, *Le jardin du Luxembourg* (1901, Hermitage, Leningrad) and *Bois de Boulogne* (1902, Pushkin, Moscow), and at least one recent canvas, *Dame sur une terrasse* (1907, Hermitage, Leningrad). The words of Muratov about the desire to move the line forward still farther and about the bolder, sometimes disharmonious combinations of colors are appropriate only to this composition.

It can be seen from Muratov's article that by mid-1908 Shchukin had already acquired the majority of the works that related to the first four periods of new French painting as classified by this critic. In the collection there were then seven paintings by Cézanne and eleven by Monet. Catalogues reflecting the final composition of the gallery indicate eight Cézannes and thirteen Monets.[8] Only the Gauguins provide a somewhat different ratio: ten and sixteen. On the whole, the interests of the Moscow collector thenceforth were concentrated on the "fifth" period to a much greater degree than on filling gaps in those parts of the collection that had become classics of the new art. In other words, Shchukin was attracted not merely by new art, but by the newest art, by that which was

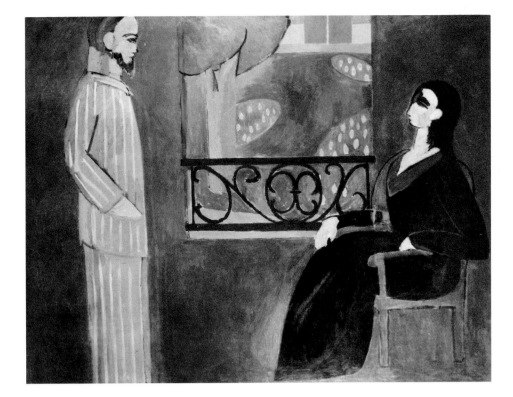

fig. 117. Henri Matisse, *Conversation*, 1908–1912. The State Hermitage Museum, Leningrad

created before his eyes. He wanted to be and became a participant in the artistic movement. This is behind his desire for direct contacts with the painters, and even for direct commissions.

Matisse must rightfully be named first among these painters. Shchukin sensed before others how tremendous was the potential of this master. For the great dining room in his home, where the long wall was given over to an ensemble of Gauguin canvases, he acquired Matisse's *La desserte rouge* (1908, Hermitage, Leningrad). Apparently Shchukin was knowledgeable about all three alterations to which the painting was subjected on the eve of the Salon d'Automne of 1908. Tremendous boldness was required in order to acquire the work when it was a blue painting, and not merely to acquire it but to give it the most prominent place in his palatial home;[9] it required still more boldness to allow the artist to transform it later into the red painting we know today, an intensive mass of the color hitherto unprecedented in European art.

If Manet's *Le déjeuner sur l'herbe*, from which Shchukin's collection may have begun the chronology of the new art, entailed a true revolution in art, Matisse's *La desserte rouge* was a revolution not only later in time, but also significantly more radical. Henceforth Shchukin boldly placed his confidence in Matisse. He followed each creative step of the artist, and the latter, in turn, had a right to count on his support.

Numerous works entered Shchukin's collection that were endowed with personal significance: *Conversation* (fig. 117) was Matisse's only canvas where he depicted himself with his wife; *La famille du peintre* (see fig. 19), where the wife and children of the artist are presented; and finally *Portrait de Mme Matisse* (all in the Hermitage). The acquisition of these paintings should not be viewed merely as successful purchases. In those years (1911–1913) Matisse did not experience acute financial need, as he did at the beginning of his career. The fact that he let the Russian collector have those paintings is indicative of the special relationship of trust that had taken shape between them. Many years later the artist's son Pierre Matisse recalled the collector with genuine respect,

emphasizing that he never attempted to impose anything upon the artist, or to interfere in any way in the creative process. Visiting in Matisse's studio, Shchukin could see unfinished paintings, but it would not even enter his head to give any instructions.

The 1909 commission for two large panels for the stairwell in Shchukin's home became the culmination of the cooperation between Shchukin and Matisse. The creation of *La danse* and *La musique* (both Hermitage, Leningrad) signified a major landmark in the history of French, and perhaps all of European painting. The fifteen thousand francs paid for the first panel and twelve thousand for the second now seem absurdly small sums; however, in 1909 they enabled Matisse to rent, and four years later to buy a home in Issy-les-Moulineaux. The spacious accommodations there enabled the master to work without interference on huge canvases: *La danse* and *La musique*, *Les demoiselles à la rivière* (fig. 30), *Les Marocains* (1915–1916, cat. 24).

When Matisse went to Russia in autumn 1911, visiting first Saint Petersburg and then Moscow where he stayed with his hospitable collector (they had traveled together from Paris), Shchukin's collection numbered twenty-five Matisses. In the next two years it was augmented with *Conversation* and *La famille du peintre*, *L'atelier rose*, *Coin d'atelier*, *Capucines à "La danse,"* all now in the Pushkin, Moscow, as well as *Café marocain* and a significant group of Moroccan paintings now in the Hermitage, Leningrad (figs. 113, 118).

Shchukin is frequently called Matisse's patron, and in a certain sense he was, but not in the sense characteristic of the era of the Old Masters. The twentieth century inevitably gave special meaning to the relationship between artist and collector. Shchukin never attempted to foist his will upon the painter, except for the special case of the commission for *La musique*. The Moscow collector insisted on this subject to counterbalance *Les demoiselles à la rivière*, a work that Matisse clearly preferred. Shchukin's reasons for this[10] were in part associated with the decorative purpose of the panels and

fig. 118. *Shchukin's Dining Room,* c. 1914

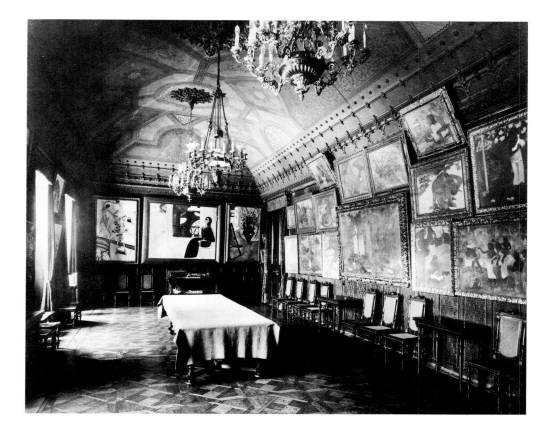

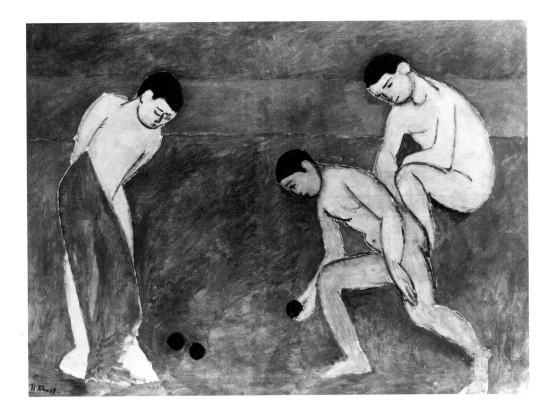

fig. 119. Henri Matisse, *Les joueurs de boules*, 1908. The State Hermitage Museum, Leningrad

their placement on the second story of the stairwell, and were conditioned in part by private motives.

The evolution of Matisse's art—from the early still lifes to *La desserte rouge*, and then to the decorative/symbolic canvases (*Les joueurs de boules* [fig. 119], *Nymphe et satyre*, [Hermitage, Leningrad], *La danse*, and *La musique*), and further to the Moroccan cycle—could not but have an effect on Shchukin. The maturation of the collector's taste was determined by his attitude toward the various phenomena of the latest art, and a great role here was played by his contacts with Matisse, who without any doubt became "Shchukin's artist," more completely represented in the gallery than anyone else. Shchukin did not fear that his acquisition of many, and moreover very large canvases by Matisse would lead to a distortion in his collection. The boldness of the artist encouraged boldness in the collector. Even so it cannot be said that Shchukin never vacillated, for he almost refused *La danse* and *La musique* after the harsh critical attacks on the panels at the 1910 Salon d'Automne.[11] However, his great faith in Matisse and in his own instincts enabled him to surmount the doubts caused by the criticism.

The period of Matisse's highest achievements, from *La desserte rouge* to *Café marocain* (cat. 23), when he worked at maximum intensity, a period whose motto became "all or nothing,"[12] coincided with an especially difficult time and turning point in the life of the Russian collector. The deaths of four members of his family forced him to look at things differently. His wife Lidya died suddenly during the night of 3–4 January 1907;[13] that same year his son Grigorii, who was congenitally deaf, shot himself (Shchukin's son Sergei had committed suicide two years earlier). In 1908 his brother Ivan, a resident of Paris who had provided him many contacts with the art world there and who had become enmeshed in debt, poisoned himself. In the same year Shchukin made a will, by which his collection would go to the Tretyakov Gallery in the case of his death. Loneliness may have been one of the reasons that caused him in 1909 to open the doors

of his home to the public, seek contact with it, and explain the paintings that belonged to him. (Just a few months earlier Muratov had complained that "the fame of the gallery so far does not go beyond our too-close circle of artists and a few art lovers.")[14]

Shchukin's approach to art became more personal and profound. He clearly sought in his collection echoes of the dramatic situation in which he found himself. He became the owner of two *memento mori—Nature morte au crâne*, by Derain and *Composition avec tête de mort*, by Picasso (both in the Hermitage). Hearing harsh, dramatic music in Picasso's early cubist canvases, he quickly became their most ardent collector after overcoming his initial lack of sympathy for them.

Matisse said that when Shchukin came to see him he was always able to choose the best canvas. Matisse had in mind, of course, the artistic qualities of the work. But beyond the beauty and singularity of the paintings, Shchukin now responded to the qualities that appealed to his profoundly personal thoughts and experiences, to his spiritual disquiet. Shchukin took and loved *La danse* and *La musique* not only because they fit the nature of his home where concerts were given regularly, but also because the paintings were endowed with deep philosophical meaning, containing indications of the sources of the art and the eternal drama of life and sex. *Les joueurs de boules* attracted Shchukin both for its laconic style and for its philosophical and symbolic content, compelling him to associate the subjects of Matisse's painting with his own sons. *La famille du peintre* is not so much a portrait as a decorative composition, and at the same time the embodiment of a family idyll. Shchukin acquired the painting soon after it was painted perhaps because he missed the warmth of his family. At this time he unsuccessfully proposed marriage to Vera Scriabina, the former wife of the famous composer. Their relationship may explain Shchukin's stubborn wish to have the big music panel.[15]

When *La famille du peintre* was being created, Shchukin became acquainted with Nadezhda Konius, the wife of a well-known pianist and a good friend of Vera Scriabina. Four years later, after Nadezhda and her husband were divorced, she and Shchukin were married. The years 1911 through 1914, the time of his unstable private life, became the last period of Shchukin's collecting. Were the turns in his life reflected in this activity? Probably so. And could it be otherwise, given the importance Shchukin placed upon art, and given the all-consuming position it occupied in his life? Shchukin was far from young, and he was seeking stability, not only in his life, but also in modern art, which put forward for him three key figures—Matisse, Picasso, and Derain. He understood and appreciated classical tendencies in the work of all three in the brief period before his collecting was cut short by World War I.

For Matisse those same years were a time of relative reconciliation, and also a search for constructive art principles. Large decorative interiors, still-life interiors, as well as decorative portraits now occupied the central place in his creativity. The best of them went to Shchukin. Thus in 1912 *L'atelier rose* and *Poissons rouges* (figs. 102, 108), created the year before, were acquired, and the recently painted *Capucines à "La danse"* (fig. 105) and *Coin d'atelier.*

Shchukin as were few others was prepared to receive the paintings that resulted from Matisse's trips to Tangier. The still life *Vaisselle et fruits sur un tapis rouge et noir* (fig. 120), which had entered his collection earlier, reminded the collector of northern Africa and his own travels in Egypt. For in addition to his French orientation, Shchukin also had an inclination toward the Orient. He loved the culture of ancient Egypt. Matisse himself said: "In Paris his favorite pastime was to visit the halls of Egyptian antiquities in the Louvre. He found there parallels with Cézanne's peasants."[16]

Some facts about S. I. Shchukin's interest in the Orient are disclosed in his letters to his brother Petr, which are preserved in the archives of the State Historical Museum in

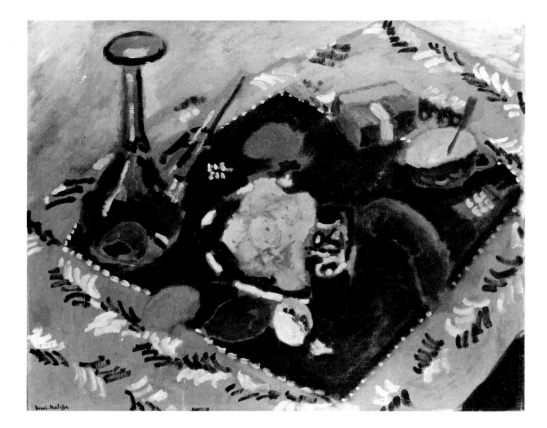

fig. 120. Henri Matisse, *Vaisselle et fruits sur un tapis rouge et noir*, 1906. The State Hermitage Museum, Leningrad

Moscow. The first letter describes a trip to the East in 1891, and the sixth tells about a trip to India in 1895. In October 1907 Sergei Ivanovich was in the Middle East. He wrote from there: "In Cairo I was unable to answer your kind letter. For the last several days I have had to bustle a great deal about my caravan. There will be eighteen camels and fifteen servants. . . . I am going first through the Sinai Desert to the Saint Catherine monastery on Mount Sinai, and then to El Aloba (it is dangerous there), to cross the border and pass by Bedoin nomads. . .then through the Jordan desert. . .to Jerusalem. It should take about two months. Therefore, do not be disturbed if you do not hear any news from me for a long time. There is no mail here." There is one more message, dated 30 June 1908: "In mid-August I am going to the East (Constantinople) with Myasnovo."[17]

Both his Russian origin and the nature of his business contributed to Shchukin's orientalism. As an importer of textiles he could not help but be confronted with the goods of the East long before he became a collector. His ardent attachment to the works of Gauguin was to a significant degree nurtured by his interest in the East, which was so clearly shared by Gauguin himself. Shchukin acquired Gauguin's *Les tournesols* (1901, Hermitage, Leningrad), as well as several paintings of motifs from the reliefs of the temple at Borobudur. Shchukin undoubtedly knew examples of orientalist painting of the romantics at the Kushelev Gallery, then housed in the Petersburg Academy of Arts, where he had the opportunity to see the paintings of Delacroix, Decamps, Marilhat, and Fromentin (now they are stored in the Hermitage). To this orientalism of the past, just as to its latest Salon continuations, Shchukin contrasted Matisse's new Moroccan canvases.

Of the eleven paintings presented at the Matisse Moroccan exhibition in April 1913 at the Bernheim-Jeune Gallery in Paris,[18] four were designated as belonging to Monsieur S. S. (Sergei Shchukin), another three to Monsieur I. M. (Ivan Morosov), and three re-

mained unsold. Among the unsold paintings was *Café marocain* (cat. 23). Shchukin did not decide to purchase *Café marocain* on the spot, as he did *Zorah debout, Le rifain debout* (cats. 16, 18), and two large Tangier still lifes (cats. 20, 21). The stunning simplicity of this composition required some time, even for him, to truly understand it.[19] It is known from the correspondence between Matisse and Camoin that in September 1913 *Café marocain* was sold to Shchukin and sent to Moscow,[20] the collector needing this much time for his interest in the work to mature. Only weeks later Shchukin wrote the artist that he loved this painting more than all the others, and looked at it for no less than an hour each day. He also reported that he had placed the painting in his dressing room;[21] apparently, ordinary visitors to Shchukin's gallery could not see it. Shchukin's reaction to the painting was perhaps flattering for the artist, but it may also have been surprising to him. He told Marcel Sembat: "What amazed me most of all was the ability of these fellows to remain for hours absorbed in contemplation before some flower or red fish."[22]

Matisse undoubtedly found in this contemplation an attribute of the Eastern character, alien to Parisians but so openly displayed by the Russian collector. It becomes understandable why, in the well-known portrait drawing of Shchukin (fig. 121), the artist stressed Mongol, eastern features that were more divined than obvious, and which are almost imperceptible in photographs of the collector. It is understandable how *Café marocain* became his favorite painting, for its appreciation required a special key. Matisse, who was imbued with the spirit of the people of the East, created a work

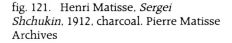

fig. 121. Henri Matisse, *Sergei Shchukin*, 1912, charcoal. Pierre Matisse Archives

that evoked an authentic reaction from a man who had not fully broken away from the eastern world.

One more factor explains Shchukin's and Morosov's interest in Matisse's Moroccan paintings. In 1913 Shchukin enthusiastically told the artist that he saw "a great development" in his recent works.[23] Perhaps Shchukin admired the flatness and simplicity of such paintings as *Café marocain*, the marvelous and indisputably concise composition, the melodically soft and complete contours, and the lyrical color; for these are traits that speak much to one familiar with the world of the ancient Russian icon and fresco. The figures in the painting are capable of evoking associations with those in ancient Russian paintings. In particular, the Arab lying in the foreground recalls figures on various ancient icons, for example, Anna from the fourteenth-century *Birth of the Mother of God* (Tretyakov Gallery, Moscow).

Shchukin's gallery became the museum of modern western art long before it was so named as a result of the nationalization that took place in 1918. The gallery was the place where one could become acquainted with Matisse's paintings better than anywhere else as early as 1913. Shchukin reported visits by Karl Osthaus, founder of the museum in Hagen,[24] and the directors of a number of other European institutions. Shchukin was seeking like-minded people and telling them in detail what they needed to do in order to acquire paintings—how to make contact with Matisse or his Paris dealer, Bernheim-Jeune. Many students and graduates of the Moscow School of Painting, Sculpture and Architecture were captivated by the example of Henri Matisse, thanks to Shchukin.

Shchukin's friend Morosov began to collect only after the death in 1903 of his older brother Mikhail, who had been an unusually shrewd collector whose tradition Ivan Abramovich wished to continue. Mikhail had purchased Russian as well as French paintings, including the work of impressionists, Gauguin, and members of the Nabis. Ivan Morosov's tastes developed rather quickly after he dedicated his large home on Prechistenka (fig. 122), now Kropotkin Street in Moscow—a house that was occupied by the Academy of Arts after the closing of the Museum of Modern Western Art in 1948—to exhibiting hundreds of works. In the same letter to Matisse of 10 October 1913, Shchukin expressed his delight with the Moroccan Triptych, which had gone to Morosov. The letter contains not a trace of envy, for it was Shchukin who had introduced Morosov to the artist in about 1907.[25] For the tastes of the two prominent collectors were in many ways similar, though Morosov acted more carefully and thought over his acquisitions longer. He listened very attentively to the advice of the dealers with whom he had transactions and the few artists with whom he had friendships, thereby expanding his knowledge and judgment.

In contrast to Shchukin's collection, Morosov's included not only French works, but also as many Russian paintings. Another difference was its lack of accessibility to the public. But his main goal was the same as Shchukin's, to collect an ensemble of paintings worthy of a museum.

Characteristically, the first French painting Morosov bought was a Sisley. Whereas Shchukin had skipped the work of Sisley altogether, considering him apparently merely a follower of Monet, Morosov recognized Sisley's subtlety. This and the fact that he was less in the vanguard were dear to Morosov. Morosov also cherished the work of Bonnard, again in contrast to Shchukin.

In 1907–1908 Morosov brought five superb Monet landscapes from Paris, as well as unique Mongeron landscapes, eight prominent Gauguins, and his first Cézannes. Later, answering a question posed by Fénéon about his best-loved painters, Morosov placed Cézanne first, adding with pride that Cézanne's genius could be proven by the paintings in his own collection.[26] The Matisses in Morosov's collection are quieter than those of

fig. 122. *Morosov's House, Kropotkin Street, Moscow* (now Academy of Fine Arts)

Shchukin, and still lifes predominate, some of them with Cézannesque qualities. Morosov seemed to wish to note especially the factors that linked Matisse with Cézanne. Matisse's *Les capucines à "La danse"* (see fig. 105) is so strongly constructed that it compares well with the best compositions by Cézanne.

Morosov entertained an obvious partiality for decorative monumental painting. He differed from other collectors also in that he not only bought paintings, but at times loved to commission them. Bonnard's delightful Paris suite, *Le matin à Paris* and *Le soir à Paris* (now in the Hermitage, Leningrad), are the result of such an order. His notion about commissioning Bonnard's large triptych, *Mediterranée*, which decorated the stairs of his home, was a fortunate one. World War I, which had broken out, prevented Morosov from following Shchukin's example and commissioning large decorative canvases from Matisse.

Landscapes were a favorite of Morosov's. He painted landscapes himself, studying at the school of the prominent Russian impressionist landscapist K. A. Korovin. He hunted for a long time, and unsuccessfully, for a painting by Edouard Manet, not merely for a good painting, but namely for a landscape of the highest merit, which, in his thinking, would underscore the link between Manet and the impressionists.

Morosov commissioned landscapes from Matisse that were not delivered immediately to the collection, which the artist mentioned in letters to Morosov in 1911–1912.[27] Matisse intended to paint these landscapes for Morosov in France, possibly in Collioure, then decided to do them in Sicily, and finally shifted the work to Morocco. The two Moroccan landscapes became *Paysage vu d'une fenêtre* (cat. 12) and *Porte de la Casbah* (cat. 14), pieces of a single ensemble with *Sur la terrasse* (cat. 13) in the center, the group of three now known as the Moroccan Triptych. Knowing what a grand collection Morosov possessed, perhaps Matisse delayed fulfilling his promise to Morosov until he visited his home in 1911. Matisse was received by the Morosovs with due respect, and when he wrote to Morosov after that he usually sent his regards to Mme Morosov.

Oriental motifs were important to Morosov, as is apparent from the Russian part of

his collection: the études of M. A. Vrubel, done during the artist's travels around the eastern Mediterranean (1894), the landscapes of Blue Rose members Pavel Varfolomeevich Kuznetsov, *Flowering Garden in Bakhchisaray* (1907) and *Mirage in the Steppe* (1912), and those of Martiros Sergeevich Saryan, *At the Pomegranate Tree* (1907) and *Street of Constantinople* (1910, all Tretyakov Gallery, Moscow). Saryan was frequently called the "Russian Matisse" in those years. For Shchukin and Morosov as well as for their visitors, Matisse's paintings were additionally attractive because they satisfied their oriental leanings. Instructive in this regard are the words of the well-known Russian critic Yakov Tugendhold, stated in early 1914 in an article about Shchukin's gallery. "The paintings of Matisse are conscious orientalism. From his very first teacher, Gustave Moreau, he acquired love for the flowery and sparkling spot. Then began his trips to the East, and there is no doubt that his impressions of Spain, Morocco, and Algiers played a big role in his artistic development. He is also close to Arab-African and Persian culture with his turquoise and sapphire blue color, and by his inner inclination toward 'alien disturbing and thought-provoking' questions.

"His work is not decorative painting in the European sense of the word, but decoration as understood in the East. And Viollet-le-Duc already defined the difference between one and the other. In Greco-Roman mural painting the article pictured seemingly stands in opposition to its background: such are the grotteschi of Rome, Pompeii, and the Renaissance. In Eastern painting the drawing merges with the background into one ornamental blend, into one decorative whole, one vibrating carpet; such are the arabesques of Tunisia, Algiers, and the palace of the Alhambra. It is precisely this lack of a division of the painting into the 'drawing' and the background that is a characteristic feature of Matisse's painting. In his works, both are identically intensive, identically meaningful and ornamental; and both are the same carpet, one ensemble."[28]

Morosov's collection of eleven Matisses was smaller than Shchukin's thirty-seven, but among them were such masterpieces of compositional skill and magical color as *Les capucines à "La danse"* and the Moroccan Triptych (as Matisse recalled in telling Tériade about the Russian collectors).[29] Morosov was a more systematic collector than Shchukin. Whereas the latter's collecting activity took place in waves, with little concern about completeness, Morosov acted more methodically. Thus in 1911 he acquired the very early *Nature morte à la bouteille de Schiedam* (1896, Pushkin Museum, Moscow). There can be no doubt that, had it not been for the war in 1914 and then the Russian Revolution that put an end to his collecting activity, Morosov as well as Shchukin would have achieved much more.

1. Attempts to find documents concerning the art activity of Sergei Shchukin in Moscow archives have been in vain. Only a collection of textile samples has been preserved. Because there are a dozen or so mostly unpublished letters from Shchukin to Matisse in the Archives Henri Matisse in Paris, it is possible that Shchukin at one time possessed letters from Matisse. The conditions of Shchukin's escape from Moscow during the civil war make it difficult to imagine that he could have taken such letters with him, for they would have aroused the suspicions of the authorities.

2. Kean 1983, 135–137. Kean's book still remains the most complete account of the history of the S. I. Shchukin and I. A. Morosov collections. Unfortunately, along with much valuable information, it is not free of a number of inaccuracies. Kean speculated that the collection was put together by Shchukin's father or by the former owners of the house. The latter is entirely unlikely, for the Russian aristocrats who had owned the house before Shchukin's father would not have been interested in the art of the Peredvizhnidi (itinerants); Kean's other hypothesis, that this home, the former Trubetskoy palace, was a late wedding present to Shchukin from his father, is just as unlikely. It is more plausible that Shchukin's father chose him to head the family business, and therefore, not long before his death, transferred the house to Sergei Ivanovich.

3. Rukopisnyy otdel Pushkinskogo doma (Manuscript Department, Pushkin House), Leningrad.

4. "Matisse parle a Tériade," *Art News Annual* 21, 1952. *Henri Matisse. Ecrits et propos sur l'art* (Paris, 1972), 118.

5. P. P. Muratov, "Shchukinskaya galereyta. Ocherk iz istorii noveyshey zhivopisi" (Shchukin's gallery. Essay from the history of the latest painting), *Russkaya mysl.* (1908), no. 8, 116.

6. Muratov 1908, 130.

7. Muratov 1908, 138.

8. *Katalog Kartin sobraniya S. I. Shchukina* (Catalogue of paintings in the S. I. Shchukin collection), (Moscow, 1983); *Katalog Gosudarstvennogo muzeya movogo zapadnogo iskusstva* (Catalogue of the State Museum of Modern Western Art), (Moscow, 1928).

9. The work was known as *Panneau décoratif pour salle à manger (appartient à M. Sch.)*. Salon d'Automne. 6ᵉ exposition. 1 Octobre-8 Novembre 1908. Paris, Grand Palais, no. 898. One could easily suppose that Shchukin had acquired the picture when it was blue, a color that matched the Gauguins in his dining room.

10. Letter by S. I. Shchukin to Matisse, 31 March 1909, in Barr 1951, 555.

11. See A. Kostenevich, "La Danse and La Musique by Henri Matisse. A New Interpretation," *Apollo* 154 (December, 1974), 512–513; Flam 1986, 291–292, 496.

12. Words of Matisse in postcard to Michael Stein, 26 May 1911. Barr 1951, 153.

13. V. A. Serov painted Lidya Shchukin in her coffin. Several years ago this painting entered the collection of the State Pushkin Museum of Fine Arts, Moscow.

14. Muratov 1908, 116.

15. See Albert Kostenevich, "Collector's Choice," *Art Institute of Chicago Museum Studies* 16, no. 1 (Spring 1990).

16. "Matisse parle à Tériade," 118.

17. Postcards to P. I. Shchukin postmarked Constantinople, 28 August and 12 September. Gosudarstvennyy istoricheskiy musey, GIM. OPI. Fond 265, delo 213 (State Historical Museum, OPI fund 265, work 213), Moscow.

18. See Paris 1913.

19. Thinking that Shchukin would not buy the painting, Matisse attempted unsuccessfully to interest Morosov in it.

20. Giraudy 1971, 16.

21. Barr 1951, 147.

22. Sembat 1913, 191.

23. Letter of 10 October 1913. Barr 1951, 147.

24. Letter of 10 October 1913. Barr 1951, 147.

25. In October 1907 Morosov acquired his first Matisse, *Flower Bouquet (Vase with Two Handles)*, painted in the spring of that year and now in the Hermitage, Leningrad. The painting has an oriental-style vase as its subject, which was brought by Matisse from Biskra, Algeria, a year before.

26. Félix Fénéon, "Quelques grands collectionners: Ivan Morosoff," *Bulletin de la vie artistique* (15 May 1920), 355.

27. Moscow/Leningrad 1969, 129.

28. Tugendhold 1914, 25–26.

29. "Matisse parle à Tériade," 118.

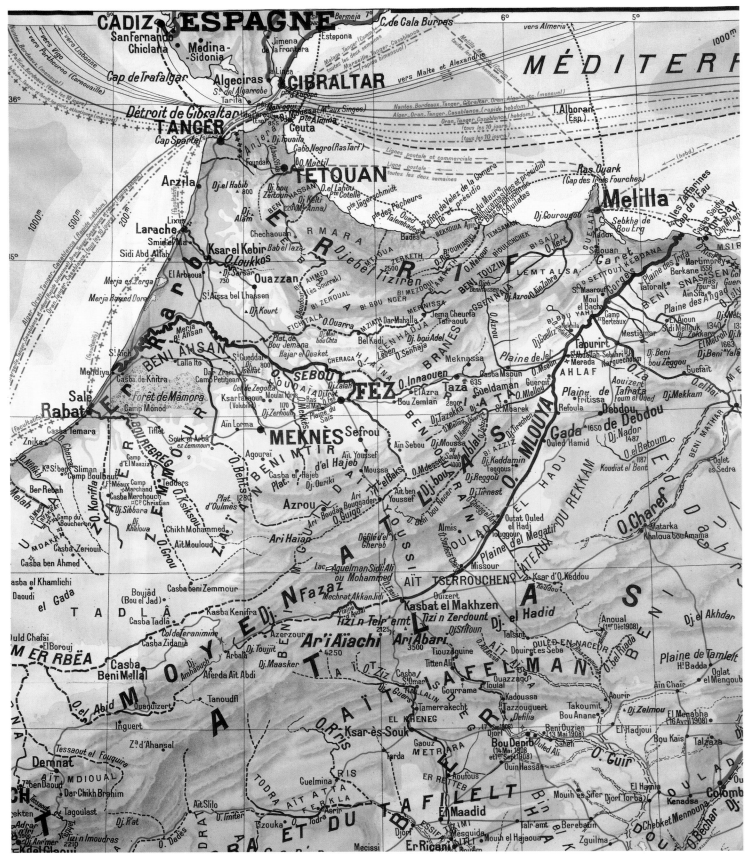

fig. 123. *Morocco* (detail), 1914. Geography and Map Division, Library of Congress

Chronology

mid-November 1910–mid-January 1911
Matisse visits Spain: Madrid, Cordoba, and Seville. Francisco Iturrino (Spanish, 1864–1924) travels and paints with him.

mid-August–mid-September 1911
Albert Marquet (French, 1875–1947) travels to Tangier and paints several views of the Casbah (fig. 7).

fig. 124. Leslie Hamilton Wilson, *Tangier*, 1913. ©Harvard University, Carpenter Center for the Visual Arts

November 1911
On 1 November Matisse travels from Paris to St. Petersburg with Sergei Ivanovich Shchukin, and then with Shchukin to Moscow, arriving on 4 or 5 November. He stays with his patron on Znamensky Lane until leaving for Paris on 22 November. Ilya Ostroukhov, a trustee of the Tretyakov Gallery and a pioneer collector of ancient Russian painting, serves as Matisse's guide in Moscow. Matisse sees Shchukin's and Ivan Abramovich Morosov's collections as well as Ostroukhov's collection of icons, which is one of the best in Russia and greatly impresses Matisse. He also visits the Tretyakov Gallery, Uspensky Cathedral in the Kremlin, the Patriarchal Vestry, one of the Old Believer chapels, and other places of historical and cultural interest.

fig. 125. *Tangier—A Street in the Casbah.* Harvard University

fig. 126. James Wilson Morrice, *View from a Window, Tangier*, 1912–1913, oil on canvas. Private collection

29 January 1912
Arriving on the packet S. S. *Ridjani* from Marseilles, Matisse lands with his wife Amélie in Tangier. During this visit and his second one in the fall and winter of 1912–1913, he stays in what was then one of the best hotels in the city, the Hôtel Villa de France. Matisse's room no. 35 has spectacular views of the Grand Socco (large market), the Anglican church of Saint Andrew's, the Casbah and the medina (the oldest parts of the city of Tangier), and the beaches along the Bay of Tangier (see figs. 71, 127).

fig. 127. *Tangier—View from the Hôtel Villa de France.* Harvard University

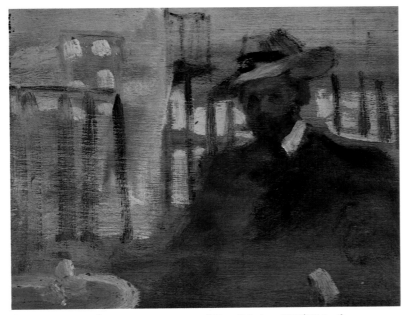

fig. 128. James Wilson Morrice, *Portrait of Henri Matisse*, 1912/1913, oil on wood. Private collection

James Wilson Morrice (Canadian, 1865–1924) leaves Montreal for Tangier and stays at the Hôtel Villa de France. Matisse and Morrice had met during their student days in Paris, but evidently did not know they would both be in Tangier at the same time. Renewing their friendship, they would spend much of their time together exploring Tangier (figs. 126, 128, 133).

Iturrino paints in Tangier sometime between his travels with Matisse in Spain in 1910–1911 and an exhibition of Iturrino's Moroccan work, 16 August–15 September 1915, at the Salón de la Asociación de Artistas Vascos in Bilbao (fig. 129). The Spanish painter's visit to Morocco may have overlapped one or both of Matisse's stays.

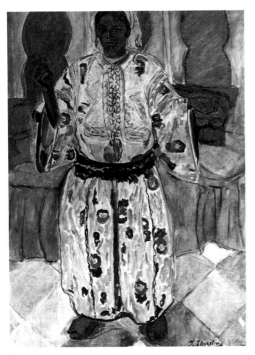

fig. 129. Francisco Iturrino, *Moroccan Woman*, c. 1912/1915, oil on canvas. Museo Nacional de Bellas Artes, Buenos Aires

above right: fig. 130. Postcard from Matisse to Henri Manguin, 1912/1913, with a sketch by Matisse. Archives de la famille Manguin, Jean-Pierre Manguin

below right: fig. 131. *Tangier—Small Market*, postcard from Matisse to Gertrude Stein, 16 March 1912

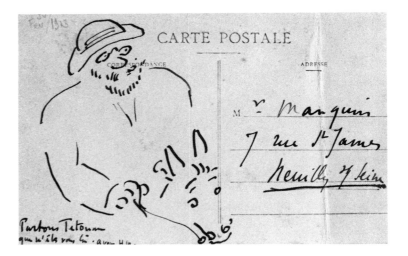

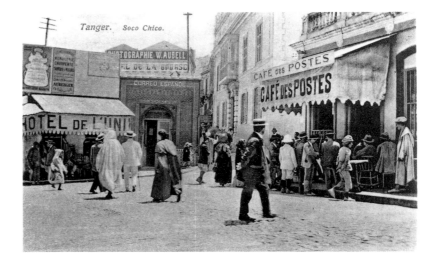

fig. 132. *S.S. "Ophir,"* postcard from Matisse to Henri Manguin, 8 October 1912. Archives de la famille Manguin, Jean-Pierre Manguin

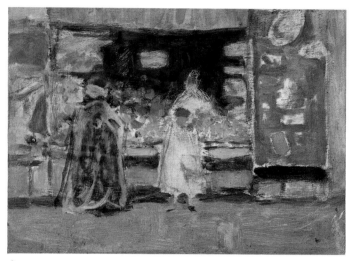

fig. 133. James Wilson Morrice, *Bazaar, Study for Fruit Market, Tangier,* 1912/1913, oil on wood. Gift of the artist's estate, The Montreal Museum of Fine Arts' Collection, 925.340

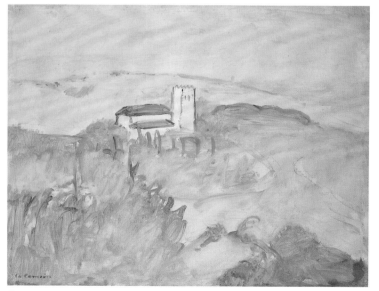

fig. 134. Charles Camoin, *View of the English Church, Tangier,* 1912/1913, oil on canvas. Private collection

27–28 March 1912
Matisse rides southeast, probably by mule, to the scenic Rif village of Tetouan in a day, stays overnight, and rides back to Tangier.

31 March 1912
Amélie Matisse leaves Tangier by packet for Marseilles and then travels to Paris.

early April 1912
Matisse decides not to visit Fez because of rumors of unrest. (Apparently he did not visit Fez or Meknes on either of his visits to Morocco.)

14 April 1912
Matisse departs Tangier for Marseilles and then travels to Paris. During his first sojourn, he completed *Le vase d'iris* (cat. 1), *Vue sur la baie de Tanger* (cat. 2), *Corbeille d'oranges* (cat. 4), *Les acanthes* (cat. 5), *Les pervenches (Jardin marocain)* (cat. 6), *La palme* (cat. 7), *Amido* (cat. 8), and *Zorah en jaune* (cat. 9). He probably also painted *Le marabout* (cat. 3) and *La Marocaine* (cat. 11), possibly *Zorah assise* (cat. 10), and all but finished *Paysage vu d'une fenêtre* (cat. 12).

spring and summer 1912
Matisse returns to his home in the Paris suburb of Issy-les-Moulineaux. During the summer he visits Collioure on the French Mediterranean. Between his two visits to Tangier, Matisse paints several important pictures including *Poissons rouges* (fig. 108), *Intérieur aux poissons rouge* (fig. 107), and two versions of *Capucines à "La danse"* (figs. 104, 105).

1 October–8 November 1912
The Salon d'Automne is presented at the Grand Palais, Paris. Matisse exhibits *Capucines à "La danse"* (fig. 105) and *Coin d'atelier* (State Pushkin Museum of Fine Arts, Moscow), and Morrice shows several paintings of Tangier.

8 October 1912

Matisse arrives in Tangier after a voyage from Marseilles on the packet S. S. *Ophir* (fig. 132), intending to stay for only a short time.

end October–November 1912

Matisse decides to extend his stay in Tangier. Amélie joins him in Tangier around 24 November, having traveled there with Matisse's painter friend Charles Camoin (French, 1879–1965). Matisse explores Tangier, painting and drawing with Camoin (figs. 134, 137, 138). Camoin will exhibit ten paintings from his trip in a large exhibition of his work at Galerie E. Druet, Paris, in March 1914.

December 1912

Morrice returns to Tangier.

11 February 1913

Matisse plans to visit Tetouan again, but it is not certain that he made the trip.

mid-February 1913

Matisse leaves Tangier with Amélie while Camoin remains. By the end of his second stay Matisse had finished twenty-three paintings, including those completed by 14 April 1912 and several that were painted during the second sojourn: *Sur la terrasse* (cat. 13), *Porte de la Casbah* (cat. 14), *La mulâtresse Fatma* (cat. 15), *Zorah debout* (cat. 16), *La petite mulâtresse* (cat. 17), *Le rifain debout* (cat. 18), *Le rifain assis* (cat. 19), *Arums* (possibly started on the first trip, cat. 20), *Arums, iris et mimosas* (cat. 21), *Fenêtre ouverte à Tanger* (cat. 22), and *Café marocain* (cat. 23).

27 February 1913

Matisse is with his wife in Marseilles. They had already visited Menton and Ajaccio, Corsica.

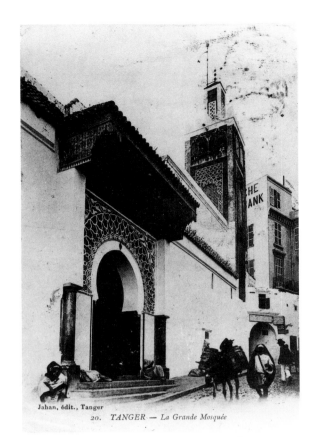

fig. 135. *Tangier—The Great Mosque*, postcard from Matisse to Gertrude Stein, 26 January 1913. Yale University

fig. 136. Henri and Amélie Matisse, after mid-November 1912, probably Tangier. Archives Charles Camoin

31 March–12 April 1913

Marquet includes three paintings of the Casbah in a large exhibition of his work at Galerie E. Druet, Paris.

14–19 April 1913

Galerie Bernheim-Jeune, Paris, presents *Exposition Henri-Matisse: Tableaux du Maroc et Sculpture.* Eleven Moroccan paintings are included in the exhibition catalogue. *Vue sur la baie de Tanger, Les pervenches (Jardin marocain)*, and two drawings, *Trois études de Zorah* (cat. 44) and one of Zorah seated (unlocated), although not listed in the catalogue, appear in installation photographs of the exhibition (figs. 1–5).

mid–end April 1913

Morosov's Moroccan Triptych (*Paysage vu d'une fenêtre, Sur la terrasse*, and *Porte de la Casbah*), and some or all of Shchukin's works in the April 1913 exhibition at Bernheim-Jeune (*Zorah debout, Le rifain debout, Arums*, and *Arums, iris et mimosas*) are sent from the Bernheim-Jeune exhibition to be shown the first week of May at the Kunstsalon Fritz Gurlitt in Berlin before being shipped to Moscow.

spring and summer 1913

Matisse returns to Issy-les-Moulineaux and visits Collioure and Cassis on the French Mediterranean.

August–September 1913

Albert Marquet returns to Morocco (fig. 139).

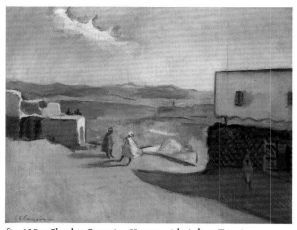

fig. 137. Charles Camoin, *House with Arbor, Tangier,* 1912/1913, oil on canvas. Private collection

fig. 138. Charles Camoin, *Moroccans in a Café*, 1912/1913, oil on canvas. Private collection

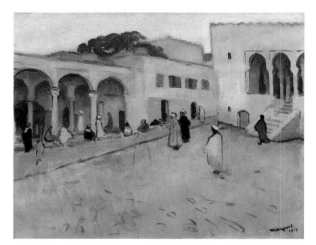

fig. 139. Albert Marquet, *The Palace of Justice (Sultan's Palace)*, 1913, oil on board. Private collection

15 November 1913–5 January 1914
The Salon d'Automne is presented at the Grand Palais, Paris. Matisse exhibits only the *Portrait de Mme Matisse* (State Hermitage Museum, Leningrad), and Morrice exhibits five paintings of Tangier.

by November 1913
Although planning to return for a third visit to Tangier, Matisse changes his mind and establishes a studio in Paris when a studio below Marquet's on the Quai Saint Michel (where Matisse had had a studio during his fauve period) becomes vacant. Matisse never returned to Morocco.

PEINTURE

MAROC, 1912-1913

* **1.** *Le rifain assis.*
 2ᵐ×1ᵐ60.

* **2.** *Café marocain.*
 1ᵐ75×2ᵐ10.

* **3.** *La mulâtresse Fatma.*
 1ᵐ46×0ᵐ61.

 4. *La mulâtresse Fatma.*
 App. à M. M. S.

Seuls sont à vendre les trois tableaux dont le titre est marqué d'une étoile.
Dans l'indication du format de chaque tableau, le premier nombre correspond à la hauteur.

5. *Le rifain debout.*
 1ᵐ46×0ᵐ97. *App. à M. S. S.*

6. *Paysage vu d'une fenêtre.*
 1ᵐ15×0ᵐ80. *App. à M. I. M*

7. *Sur la terrasse.*
 1ᵐ14×1ᵐ. *App. à M. I. M*

8. *Porte de la casbah.*
 1ᵐ15×0ᵐ80. *App. à M. I. M*

9. *Zorah.*
 1ᵐ46×0ᵐ61. *App. à M. S. S.*

10. *Arums, iris et mimosas.*
 1ᵐ45×0ᵐ97. *App. à M. S. S*

11. *Arums.*
 1ᵐ45×0ᵐ97. *App. à M. S. S.*

Paintings checklist from the catalogue of Matisse's exhibition at Galerie Bernheim-Jeune, Paris, 1913

Letters Relating to the Morosov and Shchukin Commissions

Beatrice Kernan
Laura Coyle

Appendix 1 traces the commissions and acquisitions by the Russian collectors Ivan Morosov and Sergei Shchukin of Matisse's Moroccan paintings through Matisse's correspondence with his Russian patrons, his friends, and his family. Divided into two parts, the first section of Appendix 1 concerns Morosov's commissions and acquisitions, and the second, Shchukin's. Within each section, the letters are cited chronologically and numbered.

The correspondence is in two forms, complete letters and excerpts. Since some of the correspondence refers to both Morosov's and Shchukin's commissions and acquisitions, certain letters are cited twice, once in each section. With the first mention of a letter for which we have the complete text, the entire letter is printed, with the parts relevant to that commission or acquisition in italics. With the first mention of an excerpted letter, all that is known about the letter is provided with that entry in a note. If a letter or excerpt is cited a second time, a cross-reference to the first more complete mention is provided.

The Archives Henri Matisse graciously provided us with most of the excerpts cited in Appendix 1. This new material assisted us greatly in our understanding of the chronology of the Moroccan period. With the exception of certain key phrases, the excerpted letters were made available to us in paraphrase form. The dating of the letters from Shchukin to Matisse presents a special problem. Before 1918, the dates in the Russian calendar were thirteen days ahead of the western calendar. We have assumed that Shchukin converted the dates in the text of his letters for Matisse's benefit (see for example Morosov commission letter 12 and Shchukin commission letter 3). A reference to a future 20 October 1913 visit in a letter from Shchukin dated 10 October 1913 (Morosov commission letter 12, which, if it were Russian calendar would have been 23 October 1913), seems to suggest that Shchukin also adapted the dating of his letters to the western calendar. Therefore, we have maintained the dates of Shchukin's letters as they appear rather than add thirteen days. In any event, adding thirteen days to these letter dates would not alter the sequence of events described in this chronology.

Morosov's Commissions

Ivan Morosov commissioned from Matisse two landscapes and a still life. He eventually acquired three Moroccan paintings: *Paysage vu d'une fenêtre* (cat. 12), *Sur la terrasse* (cat. 13), and *Porte de la Casbah* (cat. 14).

1. Matisse to Morosov, 19 September 1911[1]

Collioure, 19 September 1911

Monsieur:

I have been thinking about your landscapes since I have been in Collioure[2] and I fear that I will not be able to do them this summer. Rather, I am thinking of working on them in Sicily[3] where I think I will spend the winter.

You will see at the Salon d'Automne a landscape that was meant for you and has remained only in the state of a sketch (esquisse).[4] I am very taken at this moment by an important decorative work.[5] *I think that you would not hold it against me if you do not have your landscapes for the Salon d'Automne, since I warned you when you ordered them of the uncertain date of their production. Be convinced, Sir, that I will make them for you as soon as possible, and I pray you will accept this favorably.*

As for the still life[6] of which you have spoken to me, I think it's useless to bother you to send it to me because I must go to Moscow[7] at the end of October. There I will see what it is a question of and I can remedy it if need be.

I pray to you, Sir, to accept my devoted sentiments.

<div style="text-align:right">

Henri Matisse
at Collioure P.V.

</div>

2. Matisse to his family, Monday [1 April] 1912[8]

Matisse wrote that he had that morning written a nicely phrased letter to Shchukin and had added a sketch (*croquis*) of the still life and two landscapes for Morosov, the blue one (*le bleu*) and periwinkles (*pervenches*).[9] He added that it made a nice *croquis*, triptych.[10]

3. Matisee to Marquet, 1 April 1912[11]

Matisse wrote that he stayed on to finish a picture but it was raining again and he could not [work on it].[12]

4. Matisse to his family, Wednesday [3 April] 1912[13]

Matisse wrote that if he felt well enough, he would stay to do the landscape for Morosov[14] and that Morrice saw the two landscape sketches (*esquisses*)[15] and liked them very much.

5. Matisse to his wife, 12 April 1912[16]

Matisse wrote that he was leaving Sunday [14 April], that he had packed his canvases the day before, that the still life was barely dry, and that he had made a crate for his still life for Morosov[17] and his two sketches (*esquisses*).[18]

6. Matisse to Morosov, 29 September 1912[19]

Issy, 92 Route de Clamart
29 Sept. 1912

Dear Sir,

I am embarrassed to write to you that I have not been able to do your two landscapes;[20] consequently they will not be at the Salon[21] as I had written you, but I leave tomorrow for Morocco[22] where I count on painting them.

In presenting my excuses, I ask that you pay my respects to Madame and that you consider me your devoted

Henri Matisse

7. Matisse to his wife, 16 October 1912[23]

Matisse wrote that he had begun a landscape for Morosov.[24]

8. Matisse to Camoin, around the end of October 1912[25]

Tuesday

My dear Camoin:

Your letter gave me great pleasure. I am happy that you have concluded your business with Druet,[26] who is a big pig but sometimes necessary. Allow me to recommend that you not argue with him, because you cannot understand each other and it is useless to offend him. You must take him for what he is. For the moment, he will allow you to work in peace if you know how to arrange it wisely; that's very important for you. Maybe we can meet this winter in some sunny country for I won't stay here a long time, the rains won't hold off much longer. Until now the weather has been very beautiful and I am profiting from it. I began a Moorish woman on a terrace as a pendant to last year's young Moroccan;[27] but a lot of wind and an irritating model worked against me. Also, when I thought I had finished, I brought the painting home, and I haven't the courage to turn it around for fear of disappointment. It's a decorative painting that I must do and I think that will be it, but I would have wanted more. *Then two landscapes that are beginning to become serious,*[28] *until now they were mere child's play—I came to do the Moorish woman and the two landscapes;* more work than that would be welcome. But as bad weather is about to arrive, I ask myself if I wouldn't be better off to go to some less windy, less rainy region—like Collioure, Barcelona, or Corsica. I hope that you will come with me if you are grumbling about winter in Paris, it would be better for you in the Midi. Do you have any ideas on this subject? Have you seen the exhibition at Manzi?[29]

My wife is in Issy. If you would go to see her, it would please her—the same with Marquet.

Drop me a line because I lack distractions and all news is pleasing.

Your devoted, H.M.

My best to Marquet.

9. Shchukin to Matisse, 11 April 1913[30]

Shchukin wrote that he was very pleased that Matisse had finished two landscapes for Morosov and a still life for Madame Morosov.[31]

10. Shchukin to Matisse, 16 April 1913[32]

Shchukin wrote that the Morosovs had not received their paintings, but that they knew Matisse wanted to show them at Bernheim[33] and Gurlitt.[34]

11. Matisse to Morosov, 19 April 1913[35]

Issy-les-Moulineaux, 19 April 1913

Dear Sir:

The three paintings in question are on exhibition at Bernheim's until today.[36] *They have been a great success and I think surely that you will be satisfied although you have waited a long time. I also think Madame Morosov will be happy.*[37] *The three paintings have been combined to be placed together and in a given direction—that is to say, the view from the window goes on the left, the gate of the Casbah on the right, and the terrace in the middle as this sketch (fig. 141) shows you.*

The frames have been designed for these paintings and are gray—they have been painted with glue [-based paint]. In case they have fingerprints, you can remove the stains by rubbing gently with a damp sponge (barely damp); the surface of the paint can be brought up by rubbing with a sponge; if it is not possible for you to do it, any painter-decorator you find can repaint them for you after removing the gray paint on the frame with water down to the white layer.

I gave in to the entreaties of my friends as well as the necessity of showing my paintings before they go to Moscow by promising that they would be exhibited in Berlin for eight days on their way to Moscow, with those of M. Shchukin.[38] And I have arranged it thus: the costs of transport and insurance are borne by the dealer who is doing the exhibition, from Paris to Berlin, and the shippers for you are M. Charchewsky and for M. Shchukin, M. Schreter, to whom their own agents in Berlin are answerable. I have even thought to go there to reassure myself that the paintings, which will leave Berlin around 8 May, will be routed perfectly.

Their price is as agreed (8,000Fr each) 24,000Fr, which you may deposit in my account at the Comptoir national d'Escompte de Paris, Branch 0, Place de Rennes 7.

If you come to Paris this summer, I hope that these three paintings will make you want to come and see two large paintings of about 2 meters by 1.70 in my studio that represent a grand Riffian and an Arab café.[39] I could send you photographs of them if they interest you.

While asking you to pay my respectful regards to Madame Morosov, I pray you to believe me, dear sir,

your devoted
Henri Matisse

12. Shchukin to Matisse, 10 October 1913[40]

Moscow, 10 October 1913

Cher Monsieur!

It is two weeks since my return to Moscow and during that time I've had the pleasure of a visit from Mr. Osthaus, founder of the museum at Hagen, and again the visit of many museum directors (Dr. Peter Tessen of Berlin, Dr. H. von Trenkmold of Frankfort, Dr. Hampe of Nuremberg, Dr. Polaczek of Strassburg, Dr. Sauerman of Flensburg, Dr. Stettiner of Hamburg, Dr. Back of Darmstadt, Max Sauerlandt of Halle, and Jens Thiis of Christiania). All these gentlemen looked at your pictures with the greatest attention and everybody called you a great master ("ein grosser Meister"). Mr. Osthaus has come here twice (once for luncheon once for dinner). I observed that your pictures made a deep impression on him. I spoke of your blue still life[41] which you had done for him, what a beautiful picture I found it, and *what a great development I felt in your recent works (Arab Café,[42] Blue Still Life, Mr. Morosov's Fatma[43])*. Jens Thiis, director of the museum of fine arts at Christiania (in Norway) spent two days in my house studying principally your pictures (the second day he stayed from ten o'clock in the morning until six in the evening). He is so taken that he hopes to buy a picture for his museum.

The other gentlemen also asked where one could buy your pictures and I replied at Bernheim's in Paris or directly from you. Mr. Osthaus will write you his own impressions regarding your works.

The *Arab Café* arrived in good condition and I have placed it in my dressing room. It is the picture which I love now more than all the rest and I look at it every day for at least an hour.

Mr. Morosov is ravished by your Moroccan pictures.[44] I've seen them and I understand his admiration. All three are magnificent. Now he is thinking of ordering from you three big panels for one of his living rooms. He is returning to Paris the 20th of October and will speak to you about it.[45]

I hope that the portrait of Madame Matisse[46] will also be an important work.

The 10,000 francs I owe you for the *Arab Café* you will receive in December.

My health is good, also that of my whole family, but I am very busy.

When you have time write me a word about your work and your projects for the winter.

Also don't forget my living room. It's beginning to be a real museum of your art.

My compliments to Mme Matisse

Votre tout dévoué
Serge Stschoukine

P.S. When will the Salon d'Automne[47] open? Are you going to exhibit?[48]

Shchukin's Commissions

Sergei Shchukin acquired seven works from Matisse's Moroccan period: *Le vase d'iris* (cat. 1), *Amido* (cat. 8), *Zorah debout* (cat. 16), *Le rifain debout* (cat. 18), *Arums* (cat. 20), *Arums, iris et mimosas* (cat. 21), and *Café marocain* (cat. 23). Shchukin commissioned three of these works.

1. Shchukin to Matisse, 13 March 1912[49]

Shchukin asked Matisse to reserve a souvenir of Tangier.[50]

2. Matisse to his family, 6 April 1912[51]

Matisse wrote that a young groom from the [Hôtel Villa] Valentina might pose.[52]

3. Shchukin to Matisse, 19 June 1912[53]

Shchukin wrote that he thought he would come to Paris around 20 July 1912.[54]

4. Shchukin to Matisse, 6 August 1912[55]

Shchukin requested that Matisse make a nice frame for the large blue picture[56] and that he send as soon as possible the three works destined for his salon.[57]

5. Shchukin to Matisse, 22 August 1912[58]

Moscow

Dear Sir!

I received yesterday your letter of 17 August and I consent and even with pleasure to have you show *Capucines à la danse* at the Salon d'Automne.[59] *But I beg you to send the other two paintings (the Moroccan and the goldfish[60]) to Moscow very quickly. I think a great deal of your blue painting (with two people).[61] I find it like a Byzantine enamel, so rich and deep in color. It is one of the most beautiful paintings, which now remains in my memory.*

The weather in Moscow is very bad, very cold and always raining. My health is very good.

I hope that you are fine and that work goes well.

Do not forget the pendant for my fish.[62]

My compliments to Mme Matisse.

Please be assured of my complete devotion.

Sergei Shchukin

6. Matisse to his wife, 16 October 1912[63]

Matisse wrote that he was working on a Moorish woman (*une mauresque*) for Shchukin.[64]

7. Matisse to Camoin [around the end of October 1912][65]

"I began a Moorish woman (*une mauresque*) on a terrace as a pendant to the young Moroccan (*marocain*) I did last year,[66] but a lot of wind and an irritating model are working against me. . . . I came to do the Moorish woman and two landscapes . . . more work than that would be welcome."

8. Matisse to his family [around 8–12 November 1912][67]

Matisse wrote that his letter included three *croquis* [of three paintings] representing two Moorish women (*mauresques*) and that one of the paintings was destined to be a pendant to Shchukin's Moroccan (*marocain*), one was for Bernheim, and the third was a little canvas for Sembat,[68] which was not yet finished.[69]

9. Matisse to his family, 21 November 1912[70]

Matisse wrote that he had begun a painting the same size as Shchukin's goldfish,[71] a portrait of a Riffian.[72]

10. Shchukin to Matisse, 11 April 1913[73]

He wrote he was pleased Matisse had completed four paintings for him.[74]

11. Matisse to Shchukin, 21 August 1913[75]

Matisse reported that he had been ill and therefore had not been able to attend to the shipment of *Café marocain*,[76] the packing of which he must absolutely supervise.[77]

12. Shchukin to Matisse, 10 October 1913[78]

"What a great development I felt in your recent works (*Arab Café*, *Blue Still Life*, Mr. Morosov's Fatma) The *Arab Café* arrived in good condition and I have placed it in my dressing room. It is the picture which I love now more than all the rest and I look at it every day for at least an hour The 10,000 francs I owe you for the *Arab Café* you will receive in December."

1. Moscow/Leningrad 1969, 129.

Collioure, 19 September 1911

Monsieur,

Je pense à vos paysages depuis que je suis à Collioure et je crains bien ne pas pouvoir les faire cet été. Plutôt je pense y travailler en Sicile où je pense passer l'hiver.

Vous verrez au Salon d'Automne un paysage qui vous était destiné et qui n'est resté qu'à l'état d'esquisse. Je suis très pris en ce moment par un travail décoratif important. Je pense que vous voudrez bien ne pas m'en vouloir si vous n'avez pas vos paysages pour le Salon d'Automne, puisque je vous ai prévenu lors de votre commande de la date incertaine de leur confection. Soyez convaincu, Monsieur, que je vous les ferai le plus tôt possible, et je vous prie d'entendre ceci dans le meilleur sens.

Quant à la nature morte dont vous me parlez, je pense inutile de vous donner l'ennui de me l'envoyer car je dois aller à Moscou fin octobre. Là, je verrai ce dont il s'agit et je pourrai y remédier s'il y a lieu.

Je vous prie, Monsieur, de croire à mes sentiments dévoués.

Henri Matisse
à Collioure P. V.

2. Matisse was in Collioure from June to September.
3. Matisse did not go to Sicily for the winter. He went instead to Tangier, arriving on 29 January 1912.
4. Probably *Vue de Collioure* (fig. 23). The Salon d'Automne at the Grand Palais, Paris, was from 1 October to 8 November 1911. Matisse sent two paintings, probably *Vue de Collioure* and *Nature morte aux aubergines* (Private collection, New York). See Elderfield essay in this volume, p. 211, and New York 1978, 82.
5. Probably *Intérieur aux aubergines*, 1911 (fig. 20). See also Elderfield essay in this volume, p. 211.
6. Between 1907 and 1911, Morosov had acquired seven Matisse still lifes (for provenance information, see Izerghina 1978, 115–192). One of these would seem to have required conservation.
7. Matisse was in Leningrad and Moscow in November 1911.
8. Archives Henri Matisse. Letter, Monday, 7 pm [1 April] 1912. This letter mentions that Mme Matisse had left Tangier thirty hours earlier. Since she left on Sunday, 31 March 1912, the date of this letter is presumably 1 April 1912. See also Schneider essay in this volume, note 142.
9. This still life is probably *Corbeille d'oranges* (see cat. 4). This is the first reference to a still life for Morosov, which would be referred to by Matisse again on 12 April 1912 and by Shchukin on 11 April 1913 as intended for Mme Morosov (see Morosov commission letters 5 and 9 below).
 "*Le bleu*" is probably *Paysage vu d'une fenêtre* (see cat. 12), but the possibility that it is *Les acanthes* (see cat. 5) cannot be entirely ruled out. "*Pervenches*" is certainly *Les pervenches (Jardin marocain)* (see cat. 6). Matisse consigned *Corbeille d'oranges* and *Les pervenches* to Galerie Bernheim-Jeune, Paris, shortly after he returned to Paris in the spring of 1912, thereby removing them from consideration for Morosov.
10. This letter includes other information: that his still life was now viable, and that Mme Davin [the proprietor of the Hôtel Villa de France] told him he could work in a studio [the name of the person to whom the studio belonged is illegible] where the young Arab girl [probably Zorah, see cat. 9] might come without being seen.
11. Archives Albert Marquet. This letter is postmarked 2 April 1912 but was presumably written on 1 April 1912, since Matisse also said in it that his wife left Tangier the day before. She left on 31 March 1912.
12. This must, therefore, be a landscape. Since *Paysage vu d'une fenêtre* was almost certainly completed (see cat. 12 and Morosov commission letter 2) and Matisse's [3 April] 1912 letter to his family suggests *Les pervenches (Jardin marocain)* and *La palme* were definitely completed by this date (see cats. 6 and 7 and Morosov commission letter 4), Matisse presumably must have been referring to *Les acanthes*, the only remaining first-trip landscape ambitious enough to warrant such a mention. This letter includes other information: that the situation in Fez is dangerous, and he would not go there.
13. Archives Henri Matisse. This letter mentions that Matisse had not yet heard from his wife who had left on 31 March 1912. Matisse mentioned in a letter on Friday [5 April] that he had received a telegram from his wife (Archives Henri Matisse). The date of the Wednesday letter is presumably 3 April 1913.
14. This was probably *Les acanthes* (see Morosov commission letter 3).
15. Canadian painter James Wilson Morrice, who probably saw *Les per-*

venches (Jardin marocain) and La palme (see cats. 6 and 7), at this time presumably not themselves under consideration for the commission.

16. Archives Henri Matisse.
17. Probably Corbeille d'oranges. See note 9 above.
18. Probably Les pervenches (Jardin marocain) and La palme (see Morosov commission letter 4).

This letter includes other information: that Morrice put a drawing in the guest book for Mme Davin (see note 10 above), that Matisse went back to the garden at the Villa Brooks (see cats. 5, 15) and did two drawings, and that he had two ideas for a picture (possibly he meant pictures) that he intended to paint when he returned home. See also Schneider essay in this volume, notes 116 and 149.

19. Moscow/Leningrad 1969, 129.

Issy, 92 Route de Clamart
29 Sept. 1912

Cher Monsieur,

Je suis tout confus en vous écrivant que je n'ai pu faire vos 2 paysages; qu'ils ne seront pas au salon par conséquent comme je vous l'avais écrit; mais que je pars demain au Maroc où je compte les peindre.

En vous présentant mes excuses, je vous prie de faire part à Madame de mes respectueux hommages et de me croire votre dévoué

Henri Matisse

20. This implies that Matisse had removed from consideration for Morosov all the hitherto painted Moroccan landscapes. However, when Matisse returned to Tangier in early October 1912, he appears to have brought Paysage vu d'une fenêtre and Les acanthes back with him (see cats. 12 and 5), initially with the intention of continuing work on the latter. Although he was satisfied with Les acanthes, it was not offered to Morosov, but Paysage vu d'une fenêtre was (see cats. 12, 5, and Morosov commission letter 11).
21. The Salon d'Automne at the Grand Palais, Paris, was from 1 October to 8 November 1912. Matisse sent Capucines et "La danse" (fig. 105) and Coin d'atelier (State Pushkin Museum of Fine Arts, Moscow).
22. Matisse arrived in Tangier 8 October 1912.
23. Archives Henri Matisse.
24. The landscape was probably Porte de la Casbah or Fenêtre ouverte à Tanger (see cats. 14 and 22). Apparently Matisse decided not to try another garden picture, perhaps because the landscape had changed significantly over the hot, dry summer (see cats. 5 and 22). In fact, he removed Les acanthes from consideration and shifted the focus of the Morosov commission to representations of the city of Tangier. This letter includes other information: that he had done a "une mauresque" for Shchukin (see Shchukin commission letters 6, 7, and 8).
25. Archives Charles Camoin. This undated letter was probably written around the end of October 1912, after Matisse's work was under way and he had received in Tangier a letter from Camoin about Druet (Giraudy 1971, 13), but before Matisse started working on the paintings he wrote about in a letter of around 8-12 November 1912 (see Shchukin commission letter 8) and before Camoin decided to travel with Mme Matisse to join Matisse in Tangier (they arrived in late November 1912). Letter also published in Giraudy 1971, 13, but with some inaccuracies.

Mardi

Mon cher Camoin,

Ta lettre m'a fait bien plaisir. Je suis heureux de la conclusion d'affaires avec Druet qui est un gros porc mais est quelquefois nécessaire. Permet moi de te recommander de ne pas discuter avec lui car vous ne pouvez vous entendre et il est inutile de le froisser. Il faut le prendre pour ce qu'il est. Pour l'instant il te permet de travailler un peu tranquillement si tu sais t'arranger sagement, il est donc très important pour toi. Peut-être nous reverrons nous cet hiver dans quelque pays de soleil car je resterai pas ici longtemps les pluies ne pouvant tarder. Jusqu'ici il fait très beau temps et j'en ai profité. J'ai commencé par faire une mauresque sur une terrasse pour faire pendant au petit marocain de l'an dernier; mais beaucoup de vent et modèle agaçant m'ont contrarié. Aussi quand j'ai cru avoir conclus, j'ai rentré ma toile chez moi, et je n'ai pas osé la retourner depuis par crainte de mécontentement. C'est une toile décorative que je dois faire et je pense qu'elle le sera, mais j'aurai voulu davantage. Ensuite deux paysages qui commencent à devenir sérieux, jusqu'ici ils n'étaient que badinage agréable—je suis venu pour faire la mauresque et les 2 paysages; le travail en plus sera le bienvenu. Mais comme le mauvais temps est sur le point de venir, je me demande si je ne ferais pas

mieux de remonter vers des régions moins venteuses, moins pluvieuses—comme Collioure, Barcelone ou la Corse. J'espère que tu viendras peut-être si tu te plains de l'hiver à Paris, il vaudrait mieux le midi pour toi. As-tu quelqu'idée à ce sujet? As-tu vu l'exposition Manzi?

Ma femme est à Issy. Si tu vas la voir ça lui fera plaisir—ainsi que Marquet.

Ecris-moi un petit mot car je manque de distractions et toutes nouvelles sont bien agréables.

Ton dévoué, H. M.

Amitiés à Marquet.

26. Galerie E. Druet, Paris, was Camoin's dealer.
27. See Shchukin commission letters 1, 2, 5, 6, 7, 8.
28. These were presumably paintings for Morosov, probably Porte de la Casbah and Fenêtre ouverte à Tanger (see cats. 14 and 22 and note 24 above), although Morosov did not acquire the latter.
29. Galerie Manzi Joyant & Cie, Paris.
30. Archives Henri Matisse.
31. In the end, Morosov acquired the Moroccan Triptych, Paysage vu d'une fenêtre, Sur la terrasse, and Porte de la Casbah (see cats. 12, 13, 14). They were exhibited 14-19 April 1913 at Galerie Bernheim-Jeune in Paris. In the catalogue "App. à M. I. M." [belonging to M. Ivan Morosov] appears after the titles of these paintings, indicating that Morosov had probably acquired them before Shchukin wrote this letter to Matisse. The checklist of this exhibition is illustrated in the Chronology.

If this letter is a reply to a letter from Matisse, as it seems to be, Matisse was still referring to the commissioned works for Morosov as two landscapes and a still life in early April 1913, on the eve of the exhibition of the Moroccan Triptych. Alternatively, Shchukin had learned from Matisse simply that three works had been completed for Morosov and assumes here that they would be the two landscapes and the still life that had been under discussion the previous year.

This letter includes other information: that Shchukin was pleased that Matisse had completed four paintings for him (see Shchukin commission letter 10).

32. Archives Henri Matisse.
33. See note 31 above.
34. The exhibition of Matisse paintings at Kunstsalon Fritz Gurlitt, Berlin, was held around 1-8 May 1913. Apparently Matisse sent all of the paintings in the April 1913 exhibition at Bernheim-Jeune that belonged to Morosov and some or all that belonged to Shchukin (see the checklist in the Chronology) to the exhibition at Gurlitt. For a review of this exhibition, see Kunstchronik 1913.
35. Moscow/Leningrad 1969, 129-130.

Issy-les-Moulineaux, 19 avril 1913

Cher Monsieur,

Les trois tableaux en question sont exposés chez Bernheim jusqu'aujourd'hui. Ils ont eu un grand succès et je pense bien que vous serez satisfait quoique vous ayez attendu si longtemps. Je pense aussi que Madame Morozoff sera contente. Les trois tableaux ont été combinés pour être placés ensemble et dans un sens donné—c'est à dire que la vue de la fenêtre vient à gauche, la porte de la Casbah à droite, et la terrasse au milieu comme ce croquis vous le représente.

Les cadres ont été destinés pour les tableaux et sont gris—ils sont peints à la colle. Dans le cas où ils auraient des traces de doigts, en les frottant légèrement avec une éponge un peu humide (légèrement humide) on pourrait enlever ces taches: la surface de la peinture s'enlevant en frottant avec l'éponge; au cas où il serait impossible de le faire, n'importe quel peintre décorateur vous les repeindra après avoir enlevé à l'eau jusqu'à l'enduit blanc la peinture grise du cadre.

Ce gris est fait avec du blanc d'Espagne ou un autre blanc en poudre, un peu de noir et un peu de bleu outremer et de la gélatine pour coller.

J'ai cédé aux sollicitations de mes amis et aussi à la nécessité de montrer mes toiles avant de les envoyer à Moscou, en promettant qu'elles seraient exposées à Berlin 8 jours en passant pour aller à Moscou—ainsi que celles de M. Stschoukine. Et je me suis arrangé ainsi: les frais de port et d'assurances sont supportés par le Marchand qui fait l'exposition, de Paris à Berlin, et les expéditeurs sont pour vous M. Charchewsky et pour M. Stschoukine M. Schreter, et à Berlin leurs correspondants dont ils répondent. Je pense même y aller pour m'assurer de la parfaite réexpédition des toiles qui quitteront Berlin vers le 8 mai.

Leur prix est comme il a été convenu (à 8000 f. pièce) 24 000 f. que vous

pourrez faire verser à mon compte, au Comptoir national d'Escompte de Paris, Agence 0, Place de Rennes 7.

J'espère que ces 3 toiles vous donneront envie de venir voir dans mon atelier si vous venez à Paris cet été deux grandes toiles de deux mètres sur 1.70 environ qui représentent un grand Riffain [sic] et un café arabe. Je pourrais vous en envoyer des photographies si elles vous intéressaient.

En vous priant de présenter mes hommages respectueux à Madame Morozoff, je vous prie de me croire, cher Monsieur,

votre dévoué
Henri Matisse

36. See note 31 above.

37. Mme Morosov may have wanted a still life. See notes 9 and 31 above.

38. See note 34 above.

39. *Le rifain assis* (cat. 19) and *Café marocain* (cat. 23).

40. This letter, translated from the French, is printed here as it appeared in Barr 1951, 147. A transcript of the original French letter was not included in Barr's text and is not available.

41. *La fenêtre bleue*, 1913 (The Museum of Modern Art, New York).

42. *Café marocain.*

43. Morosov never owned a painting of Fatma. Presumably Shchukin meant Morosov's *Sur la terrasse*, a painting of another Moroccan woman, Zorah.

44. See note 31 above.

45. Morosov did not, in fact, commission additional works from Matisse.

46. *Portrait de Mme Matisse*, 1913 (State Hermitage Museum, Leningrad).

47. The Salon d'Automne at the Grand Palais, Paris, was held from 15 November 1913–5 January 1914.

48. Matisse exhibited one painting, *Portrait de Mme Matisse*, 1913.

49. Archives Henri Matisse. From a letter he wrote to his family, we know that Matisse wrote to Shchukin, possibly in reply to this letter, on 1 April 1912, but the full contents of the letters are not known. See Morosov commission letter 2.

50. Two of the works Shchukin acquired, *Le vase d'iris* and *Amido*, were painted on the first trip. The latter would seem to have been the souvenir referred to here, since a record of a letter of 27 April 1912 in the Archives Henri Matisse indicates that Matisse's dealer Bernheim had seen a "marocain" in Matisse's studio that was the result of a commission from Shchukin. Matisse painted three pictures of Moroccan men: *Amido*, *Le rifain debout*, and *Le rifain assis* (cat. 19). The latter two were definitely painted during Matisse's second visit; therefore the "marocain" in Matisse's studio in the spring of 1912 must have been *Amido* (see cat. 8).

51. Archives Henri Matisse.

52. Possibly *Amido* (see Shchukin commission letter 1). This letter includes other information: that he no longer touched his still life any more (probably *Corbeille d'oranges*, see cat. 4), that he would have liked to work the day before with the young girl (probably Zorah, see cat. 9) but it was not possible because it would have angered her brother, that he took his canvases from the Spaniard's home because the lessor wanted the rooms back (possibly the Spaniard was Francisco Iturrino, see Chronology), that he returned to the gardens of the Villa Brooks the day before, that if he felt well enough he would stay on, and that he had visited Mme Sixsu [sic] (see Cowart essay in this volume, note 11). See also Schneider essay in this volume, notes 114, 115, and 118.

53. Archives Henri Matisse.

54. In a letter of 2 July 1912 in the Archives Henri Matisse, Shchukin thanked Matisse for having reserved some pictures for his grand salon and dining room.

55. Archives Henri Matisse.

56. *Conversation* (fig. 117).

57. Presumably these were paintings Shchukin had seen in Matisse's studio. The first two sentences of Shchukin's letter of 22 August 1912 (see Shchukin commission letter 5) suggest that they were *Capucines et "La danse"* (fig. 105), *Amido*, and *Les poissons rouges* (fig. 108).

58. Pierre Matisse Archives. Also printed in Barr 1951, 555, corrected in Kean 1983, 298–299.

Moscou, 22 aout 1912

Cher Monsieur!

J'ai reçu hier votre lettre du 17 aout et je consens et même avec plaisir que vous exposez au Salon d'Automne le tableau des "Capucines à la danse." Mais je vous prie d'envoyer les deux autres tableaux (le maroquain et les poissons d'or) à Moscou grande vitesse. Je pense beaucoup à votre tableau bleu (avec 2 personnes), je le trouve comme une émaille byzantine, tellement riche et profond de couleur. C'est un des plus beaux tableaux, qui reste maintenant dans ma mémoire.

Il fait maintenant à Moscou un temps bien mauvais, très froid et toujours de la pluie. Ma santé et très bonne.

J'espère que vous êtes bien portant et que le travail marche bien.

N'oubliez pas le pendant pour mes poisons [sic].

Mes compliments à Mme Matisse.

Recevez l'assurance de mon entier devouément [sic].

Serge Stschoukine

59. Matisse painted this picture (fig. 105) upon his return from his first visit to Morocco, and Shchukin had recently purchased it, presumably after seeing it in Matisse's studio (see Shchukin commission letter 4). See Elderfield essay in this volume, p. 222, and note 21 above.

60. *Amido*, the painting that presumably fulfilled Shchukin's 13 March 1912 request for a souvenir of Tangier (see Shchukin commission letter 1), and *Poissons rouges* (fig. 108).

61. *Conversation* (fig. 117).

62. See Shchukin commission letter 9 for further reference to a pendant for *Les poissons rouges*.

63. Archives Henri Matisse (see also Morosov commission letter 7).

64. Presumably intended to be the pendant for *Amido* (see Shchukin commission letter 7), at this stage probably *La mulâtresse Fatma* (see cat. 15 and Elderfield essay in this volume, p. 223).

65. For complete text, see Morosov commission letter 8.

66. The Moorish woman on a terrace was probably *La mulâtresse Fatma* (see cat. 15 and Elderfield essay in this volume, p. 223 n. 8), and the young Moroccan was *Amido*, the only first-trip painting of a male Moroccan (see Shchukin commission letter 1).

67. Archives Henri Matisse. This letter is not dated, but in it Matisse said he had received good news from Paris that his dealer had sold *Zorah en jaune* (cat. 9). Since Matisse had received a letter from Félix Fénéon dated 2 November 1912 (in the Archives Henri Matisse) informing him of the sale, the undated letter was probably written shortly after Matisse had received Fénéon's letter, around 8–12 November. See also Schneider essay in his volume, note 146.

68. Shchukin's Moroccan is *Amido* (see Shchukin commission letter 1), the pendant is probably *Zorah debout*, and the one for Bernheim (Matisse's dealer) is probably *La mulâtresse Fatma*. *Zorah debout* apparently replaced *La mulâtresse Fatma* as the pendant to *Amido*. See Shchukin commission letters 6 and 7, cats. 15 and 16, and Elderfield essay in this volume, p. 223. The painting for Sembat is *La petite mulâtresse* (see cat. 17).

69. This letter includes other information: that the painting for Sembat was 30 x 27 cm, that the other two paintings were 150 cm high, and that as soon as he had finished the *mauresque* for Sembat, he would begin a painting of a young Moroccan from the Rif. He wrote also that he worked with models in the afternoon, doing only one *séance* a day, that he was happy with his work, and had decided to stay as long as possible. He wrote that he had already cabled his wife and thought that Camoin would accompany her to Tangier.

70. Archives Henri Matisse. See also Schneider essay in this volume, note 147.

71. *Les poissons rouges.*

72. *Le rifain debout.* Shchukin acquired this painting as well as two other paintings the same size as *Les poissons rouges*: *Arums* and *Arums, iris et mimosas*. It is not certain which of these three paintings was intended as the pendant. See cats. 18, 20, 21.

This letter includes other information: that his wife was in Marseilles and was ready to take the boat that would arrive sixty hours later in Tangier, that the weather was radiant and that he worked in the afternoons, and that there had been a drought. See also Schneider essay in this volume, note 150.

73. See also Morosov commission letter 9.

74. Presumably *Zorah debout*, *Le rifain debout*, *Arums*, *Arums, iris et mimosas*, the four works credited "App. à M. S. S." (belonging to M. Sergei Shchukin) in the catalogue for the April 1913 exhibition at Galerie Bernheim-Jeune, Paris (the checklist for this exhibition is illustrated in the Chronology). The two first-trip works, *Le vase d'iris* and *Amido* (the latter almost certainly in Russia by this date, see Shchukin commission letter 5), were not included in this exhibition. *Café marocain* was included in the exhibition, but had not yet been acquired by Shchukin (see cat. 23).

75. The letter remains in the Archives Henri Matisse, and presumably was not sent.

76. Earlier, in letters dated 19 April 1913 (see Morosov commission letter 11 for complete text) and 25 May 1913 (Moscow/Leningrad 1969, 130), Matisse had tried to interest Morosov in *Café marocain* (see cat. 23).

77. In a letter to Camoin on 15 September 1913, Matisse wrote: "Did you know that I sold *Café marocain* to Shchukin? The picture must have already arrived in Moscow. . . ." Giraudy 1971, 16 (see cat. 23, note 25).

78. For complete text see Morosov commission letter 12.

Triptychs, Triads, and Trios: Groups of Three in Matisse's Paintings of the Moroccan Period

Pierre Schneider
Jack Cowart
Laura Coyle

Good things come in threes. This adage is illustrated beautifully in Matisse's work around 1912–1913, as many of the paintings from this period fall comfortably into sets of three. The most obvious example is, of course, the so-called Moroccan Triptych, formed when Matisse sold to Ivan Morosov *Paysage vu d'une fenêtre, Sur la terrasse,* and *Porte de la Casbah* (cats. 12, 13, 14) with specific instructions on how to hang them together.[1] It should be remembered that Matisse shifted his stand several times on what paintings he planned to sell Morosov, thereby starting this game of combination and permutation himself.[2] Other assemblies of three, such as the Moroccan garden paintings (cats. 5, 6, 7) and *Amido, Zorah debout,* and *La mulâtresse Fatma* (cats. 8, 16, 15) come easily to mind. Elsewhere in this catalogue the reasons why Matisse created paintings in sets of three are explored.[3] Here these groups are presented visually.

No evidence exists to suggest that Matisse created any triptychs as the word is usually defined: a group of three pictures, conceived for presention side by side, so that all the elements form part of, and are necessary to make, the whole. A medieval altarpiece, with a central subject flanked by two subsidiary subjects, is the most familiar example of a triptych. Although the word triptych is often used when discussing Matisse's work of the Moroccan period, under this strict definition he made none.

Around 1912–1913 Matisse did, however, form triads. He grouped his pictures in threes in one of two ways: on paper in his letters, which were occasionally accompanied by *croquis,* and on the walls of the exhibition of his Moroccan work at Galerie Bernheim-Jeune in Paris in April 1913. The identification of these triads in Matisse's correspondence is complicated. Although clearly he was referring to three specific pictures in certain letters, in some cases it is impossible to determine precisely which three he was writing about. Furthermore, the *croquis* he referred to are often missing. In these cases, the most likely combinations of three are illustrated here.

The artist also assembled triads of his Moroccan paintings when he hung or approved the hanging of his paintings in groups of three for his Paris 1913 exhibition.[4] This is documented by the extant installation photographs of several (if not all) of the walls (figs. 1–5).

The final category considered is the trio. This is a group of three for which no evidence exists except for a compelling coincidence of size, subject matter, or both. Although the artist did not refer to any of the trios illustrated here, they are impossible for us to ignore.

Often the triads and trios began with an existing painting to which Matisse added another to make a pair, and then added a third, reminding us of the French proverb "Jamais deux sans trois (Never two without three)." The paintings within his triads and trios often bridged the summer between his two trips to Morocco, which served as a gestational period for his creative process.

Each triad or trio illustrated is accompanied by a brief text. Where specific information about the paintings is mentioned in these captions, particularly with regard to dating and the identification of paintings in Matisse's correspondence, the painting entries and Appendix 1, which are supported with more complete references, are the source. We hope that the sets of three we present will inspire those who have had second thoughts about their existence to devote a third thought to the matter.

Triad
The Still Life and Two Landscapes for Morosov

In April 1912 Matisse wrote to his family that he had sent Shchukin a letter with a *croquis* of the still life and two landscapes for Morosov, which he called "le bleu" and "pervenches." He added that the sketch "fait un joli triptique" (makes a nice . . . triptych).[5] Because the letter to Shchukin and the *croquis* that accompanied it have not come to light, we have been able to narrow our number of assemblies to no fewer than six.

"Pervenches" is certainly *Les pervenches (Jardin marocain)*, but "le bleu" could be either of two blue landscapes the same size as *Les pervenches*: *Paysage vue d'une fenêtre* or *Les acanthes*. Since the more blue of the two paintings, *Paysage vu d'une fenêtre*, is called "le paysage bleu" in the Archives Henri Matisse, it is probably the landscape Matisse referred to, but the possibility that it may be *Les acanthes* cannot be entirely ruled out. The still life reference is even harder to pin down. For reasons cited in the catalogue entry, it seems most likely that the still life for Morosov was *Corbeille d'oranges*. However, since this is not known for a fact, *Le vase d'iris* (completed on the first trip) and *Arums* (cat. 20, possibly painted on the first trip) are also illustrated. Thus the six possible combinations are: cats. 6, 4, 12; cats. 6, 4, 5; cats. 6, 1, 12; cats. 6, 1, 5; cats. 6, 20, 12; and cats. 6, 20, 5.

Triad
A Still Life for Morosov and Two *Esquisses*

Matisse associated three paintings in a 12 April 1912 letter to his family, telling them that he had had a special crate made for his still life for Morosov and two *esquisses*.[6] Which of the Moroccan still lifes was meant for the artist's patron is not known. We propose that it was *Corbeille d'oranges*, but two other possibilities, *Le vase d'iris* and *Arums*, are also illustrated. With more certainty we propose that *Les pervenches (Jardin marocain)* and *La palme* are the two *esquisses*.

cat. 6

cat. 4

cat. 7

cat. 1

cat. 20

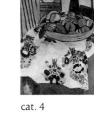

cat. 6

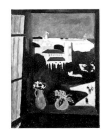

cat. 4

cat. 12

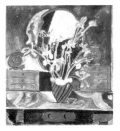

cat. 1

cat. 5

cat. 20

Triad
Zorah debout, *La petite mulâtresse*, *La mulâtresse Fatma*

With a letter to his family around 8–12 November 1912 Matisse included three *croquis*. He wrote that they represented two *mauresques*, gave the sizes of the paintings as 150 cm for two and 30 × 27 cm for the third, and pronounced that one 150 cm-canvas was destined to become the pendant to Shchukin's *marocain* (*Amido*), the other was for Bernheim, and the third little canvas was for Sembat.[7] Although the sketches are lost, it is certain that he was referring to *Zorah debout*, *La petite mulâtresse* (cat. 17), and *La mulâtresse Fatma*. The illustrations here are reproduced to scale, but it is possible that Matisse drew them as if they were closer in size.

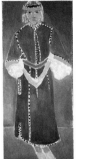

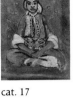

cat. 17

cat. 16

cat. 15

Triad
The Moroccan Triptych

Matisse's most celebrated group of three pictures is the Moroccan Triptych, formed when Matisse sold *Paysage vu d'une fenêtre*, *Sur la terrasse*, and *Porte de la Casbah* to Morosov with instructions and a sketch indicating how they should hang together.[8]

Henri Matisse, sketch from letter of 19 April 1913 to Morosov

Three Triads

Matisse hung, or at least approved the hanging of three groups of three paintings in his April 1913 exhibition of Moroccan works at Galerie Bernheim-Jeune, Paris. The Moroccan Triptych was installed on one wall (fig. 4), *Arums*, *Le rifain assis* (cat. 19), and *Arums*, *iris et mimosas* (cat. 21) on another (fig. 2), and *Zorah debout*, *Le rifain debout* (cat. 18), and *La mulâtresse Fatma* on the third (fig. 1).

Trio
Les acanthes, *Les pervenches (Jardin marocain)*, *La palme*

Matisse painted all three of these same-size landscapes in the gardens of the Villa Brooks on his first trip to Tangier. In the earliest monograph on the artist's work, Marcel Sembat wrote: "Matisse escaped to Morocco. He brought his need for calm and for decorative ensembles. . . . The gardens above all were revelations. I know this garden, three times redone, and each time brought further toward decoration, toward calm, toward abstract simplicity. . . ."[9]

cat. 5

cat. 6

cat. 7

Trio
Amido, *Zorah debout*, *La mulâtresse Fatma*

Each of these paintings features a full-length standing figure in Moroccan costume in the same unusual format. This trio encompasses an actual pendant pair. Matisse painted *Amido* on the first trip and sold it to Shchukin the following summer. When the artist returned to Tangier in the autumn of 1912, he wrote to Camoin[10] and his family[11] that he was working on a pendant to *Amido*. Matisse apparently considered *La mulâtresse Fatma* as *Amido*'s possible mate, but ultimately he sold *Zorah debout* to Shchukin and *Fatma* to his dealer.

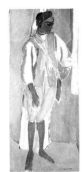
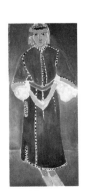

cat. 8

cat. 16

cat. 15

Trio
Arums, Corbeille d'oranges, Arums, iris et mimosas

The four still lifes Matisse painted in Tangier provide a number of possibilities for trios, but we have chosen to illustrate the one that seems the most harmonious. *Arums* and *Arums, iris et mimosas* are natural pendants because of their identical size and similar subjects; possibly Shchukin acquired them both for that reason. The third of the trio proposed, *Corbeille d'oranges*, is probably set on the same table, ostensibly in the same room shown from different angles. Together they form an opulent trio of fruits and flowers native to Tangier. Although the sizes are not uniform, Matisse was not against using flanking pictures of the same dimensions with a middle picture of a different size, as he demonstrated in the triads he exhibited at Galerie Bernheim-Jeune.

cat. 20

cat. 4

cat. 21

Trio
Arums, Poissons rouges, Arums, iris et mimosas

Shchukin asked Matisse to paint a pendant to *Poissons rouges*. If Matisse did not intend *Le rifain debout* to be the pendant, he may have painted either *Arums* or *Arums, iris, et mimosas* to go with the goldfish. Shchukin acquired both flower still lifes, and therefore he could have assembled three pendant pairs as well as the trio we propose.

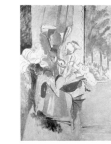

cat. 20

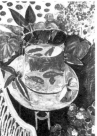

fig. 108

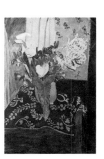

cat. 21

Trio
Poissons rouges, Le rifain debout, Fenêtre ouverte à Tanger

When Shchukin wrote to Matisse in August 1912, he reminded the artist that he wanted a pendant to *Poissons rouges*.[12] On 21 November 1912 Matisse wrote to his family that he had begun a painting of a Riffian (*Le rifain debout*) the same size as Shchukin's *Poissons*.[13] Possibly Matisse intended, and Shchukin perceived, *Le rifain debout* as the pendant the patron desired; at the very least they are associated because both were in Shchukin's collection.

The third of this trio, *Fenêtre ouverte à Tanger*, is the same size as *Les poissons rouges* and *Le rifain debout* and was probably painted on Matisse's second trip to Tangier. As Schneider proposed, "this trio treats in the epic key . . . the themes of Morosov's lyrical Moroccan Triptych: a window, a human figure, and goldfish."[14]

fig. 108

cat. 18

cat. 22

Trio
Arums, Fenêtre ouverte à Tanger, Arums, iris et mimosas

This trio combines the motifs of two of Matisse's most favored subjects: bouquets of flowers and windows.

cat. 20

cat. 22

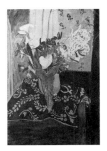

cat. 21

Trio
Arums, Le rifain debout, Arums, iris et mimosas

Another trio springing from the bountiful Shchukin collection is this combination of flower still lifes with a Moroccan warrior. This assembly may seem bizarre, but Matisse himself hung the other Riffian painting, *Le rifain assis*, between these two flower still lifes for his Paris 1913 exhibition at Bernheim-Jeune. Furthermore, the affinity of Matisse's figures of this period to flowers and plants should be considered.[15]

cat. 20

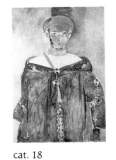

cat. 18

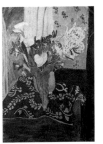

cat. 21

1. 19 April 1913, Pushkin/Hermitage 1969, 129. For the complete text of this letter, see Appendix 1.
2. See Appendix 1.
3. See Schneider essay in this volume, pp. 41–43.
4. Matisse took great interest in how his works were hung. See Schneider 1984b, 178.
5. Monday [1 April] 1912, Archives Henri Matisse. See also Schneider essay in this volume, note 142.
6. Archives Henri Matisse.
7. Archives Henri Matisse.
8. See note 1.
9. Sembat 1920a, 9–10.
10. Around the end of October 1912, Giraudy 1971, 13.
11. 16 October and c. 8–12 November 1912, Archives Henri Matisse.
12. State Pushkin Museum of Fine Arts, Moscow. See Kean 1983, 298–299. For text of letter see Appendix 1.
13. Archives Henri Matisse.
14. See Schneider essay in this volume, p. 42.
15. See Schneider essay in this volume, pp. 37–39, 48–51.

Provenance, Exhibition History, Literature for Paintings

1 Le vase d'iris

PROVENANCE

24 May 1912, Galerie Bernheim-Jeune, Paris; by 1913, Sergei I. Shchukin, Moscow; 1918, First Museum of Modern Western Painting, Moscow; 1923, Museum of Modern Western Art, Moscow; 1948, State Hermitage Museum, Leningrad.

EXHIBITIONS

La Triennale, Galerie Jeu de Paume, Paris, June–July 1912; Moscow/Leningrad 1969, 68, no. 38, ill. no. 38; Dresden 1976, no. 19; Lugano 1987, no. 33; Barcelona 1988, 35, 197, no. 15, ill. (color) 137.

LITERATURE

Shchukin 1913, no. 117; Tugendhold 1914, 42; Museum of Modern Western Art 1928, no. 333; Réau 1929, 118, no. 947, cat. 333; Cahiers d'art 1950, 343, no. 333; Sterling 1957, 181, fig. 141 (color); French Masters 1970, no. 32; Kostenevich 1974, 162; Izerghina 1975, ill. (color) no. 168; Hermitage 1976, 278; Izerghina 1978, 20, 165, ill. (color) no. 39, ill. (b/w) 165; Flam 1986, 325, fig. 326; Kostenevich 1984, ill. (color) cover and n.p; Kostenevich 1989, 493, ill. (color) no. 212.

2 Vue sur la baie de Tanger

PROVENANCE

27 April 1912, Gallerie Bernheim-Jeune, Paris; by 30 April 1912, Marcel Sembat, Paris; 1923, Musée de Grenoble (Legs Agutte-Sembat).

EXHIBITIONS

Paris 1913, *hors catalogue*; *Les chefs d'oeuvre du Musée de Grenoble*, Petit Palais, Paris, 1935, 132, no. 259; Liège 1937 and/or 1939 (?); *Exposition de peinture*, Salons de L'Hôtel Gray d'Albon, Cannes, 1947, no. 49 (?); Ostende 1951 (?).

LITERATURE

"Nouvelles salles au Musée de Grenoble," *Bulletin de la vie artistique* 19 (1 October 1924), 441; Arsène Alexandre, "Un musée rajeuni la Collection Marcel Sembat à Grenoble," *La Renaissance de l'art français et des industries de luxe* 11 (November 1924), 595, ill.; Barr 1951, 540; Courthion 1970, ill. (color) 50; Luzi 1971, 93, ill. 93; Fourcade 1975, 18, 20, 39, ill. (color) 17; Flam 1982, 78, ill. (color) 74–75; Flam 1986, 326–327, 411, 499, 500, ill. fig. 330.

3 Le marabout

PROVENANCE

Private collection.

EXHIBITIONS

Aix-en-Provence 1960, no. 12, ill. n.p.

4 Corbeille d'oranges

PROVENANCE

27 April 1912, Galerie Bernheim-Jeune, Paris; 24 May 1912, Carl Sternheim; Théa Sternheim; Fabiani(?); 1944, Pablo Picasso, Paris; 1973, Musée du Louvre, Donation Picasso, Paris; 6 June 1985, Musée Picasso, Paris.

EXHIBITIONS

Henri Matisse, Galerie Georges Petit, Paris, 1931, no. 13, 14; *Les Maîtres de l'Art Indépendant, 1895–1937*, Petit Palais, Paris, 1937, 36, no. 31; *Salon d'Automne* ("Liberation Salon"), Paris, 1944, *hors catalogue*; *Henri Matisse—Chapelle, Peintre, Dessins, Sculptures*, Paris, 1950, no. 40; Paris 1956, 22, no. 33, ill. pl. XIII; Los Angeles 1966, 186, no. 33, ill. (color) 63; Paris 1970, 80, no. 117, ill. 191; *Donation Picasso*, Musée du Louvre, Paris, 1978, 9–10, 54, no. 21, ill. (color) cover and 55, ill. (b/w) 8; Zurich 1982, no. 38, ill. (color) n.p.

LITERATURE

Schacht 1922, ill. 69; Zervos 1931a, 28; Zervos 1931b, 26, ill. 54; Barnes 1933, 436, no. 53; Cassou 1939, ill. (color) no. 5; Grünewald 1944, ill. 46; *Matisse, Trésors de la peinture française*, Geneva, 1946, pl. 3; Barr 1951, 145, 155, 159, 211, 259, 540, ill. 389; Diehl 1954, ill. (color) 60; Brassaï, *Conversation avec Picasso*, Paris, 1964, 175; Françoise Gilot and Carlton Lake, *Life with Picasso*, New York, 1964, 17, French edition *Vivre avec Picasso*, Paris, 1965, 15; New York 1966, ill. 34 (not in exhibition); "The Magic of Matisse," *Apollo* (April 1966), 245; Guichard-Meili 1967, ill. 80; Russell 1969, 70, ill. (color) 68; Luzi 1971, 92, ill. 92; André Malraux, *La tête d'obsidienne*, Paris, 1974, 14, 15, 20, 250; Hélène Parmelin, "Picasso ou le collectionneur qui n'en est pas un," *L'Oeil* (September 1974), 8–9; Schneider 1982, no. 172; Schneider 1984b, 269, 462–463, 734; *Musée Picasso: Catalogue sommaire des collections*, Ministère de la Culture, Editions de la Réunion des musées nationaux, Paris, 1985, 1:229, 245, no. T-50, ill. 245; Flam 1986, 331, ill. (color) fig. 337.

5 Les acanthes

PROVENANCE

20 December 1913, Galerie Bernheim-Jeune, Paris; 4 March 1914, Léonce Rosenberg; Walther Halvorsen, Paris; 1917, donated to Moderna Museet, Stockholm.

EXHIBITIONS

Art Français, Oslo, 1918, no. 45; Copenhagen, October 1924, 38; *Fransk genombrottskonst från nittonhundratalet*, Stockholm, Oslo, Göteborg, Copenhagen, 1931, no. 112; Lucerne 1949, no. 51; Nice

1950, no. 9; New York 1951, 9, no. 29, ill. 20; *Notre Musée tel qu'il devrait être*, Moderna Museet, Stockholm, 1964; Copenhagen 1970, no. 32, ill. n.p; Paris 1970, 78, no. 113, ill. 186; Zurich 1982, no. 34 (Zurich only), ill. (color) n.p; London 1984b, 211–212, no. 99a, ill. (color) 112, ill. (b/w) 212; Washington 1984, 189–190, 77a, ill. (color) 112, ill. (b/w) 190; Stockholm 1984, no. 18.

LITERATURE

Sembat 1913; 194; Sembat 1920a, 10; Sembat 1920b, 194; Zervos 1931a, ill. 49; Zervos 1931b, 26, ill. 48; Swane 1944, 96, fig. 21; Barr 1951, 144, 145, 154, 155–156, ill. 380; Escholier 1956a, 710; Fiala 1967, ill. (color) 42; Guichard-Meili 1967, ill. 73; Courthion 1970, 54; Luzi 1971, 93, colorplate 26, ill. 93; Paris 1975, 90 (not in exhibition); Izerghina 1978, 171, ill. 171; Gowing 1979, 121; Flam 1982, 80, ill. (color) 85; Schneider 1982, no. 182; Schneider 1984b, 462, ill. (color) 462; Flam 1986, 314, 327, 331, 345, 349, 499, 500, 505, fig. (color) 336; Flam 1988, (color) pl. 43.

6 Les pervenches (Jardin marocain)

PROVENANCE

27 April 1912, Galerie Bernheim-Jeune; Private collection, Germany (?); by 1942, Valentine (Dudensing) Gallery, New York; 1942, Joseph Pulitzer, Jr., St. Louis; 1948, Fine Arts Associates, New York; June 1948, M. Knoedler & Company, New York, with Fine Arts Associates, New York; October 1951, Mr. and Mrs. Samuel A. Marx, Chicago; 1985, The Museum of Modern Art, New York, Gift of Florene M. Schoenborn (the former Mrs. Samuel A. Marx).

EXHIBITIONS

Paris 1913, *hors catalogue*; New York 1936, no. 2, as *Maroc*, 1912 (?); New York 1948, as *Moroccan Landscape*, 1912 (?); *The Post-Impressionists and Their Followers*, Society of the Four Arts, Palm Beach, 1949, no. 33, as *Paysage*, 1911–1912; New York 1951, 9, no. 30, as *Moroccan Garden*; New York 1955, 15, as *Moroccan Garden*; New York 1965, as *Moroccan Garden*, 1, 7, ill. (color) 2; London 1984b, 211–212, no. 99b, ill. 212, ill. (color) 110, as *Moroccan Garden (Le jardin marocain)*; Stockholm 1984, 25, no. 19 as *Jardin marocain, pervenches*, 1912; Washington 1984, no. 77b, as *Moroccan Garden (Le jardin marocain)*, 189–190, ill. 190, ill. (color) 110.

fig. 140. Composite of infrared photographs of *Les pervenches (Jardin marocain)*

LITERATURE

Sembat 1920a, 10 (?); Sembat 1920b, 194 (?); Art Digest 1936, 7; Romm 1947, 10–11; Barr 1951, 144–145, 154–156, 529, 540, ill. 380 as *Moroccan Garden*; Tériade 1952, 43; Diehl 1954, 69, 139, 154, no. 63, ill. (color) pl. 63; Escholier 1956a, 710, as *Jardin Marocain*, ill. 708; Escholier 1956b, 108; Hunter 1956, no. 8, ill. (color) as *Moroccan Garden*; Escholier 1960, 94; London 1968, 30 (not in exhibition); Paris 1970, 78, ill. 187, as *Pervenches* (not in exhibition); Aragon 1971, 2:361, as *Jardin Marocain* or *Les Pervenches*, ill. color p. 120, pl. XXV; Luzi 1971, 93, ill. fig. 166; Jacobus 1973, 32, 134, ill. color pl. 25 as *Moroccan Garden (Pervenches)*; Izerghina 1978, 171, ill; Gowing 1979, 121, 209, ill. color p. 120, no. 107 as *Jardin Marocain (Pervenches)*; Hooper 1981, 37, 40–41, 43, 44, 46, 106, ill. 130, ill. color 116; Zurich 1982, no. 34, as *Jardin Marocain* (not in exhibition); Flam 1982, 82, ill. (color) 84; Schneider 1982, ill. 93, no. 166 as *Pervenches*; Schneider 1984a, 450, 461–462, ill. (color) 463 as *Pervenches*; Schneider 1984b, 450, 461–462, ill. (color) 463, as *Moroccan Garden (Periwinkles)*; Flam 1986, 349, 360, 500, fig. 350; Museum of Modern Art 1988, 78.

7 La palme

PROVENANCE

27 April 1912, Galerie Bernheim-Jeune, Paris; by 1914, Oskar and Greta Moll, Breslau; around 1932, Justin K. Thannhauser, Berlin; Weyhe Galleries, New York; by late 1940s, Mr. and Mrs. Alfred H. Barr, Jr., New York; 1978, National Gallery of Art, Washington, Chester Dale Fund.

EXHIBITIONS

Berlin 1913b, no. 60; *Six Centuries of Landscape*, Montreal Museum of Fine Arts, 1952, no. 64, ill. 31; Paris 1956, 22, no. 32, ill. pl. XIV; *The Dial and the Dial Collection*, Worcester Art Museum, 1959, 78, no. 60; Paris 1970, 78, no. 114, ill. 186; Zurich 1982, no. 35, ill. (color) n.p; London 1984b, 211–212, no. 99c, ill. (color) 111, ill. (b/w) 190; Washington 1984, 189–190, no. 77c, ill. (color) 111, ill. (b/w) 212; Stockholm 1984, no. 20, ill. (color) no. 20; *Twentieth-Century Art: Selections for the Tenth Anniversary of the East Building*, Washington, 1988, cat. 26, ill. (color) 27.

LITERATURE

Sembat 1920a, 10; Sembat 1920b, 194; *Dial* 78 (February 1925), ill. (color), opp. 91; Barr 1951, 144, 145, 154, 155, 156, 157, 540, ill. 381; Diehl 1954, 69; Escholier 1956a, 710; John Gross, "Matisse Retrospective in Paris," *Burlington Magazine* 98 (October 1956), 387; Luzi 1971, ill. 93; Siegfried and Dorothea Salzmann, *Oskar Moll: Leben und Werk* (Munich, 1975), 62; Izerghina 1978, 171, ill. 178; *1979 Annual Report National Gallery of Art*, Washington, 1980, 12, 27, ill. 10; Gowing 1979, 121; "La Chronique des Arts," *Gazette des Beaux-Arts*, supplement, no. 1334 (March 1980), ill. no. 239; Flam 1982, 82, ill. (color) 84; Schneider 1982, ill. no. 167; Gail Levin, "Current Museum Exhibitions: Old Options and New Approaches; The Cubist Rivera, the Late Bonnard, the Folding Image, and the Orientalists," *Arts Magazine* 59 (October 1984), 125, ill. 125; Schneider 1984b, ill. (color) 463; *European Paintings: An Illustrated Catalogue*, Washington, 1985, ill. 265; Flam 1986, 349, 419, 500, fig. 351.

8 *Amido*

PROVENANCE

By 22 August 1912, Sergei I. Shchukin, Moscow; 1918, First Museum of Modern Western Painting, Moscow; 1923, Museum of Modern Western Art, Moscow; 1934, State Hermitage Museum, Leningrad.

EXHIBITIONS

Moscow/Leningrad 1969, 68–69, no. 40, ill. no. 40; Paris 1970, 79, no. 115, ill. 188; Barcelona 1988, 35, 197–198, no. 16, ill. (color) 139.

LITERATURE

Shchukin 1913, no. 119; Tugendhold 1914, 26, 42; Tugendhold 1923, 72; Museum of Modern Western Art 1928, no. 337; Réau 1929, 118, no. 951, cat. 337; Fry 1935, ill. pl. 22; Cahiers d'art 1950, 343, no. 337; Barr 1951, 144, 154, 155, 246, 537, 555, ill. 378; Escholier 1956a, 710, 711; Sterling 1957, 184–185; Hermitage 1958, 414; French Masters 1970, no. 33; Giraudy 1971, 13; Luzi 1971, ill. 93; Izerghina 1975, ill. (color) no. 169; Hermitage 1976, 279; Izerghina 1978, 20, 166, 167, ill. (color) cat. 41, ill. (b/w) 166, 167; Flam 1982, 78; Schneider 1982, no. 161; Kean 1983, 223, 296, 298; Schneider 1984b, 460, 462, 466–467; Flam 1986, 349, 352, 500, ill. fig. 353; Kostenevich 1989, 492, ill. (color) no. 210.

9 *Zorah en jaune*

PROVENANCE

24 September 1912, Galerie Bernheim-Jeune, Paris; by early November 1912, Mr. Butler, Shrivenham, England; Hon. James Smith Collection, London; 1946, Leicester Galleries, London; M. Knoedler & Co., New York; 1949, Mr. and Mrs. Alfred Cowles, Lake Forest, Illinois; Private collection, New York.

EXHIBITIONS

Exhibition of Twentieth-Century French Paintings and Drawings, Council for the Encouragement of Music and the Arts, London, 1943–1944, no. 28; *French Painting 1847–1947*, Wilmington Society of Fine Arts, Delaware, 1948; New York 1951, no. 31; *Treasures of Chicago Collections*, Art Institute of Chicago, 1961; Los Angeles 1966, 186, no. 32, ill. (color) 62; London 1968, no. 46, ill. 163.

LITERATURE

Barr 1951, 159, 540, ill. 379; Matisse 1954, 151, ill. (color) 101; Georges Duthuit, *Matisse, Period Fauve*, Paris, 1956, pl. 15; Escholier 1956a, 711; Selz 1964, ill. (color) 32; Guichard-Meili 1967, ill. 74; Luzi 1971, ill. 93; Izerghina 1978, 166, ill. 173; Schneider 1982, no. 164; Flam 1986, 327, 337, 343, fig. 334.

10 *Zorah assise*

PROVENANCE

Private collection, New York.

EXHIBITIONS

Baltimore 1971, 60, no. 20, ill. 61; Marseilles 1974, no. 15, ill. no. 15; Paris 1975, 90, no. 43, ill. 90; London 1984a, 257, no. 25, ill. 155.

LITERATURE

Izerghina 1978, ill. 173; Schneider 1984b, ill. 470; Flam 1986, 327, 499.

11 *La Marocaine*

PROVENANCE

Private collection.

12 *Paysage vu d'une fenêtre*

PROVENANCE

By April 1913, Ivan A. Morosov, Moscow; 1918, First Museum of Modern Western Painting, Moscow; 1923, Museum of Modern Western Art, Moscow; 1948, State Pushkin Museum of Fine Arts, Moscow.

EXHIBITIONS

Paris 1913, no. 6, as "Paysage vu d'une fenêtre"; Berlin 1913a; Moscow 1939, 39; Moscow 1955, 45; Leningrad 1956, 38; *XXI Biennale*, Venice 1962, no. 16; London 1968, 163, no. 47, ill. (color) 20; Moscow/ Leningrad 1969, 69, 129, 136, no. 43, ill. no. 43; Paris 1970, 79, no. 116A, ill. 188; *French Painting of the 19th and 20th Centuries from the Pushkin Museum in Moscow*, Museum of Western Art, Kiev, 1974 *hors catalogue*; Lille 1986, 64, no. 15; *Masterpieces of Painting from the Pushkin Museum*, Novosibirsk Irkutsk, Krasnoiark, 1987, 20.

LITERATURE

Sembat 1920a, 49; Purrmann 1920, 189; Faure 1923, no. 6; M. Osborn, "Die Junge Kunst in den russischen Museen und Sammlung, *Der Cicerone* (September 1924), no. 19, 5, 901; Ternovetz 1925, 484, no. 12; Museum of Modern Western Art 1928, no. 353; Réau 1929, no. 965; Ternovetz 1933, 61, 65, no. 1; Romm 1935, 63; Romm 1937, 54, 65; Barr 1951, 144, 145, 147, 154, 155, 156, 157, 159; Diehl 1954, 69, 117; Pushkin 1957, 89; Sterling 1957, 185, 186; Matisse 1958, ill. 106; Lassaigne 1959, 78; Pushkin 1961, 121; N. Volkow, *Tsvet v yívopisi* (Color in Painting) (Moscow, 1965), 114, 115; Alpatov 1973, 76–77, ill. (color) no. 24; T. A. Sedova, *Frantsuzkaya yívopis konstá XIX-nachala XX veka V sobranii Gosuclarstvennogo musea isobrasítel'nj ímeni A. S. Pushkino* (French Painting from the End of the 19th to

fig. 141. Henri Matisse, sketch from letter of 19 April 1913 to Morosov

20th Centuries in the Pushkin Museum Collection), 1970, 118, no. 44; Luzi 1971, ill. 93; Irina Antonova, *Die Gemäldegalerie des Pushkin-Museums in Moskau* (Leipzig, 1977), no. 140; Watkins 1977, 9, ill. 20; Izerghina 1978, 20–21, 171–172, ill. (color) no. 44, ill. (b/w) 171; Guéorguievskaya-Kouznetsova 1980, 372, no. 234; Antonova 1981, no. 129; Flam 1982, 78, ill. (color) 77; Schneider 1982, 93, no. 158; Schneider 1984b, 492, ill. (color) 460; Flam 1986, 325–327, 349, 360, 362, 441, 500, fig. (color) 328; Pushkin 1986, 116.

13 *Sur la terrasse*

PROVENANCE

By April 1913, Ivan A. Morosov, Moscow; 1918, First Museum of Modern Western Painting, Moscow; 1923, Museum of Modern Western Art, Moscow; 1948, State Pushkin Museum of Fine Arts, Moscow.

EXHIBITIONS

Paris 1913, no. 7, as "Sur la terrasse"; Berlin 1913a; Moscow 1939, 81; Moscow/Leningrad 1969, 69, 129, 136, no. 44, ill. no. 44; Paris 1970, 79, no. 116b, ill. 189; Lille 1986, 65, no. 116.

LITERATURE

Faure 1923, no. 6; Ternovetz 1925, 484; Museum of Modern Western Art 1928, 69, no. 354; Réau 1929, 119, no. 966; Zervos 1931, 256; Ternovetz 1933, 61, 65, no. 1; Barnes 1933, 197, 262, no. 54; Romm 1935, 45, 63; Fry 1935, no. 24; Romm 1937, 45, 64; Cassou 1939, 9; Barr 1951, 145, 147, 154, 159, 203; Diehl 1954, 62, 117, ill. 61; Sterling 1957, 185, 186; Matisse 1958, 106, 107; Lassaigne 1959, 78, ill. 80a; Pushkin 1961, 121; Luzi 1971, ill. 93; Orienti 1971, 33; G. A. Borovaya, *Musei isobrasitel'nij iskustv inn A. S. Pushkina. Moscow. Frantsuzska yivopis' 20-go veka* (Pushkin Museum of Fine Arts, Moscow. 20th-Century French Painting) (Leningrad, 1972), no. 23; Jacobus 1972, 136; Alpatow 1973, 75, ill. (color) no. 22; Irina Antonova, *Die Gemäldegalerie des Pushkin-Museums in Moskau* (Leipzig, 1977), no. 137; Izerghina 1978, 21, 173, ill. (color) no. 45, ill. (b/w) 173; Guéorguievskaya-Kouznetsova 1980, 235, 373; Antonova 1981, 131, no. 130; Flam 1982, 78, ill. (color) 78; Schneider 1982, 93, no. 165; Schneider 1984b, 420, 462, 467, ill. (color) 461; Flam 1986, 349, 355, 360, 362, 365, 441, 500, (color) fig. 354; Pushkin 1986, 116.

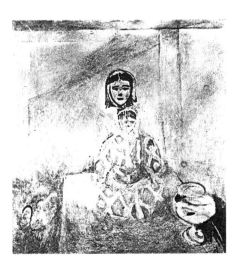

fig. 142. X-ray photograph of *Sur la terrasse*

14 *Porte de la Casbah*

PROVENANCE

By April 1913, Ivan A. Morosov, Moscow; 1918, First Museum of Modern Western Painting, Moscow; 1923, State Pushkin Museum of Fine Arts, Moscow; 1948, State Hermitage Museum, Leningrad; 1968, State Pushkin Museum of Fine Arts, Moscow.

EXHIBITIONS

Paris 1913, no. 8, as "Porte de la casbah"; Berlin 1913a; Leningrad 1956, 38; Moscow/Leningrad 1969, 69, 129, 136, ill. no. 45; Paris 1970, 79, no. 116c, ill. 189; Tokyo 1981, no. 34; Lille 1986, 65, no. 17.

LITERATURE

Faure 1923, no. 6; Ternovetz 1925, 484; Museum of Modern Western Art 1928, 69, no. 355; Réau 1929, 119, no. 967; Zervos 1931, 245; Ternovetz 1933, 61, 65, no. 1; Barnes 1933, 262, no. 54; Romm 1935, 45; Fry 1935, no. 24; Barr 1951, 145, 154, 156, 159; Diehl 1954, 69, 117; Sterling 1957, 185, 186; Lassaigne 1959, 78, ill. 80b; Luzi 1971, ill. 93; Orienti 1971, 31, ill. 12; Izerghina 1978, 21, 174, ill. (b/w), ill. (color) no. 46, ill. (b/w) 174; Guéorguievskaya-Kouznetsova 1980, 391, no. 236, no. 374; Flam 1982, 78, ill. (color) 79; Schneider 1982, no. 160, 93; Schneider 1984b, 462, 492, ill. (color) 461; Flam 1986, 327, 349, 360, 441, fig. (color) 331; Pushkin 1986, 116.

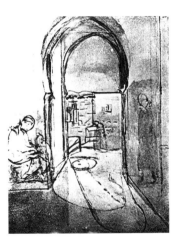

fig. 143. X-ray photograph of *Porte de la Casbah*

15 *La mulâtresse Fatma*

PROVENANCE

20 March 1913, Galerie Bernheim-Jeune, Paris; probably 1916, Josef Müller, Solothurn; Private collection.

EXHIBITIONS

Paris 1913, no. 3, as "La mulâtresse Fatma"; Basel 1931, no. 29; Lucerne 1949, 29, no. 41; Paris 1970, 80, no. 118; Zurich 1982, no. 36 (Zurich only), ill. (color) no. 36, n.p.

LITERATURE

Sembat 1913, 194; Barr 1951, 144, 145, 147, 154, 155, ill. 378; Escholier 1956a, 710; Luzi 1971, ill. 93; Izerghina 1978, 20, 166, 167, ill. 166; Schneider 1982, no. 179; Schneider 1984b, 460, 462, 466, 467, ill. (color) 467; Washington 1986, 266a, not in exhibition; Flam 1986, 349, 355, 500, ill. 352.

16 *Zorah debout*

PROVENANCE

By April 1913, Sergei I. Shchukin, Moscow; 1918, First Museum of Modern Western Painting, Moscow; 1923, Museum of Modern Western Art, Moscow; 1948, State Pushkin Museum of Fine Arts, Moscow; 1968, State Hermitage Museum, Leningrad.

EXHIBITIONS

Paris 1913, no. 9, as "Zorah"; Berlin 1913a (?); Bordeaux 1965, 87, no. 92; Paris 1965, 223, no. 89, ill. 222; Moscow/Leningrad 1969, 68, no. 39, ill. no. 39; Kyoto 1979, no. 33; Lugano 1987, no. 34; Barcelona 1988, 35, 198–199, no. 17, ill. (color) 141.

LITERATURE

Shchukin 1913, no. 127; Tugendhold 1914, 26, 42; Tugendhold 1923, 72; Museum of Modern Western Painting 1928, no. 338; Réau 1929, 118, no. 952, cat. 338; Zervos 1931a, 28; Zervos 1931b, 26; Romm 1935, ill. 47; Romm 1937, frontispiece (color); Cahiers d'art 1950, 343, no. 338; Barr 1951, 144, 145, 154, 155, 157, 159, 246, ill. 378; Diehl 1954, pl. 65; Escholier 1956a, 710, ill. 706; Sterling 1957, 184, 185, ill. fig. 56 on back endpapers; Lassaigne 1959, 78, ill. 78; Pushkin 1961, 121, no. 3304; Guichard-Meili 1967, 72, 80, ill. (color); Alpatow 1969, 75, pl. (color) 23; Giraudy 1971, 13; Luzi 1971, 93, ill. 93; Izerghina 1975, ill. (color) no. 170; Hermitage 1976, 279; Izerghina 1978, 20, 166, 167, ill. (b/w) 166, ill. (color) no. 40; Gowing 1979, ill. 119; Schneider 1982, no. 163; Schneider 1984b, 460, 462, 466, 467; Flam 1986, 327, 349, 386, 500, fig. 333 (color); Kostenevich 1989, 493, ill. (color) no. 211.

17 *La petite mulâtresse*

PROVENANCE

November 1912, Marcel Sembat, Paris; 1923, Museé de Grenoble (Legs Agutte-Sembat).

EXHIBITIONS

Paris 1913, no. 4, as "La mulâtresse Fatma"; "Nouvelles salles au Musée de Grenoble," *Bulletin de la vie artistique* 19 (1 October 1924), 441; *Les chefs d'oeuvre du Musée de Grenoble*, Petit Palais, Paris, 1935, 131, no. 257; *Exposition du Musée et de la Bibliothèque de Grenoble*, Kunsthaus Zurich, 1946, no. 158; Paris 1956, 22, no. 34; *Matisse et ses élèves allemands*, Château de Kaiserlautern, 1988.

LITERATURE

Zervos 1931a, 271; Zervos 1931b, ill. 51; Barr 1951, 155, 159, 540, ill. 387; Escholier 1956a, 711; Marchiori 1967, 59, ill. (color) 59; Guichard-Meili 1967, 75; Lévêque 1968, ill. (color) 26; Courthion 1970, ill. (color) 60; Luzi 1971, ill. 93; Fourcade 1975, 20, 39, ill. (color) 20; Izerghina 1978, ill. 167; Schneider 1982, no. 162.

18 *Le rifain debout*

PROVENANCE

By April 1913, Sergei I. Shchukin, Moscow; 1918, First Museum of Modern Western Painting, Moscow; 1923, Museum of Modern Western Art, Moscow; 1948, State Hermitage Museum, Leningrad.

EXHIBITIONS

Paris 1913, no. 5, as "Le rifain debout"; Berlin 1913a (?); Bordeaux 1965, 86, no. 91, pl. 30; Paris 1965, 227, no. 91, ill. 226; London 1968, 30, no. 48, ill. (color) 21; Moscow/Leningrad 1969, 69–70, no. 46, ill. no. 46; Prague 1969, no. 14; Lugano 1983, 92, no. 30, ill. (color) 93; Quebec 1986, no. 30; Washington 1986b, 98, no. 30, ill. (color) 99; Lugano 1987, no. 30; Barcelona 1988, 35, 202–203, no. 23, ill. (color) 151.

LITERATURE

Sembat 1913, 194; Shchukin 1913, no. 126; Tugendhold 1914, 42; Sembat 1920a, 10, ill. 51; Sembat 1920b, 194; Museum of Modern Western Art 1928, no. 336; Réau 1929, 118, no. 950, cat. 336; Zervos 1931a, 28; Zervos 1931b, 26; Fry 1935, pl. 23; Romm 1935, 48, 54; Escholier 1937, 116, 123, ill. 25; Cassou 1939, n.p; Cahiers d'art 1950, 343, no. 336; Barr 1951, 145, 155, 159, ill. 390; Diehl 1954, 62, 140; Escholier 1956a, 708; Sterling 1957, 186, fig. 54 on back endpapers; Hermitage 1958, 414; Lassaigne 1959, 78, ill. 82; Paris 1965, 227, ill. 226; Jean Leymarie, "Evoluzione di Matisse," *L'Arte moderna* 10, no. 83 (1967), 49; Marchiori 1967, 53, ill. 53; Alpatow 1969, 76, pl. 25; Courthion 1970, ill. 54; French Masters 1970, 35; Aragon 1971, 1:301, ill. (color) 327; Luzi 1971, ill. 93; Izerghina 1975, ill. (color) no. 171; Hermitage 1976, 279; Izerghina 1978, 20, 175, ill. (color) cat. 47, ill. 175; Gowing 1979, 121, ill. 119; Schneider 1982, no. 178; Schneider 1984b, 460, 466, 467, ill. (color) 458; Flam 1986, 355, fig. 356; Kostenevich 1989, 492, ill. (color detail) no. 208, ill. (color) 209.

19 *Le rifain assis*

PROVENANCE

By 1920, Christian Tetzen-Lund, Copenhagen; around 1924, Barnes Foundation, Merion, Pennsylvania.

EXHIBITIONS

Paris 1913, no. 1, as "Le rifain assis"; Copenhagen 1924, 14, no. 41.

LITERATURE

Sembat 1913, 194; Sembat 1920a, 10; Sembat 1920b, 194; Zervos 1931a, 28; Zervos 1931b, 26; Barnes 1933, 387–389, ill. 266; Cassou 1939, n.p; Swane 1944, 94, 96, ill. fig. 22; Matisse 1954, ill. 25; Escholier 1956a, 708, 710, 711, ill. 708; Aragon 1971, 1:301; Barr 1951, 145, 155, 159, ill. 391; Diehl 1954, 62, 139–140, pl. 64; Guichard-Meili 1967, ill. 76; Sterling 1957, 186; Luzi 1971, ill. 93; Izerghina 1978, 175, ill. 175; Schneider 1982, no. 177; Schneider 1984b, 403, 467, ill. 400; Flam 1986, 355, 357, 360, ill. fig. 357; Flam 1988, 150.

20 Arums

PROVENANCE

By April 1913. Sergei I. Shchukin, Moscow; 1918, First Museum of Modern Western Painting, Moscow; 1923, Museum of Modern Western Art, Moscow; 1934, State Hermitage Museum, Leningrad.

EXHIBITIONS

Paris 1913, no. 11, as ''Arums''; Berlin 1913a (?); Moscow/Leningrad 1969, 70, no. 47, ill. no. 47; Lugano 1983, no. 32; Washington 1986b, 102, no. 32, ill. (color) 103; Quebec 1986, no. 32.

LITERATURE

Shchukin 1913, no. 128; Tugendhold 1914, 42; Schacht 1922, ill. 68; Museum of Modern Western Art 1928, no. 335; Réau 1929, 118, no. 949, cat. 335; Zervos 1931a, ill. n.p; Cahiers d'art 1950, 343, no. 335; Sterling 1957, 186, ill. fig. 62 on back endpapers; Hermitage 1958, 414; Izerghina 1975, ill. (color) no. 172; Hermitage 1976, 279; Izerghina 1978, 20, 176, ill. (color) no. 48, ill. (b/w) 176; Schneider 1984b, 462–463, ill. (color) 468; Kostenevich 1989, 493, ill. (color) no. 213.

21 Arums, iris et mimosas

PROVENANCE

By April 1913, Sergei I. Shchukin, Moscow; 1918, First Museum of Modern Western Painting, Moscow; 1923, Museum of Modern Western Art, Moscow; 1948, State Pushkin Museum of Fine Arts, Moscow.

EXHIBITIONS

Paris 1913, no. 10, as ''Arums, iris et mimosas''; Berlin 1913a; French Art of the 15th–20th Centuries, State Pushkin Museum of Fine Arts, Moscow, 1955; French Art of the 12th–20th Centuries, State Hermitage Museum, Leningrad, 1956, 39; Moscow/Leningrad 1969, no. 48; Prague 1969, no. 13, ill. cover.

LITERATURE

Shchukin 1913, no. 125; Tugendhold 1914, 42; Museum of Modern Western Art 1928; Réau 1929, no. 948; Barr 1951, 159, 206, 215, pl. 389; Diehl 1954, 69; Pushkin 1957, 89; Sterling 1957, 186; Pushkin 1961, 121; Schneider 1984b, 463, ill. (color) 469.

22 Fenêtre ouverte à Tanger

PROVENANCE

Private collection, France; Private collection.

EXHIBITIONS

Aix-en-Provence 1960, no. 11; New York 1966, no. 25, ill. 34; Los Angeles 1966, no. 34, 186, ill. 64; London 1968, no. 49, ill. 89; Paris 1970, 80, no. 119, ill. 190.

LITERATURE

Schneider 1970, ill. 93; Luzi 1971, ill. 93; Izerghina 1978, ill. 171; Schneider 1982, no. 181; Schneider 1984b, ill. (color) 465; Flam 1986, ill. (color) fig. 358.

23 Café marocain

PROVENANCE

By mid-September 1913, Sergei I. Shchukin, Moscow; 1918, First Museum of Modern Western Painting, Moscow; 1923, Museum of Modern Western Art, Moscow; 1948, State Hermitage Museum, Leningrad.

EXHIBITIONS

Paris 1913, no. 2, as ''Café marocain''; Moscow/Leningrad 1969, 70, no. 49, ill. (color) no. 49.

LITERATURE

Apollinaire 1913, 306; Sembat 1913, 191–193, 194; Shchukin 1913, no. 233; Tugendhold 1914, 26; Faure 1920, ill. no. 14; Sembat 1920a, 10; Sembat 1920b, 194; Schacht 1922, ill. 66; Tugendhold 1923, 72, 74; Ternovetz 1925, 484; Museum of Modern Western Art 1928, no. 340; Réau 1929, 118, no. 953, cat. 340; Zervos 1931a, 28; Zervos 1931b, 26; Romm 1935, 42; Escholier 1937, 116; Grünewald 1944, ill. 36; Cahiers d'art 1950, 343, no. 340; Barr 1951, 145, 147, 155, 160, 164, 209, ill. 388; Diehl 1954, 62, 65; Sterling 1957, 186; Hermitage 1958, 414; Courthion 1970, ill. 52; I. Nogid, ''Restoration of Matisse's Painting Arab Café,'' Papers of the All-Union Central Research Laboratory for Conservation and Restoration (in Russian), Moscow, 1970, 169–176; Giraudy 1971, 16; Luzi 1971, ill. 93; Izerghina 1975, ill. (color) no. 174; Reff 1975, 113, ill. 113; Hermitage 1976, 279; New York 1978, 110, ill. 209 (not in exhibition); Izerghina 1978, 20, 22, 178–179, ill. (color) cat. 50, ill. (b/w) 178; Flam 1982, 78, 84, ill. (color) 82–83; Schneider 1982, no. 180; Kostenevich 1984, 238–239, ill. 239; Schneider 1984b, 103, 119, 183, 270, 284, 303, 307, 344, 350, 352, 373, 381, 420–421, 448, 462, 467–473, 488–489, ill. (color) 471; Flam 1986, 327, 350–351, 355, 360, 362, 365, 411, 500, fig. 355 (color); Flam 1988, 148–149, ill. (b/w) 133, ill. (color) 162; Kostenevich 1989, 493–494, ill. (color) no. 214.

24 Les Marocains

PROVENANCE

1916–1952, Collection Henri Matisse; May 1952, Mr. and Mrs. Samuel A. Marx, Chicago, promised gift to Museum of Modern Art, New York; 1955, Museum of Modern Art, New York.

EXHIBITIONS

New York 1927; New York 1931, no. 31, ill. 83; Paris 1937, no. 60 (dated 1915); Avignon 1947, no. 122, as Les Marocains sur la Terrasse, 1915; Philadelphia 1948, no. 33, ill; Lucerne 1949, no. 47, ill. pl. V; Venice 1950, no. 32; Hamburg 1951, no. 14, ill. 83, fig. 31; New York 1951, no. 41; New York 1955, 15; Paris 1956, no. 39, ill. pl. XVI; Washington 1963, ill. (color) pl. 25; New York 1965, ill. (color) 15, ill. (color) cover; London 1968, no. 66, ill. (color) 33; Paris 1970, no. 144, as Les Marocains or Les Marocains sur la Terrasse, ill. 213; New York 1978, 10, 12, 92, 110–113, 209, ill. (color) cover and 111, 210; Paris 1980.

LITERATURE

Einstein 1926, 635, no. 244, ill. 244; Fry 1928, in Lazzaro 1970, 17; Fels 1929, no. 13, ill.; Barr 1931, 48, ill. 83, fig. 31; Zervos 1931a, 56; Zervos 1931b, 56–58; Schapiro 1932, 7; Barnes 1933, 156, 437; Fry 1935, n.p., ill. pl. 26; Escholier 1937, 123–124; Cassou 1939, n.p; Severini 1944,

fig. 144. Henri Matisse, sketch from letter of 22 November 1915 to Camoin. Archives Charles Camoin

, fig. 145. Composite of x-rays of *Les Marocains*

11; Hess 1948, 57, ill. 19; Landholt 1949, 13, 29, ill. pl. V; Pallucchini 1950, ill. no. 20; Raynal 1950, 16, 49–50, 140, ill. (color) 49; Barr 1951a, 173, 190–192, 200, 222, ill. (color) 172; Barr 1951b, 6, 10, ill. 25; Trapp 1951, 215–217 as *Moroccans at Prayer*, ill. fig. 169; Tériade 1952, 47; Diehl 1954, 65–66, 154, 241, no. 75, ill. color pl. 75; Duthuit 1956, 25; Escholier 1956a, 707, 711–712; Escholier 1956b, 106, 109; Hunter 1956, n.p., ill. (color) no. 13; Lassaigne 1959, 83, ill. (color) 85; Escholier 1960, 92, 95; Mannering 1962, 52–53; Barr 1963, 7, ill. (color) pl. 25; Selz 1964, 47–48; Barr 1965, 7, 14, ill. (color) 15, ill. (color) cover; Leymarie 1966, 14–15; Fiala 1967, 47; Guichard-Meili 1967, 86–87, 231, 247, 249, ill. (color) 84, no. 72; Gordon 1968, ill. 187, fig. 4; Gowing 1968, 30, 34, 164, ill. (color) 33; Melville 1968, 294, ill. fig. 5; Russell 1969, 90, 122, 129, ill. (color) 90–91; Finsen 1970, n.p; Guichard-Meili in Lazzaro 1970, 63; Leymarie in Lazzaro 1970, 26; Marchiori 1970, 8; Millard 1970, 543–544; William S. Rubin, *Frank Stella*. Exh. cat. The Museum of Modern Art. New York, 1970, 146, 149; Schneider 1970a, 38, 85, ill. 213, no. 144; Schneider 1970b, 94; Aragon 1971, 1:301, 351, ill. (color) 335–336, pl. XLIX, 2:35; Flam 1971, 356–357, ill. 358, fig. 12; Giraudy 1971, 16, 18–19; Luzi 1971, 11, 94, ill. (color) pls. XL–XLI, ill. 95, fig. 199; Pleynet 1971, 80, 84; Fourcade 1972, 12, 117, 117n, 119n, 203; Fry 1972, 407; Flam 1973, 107, 133; Franc 1973, 116, ill. (color); Jacobus 1973, 32, 33, 148, ill. (color) pl. 32, opp. 148; Kramer 1973, 181–182; Toshio Nishimura ed. *Les grands maîtres de la peinture moderne, no. 15: Matisse*, 1973, 103, ill. (color) pl. 14; Fourcade 1974, 468; Lebensztejn 1974, 401; Ashton 1975, ill. 70; Linker 1975, 78, ill. (color) 77; Russell 1975, 10–11, ill. 10, fig. 18; Barr 1977, 640, no. 55, 567, ill. p. 55; New York 1977, 63; Elderfield 1978, 16, ill. p. 18, fig. 16; Golding 1978, 12–13; Bioulès 1979, 10, ill. as *Praying Moroccans*; Gowing 1979, 128, 209, ill. 128, no. 112; Hooper 1981, 70, 74, 88–89, ill. (color) 125; National Museum of Modern Art 1981, ill. fig. 23; Russell 1981, 264, ill. 263; Zurich 1982, 36, 38, 71–72 (not in exhibition); Flam 1982, 78, 86, ill. (color) 86; Rose 1982, 20–21, ill. 20; Rosenthal 1982, 151, 154, ill. 152, fig. 148; Schneider 1982, 9, 83, ill. (color) pls. XL–XLI, ill. 95, no. 199; Hunter 1984, 27, 75, ill. (color) 74, no. 51; Schneider 1984b, 85, no. 144, 391, 464, 473, 476–477, 488–489, ill. (color) 476–477; London 1984b, 212 (not in exhibition); Washington 1984, 190 (not in exhibition); London 1984a, 128 (not in exhibition); Watkins 1985, 118, 127, 130–131, 134, 138–139, fig. 116; Flam 1986, 8, 327, 366, 405, 408, 410–411, 414–417, 419, 504–505, (color) fig. 418; Nice 1986, 54, ill. opp. 54 (not in exhibition); Tono 1986, 35, 98, ill. (color) 34–35, pl. 30; Guillaud 1987, 71, 638, ill. (color) fig. 61; Flam 1988, 17, 178, ill. 186, pl. 57; Kostenevich 1988, 240, 461; Museum of Modern Art 1988, 78; Jedlicka n.d., ill.

fig. 146. Composite of infrared photographs of right central section of *Les Marocains*

fig. 147. Composite of infrared photographs of left central section of *Les Marocains*

Select Bibliography

Matisse's Moroccan Period

Aix-en-Provence 1960
Matisse. Exh. cat. Pavillon de Vendôme.

Alpatow 1973
Alpatow, Michael W. *Henri Matisse*. Dresden, 1973. Translated from the Russian (1969).

Antonova 1981
Antonova, Irina Aleksandrovna. *Muzei isobrazitel' nykh iskusstv imeni. A.S. Pushkina* (Pushkin Museum of Fine Arts). Moscow, 1981.

Apollinaire 1913
Apollinaire, Guillaume. "Henri Matisse." *L'Intransigeant* (17 April 1913), translated in *Apollinaire on Art: Essays and Reviews 1902–1918*. New York, 1972, 306.

Aragon 1971
Aragon, Louis. *Henri Matisse, roman*. Paris, 1971, 2 vols.

Art Digest 1936
"20 Paintings by Matisse Create a Sea of Decorative Color." *Art Digest* 11 (1 December 1936), 7.

Ashton 1975
Ashton, Dore. "Matisse and Symbolism." *Arts* 49 (May 1975), 70–71.

Avignon 1947
Exposition de Peintures et Sculptures Contemporaines. Exh. cat. Palais des Papes.

Baltimore 1971
Matisse as a Draftsman. Exh. cat. Baltimore Museum of Art.

Barcelona 1988
Henri Matisse: Pituras y dibujos de los Museos Pushkin de Moscú y el Ermitage de Leningrad. Exh. cat. Museu Picasso.

Barnes 1933
Barnes, Albert C., and Violette de Mazia. *The Art of Henri-Matisse*. New York and London, 1933.

Barr 1951
Barr, Alfred H., Jr. *Matisse: His Art and His Public*. New York, 1951.

Barr 1977
Barr, Alfred H., Jr. *Painting and Sculpture in The Museum of Modern Art 1929–1967: An Illustrated Catalog and Chronicle*. New York, 1977.

Basel 1931
Henri-Matisse. Exh. cat. Kunsthalle Basel.

Benjamin 1987
Benjamin, Roger. *Matisse's "Notes of a Painter": Criticism, Theory, and Context, 1891–1908*. Ann Arbor, Michigan, 1987.

Berlin 1913a
Henri Matisse. Exh. cat. Kunst-Salon Fritz Gurlitt, May.

Berlin 1913b
Kollektionen: Henri Matisse, Franz Heckendorf, E. L. Kirchner, Georg Leschnitzer. Exh. cat. Kunst-Salon Fritz Gurlitt, November.

Besson 1945
Besson, George. *Matisse*. Paris, 1945.

Bioulès 1979
Bioulès, Vincent. "Matisse." *Flash Art* 88–89 (March–April 1979), 10–11.

Bordeaux 1965
Chefs-d'oeuvre de la peinture française dans les musées de l'Ermitage et de Moscou. Exh. cat. Musée des Beaux-Arts de Bordeaux.

Braune 1920
Braune, Heinz. "Zu einem Gemälde von Henri Matisse." *Genius 2*, part 2 (1920), 197–198.

Brussels 1952
Matisse. Exh. cat. Grand salle des expositions de "la Reserve."

Cahiers d'Art 1950
"Musée d'Art Moderne Occidental à Moscou." *Cahiers d'Art* 25, no. 2 (1950), 335–348.

Cassou 1939
Cassou, Jean. *Paintings and Drawings of Matisse with a Critical Survey by Jean Cassou*. Paris and New York, 1939, repr. 1948.

Le Cateau-Cambresis 1988
Henri Matisse: Autoportraits. Exh. cat. le Musée Matisse.

Chicago 1927
Catalogue of a Retrospective Exhibition of Paintings by Henri Matisse. Exh. cat. Arts Club of Chicago.

Clair 1970
Clair, Jean. "La tentation de l'Orient." *La Nouvelle Revue Française* 18, no. 211 (1 July 1970), 65–71.

Copenhagen 1924
Henri Matisse. Exh. cat. Nationalmuseum.

Copenhagen 1970
Matisse. Exh. cat. Statens Museum for Kunst.

Courthion 1941
Typescript of nine interviews with Matisse conducted by Pierre Courthion in 1941. Archives of the History of Art, Getty Center for the History of Art and Humanities, Los Angeles.

Courthion 1942
Courthion, Pierre. *Le Visage de Matisse*. Lausanne, 1942.

Courthion 1970
Courthion, Pierre. "La conquête de la lumière." *Hommage à Matisse* numéro spécial (1970), 50–62.

Cowart 1972
Cowart, William John. " 'Ecoliers' to 'Fauves': Matisse, Marquet, and Manguin Drawings, 1890–1906." Ph.D diss., The Johns Hopkins University, Baltimore, 1972.

Dayot 1926
Dayot, Armand. *Catalogue des tableaux et études par James-Wilson Morrice*. Exh. cat. Galeries Simonson. Paris, 1926. Includes letter from Matisse to Dayot about Matisse's acquaintance with Morrice in Morocco.

Diehl 1954
Diehl, Gaston. *Henri Matisse*. Paris, 1954.

Dresden 1976
Meisterwerke aus dem Puschkin-Museum, Moscau, und aus der Ermitage, Leningrad. Exh. cat. Albertinum.

Duthuit 1956
Duthuit, Georges. "The Material and Spiritual Worlds of Henri Matisse." *Art News* 55 (October 1956), 22–25, 67.

Duthuit-Matisse 1983
Duthuit-Matisse, Marguerite, and Claude Duthuit. *Henri Matisse: Catalogue raisonné de l'oeuvre gravé établi avec la collaboration de Françoise Garnaud.* 2 vols. Paris, 1983.

Einstein 1926
Einstein, Carl. *Die Kunst des 20. Jahrhunderts.* Berlin, 1926.

Elderfield 1978
Elderfield, John. *The Cut-outs of Henri Matisse.* New York, 1978.

Escholier 1937
Escholier, Raymond. *Henri Matisse.* Paris, 1937.

Escholier 1956a
Escholier, Raymond. "Matisse et Le Maroc." *Le Jardin des Arts* 24 (October 1956), 705–712.

Escholier 1956b
Escholier, Raymond. *Matisse, ce vivant.* Paris, 1956.

Escholier 1960
Escholier, Raymond. *Matisse from the Life.* London, 1960.

Faure 1920 and 1923
Faure, Elie, and others. *Henri-Matisse.* Paris, 1920, reprinted with additional illustrations in 1923.

Fels 1929
Fels, Florent. *Henri-Matisse.* Paris, 1929.

Fiala 1967
Fiala, Vlastimil. *Henri Matisse.* Bratislava, Czechoslovakia, 1967.

Flam 1971
Flam, Jack D. "Matisse's *Backs* and the Development of His Painting." *Art Journal* 30 (Summer 1971), 352–361.

Flam 1973
Flam, Jack D., ed. *Matisse on Art.* London, 1973.

Flam 1982
Flam, Jack D. "Matisse in Morocco." *Connoisseur* 211 (August 1982), 74–86.

Flam 1986
Flam, Jack. *Matisse: The Man and His Art 1869–1918.* Ithaca and London, 1986.

Flam 1988
Flam, Jack, ed. *Matisse: A Retrospective.* New York, 1988.

Fourcade 1972
Fourcade, Dominique, ed. *Henri Matisse: Ecrits et propos sur l'art.* Paris, 1972.

Fourcade 1974
Fourcade, Dominique. "Rêver à trois aubergines." *Critique* 324 (May 1974), 467–489.

Fourcade 1975
Fourcade, Dominique. *Matisse au Musée de Grenoble.* Grenoble, 1975.

Franc 1973
Franc, Helen M. *An Invitation to See 125 Paintings from The Museum of Modern Art.* New York, 1973; reprinted 1985.

French Masters 1970
French 20th-Century Masters. Introduction by A. N. Izerghina. Notes by A. G. Barskaya, A. N. Izerghina, V. A. Zernov. Prague, 1970.

Fry 1935
Fry, Roger. *Henri-Matisse.* New York, 1935.

Fry 1972
Fry, Roger. *Letters of Roger Fry,* vol. 2. Ed. Denys Sutton. New York, 1972.

Ginsburg 1973
Ginsburg, Michael. "Art Collectors of Old Russia: The Morosovs and Shchukins." *Apollo* 98 (December 1973), 470–485.

Giraudy 1971
Giraudy, Danièle. "Correspondance Henri Matisse–Charles Camoin." *Revue de l'Art* 12 (1971), 7–34.

Golding 1978
Golding, John. *Matisse and Cubism.* Glasgow, 1978.

Gordon 1968
Gordon, Alastair. "Art in the Modern Manner." *Connoisseur* 168 (July 1968), 186–188.

Gordon 1974
Gordon, Donald E. *Modern Art Exhibitions 1900–1916.* Munich, 1974, 2 vols.

Gowing 1979
Gowing, Lawrence. *Matisse.* New York and Toronto, 1979.

Grautoff 1919
Grautoff, Otto. "Die Sammlung Serge Stschoukine in Moskau." *Kunst und Künstler* 17 (November 1919), 83–97.

Grünewald 1944
Grünewald, Isaac. *Matisse och expressionismen.* Stockholm, 1944.

Guéorguievskaya-Kouznetsova 1980
Guéorguievskaya, E., and I. Kouznetsova. *La peinture française au Musée Pouchkine.* Leningrad, 1980.

Guichard-Meili 1967
Guichard-Meili, Jean. *Henri Matisse: Son oeuvre—son univers.* Paris, 1967.

Guichard-Meili 1970
Guichard-Meili, Jean. "The Odalisques." *Homage to Henri Matisse.* Paris and New York, 1970.

Guillaud 1987
Guillaud, Jacqueline and Maurice. *Matisse: Le rythme et la ligne.* Paris and New York, 1987.

Haas 1986
Haas, Karen E. "Henri Matisse: 'A Magnificent Draughtsman.'" *Fenway Court 1985* (1986), 36–47.

Hamburg 1951
Henri Matisse: Gemälde, Skulpturen, Handzeichnungen, Graphik. Exh. cat. Hamburg Kunstverein.

Hermitage 1958
Gosudarstvennyi Ermitazh. Katalog zhivopisi T. 1 (The Hermitage. The Department of Western European Art. Catalogue of Paintings, v. 1). Leningrad-Moscow, 1958.

Hermitage 1976
Gosudarstvennyi Ermitazh. Zapadnevropeiskaya zhivopis'. Katalog T. 1 (Catalogue of the Hermitage. Western Painting). Leningrad, 1976.

Hess 1948
Hess, Thomas B. "Matisse: A Life of Color." *Art News* 47 (April 1948), 16–19, 56–58.

Hilton 1969
Hilton, Alison. "Matisse in Moscow." *Art Journal* 29 (winter 1969/1970), 166–173.

Hooper 1981
Hooper, Mary McCarthy. "Henri Matisse in Morocco: The Winters of 1911–12 and 1912–13." M.A. thesis, Hunter College, The City University of New York, 1981.

Hunter 1956
Hunter, Sam. *The Metropolitan Museum of Art Miniatures: Henri Matisse, 1869–1954*. New York, 1956.

Hunter 1984
Hunter, Sam. Introduction. *The Museum of Modern Art, New York: the History and the Collection*. New York, 1984.

Izerghina 1975
Izerghina, A. *La peinture française seconde moitié du XIXᵉ–début du XXᵉ siècle*. Leningrad, 1975.

Izerghina 1978
Izerghina, A. *Henri Matisse: Paintings and Sculptures in Soviet Museums*. Leningrad, 1978; reprinted 1986.

Jacobus 1973
Jacobus, John. *Henri Matisse*. New York, 1973.

Jedlicka n.d.
Jedlicka, Gotthard. *Henri-Matisse*. Paris, n.d.

Kean 1983
Kean, Beverly Whitney. *All the Empty Palaces*. New York, 1983.

Kiev 1974
French Painting of the 19–20th Centuries from the Pushkin Museum, Moscow. Exh. cat. Museum of Western Art.

Kostenevich 1974
Kostenevich, Albert. "Matiss i masterskaiâ Moro (Matisse in the Moreau Atelier)." *Trudy Gosudarstvennogo Ermitazha*, Leningrad, 1974.

Kostenevich 1984
Kostenevich, Albert. *Frantsuzskoe iskusstvo XIX–nachala XX veka v Ermitazhe. Ocherkputevodítel'* (French Art of the Nineteenth and Twentieth Centuries in the Hermitage). Leningrad, 1984.

Kostenevich 1989
Kostenevich, Albert. *Ot Mone do Pikasso: Frańtsuzskaiâ zhivopis' vtoroĭ poloviny XIX–nachala XX veka v Ermitazhe* (From Monet to Picasso. French Paintings of the Second Half of the Nineteenth to the Early Twentieth Century in the Hermitage). Leningrad, 1989.

Kramer 1973
Kramer, Hilton. *The Age of the Avant-Garde: An Art Chronicle of 1956–1972*. New York, 1973.

Kunstchronik 1913
"Ausstellungen." *Kunstchronik: Wochenschrift für Kunst und Kunstgewerbe*. Neue folge XXIV jahrgang 1912–1913, no. 33 (16 May 1913), 482.

Kyoto 1979
Exhibition of the Works of French Artists of the Late Nineteenth and Early Twentieth Centuries from the Collections of the State Hermitage and the A. S. Pushkin Museum of Fine Arts (in Japanese). Exh. cat.

Larson 1975
Larson, Philip. "Matisse and the Exotic." *Arts Magazine* 49 (May 1975), 72–73.

Lassaigne 1959
Lassaigne, Jacques. *Matisse and His Oeuvre*. Lausanne, 1959.

Lazzaro 1970
Lazzaro, San, and others. *Homage to Henri Matisse*. Paris and New York, 1970.

Lebensztejn 1974
Lebensztejn, Jean-Claude. "Les Textes du Peintre." *Critique* 324 (May 1974), 400–433.

Leningrad 1956
Exhibition of Art from the Nineteenth–Twentieth Centuries. Hermitage Museum, Leningrad, 1956.

Lévêque 1968
Lévêque, Jean-Jacques. *Matisse*. Paris, 1968.

Levy 1920
Levy, Rudolf. "Matisse." *Genius* 2, part 2 (1920), 186–189.

Leymarie 1970
Leymarie, Jean. "The Two Horizons of Henri Matisse." *Homage to Henri Matisse*. New York, 1970.

Lille 1986
Matisse: peintures et dessins du musée pouchkine et du musée l'ermitage. Exh. cat. Musée des Beaux-Arts.

Linker 1975
Linker, Kate. "Matisse and the Language of Signs." *Arts Magazine* 49 (May 1975), 76–78.

London 1968
Matisse. Exh. cat. Hayward Gallery.

London 1984a
The Drawings of Henri Matisse. Exh. cat. Hayward Gallery.

London 1984b
The Orientalists: Delacroix to Matisse, European Painters in North Africa and the Near East. Exh. cat. Royal Academy of Arts.

Los Angeles 1966
Henri Matisse. Exh. cat. University of California at Los Angeles.

Lucerne 1949
Henri Matisse. Exh. cat. Musée des Beaux-Arts.

Lugano 1983
Capolavori impressionisti e postimpressionisti dai musei sovietici. Exh. cat. Collezione Thyssen-Bornemisza, Villa Favorita.

Lugano 1987
Capolavori impressionisti e postimpressionisti dai musei sovietici II. Exh. cat. Collezione Thyssen-Bornemisza, Villa Favorita.

Luzi 1971
Luzi, Mario, and Massimo Carrà, *L'opera di Matisse dalla rivolta "fauve" all'intimismo 1904–1928*. Milan, 1971.

McBride 1930
McBride, Henry. *Matisse*. New York, 1930.

MacChesney 1913
MacChesney, Clara T. "A Talk with Matisse, Leader of Post-Impressionists." *New York Times*, 9 March 1913, 12.

Mannering 1962
Mannering, Douglas. *The Art of Matisse*. London, 1962.

Marchiori 1967
Marchiori, Giuseppe. *Matisse*. New York, 1967.

Marchiori 1970
Marchiori, Giuseppe. "Le Retour de Matisse." *XX^e Siècle* 35 (December 1970), 1–18.

Marseilles 1974
130 dessins de Matisse. Exh. cat. Musée Cantini.

Matisse 1954
Matisse, Henri. *Portraits*. Monte Carlo, 1954.

Matisse 1958
Matiss, Anri. Sbornik statei o tvorchestve (Matisse. A Collection of Articles). Moscow, 1958.

Melville 1968
Melville, Robert. "Matisse." *Architectural Review* 144 (October 1968), 292–294.

Millard 1970
Millard, Charles W. "Matisse in Paris." *Hudson Review* 23 (Autumn 1970), 540–545.

Monod-Fontaine 1979
Monod-Fontaine, Isabelle. *Matisse*. Paris, 1979.

Moscow 1939
Vystavka "Frantsuzskiĭ peĭzazh." (Exhibition of French Landscape Painting from the Nineteenth-Twentieth Centuries). Exh. cat. Museum of Modern Western Art, Moscow, 1939.

Moscow 1955
Vystavka frantsuzskogo iskusstva XIX–XX (Exhibition of French Art from the Nineteenth–Twentieth Centuries). Ed. I. A. Antonova. State Pushkin Museum of Fine Arts, Moscow, 1955.

Moscow/Leningrad 1969
Matiss: Zhivops', skul'ptura, grafika, pis'ma (Matisse: Painting, Sculpture, Graphic Art, Letters). Exh. cat. State Pushkin Museum of Fine Arts, Moscow.

Museum of Modern Art 1977
Painting and Sculpture in The Museum of Modern Art with Selected Works on Paper: Catalog of the Collection January 1, 1977. Ed. Alicia Legg. New York, 1977.

Museum of Modern Art 1988
Painting and Sculpture in the Museum of Modern Art. New York, 1988.

Museum of Modern Western Art 1928
Katalog Gosudarstvennogo museia novogo zapadnogo iuskusstva (Catalogue of the Museum of Modern Western Art). Moscow, 1928.

New York 1927
Henri-Matisse. Exh. cat. Valentine Dudensing Gallery.

New York 1931
Henri-Matisse Retrospective Exhibition. Exh. cat. The Museum of Modern Art.

New York 1936
Twenty Paintings by Henri Matisse. Exh. cat. Valentine Gallery.

New York 1948
Henri-Matisse: Three Decades, 1900–1930. Exh. cat. Bignou Gallery.

New York 1951
Henri Matisse. Exh. cat. The Museum of Modern Art.

New York 1955
Paintings from Private Collections. Exh. cat. The Museum of Modern Art.

New York 1965
The School of Paris: Paintings from the Florene May Schoenborn and Samuel A. Marx Collection. Exh. cat. The Museum of Modern Art.

New York 1966
Henri Matisse: 64 Paintings. Exh. cat. The Museum of Modern Art.

New York 1978
Matisse in the Collection of The Museum of Modern Art. Exh. cat. The Museum of Modern Art.

Nice 1950
Henri Matisse. Exh. cat. Galerie des Ponchettes.

Nice 1986
Matisse photographies. Exh. cat. Musée des Beaux-Arts.

Orienti 1971
Orienti, Sandra. *Matisse*. London, 1971.

Pallucchini 1950
Pallucchini, Rodolfo. *Henri Matisse*. Rome, 1950.

Paris 1913
Exposition Henri-Matisse tableaux du Maroc et sculpture. Exh. cat. Chez MM. Bernheim-Jeune & Cie, 14–19 April.

Paris 1935
Les Chefs-d'oeuvre du Musée de Grenoble. Exh. cat. Petit Palais.

Paris 1937
Origines et développements de l'art international indépendant. Exh. cat. Musée du Jeu de Paume.

Paris 1956
Rétrospective Henri Matisse. Exh. cat. Musée National d'Art Moderne.

Paris 1965
Chefs-d'oeuvre de la peinture française dans les musées de Leningrad et de Moscou. Exh. cat. Musée du Louvre.

Paris 1970
Henri Matisse: Exposition du centenaire. Exh. cat. Grand Palais.

Paris 1975
Henri Matisse: Dessins et sculpture. Exh. cat. Musée National d'Art Moderne.

Paris 1978
De Renoir à Matisse: 22 chefs d'oeuvre des musées soviétiques et français. Exh. cat. Grand Palais.

Paris 1979
Paris-Moscou 1900–1930. Exh. cat. Centre Georges Pompidou.

Paris 1980
Les Marocains. Special installation of The Museum of Modern Art's *Les Marocains* at the Musée National d'Art Moderne, Centre Georges Pompidou.

Philadelphia 1948
Henri Matisse: Retrospective Exhibition of Paintings, Drawings, and Sculpture. Exh. cat. Philadelphia Museum of Art.

Pleynet 1971
Pleynet, Marcelin. *L'enseignement de la peinture: Essais*. Paris, 1971.

Prague 1969
Henri Matisse: ze sbírek sovětských muzeí (Henri Matisse in Soviet Museum Collections). Exh. cat. Návrodní Galerie.

Purrmann 1920
Purrmann, Hans. "Über Matisse." *Genius* 2, part 2 (1920), 198.

Purrmann 1922
Purrmann, Hans. "Aus der Werkstatt Henri Matisses." *Kunst und Künstler* 20 (1922), 167–176.

Purrmann 1930
Purrmann, Hans. *Henri Matisse*. Berlin, 1930.

Purrmann 1946
Purrmann, Hans. "Über Henri Matisse." *Werk* 33 (June 1946), 185–192.

Pushkin 1957
Gosudarstvennyĭ muzeĭ izobrazitel'ñykh iskusstv imeni A.S. Pushkina. Katalog kartinnoi galerei. Zhivopis'. Skul'ptura (Pushkin Museum of Fine Arts. Catalogue of the Paintings Gallery. Paintings and Sculpture). Moscow, 1957.

Pushkin 1961
Gosudarstvennyĭ muzeĭ izobrazitel'ñykh iskusstv imeni A.S. Pushkina. Katalog kartinnoi galerei. Zhivopis'. Skul'ptura (Pushkin Museum of Fine Arts. Catalogue of the Paintings Gallery. Paintings and Sculptures). Moscow, 1961.

Pushkin 1986
Gosudarstvennyĭ muzeĭ izobrazitel'ñykh iskusstv. Katalog kartinnoi galerei. Zhivipis'. Skul'ptura. Miniatura (Pushkin Museum of Fine Arts. Catalogue of the Galleries. Painting, Sculpture, Drawings). Moscow, 1986.

Quebec 1986
Tableaux de maîtres français impressionistes et post-impressionistes de l'Unión Soviéteque. Exh. cat. Musée de Québec, 1986.

Raynal 1950
Raynal, Maurice, and others. *History of Modern Painting: Matisse, Munch, Roualt*. Geneva, 1950.

Réau 1929
Réau, Louis. *Catalogue de l'art français dans les musées russe*. Paris, 1929.

Reff 1976
Reff, Theodore. "Matisse: Meditations on a Statuette and Goldfish." *Arts* 51 (November 1976), 109–115.

Reverdy 1918
Reverdy, Pierre. *Le Jockeys Camouflés*. Paris, 1918. Includes five drawings by Matisse.

Romm 1935
Romm, Alexander. *Matiss*. Moscow, 1935.

Romm 1937
Romm, Alexander. *Henri Matisse*. Moscow, 1937.

Romm 1947
Romm, Alexander. *Matisse: A Social Critique*. New York, 1947.

Rose 1982
Rose, Bernice. *A Century of Modern Drawing from The Museum of Modern Art*. Exh. cat. New York, 1982.

Rosenthal 1982
Rosenthal, Donald A. *Orientalism: The Near East in French Painting 1800–1880*. Exh. cat. Rochester, N.Y.: Memorial Art Gallery of University of Rochester.

Rusakov 1975
Rusakov, Yu. A. "Matisse in Russia in the Autumn of 1911." *Burlington Magazine* 117, no. 866 (May 1975), 284–291, reprinted in Barcelona 1988.

Russell 1969
Russell, John. *The World of Matisse 1869–1954*. New York, 1969.

Russell 1974
Russell, John. *The Meanings of Modern Art*. New York, 1974; reprinted 1981.

Russell 1975
Russell, John. *The Meanings of Modern Art, Vol. 9: A Lost Leadership*. New York, 1975.

Russell 1981
Russell, John. *The Meanings of Modern Art*. New York, 1981.

Salles 1952
Salles, Georges. "Visit to Matisse." *Art News Annual* 21 (1952), 37–39; 79–81.

San Francisco 1936
Henri Matisse: Paintings, Drawings, Sculpture. Exh. cat. San Francisco Museum of Art.

Schacht 1922
Schacht, Roland. *Henri Matisse*. Dresden, 1922.

Schapiro 1932
Schapiro, Meyer. "Matisse and Impressionism." *Androcles* 1 (February 1932), 21–36.

Schneider 1970
Schneider, Pierre. "Henri Matisse." *La Revue du Louvre* 20 (1970), 87–96.

Schneider 1982
Schneider, Pierre, and Massimo Carrà. *Tout l'oeuvre peint de Matisse 1904–1928*. Paris, 1982.

Schneider 1984a
Schneider, Pierre. *Matisse*. Paris, 1984.

Schneider 1984b
Schneider, Pierre. *Matisse*. New York, 1984; English translation of Schneider 1984a.

Selz 1964
Selz, Jean. *Matisse*. New York, 1964, reprinted 1989.

Sembat 1913
Sembat, Marcel. "Henri Matisse." *Les Cahiers d'Aujourd'hui* no. 4 (April 1913), 185–194.

Sembat 1920a and 1921
Sembat, Marcel. *Matisse et son oeuvre*. Paris, 1920; reprinted with additional illustrations in 1921 as *Trente reproductions de peintures et dessins précédées d'une étude critique par Marcel Sembat*.

Sembat 1920b
Sembat, Marcel. "Matisse und sein Werk." *Genius* 2, part 2 (1920), 190–196.

Severini 1944
Severini, Gino. *Matisse*. Rome, 1944.

Shchukin 1913
Catalogue des tableaux de la collection de M-r Serge Stschoukine. Moscow, 1913. In Russian and French.

Soirées de Paris 1914
"Sept reproductions d'aprés les oeuvres récentes d'Henri-Matisse." *Soirées de Paris* (15 May 1914).

Sterling 1957
Sterling, Charles. *Musée de l'Hermitage: La peinture française de Poussin à nos jours.* Paris, 1957.

Stockholm 1984
Henri Matisse. Exh. cat. Moderna Museet.

Swane 1944
Swane, Leo. *Henri Matisse.* Stockholm, 1944.

Tériade 1951
Tériade, E. "Matisse Speaks." *Art News Annual* 50 (21 November 1951), 40–71.

Ternovetz 1925
Ternovetz, B. N. "Le musée d'art moderne de Moscou (anciennes collections Stchoukine et Morosoff)." *L'Amour de l'Art* 6 (1925), 455–488.

Ternovetz 1933
Ternovetz, B. N. "Piatnadtsat 'let raboti Gosudarstvennogo Muzeia Novogo zapadnogo iskusstva (Fifteen Years of Collecting at the Museum of Modern Western Art)." *Sovetskii musei* 1, 1933.

Ternovetz 1934
Ternovetz, B. N. *Museum of Modern Art.* Moscow, 1934.

Tokyo 1981
Matisse. Exh. cat. National Museum of Modern Art.

Tono 1986
Tono, Yoshiaki. *Art Gallery 10: Matisse.* Shueisha, 1986.

Trapp 1951
Trapp, Frank Anderson. "The Paintings of Henri Matisse: Origins and Early Development (1890–1917)." Ph.D diss. Harvard University, 1951.

Tugendhold 1914
Tugendhold, Yakov. "Frantsuzskoe sobranie S. I. Shchukina (The French Collection of S. I. Shchukin)." *Apollon* (1914).

Tugendhold 1923
Tugendhold, Yakov. *Pervyi muzeĭ novoĭ zapadnoĭ zhivopisi* (First Museum of Modern Western Art). Moscow, 1923.

Venice 1950
XXV Biennale di Venezia. Exh. cat. French Pavilion.

Venice 1987
Henri Matisse: Matisse et l'Italie. Exh. cat. Ala Napoleonica e Museo Correr.

Verdet 1952
Verdet, André. *Prestiges de Matisse.* Paris, 1952.

Washington 1963
Paintings from The Museum of Modern Art, New York. Exh. cat. National Gallery of Art.

Washington 1973
Impressionist and Post-Impressionist Paintings from the U.S.S.R. Exh. cat. National Gallery of Art.

Washington 1984
The Orientalists: Delacroix to Matisse. The Allure of North Africa and the Near East. Exh. cat. National Gallery of Art.

Washington 1986a
Cowart, Jack, and Dominique Fourcade. *Henri Matisse: The Early Years in Nice 1916–1930.* Exh. cat. National Gallery of Art.

Washington 1986b
Impressionist to Early Modern Paintings from the U.S.S.R. Exh. cat. National Gallery of Art.

Watkins 1977
Watkins, Nicholas. *Matisse.* Oxford, 1977.

Watkins 1984
Watkins, Nicholas. *Matisse.* London, 1984.

Watkins 1985
Watkins, Nicholas. *Matisse.* New York, 1985.

Yakobson 1974
Yakobson, Sergius. "Russian Art Collectors and Philanthropists: The Shchukins and the Morozovs of Moscow." *Studies in the History of Art* 6 (1974), 156–173.

Zervos 1931a
Zervos, Christian, and others. *Henri-Matisse.* Paris and New York, 1931.

Zervos 1931b
Zervos, Christian, and others. "L'oeuvre de Henri-Matisse." *Cahiers d'Art* 5–6 (1931), 9–96.

Zurich 1982
Henri Matisse. Exh. cat. Kunsthaus Zürich.

Moroccan Literature

Bernard 1913
Bernard, Augustin. *Le Maroc.* 2d edition. Paris, 1913.

Blayney 1911
Blayney, Thomas Lindsey. "A Journey in Morocco: 'The Land of the Moors.'" *National Geographic* 22 (August 1911), 750–775.

Botte 1913
Botte, Louis. *Au Coeur du Maroc.* From *Collection des voyages illustrés.* Paris, 1913.

Edwards 1912
Edwards, Albert. "How They Live in Morocco." *The Outlook* 100 (30 March 1912), 738–744.

Escribano del Pino 1906
Escribano del Pino, Enrique. *Tanger y sus alredores.* Madrid, 1906.

Fogg 1937
Fogg, Philéas. *Le Maroc vu de Paris.* Paris, 1937.

Holt 1913a
Holt, George E. "Intimate Glimpses on Tangier." *The Travel Magazine* 22 (November 1913), 7–11, 57–58.

Holt 1913b
Holt, George E. "Visiting Raisuli, the Moroccan Bandit." *The Travel Magazine* 22 (December 1913), 16–19, 47–50.

Holt 1914a
Holt, George E. "Along the Moroccan Coast to Casablanca." *The Travel Magazine* 22 (January 1914), 31–34, 50–52.

Holt 1914b
Holt, George E. "The Moor at Home." *The Travel Magazine* 22 (February 1914), 16–19, 48–50.

Holt 1914c
Holt, George E. *Morocco the Bizarre, or Life in the Sunset Land.* New York, 1914.

Kerr 1912
Kerr, Robert. *Morocco after Twenty-Five Years: A Description of the Country, Its Laws and Customs, and the European Situation.* London, 1912.

Laredo 1935
Laredo, D. Isaac. *Memorias de un viejo tangerino.* Leyendas y resumes historicos de Tanger, desde los tiempos mas remotos hasta hoy. Descriptiones, narraciones, biografias, documentos, instituciones, etc. Madrid, 1935.

Leared 1891
Leared, Arthur. *Marocco and the Moors: Being An Account of Travels, with a General Description of the Country and Its People.* 2d edition. Rev. and ed. Sir Richard Burton. London and New York, 1891.

Lebel 1936
Lebel, Roland. *Les voyageurs français du Maroc: L'exotisme marocain dans la littérature de voyage.* Paris, 1936.

Loti 1889a
Loti, Pierre. *Au Maroc.* Paris, 1889.

Loti 1889b.
Loti, Pierre. *Into Morocco.* New York, 1889.

Morocco 1921
Morocco. Direction des Affaires indigènes et du service des renseignements. *Tanger et sa zone (villes et tribus du Maroc).* Vol. 7. Ed. Edouard Michaux-Bellaire. Paris, 1921.

Morocco 1926 (?)
What It Is Necessary to Know of Morocco: Booklet of Information for Tourists. Issued by Direction de l'agriculture, du commerce et des forêts. French Protectorate of Morocco, 1926(?).

Navarre 1913
Navarre, Albert. *Un Voyage au Maroc.* Paris, 1913.

Perdicaris 1906
Perdicaris, Ion. "Morocco, 'The Land of the Extreme West,' and the Story of My Captivity." *The National Geographic Magazine* 17 (March 1906), 117–157.

Rix 1914
Rix, Hilda. "Sketching in Morocco: A Letter From Miss Hilda Rix." *The International Studio* 54 (November 1914), 35–40.

Sheean 1926
Sheean, Vincent. *An American Among the Riffi.* New York and London, 1926 (Copyright 1925 by Asia Magazine, Inc.).

Tangier 1930
Tangier. Office de Publicité. *Tanger. Le guide pratique. Plan et nomenclature des rues adresses utiles.* Tangier, 1930.

Vaidon 1977
Vaidon, Lawdom. *Tangier: A Different Way.* Metuchen, New Jersey, and London, 1977.

Walsh 1908
Walsh, Henry Collins. "The Rifs in Morocco." *The Travel Magazine* 17(?) (November 1908), 66–69.

Wharton 1984
Wharton, Edith. *In Morocco.* London, 1920. Reprint Century Edition, 1984.

Index

Photo Credits

Photographs have been supplied by the owners of works of art unless indicated below.

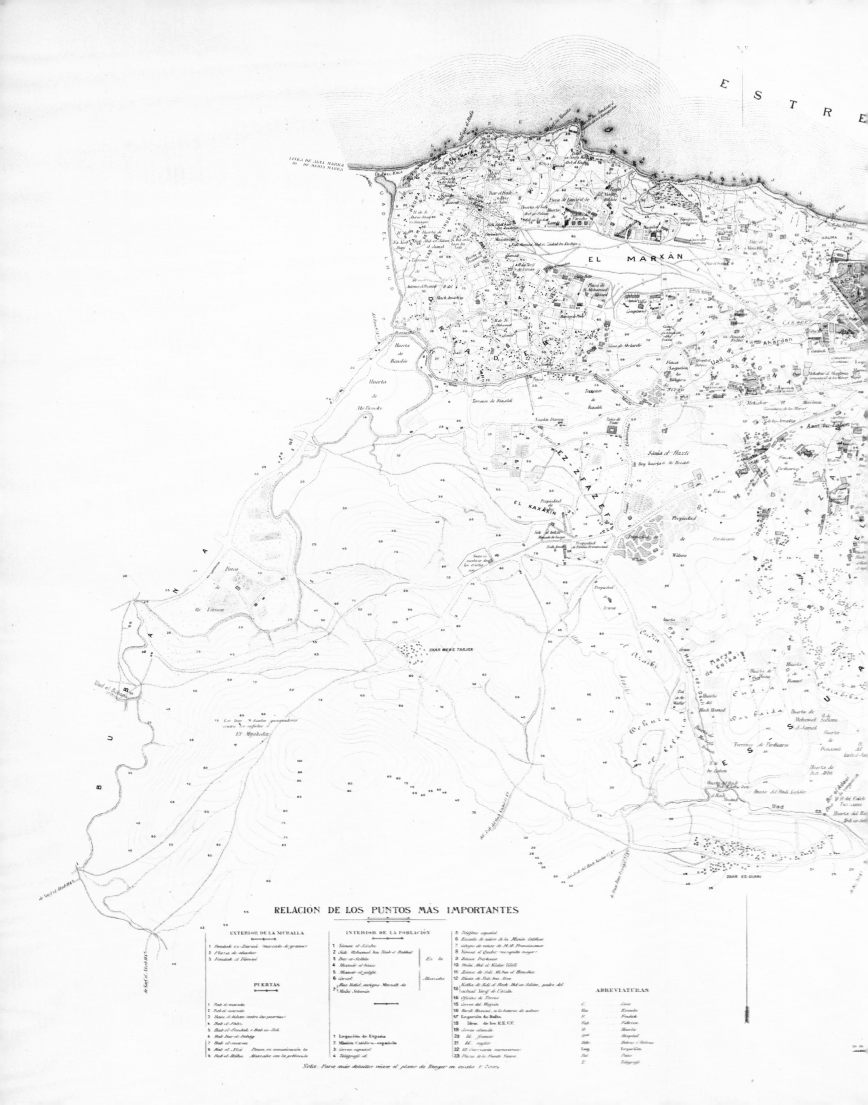

RELACION DE LOS PUNTOS MAS IMPORTANTES

EXTERIOR DE LA MURALLA

1 Fondak ez-Zuraá "mercado de granos"
2 Plaza de abastos
3 Fondak el Fámoi

PUERTAS

1 Bab el-marxán
2 Bab el-marxán
3 Bisis el-Aduin "entre las puertas"
4 Bab el-Finisi
5 Bab el-Fondak, ó Bab er-Sili
6 Bab Dar el-Debbag
7 Bab el-marsá
8 Bab el-Fási "Puan en comunicación ta"
9 Bab el-Mitlu "Alcazaba con la población"

INTERIOR DE LA POBLACION

1 Xáma el-Kebir
2 Sidi Mohamed ben Tiieb el Bakkal
3 Dar es-Soltán Es la
4 Mixmár el bisse
5 Mixmár el juliffa
6 Gircol Alcazaba
 Bisis Valid, antigua Munzáh de
7 Mulci Solimán

1 Legación de España
2 Mision Católica-española
3 Correo español
4 Telégrafo el

5 Teléfono español
6 Escuela de niños de la Mision Católica
7 Colegio de niñas de M.M. Franciscanas
8 Xáma el Quebir "mezquita mayor"
9 Xáma Barkasar
10 Mula Abd el Kéder Vileli
11 Zauia de Sidi Ali ben el Hamlisz
12 Zauia de Sidi ben Aisa
13 Kobba de Sidi el Hach Abd-es-Seláin, padre del
 actual Xérif el Arais
14 oficina de Torres
15 Cárcel del Mazén
16 Bordj Busnai, ó la batería de adion
17 Legación de Italia
18 Idem. de los EE.UU.
19 Cárcel adamále
20 Id. francesi
21 Id. inglés
22 El Contreraria marramanxx
23 Plaza de la Puerta Nueva

ABREVIATURAS

C. Cira
Esc. Escuela
F Fondak
Fab. Fabricas
H. Huerta
Hosp. Hospital
Hebr. Hebreos ó Hebrea
Leg. Legación
Pat. Paso
T. Telégrafo

Nota: Para más detalles véase el plano de Tánger en escala 1:5.000.

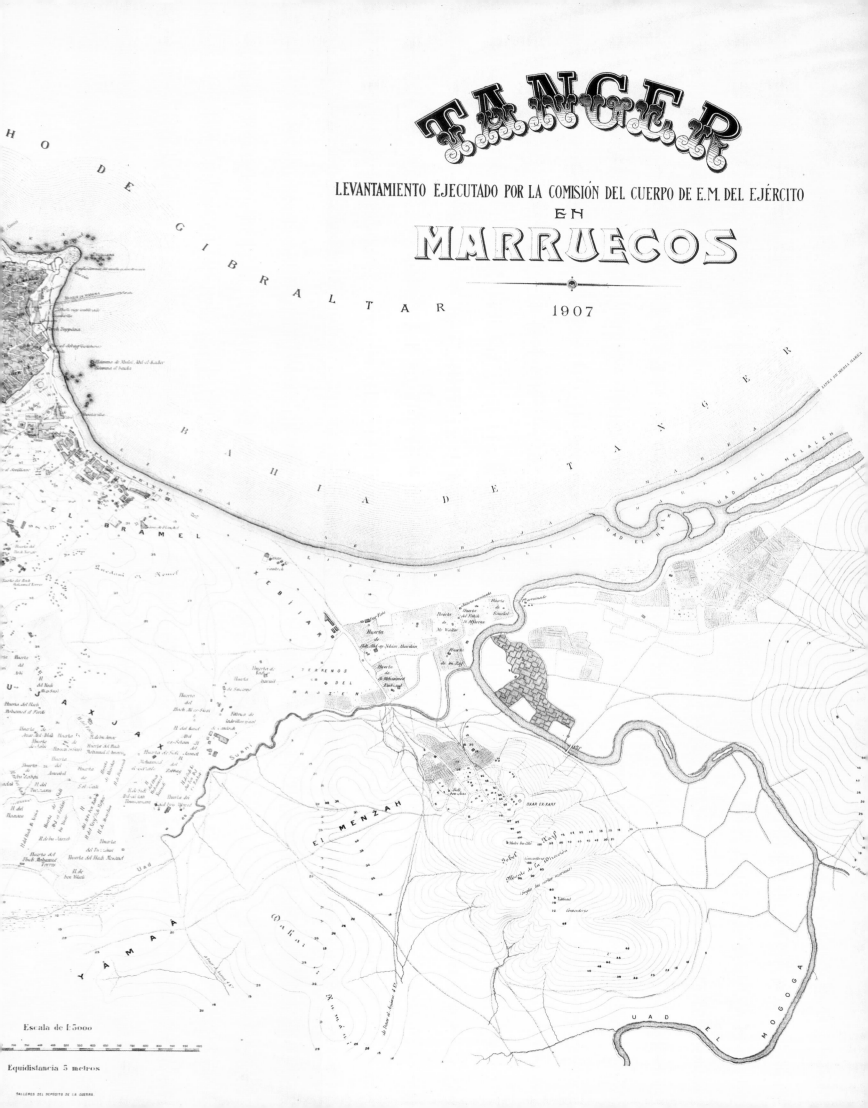

TANGER

LEVANTAMIENTO EJECUTADO POR LA COMISIÓN DEL CUERPO DE E.M. DEL EJÉRCITO

EN

MARRUECOS

1907

Escala de 1:5000

Equidistancia 5 metros